TERROUR or FRIGHT.

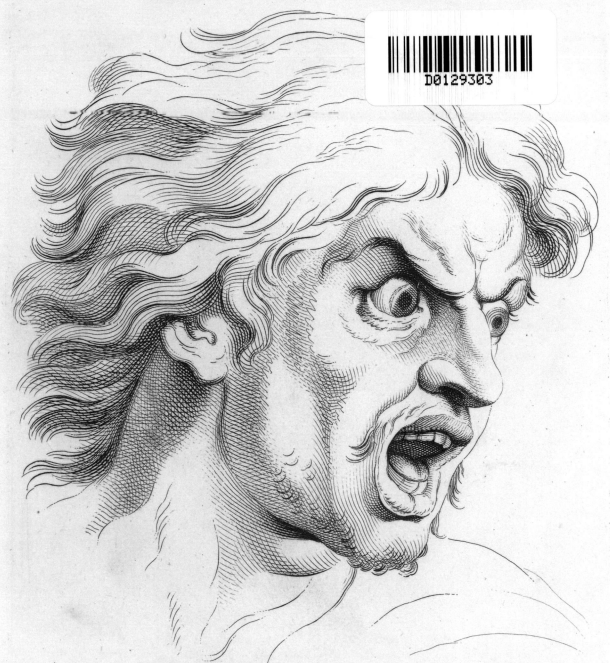

The violence of this Passion alters all the parts of the face; the eye-brow rises in the middle; its muscles are marked, swell'd, pressed one against y.ᵉ other, & sunk towards y.ᵉ nose, which draws up as well as y.ᵉ nostrils; y.ᵉ eyes are very open; y.ᵉ upper eye-lid is hid under y.ᵉ eye-brow; y.ᵉ white of y.ᵉ eye is encompassed with red; y.ᵉ eye-ball fixes toward y.ᵉ lower part of y.ᵉ eye; y.ᵉ lower part of y.ᵉ eye-lid swells & becomes livid; y.ᵉ muscles of y.ᵉ nose & cheeks swell, & these last terminate in a point toward y.ᵉ sides of y.ᵉ nostrils; y.ᵉ mouth is very open, & its corners very apparent; y.ᵉ muscles & veins of y.ᵉ neck stretch'd; y.ᵉ hair stands an end; y.ᵉ colour of y.ᵉ face, that is y.ᵉ end of the nose, y.ᵉ lips, y.ᵉ ears, & round y.ᵉ eyes is pale & livid; to conclude all ought to be strongly marked.

nᵒ16

REPRESENTING

THE PASSIONS

REPRESENTING

HISTORIES, BODIES, VISIONS

Published by the Getty Research Institute

THE PASSIONS

EDITED BY RICHARD MEYER

Issues & Debates

The Getty Research Institute Publications Program
Thomas Crow, *Director, Getty Research Institute*
Gail Feigenbaum, *Associate Director, Programs*
Julia Bloomfield, *Head, Publications Program*

Issues & Debates
Julia Bloomfield, Michael S. Roth, and Salvatore Settis, *Publications Committee*

Representing the Passions: Histories, Bodies, Visions
Edited by Richard Meyer
Elizabeth May, *Manuscript Editor*

This volume, the eleventh in the series Issues & Debates, evolved from the Getty Research Institute's 1997/1998 and 1998/1999 Scholar Years on the theme "Representing the Passions"

Published by the Getty Research Institute, Los Angeles
Getty Publications
1200 Getty Center Drive, Suite 500
Los Angeles, CA 90049-1682
www.getty.edu
© 2003 The J. Paul Getty Trust
Printed in Canada

07 06 05 04 03 5 4 3 2 1

Cover: Anne and Patrick Poirier, *Perverse Passions: Perversity Desire Obscur,* 1999. Courtesy Anne and Patrick Poirier/Bob Walker
Frontispiece: John Tinney, after Charles Le Brun, *Terrour or Fright.* From Charles Le Brun, *Monsr. Le Brun's Expressions of the Passions of the Soul* (London: printed by I. Tinney, n.d.), pl. 18. Courtesy Research Library, Getty Research Institute, ID no. 94-B17814

Library of Congress Cataloging-in-Publication Data
Representing the passions : histories, bodies, visions / edited by Richard Meyer.
 p. cm. — (Issues & debates)
Includes bibliographical references and index.
 ISBN 0-89236-676-1 (pbk.)
 1. Emotions in Art. 2. Arts. I. Meyer, Richard (Richard Evan) II. Series.
NX650.E46 R47 2003
700'.453–dc21
 2002009550

Contents

Visions

Acknowledgments

This book flows directly from a particular time and place: the two years that the Scholars and Seminars Program at the Getty Research Institute devoted to the theme of the passions. Michael Roth, then Associate Director of the Getty Research Institute, played an instrumental role in shaping the intellectual vision and collective energies of the program, and it was he who proposed that I edit this volume. I thank Michael for his support, sage advice, and professional encouragement. I am grateful as well to Salvatore Settis, formerly Director of the Getty Research Institute, and to Charles Salas, Sabine Schlosser, and JoEllen Williamson of Research and Education.

Julia Bloomfield, Head of the Getty Research Institute's Publications Program, combined unflagging patience with the utmost professionalism in bringing this book to completion. I am deeply indebted to her. Members of her staff who labored long and well on this volume include Elizabeth May, a gifted manuscript editor, and, in the development stage, Tyson Gaskill. I thank Bruce Mau and Chris Rowat for the stylishness with which the book is designed and Michelle Bonnice and Anita Keys for expert oversight of its production. Thomas Crow, Director of the Getty Research Institute, read the manuscript and offered astute suggestions for revision. I appreciate his intellectual guidance and thoughtful input.

For their support of this volume, I am especially grateful to Elspeth Brown, Juliet Koss, Reinhart Meyer-Kalkus, Adrian Piper, Linda-Ann Rebhun, Lesley Stern, Nancy Troy, and Wim de Wit. Finally, I wish to thank each of the contributors to this volume: Horst Bredekamp, Page du Bois, Martha Feldman, Stefan Jonsson, Elizabeth Liebman, Carol Mavor, Teresa McKenna, Anne and Patrick Poirier, David Román, Debora Silverman, David Summers, and Bill Viola. Their intellectual and creative passions drove this book and made the job of editing it a genuine pleasure.

—Richard Meyer

Introduction:
The Problem of the Passions

Richard Meyer

The concept of the passions has a distinctly antiquated ring. Like the seven deadly sins or the four humours of the body, the passions recall a premodern view of human nature. Rather than describing ungovernable impulses and overwhelming emotions in terms of the passions of avarice or rapture or pure love, contemporary scholars are far more apt to speak of subjectivity, sexuality, or the force of the unconscious.

On those occasions when the passions are invoked within contemporary culture, they tend to function as ciphers of extreme emotion. Consider the single major American exhibition on the theme of the passions mounted during the last decade: to coincide with the Summer Olympics in Atlanta in 1996, the High Museum of Art presented *Rings: Five Passions in World Art*, an exhibition of painting and sculpture from thirty-nine nations, spanning six continents and seven thousand years of artistic production. The exhibition was divided into five sections: "Love," "Anguish," "Awe," "Triumph," and "Joy." By way of explaining the show's organizing theme, curator J. Carter Brown noted in the catalog that "if there is an aspect of humanity that binds us together, it is our emotional selves. Whatever the color of our skin or the shape of our eyes, however conditioned by centuries of widely divergent cultural learnings, there remains in each of us fundamental human passions that we all share."[1] In Brown's conception, the passions link humankind together, regardless of racial, ethnic, or economic difference, regardless of regional, religious, or cultural identity: like the five interlocking rings of the Olympic logo, the passions stand as a sign for inclusiveness without inequity, for global equality without local conflict or context. Rather than dismissing *Rings* for its universalizing approach to art, I would stress instead how accurately the show represented what the passions have become in contemporary culture — grandly empty containers for emotion.[2]

The current status of the passions belies a long and complex history in which the term has variously described states of passivity, extreme suffering, and loss of self-control in the face of overwhelming impulses. In her contribution to this volume, Page du Bois traces the etymological roots of the passions back to the ancient Greek term *pathos*, which signified not sympathy or emotion but the more general category of lived experience, of "anything that befalls one." According to du Bois, the Greek notion of pathos later became entangled with the Christian use of the term *Passion* to name the suffering

and crucifixion of Jesus: "With the Christian description of Jesus' experience at the time of his death, the term *passion* first takes on connotations of bodily anguish and affliction."[3] The physical and emotional intensity of the Passion of Christ contributed, in turn, to the still later idea of the passions as a set of vehement, commanding, or overpowering emotions. Far from a clear transition from one meaning to the next, the semantic history of the passions is marked by multiple and overlapping associations. Passionate states such as love, sorrow, jealousy, and lust have often been likened to an external force (or affliction) that seizes the individual from without. When we speak of being "carried away by emotion," we attribute, in du Bois's words, an "external or alienated agency" to that feeling. In so doing, we return the passions to their earlier association with states of suffering and passivity.

This book proceeds from the conviction that the passions are not universal categories of emotion but historically specific, and therefore shifting, concepts of human experience and sensation. In the essays that follow, a range of scholars and artists focus on images, texts, and debates concerning the passions and their representation. Contributors look at how extreme experiences such as wonder, misery, ecstasy, and rage have been portrayed at different moments in the history of art, music, and philosophy. These essays do not attempt to catalog the passions as they have been depicted throughout Western culture. Instead they comprise a series of case studies that work through the tension between the passions and particular moments of their representation.

Most of the essays gathered here were written under the auspices of the Getty Research Institute's two successive yearlong programs on the theme of "Representing the Passions." All but two of the contributors to this book were scholars-in-residence at the Research Institute between 1997 and 1999. As a shared point of departure for its visiting scholars, the Getty outlined the challenge of representing and understanding the passions in the following manner:

> Clearly there is an important social need to name the passions, thus distinguishing them from one another, and to develop gestural and rhetorical conventions and codes about them. Yet their ungovernability threatens either to break through or to be lost by the cultural conventions and codes that attempt to fix, ritualize, and control them. The problem of coping with this ungovernability has been wrestled with by theorists of human nature, language, and politics since antiquity, and it continues to confront artists of all kinds — painters, actors, writers, musicians. "Representing the Passions" is a problem which is woven into the history of the arts and humanities and is an intricate part of their pattern still.[4]

The Research Institute's formulation of its Scholar Year theme opposes the cool and conventionalized work of representation to the hot immediacy of the passions. Representation labors to tame the passions, to "fix, ritualize, and control" them, while the passions, for their part, threaten to outstrip or

"break through" the constraints of representation. Yet why should representation be understood as containing the passions rather than constituting them? Do representations that portray passionate experience necessarily rationalize, tame, or defuse that experience? How might the passions overlap with, or even fuel the work of, representation? And, conversely, how might representation shape the experience of the passions? How clear is it that "there is an important social need to name the passions, thus distinguishing them from one another"? For whom has such a need seemed important and under what conditions?

These questions lie at the core of *Representing the Passions: Histories, Bodies, Visions*. Instead of tracing them across broad sweeps of history and culture, the essays collected here focus on specific examples of passionate representation ranging from a single philosophical text to a moment of modern political protest. *Representing the Passions* moves across multiple fields of creative and intellectual inquiry; its contributors specialize in history, art history, art practice, literature, philosophy, classics, theater studies, American studies, and musicology. The essays are linked, then, not by their objects of study but by a shared belief that the problem of the passions can best be grasped through its manifestation in particular images and texts.

Early Modern Passions

Although this book maps no single historical trajectory of the passions, six of its twelve essays touch upon the artistic and intellectual culture of early modern Europe. Given the prominence of seventeenth- and eighteenth-century European culture to this volume, I would like to offer a sketch of the problem of representing the passions during this period. My sketch centers on a famous pedagogical moment in which a French painter attempted to codify the passions for the purposes of instructing fellow artists.

In a paper presented to the Académie royale de peinture et de sculpture in Paris in 1668, Charles Le Brun cataloged some twenty-two passions, from jealousy to pure love to horror, according to the "external movements" each provoked upon the human face.[5] "Jealousy," to cite but one of Le Brun's examples, "is expressed by the wrinkled brow, the eyebrow drawn down and frowning, the eye sparkling, the pupil hidden under the eyebrow and turning towards the object which causes the passion, looking at it out of the corner of the eye while the head is turned away; the pupil must appear in ceaseless movement, and full of fire, as also are the whites of the eye and the eyelids."[6] To accompany his lecture, Le Brun sketched frontal and profile views of a male face "moved" by each of the twenty-two passions. The sketches are set against a grid, enabling the viewer to calibrate the degree to which a certain part of the face (the lower lip, say, or the left eyebrow) has been affected by the passion at issue. Like his textual descriptions, Le Brun's drawings present the various components of facial expression—the directional gaze and intensity of the eyes, the disposition of the eyebrows, the set of the mouth, the furrowing or flattening of the forehead, the bearing or hiding of the teeth—as a

function not of individual will but of the involuntary and immediate force of the passions.

Le Brun's goal was to provide a method for reproducing, in pictorial form, the expression of overwhelming emotion. His project was guided by a belief that the human body and, above all, the face, furnished a faithful index of the passions. For all the seeming precision of his analysis, however, Le Brun could not keep the various passions from sliding into one another. Jealousy (fig. 1), as it turns out, produces a facial expression so closely related to hatred that the two cannot be distinguished on visual grounds alone.[7] And hope (fig. 2)— to move to the happier side of the passionate spectrum—presents a problem insofar as "the movements of this passion are not so much external as internal" and thus produce little by way of facial expression.[8]

Within the logic of Le Brun's lecture, we find moments when the passions resist the taxonomic system into which they have been inserted, thereby evading the promised correspondence between internal sensation and external expression. Such resistance raises the possibility that the passions may never be fully codified or calibrated. Though not addressed by Le Brun, this possibility had been entertained earlier by René Descartes in his *Les passions de l'âme* (1649), the most influential philosophical text on the subject of the passions and the primary source for Le Brun's lecture to the Académie royale.[9] In his treatise on the passions, Descartes argues that the relation between passionate experience and facial expression cannot be taken as stable or fully predictable. "The soul," writes Descartes, "is able to change facial expressions, as well as expressions of the eyes, by vividly feigning a passion which is contrary to one it wishes to conceal. Thus we may use such expressions to hide our passions as well as to reveal them."[10] Descartes describes the self-conscious production of an expression at odds with the genuine emotion of the individual subject. Although he does not provide any examples of this phenomenon, Descartes elsewhere discusses the ability of the stage actor to provoke a passionate response on the part of the audience through the dramatic performance of a particular emotion.

Once we acknowledge the prospect of performing the passions, a space opens up between the passions and their visible effects, between internal experience and external expression. A feigned passion, whether in theatrical performance or everyday life, constitutes a form of representation, a self-conscious crafting of an expressive image for an audience of onlookers. Understood in this way, Descartes's concept of "vividly feigning a passion" anticipates Le Brun's attempt to catalog the visible effects of the passions so that they might be accurately imitated by artists. What Le Brun overlooked (or chose to ignore) was the possibility that individuals might exert some control over the expression of their own passions, that they might use their bodies as a way to conceal or reveal emotion selectively. Given the aims of Le Brun's lecture, such an oversight should not surprise us: to concede that the passions do not necessarily reveal themselves to the eye is to complicate the question of representing them in pictorial form.

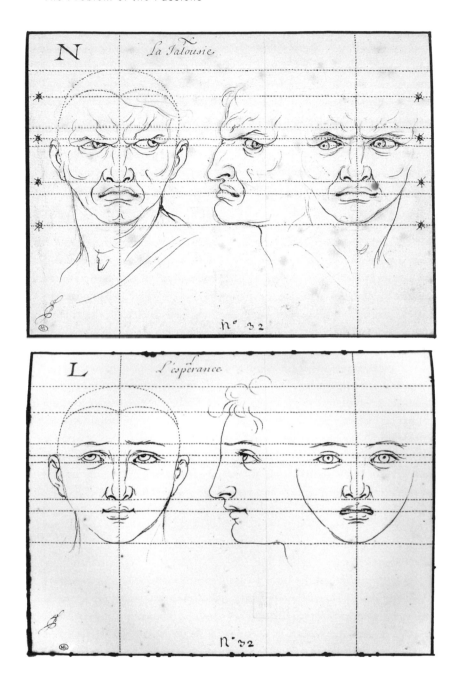

Fig. 1. Charles Le Brun (French, 1619–90)
N: La jalousie, ca. 1668, ink over black chalk, 19 × 25 cm (7½ × 9⅞ in.)
Paris, Musée du Louvre

Fig. 2. Charles Le Brun (French, 1619–90)
L: L'esperance, ca. 1668, ink over black chalk, 19 × 25 cm (7½ × 9⅞ in.)
Paris, Musée du Louvre

A key premise of *Representing the Passions* is that, *pace* Le Brun, the passions can never be fully classified or contained, that the force of extreme emotion undoes the very structure of such classification. If the passions are not fully legible, then no set of rhetorical conventions or pictorial codes can hope to describe them adequately. This is not to say, however, that all representations of the passions are equivalent in their insufficiency. As this volume of essays aims to show, certain forms of art, writing, and music have pushed representation to the limits of its expressive capacities. In such cases, representation does not capture the passions so much as it discharges a spark of their intensity.

Representing the Passions is divided into three parts — "Histories," "Bodies," and "Visions" — which stand as loose networks of association, rather than strict divisions or secure classifications. The boundaries between the sections are permeable, and virtually all the essays "migrate" at one point or another into the intellectual terrain of a neighboring section. In fact, two of the contributions to this volume literally appear in the space between sections, in the liminal zone where histories, bodies, and visions intersect. Both are the work of contemporary artists: an essay of production stills and handwritten notes by Bill Viola and a dossier of color photographs by the collaborative team of Anne and Patrick Poirier. The visual essays in the book are not intended to illustrate or explain the passions. Neither Viola nor the Poiriers should be construed as latter-day Le Bruns. Instead, these artists are responding to the emotional and corporeal intensity of the passions even as they acknowledge that the passions elude visual translation. Their art meditates on both the pleasures and constraints of passionate representation.

In the following brief description of the ten scholarly essays in this volume, I site from each so as to convey a sense of its specific texture and style of argument.

Histories

In "*Cogito* Embodied: Force and Counterforce in René Descartes's *Les passions de l'âme*," David Summers mounts a close reading of Descartes's last published work, written at the urging of his correspondent Princess Elizabeth of Bavaria. Summers takes us deep inside the Cartesian logic that links the passions to both the involuntary sensations of the body and to the free will of the soul. Toward the conclusion of his essay, Summers writes that, for Descartes, "perception never occurs without the mediations of passion." According to Summers, the Cartesian model of a consciousness shot through with "floods of individual feelings, fantasies, and memories" anticipates Sigmund Freud's much later theories of subjectivity and sexuality.

Descartes prioritized wonder as "the first of all the passions": he believed that "if the object presented has nothing that surprises us, we are not in the least moved by it and regard it without passion."[11] As Martha Feldman notes in "Music and the Order of the Passions," the Cartesian ideal of wonder was

powerfully on display in the spectacular visual marvels and "dazzling stage machines" of seventeenth-century musical performance in France and Italy. Wonder would not, however, claim center stage for long. Feldman argues that eighteenth-century opera emphasized the passionate experience of joy at the expense of wonder, in part by forging a new relation between the musical audience and the "star" singer. By attending carefully to the claims made by composers, critics, and audiences in Enlightenment Europe, Feldman demonstrates how music was used "to help valorize certain passions and censure others, and to inculcate their respective virtues and perils in listeners."

Stefan Jonsson focuses on the collective passions that provoked a particular—and particularly volatile—historical event: the mass uprising of workers in the city of Vienna on the night of 15 July 1927. In "Masses, Mind, Matter: Political Passions and Collective Violence in Post-Imperial Austria," Jonsson analyzes the class conflicts that fueled the riotous crowd and he discusses the ways in which writers and politicians retrospectively described the crowd. Perhaps more than any other contributor to this volume, Jonsson insists upon the gap between passionate experience and its representation, between, in this case, the chaotic passions of the workers and the subsequent portrayal of those passions in print. As if to give this gap a physical presence, Jonsson punctuates his essay with brief, italicized firsthand accounts, all in the present tense, of different moments from the riot: "*Just as she was kneeling down over the wounded, the fatal bullet was fired and crushed the back of her head.*" These passages rupture the smooth flow of Jonsson's historical analysis; they pierce the body of his text with fragments of sensation.

In "Observations on the Natural History of the Web," Horst Bredekamp considers the Internet as an arena in which the limits of visual experience are continually tested, transgressed, and redrawn. Beginning with a discussion of Thomas Hobbes and political theories of state power, Bredekamp argues that the Internet's promise of a free flow of data revives "the dream of a life divorced from the state." Such a dream has been complicated, however, by the predominance of pornography on the World Wide Web virtually since the moment of its debut in 1993. As Bredekamp points out, Internet pornography is regulated less by state censorship than by the entrepreneurial requirements of credit card payments, access passwords, and other forms of identification: "The Internet thus became an engine of addiction, in which money is siphoned off in return for direct access to the user's id. . . . the Web is surely the most comprehensive and protean repository of the images of taboo desires." Bredekamp's essay focuses on a specific moment in the history of the Internet and its contested role in the visual pleasures and prohibitions of contemporary culture.

Bodies

Within the history of both art and science, the boundaries of bodily experience have often been demarcated by way of the contrast between humans and animals. In "Unspeakable Passions: The Civil and Savage Lessons of Early Modern Animal Representation," Elizabeth Liebman explores how anxieties

about nature, monstrosity, and sexuality were projected on to images of monkeys and apes in eighteenth-century Europe. Drawing on scientific literature, illustrated fables, and humorous prints of the period, Liebman argues that "the figure of the primate aroused troubling and occasionally unspeakable emotions that reason neither explained nor contained." Situated at the crossroads of art history and the history of science, Liebman's research demonstrates how the discourse of the passions in early modern Europe summoned the image of animality.

David Román's essay, "The Afterlife of Sarah Siddons; or, The Archives of Performance," poses a series of questions about representation, collective memory, and the performing body. "How," Román asks, "might performance enable the transmission of cultural memory from one historical moment to another? In what ways might contemporary performances re-embody once celebrated, though now obscure, moments in theatrical history?" Román takes up these questions in a case study of the eighteenth-century English actress Sarah Siddons. Through a relay of representations that runs from Siddons as a virtuoso stage presence to Siddons as the Tragic Muse in a famous portrait by Sir Joshua Reynolds to citations of the Reynolds's portrait in twentieth-century forms of popular entertainment, Román details how Siddons's passion for performance was represented and re-embodied across two centuries of cultural production. Román proposes that the archives of performance reside not only in theatrical artifacts and material documents but also in subsequent acts of performance and recollection.

In "Pulling Ribbons from Mouths: Roland Barthes's Umbilical Referent," Carol Mavor describes the metaphorical presence of the maternal body in the later writing of Roland Barthes. In an impressionistic prose style that recalls Barthes's own, Mavor traces the presence of Barthes's mother, Henriette, in the texts *A Lover's Discourse, Roland Barthes,* and, especially, *Camera Lucida.* In this last book, a reflection on photography written shortly after the death of Henriette, the maternal body is at once powerfully described and painfully absent. In a famous act of withholding, Barthes declines to reproduce the photograph of his mother that he discusses at length in *Camera Lucida,* a book otherwise generously illustrated. Barthes's act of withholding bespeaks the impossibility of recovering the lost body of the mother, of retrieving what Mavor calls the "umbilical referent." If *Camera Lucida* simultaneously stages and mourns the loss of Henriette, so Mavor's essay alternately summons the figure of Barthes and acknowledges his absence. Mavor's text thus shuttles, as she puts it, "between real and not real, dead and alive, there and gone."

Visions
Debora Silverman maps the intersection of religious passion, lapsed faith, and modernist abstraction in "Pleasure and Misery: Catholic Sources of Paul Gauguin's and Pablo Picasso's Abstraction." Silverman argues that even as Gauguin and Picasso rejected the practice of organized religion, their work

continued to be bound by "the mental habits and filters" of Catholicism. Silverman attends not only to the theological tenets and educational training that shaped the works of Gaugin and Picasso but also to the visual form and facture of the works themselves. Silverman demonstrates how both artists restaged the passions of Catholicism within the field of modern abstract painting.

In "Collecting against Forgetting: *East of the River: Chicano Art Collectors Anonymous*," Teresa McKenna considers how the practices of art collecting and display may function as forms of communal memory and cultural affiliation. McKenna sets the collecting of Chicano art within the broader social and political context of the Chicano Civil Rights Movement and she questions the effects of collecting art that "points to the pain of social, sexual, and class inequalities." For instance, McKenna asks, "Why are these collectors, who are for the most part middle-class, attracted to objects that focus on the pain of Chicano history?" Rather than adjudicating the ethics of Chicano art collecting, McKenna outlines the passionate contradictions that lie at its core, the contradictions between artistic acquisition and material deprivation, between public history and private memory, between collective struggle and individual expression.

Although intense emotions have long been linked to the creation of art and literature, the role of the passions within scholarly research and writing is rarely addressed. In "A Passion for the Dead: Ancient Objects and Everyday Life," du Bois discusses her own passion for the material objects of the ancient world. The essay is studded with personal recollections which give way to scholarly insights. "My own passion as a classicist began one day long ago," du Bois writes, recounting her formative childhood attraction to some Roman glass in a town museum, glass that was "older than anything else in the place, older than anything else in the town besides the rocks." To this day, it is not the masterpiece of Hellenistic sculpture or Roman wall painting that most moves du Bois but, rather, the ancient object of quotidian use—the mixing bowl, terra-cotta urn, perfume vase, or shard of glass. In inviting us to see these objects through her eyes, du Bois proposes an alternative vision of both the ancient world and its modern presentation by museums and classicists.

As this sketch indicates, the categories of "Histories," "Bodies," and "Visions" structure this volume but do not determine it. *Representing the Passions* welcomes readers to move through the book according to their own patterns of interest, instead of in a linear fashion from the first essay to the last. If the passions simultaneously demand and resist the work of representation, so might readers of this book alternately engage, argue with, and reimagine its contents.

Notes

1. J. Carter Brown, "Introduction," in Michael E. Shapiro, ed., *Rings: Five Passions in World Art*, exh. cat. (New York: Harry N. Abrams, 1996), 16.

2. *Rings* provoked a series of memorably negative reviews in the press. In the *New York Times*, Roberta Smith declared that the show "deserves a special award" for "superficiality" and she lamented that the "wonderful objects" on display were "constantly degraded and limited by the show's simplistic universalizing." "Never before," claimed the *Wall Street Journal*, "have such sublime works of art been put in the service of such dopey ideas." See Roberta Smith, "Esthetic Olympics, In 5 Shades for 5 Rings," *New York Times*, 4 July 1996, sec. 3, p. 9; and Deborah Solomon, "The Art of the Olympics," *Wall Street Journal*, 5 July 1996, sec. A, p. 5. On the critical reception of *Rings*, see Elizabeth Lenhard, "Newspaper Critics Sneer at High Museum's Exhibit," *Atlanta Journal and Constitution*, 8 July 1996, sec. S, p. 19.

3. On the representation of the Passion of Christ in the visual arts, see James Marrow, *Passion Iconography in Northern European Art of the Late Middle Ages and Early Renaissance: A Study of the Transformation of Sacred Metaphor into Descriptive Narrative* (Kortrijk, Belgium: Van Ghemmert, 1979); and Jordan Kantor, *Durer's Passions*, exh. cat., 2 vols. (Cambridge: Harvard University Art Museum, 2000).

4. See http://www.getty.edu/research/programs/scholars/themes/1997-1999.html (6 May 2002). Two scholars who contributed to this volume — David Román and Carol Mavor — were not in residence at the Getty Research Institute, although Román's essay was first presented at a conference on celebrity organized by the J. Paul Getty Museum in conjunction with its exhibition *A Passion for Performance: Sarah Siddons and Her Portraitists*.

5. An excellent account of Le Brun's lecture and its implications for subsequent artists has been furnished by Jennifer Montagu, *The Expression of the Passions: The Origin and Influence of Charles Le Brun's* Conférence sur l'expression générale et particulière (New Haven: Yale Univ. Press, 1994).

6. Le Brun, as translated by and cited in Montagu, *The Expression of the Passions* (note 5), 136.

7. In *Les passions de l'âme*, René Descartes distinguishes quite explicitly between hatred and jealousy. He identifies hatred as one of the six "primitive" passions, the others being wonder, love, desire, joy, and sadness. All other passions Descartes views as combinations and subsidiaries of these six; he places jealousy as a subsidiary passion of desire and defines it as "a kind of anxiety which is related to our desire to preserve for ourselves the possession of some good. It does not result so much from the strength of the reasons which make us believe we may lose the good, as from the high esteem in which we hold it. This causes us to examine the slightest grounds for doubt, and to regard them as very considerable reasons." See René Descartes, *The Passions of the Soul*, trans. Robert Stoothoff, in idem, *The Philosophical Writings of Descartes*, ed. John Cottingham, Robert Stoothoff, and Dugald Murdoch (Cambridge: Cambridge Univ. Press, 1985), 1:§167.

8. Le Brun, as translated by and cited in Montagu, *The Expression of the Passions* (note 5), 135.

9. On Le Brun's debt to Descartes, see Montagu, *The Expression of the Passions* (note 5), 17–19, 101.

10. Descartes, *The Passions of the Soul* (note 7), 1:§113.

11. Descartes, *The Passions of the Soul* (note 7), 1:§53.

Histories

Cogito Embodied: Force and Counterforce in René Descartes's *Les passions de l'âme*

David Summers

When Thomas Hobbes wrote in chapter 2 of his *Leviathan* (1651) that "a thing...in motion...will eternally be in motion, unless something else stay it,"[1] he was not stating a principle of astronomy or physics; rather, he was extending one of the emergent principles of modern dynamics to human psychology. For Hobbes, light was a material activity, a force which, once its motion had been initiated, continued to work, first in sense, then in imagination: Light "presseth" the organ of sight, and this pressure is conducted by the nerves to the center, the heart, where it meets a "counter-pressure." Diverse external motions trigger diverse internal motions, "for motion, produceth nothing but motion." The "counter-pressure" is in its turn dynamic, and its outward direction in response to incoming force is the basis for our apprehension of the external world *as* external. When we apprehend the world in this way, we are perceiving external things, but only indirectly; things as they appear are "representations," merely "fancy," "the same waking, that sleeping."[2] Hobbes's materialist account had the somewhat paradoxical effect of giving a new and distinctively modern centrality to the *representation* of imagination, which now stood at the origin and threshold of human reality, in immediate opposition to the active external world.

Hobbes's scheme might be called inframodern, underlying as it does many successive variants up to the present. Certainly, the emergence of imagination and representation in their modern forms is a first major instance of the transformation of the traditional faculties of the soul according to the modern conviction that *force* is a final principle. If the external world is a theater of forces in interaction, the internal world, the experienced world of the subject, arises from a counterforce, somehow like force in being susceptible to it, but different in being a determinate resistance. Force and counterforce have provided an armature for two vast, ongoing modern projects: natural science and technology, and the correlative definition and institutionalization of the "subject" and "subjectivity."

Mechanism

At the beginning of his treatise *Les passions de l'âme* (1649), René Descartes proclaimed his project "modern," observing that the ancients had contributed very little to the matter. By this, Descartes meant that he was building upon

the advances of the astronomer Nicolaus Copernicus and the anatomists Andreas Vesalius and William Harvey, and he claimed to be approaching his subject from the position of a natural philosopher.[3] Descartes's opening arguments begin and end with a general definition of *passion* as relative to the subject to which it happens, and of *action* as relative to that which makes it happen.[4] This distinction stands, as Descartes would have known, in the long tradition of commentary on Aristotle, according to whom "active and passive things are called relative in virtue of an active or passive potentiality or actualization of the potentialities; e.g., that which can heat is called relative to that which can be heated."[5] The human passions are actualizations of potential reactions to the external world. Descartes wrote that nothing "acts more directly upon our soul than the body to which it is joined," that is, the soul suffers passions in its union with the body. At the same time, "a passion in the soul is usually an action in the body"; we are passive to what happens to us, but our passions, properly speaking, are evident in our reactions to what happens to us.[6]

The symmetry/asymmetry of soul and body as passion and action bespeaks Descartes's affinity for the Aristotelian idea of the substantial union of form and matter: although thinkable in themselves, form and matter only exist in the actualities relative to which they are both potentialities, that is, in real things.[7] Descartes of course rejected Aristotelian hylomorphism, which entailed explanation by final cause, and came to refer to *form* as the shapes and sizes resulting from motions in extended matter.[8] But if for Descartes all natural movements, including those of animals, could be explained as movements of matter, free intellective movements could not, and he therefore reserved a kind of hylomorphism for human beings. Descartes often referred to the human being as a *compositum*, the Scholastic term for the unity of matter and form, suggesting that what most interested him was precisely the *union* of matter and form, that is, the modalities of substantial individuality.[9]

Les passions de l'âme was Descartes's last philosophical work published in his lifetime. It was written during the winter of 1645 for Princess Elizabeth of Bohemia, to whom Descartes had dedicated his *Principia Philosophiae* (1644) in the previous year. After reading his *Meditationes de Prima Philosophiae* (1641), Elizabeth, about half Descartes's age, wrote to the great philosopher in 1643 asking how a thinking substance could cause the body to perform voluntary actions. Descartes responded that we must not suppose this interaction to be like that of physical bodies. Gravity, in fact, a force that does not work by the contact of bodies, was "given us for the purpose of conceiving the manner in which the soul moves the body."[10] Elizabeth replied that she could not understand this argument, excusing herself by saying that the duties of her position kept her from the necessary mental exertion. But Elizabeth's questions lingered, and Descartes's treatise on the passions was written in dialogue with her.[11]

If Descartes was self-consciously modern in considering the passions from the standpoint of post-Vesalian anatomy and the embracing mechanics of

Copernican nature, he was also modern in being Christian as opposed to pagan. Descartes accepted the traditional Christian idea that the soul is joined to the body by God; that it is both free and fully *incarnated;* that it is not simply a "helmsman" in a ship, but "must be more closely joined and united with the body in order to have, besides [the] power of movement, feelings and appetites like ours and so constitute a real [person]."[12]

Descartes's adoption of the modern doctrine of mechanism—based on the belief that all events may be analyzed into relations of efficient causes—made it possible for him to dismiss the division of the soul that had descended over the millennia from Plato, who distinguished between reason and the lower concupiscent, or appetitive, and irascible functions of the soul.[13] Descartes maintained that there could be no division within the human soul.[14] Growth, bodily processes, and locomotion—all long attributed to the lower functions of the soul—were to be explained instead as the workings of a machine that kept going as long as fire remained in its heart. A human corpse, Descartes argued, is like a broken clock.[15]

In *L'homme*—written between 1629 and 1633 and published posthumously in 1664—Descartes imagined an automaton able to "imitate perfectly the movements of a real man": "the digestion of food, the beating of the heart and arteries, the nourishment and growth of the limbs, respiration, waking and sleeping," the activities of the external and internal sense organs, "the internal movements of the appetites and passions, and finally the external movements of all the limbs (movements . . . appropriate not only to the actions of objects presented to the senses, but also to the passions and impressions found in the memory)."[16] Descartes's list of mechanical movements represented the passions as reflexive or involuntary reactions; insofar as this type of reaction is also characteristic of human beings, human beings are like animals, which Descartes considered automata, not because they lack feelings but because they can only react immediately and mechanically. There are in fact many examples of human movements absent conscious volition; at the level of the passions, when we perceive something frightful, Descartes, the onetime soldier, wrote that "the body may be moved to take flight by the mere disposition of the organs, without any contribution from the soul."[17]

This line of thinking immediately raises a question, one that is magnified by Descartes's embrace of the ancient analogy of nature and art. The "works" of nature and art, he argued, are analogous as mechanisms; the difference between them is simply one of scale. Human artifacts are necessarily made in sizes suitable to the human hand and eye, while natural artifacts are realized at the level of the "interaction of bodies that cannot be perceived."[18] But if the art of God and nature is simply much more subtle and intricate than human art, why is it not possible that a human being is a more complex automaton, with more and more minute, reactive mechanisms than any of which human art is capable?

Descartes evidently believed that the definition of the mechanical "disposition of the organs" could also help define those movements only attributable

to the free intellective soul. An automaton, Descartes wrote in the sixth of his *Meditationes,* could only perform movements *not* under the control of the will or the mind.[19] Sensations move the spirits and the central "pineal" gland of animals (Descartes called the pineal gland "the principal seat of the soul"), but these movements only sustain and strengthen the movements of nerves and muscles; in human beings, by contrast, sensations sustain and strengthen the *passions themselves.*[20] This higher activity is distinctively human and moreover immediate to the soul. The passions, and not the senses alone, are responses to reality as it is encountered; but the passions also present the soul with reality as the constant opportunity for free choice, while at the same time tending to counter free choice.

The "animal spirits" — by means of which communication is effected between the organs of sense (*organon* in Greek means tool or implement) and the soul — are a version of a much older physiology. *Pneuma,* which became the Latin *spiritus,* originally *breath,* was associated with life and was a medium between soul and body.[21] The ancient and pervasive hierarchy of mind over body entailed a polarity, which spirit resolved. Descartes's animal spirits, coursing back and forth between the body's organs and the pineal gland, although material, are higher on the ontological ladder than the mechanical body; more like the soul, these spirits have degrees of subtlety suiting them to higher and higher functions.

I see a lion, I am afraid and my body inclines me to run, but I may choose not to. I am inclined as I am, not simply because I see the lion but because I *fear* the lion I see. In order to explain this extrasensational response, it is necessary, Descartes argued, to suppose that the animal spirits carry *two* kinds of movements. The first are the "representations" or "impressions" of sense that inform the soul (as in animals) but do not affect the will; the second "cause the passions and [at the same time] *the movements of the body that accompany them,*" to which the will may react.[22] The passions, however, move the soul to consent to such movements, which the soul may or may not do. The will cannot counter the animal spirits directly but can only "repugn" their urgings by advancing alternative representations (I might think of the praise I will receive for not running when frightened) or by restraining our actions (I may not strike, as I am predisposed to do when angry).[23]

In general, Descartes's taxonomy of the passions was a development and clarification of previous arguments concerning the most basic passivity of sensation. In the *Principia Philosophiae,* Descartes argued that we know about the close conjunction of body and mind in much the same way that we know about external objects; we perceive clearly that "pain and other sensations come to us quite unexpectedly. The mind is aware that these sensations do not come from itself alone, and that they cannot belong to it simply in virtue of its being a thinking thing; instead, they can belong to it only in virtue of its being joined to something other than itself which is extended and moveable — namely what we call the human body."[24] Furthermore, these sensory perceptions, which exist only for the actual union of body and soul, in real indi-

viduals, instruct us not in the nature of things themselves but, rather, in what is beneficial or harmful for this union. The passions develop and refine this conception of the fundamental purpose of the soul's passivity. In the most general terms, the passions are "all of those kinds of perceptions and knowledge [*perceptions et connaissances*] found in us; because it is often not the soul that makes them as they are, rather the soul receives them from what is represented to it."[25]

The higher activities of the animal spirits associated with the passions have indefinite durations, and they differ in their variable temporality from the sensations and memories to which they are joined. This fact points to a fundamental functional difference between sensations and passions. The eye that *sees* the lion does not *fear* it. The senses may distinguish between things, but the passions define given external objects that occasion sensation as either harmful or beneficial to us, or of "general importance" to us. "The utility of all the passions consists simply in the fact that they strengthen and prolong thoughts in the soul which it is good for the soul to preserve and which otherwise might easily be erased from it."[26] Put another way, the passions "dispose the soul to will [*vouloir*] things that nature tells us are useful, and to persist in this will." In general, in order to enumerate the passions, it is necessary to consider "all the various ways having importance for us in which our senses can be stimulated by their objects."[27] The passions, or at least what Descartes called the "primitive" passions, are thus, in a broad and untendentious sense of the word, "selfish." The quasi-mechanism of the passions focuses the world of sensation, defining it for the purposes of the preservation and augmentation of the embodied self.

The animal spirits work their effects in the cavities of the brain, where they also preserve a lingering surplus of their motions. These surpluses are not necessarily predictable (or mechanical) in their workings, and they may prolong thoughts beyond their usefulness, or cause us to dwell on the wrong thoughts altogether.[28] Individual memory is continually shaped by things, but also by the passions associated with them, so that temperament is part of the fabric of consciousness. Drifting surpluses of passion explain the intrusion into consciousness of dreams and daydreams, and other passions may be aroused by the "impressions which happen to be present in the brain, as when we feel sad or joyful without being able to say why."[29] Some surpluses last indefinitely. A person may not remember being repelled by roses or frightened in the cradle by a cat, but such passionate reactions, lodged in the eddies of the higher animal spirits, may result in lifelong aversions to roses or cats.[30]

In general, passions alter perception itself, making both goods and evils appear "greater and more important than they are."[31] The autonomy of this pneumatic activity in relation to consciousness thus provides a physiological basis for Descartes's systematic doubt. "Everything the soul perceives by means of the nerves [that is, all sensations conveyed by the animal spirits] may also be represented to it through the fortuitous course of the spirits."[32] Perception is force and motion mediated to the soul; because the mechanism

of mediation itself has activities independent of sensation, dreams may seem as real as reality.

Descartes generalized and extended the principle of somatic memory as a kind of association, not just of ideas themselves but of ideas, passions, and predispositions, any of which could trigger the others: "our soul and our body are so linked that once we have joined some bodily action with a certain thought, the one does not occur afterwards without the other occurring too."[33] But if, from the beginning of our lives, nature has linked our thoughts to the movements of the pineal gland, we may still change these links through habit. Language provides an illustration. Our senses see only the shapes of letters or hear the sounds of syllables, but custom makes us conceive what they signify. Language teaches us to see or hear one thing and think something else entirely — for instance, to hear the word *autumn* and be filled with memories and feelings. By the same token, the movements representing objects to the soul may be recoupled with very different things. Dogs who chase birds and run away at gunshots may be trained to point and retrieve at the same sensation-signals. We human beings, precisely because we have passions that are relatively separable from sensations, are even better able to "educate" our behavior. Through such conditioning, even the weakest souls (that is, those whose lives are most defined by their passions) may achieve absolute dominion over their passions. The passions are all by nature good, and "we have nothing to avoid but their misuse or their excess."[34]

In conformity with the nominalist principle that explanation should be sought among already posited entities, themselves subject to reduction if possible, Descartes looked to prenatal experience to locate the origins of the primordial linkages of passions and predispositions to movement. When the soul begins "to be joined to our body," the fetus discriminates between nourishment that best maintains the heat of life and that which least maintains or threatens it, striving to obtain the one and avoid the other, thus laying the basis for love and hate. When there is an abundance of nourishment, and no effort is necessary, the somatic basis for joy is established, just as times of lack establish the basis for sadness. In the fetus, as preparation for life, the animal spirits begin to move all the sense organs and muscles in all possible ways.[35] The "primitive" passions, the fundamental urges to seek the perceived beneficial and harmful, are innate, somatic memory by the time we are born.

Consciousness

For Descartes, sensations, appetites, and passions are "subjective" in a modern sense of that modern word. In fact, the very idea of the subjective as *feeling* in contrast to the physical-mathematical "objective" is taking shape in Descartes's writing: what we call subjective experiences "arise from the close and intimate union of soul and body"; they are *for a consciousness* and, taken together, constitute an individual life.[36]

Not only the body but the soul itself is a source of "perceptions"; thus there is a "perceiver," a consciousness, of external and internal sensations as

well as of volitions. We *will* certain things, and we do so with a necessity and awareness comparable to the necessity and awareness of external perception: "For it is certain that we cannot will anything without thereby perceiving that we are willing it."[37] An action of the soul, or volition, may also be said to be a passion *in* the soul, taking the term *passion* in a broad sense, as, like sensation, something that happens to the soul. But, Descartes argued, since the perception of the volition is the same as the volition itself, it is not really a passion after all, but an action. He seems to say that what wills is also what "perceives," presumably because if it were not so, volitions would be the same as sensations or passions, and consciousness would be indistinguishable from its content. That is to say, the free, intellective soul is self-aware at the same time that it is aware of its experience; or, consciousness is an individual free intellective soul.

In book 9 of the *Nicomachean Ethics*, Aristotle argued that in human beings, life is defined by the capacity (*dynamis*) for perception and thought, and that the reality of this capacity lies in its activity (*energeia*).[38] In *De somniis*, he wrote that "it is not by sight" that we are aware that we see, but rather by virtue of a common faculty, the same as that by which we are able to judge (*krinein*) that white is not sweet—that is, that different senses produce different sensations. Such discriminations are made by the "common" sense (*koine aisthesis*), which Aristotle here called the "master sense organ" (*kyrion aisthētērion*) and which he characterized as acting in different ways through different organs with respect to different sensibles. This master sense organ is closely related to touch.[39] No animal may live without touch, Aristotle argued, and the other senses all presuppose touch, which is immediate to conditions that must be sought or avoided in order for an animal to survive. Taste is a kind of touch, and the remaining three senses are mediated, at a distance from their objects, and exist for the "well-being" of the animal. That is, sight, hearing, and smell enable an animal to put itself in proximity to what may be touched (and eaten) with good results.[40] This account of basal or common sensation offers a close schematic parallel to Descartes's "primitive" passions; and Descartes too would give unprecedented priority to the sense of touch.

Life, Aristotle asserted, is a good that we all desire, and we have the capacity to perceive (*aisthanomai*) that we see, that we hear, that we walk; in short, we are conscious of all our activities, which are in fact realizations of potentials. Such consciousness is itself a faculty, the potentiality of which is actualized as we perceive or think. When we perceive that we perceive or that we think (as well as when we are conscious of our bodies, as we must be in some sense in order to walk at all), we are also conscious that we exist. Since life is good, we are pleased to be aware that we possess it, and, Aristotle concluded, we are most pleased when we lead the best life.[41]

If we understand this argument in light of the passage from *De somniis* just considered, Aristotle meant that consciousness *is* the realization of the master sense organ, the common sense, to which the particular senses are secondary and for which they *are* organs. Since Aristotle included in this list

walking along with seeing and hearing, walking must correspond to touch. Our awareness of walking, as sensation, is tactile, somatic, and proprioceptive; and if touch and common sense are analogous, then our functional awareness of walking as a living act is inseparable from consciousness.

At the beginning of the *Principia Philosophiae*, Descartes argued that our knowledge of our thought is prior to, and more certain than, our knowledge of any corporeal thing. He defined thinking (*penser*) as "everything which we are aware of as happening within us, insofar as we have awareness of it"; and, he continued, "thinking is to be identified not only with understanding, willing and imagining, but also with sensory awareness." That is, sensing is thinking because we are aware of it in the same way that we are aware of understanding, willing, and imagining. It is not, however, possible to say "'I am seeing,' or 'I am walking,' therefore I exist," since seeing and walking may be doubted; I might be dreaming that I see or move, and I might even have no body at all. If by such a statement, however, I mean only to refer to "the actual sense or awareness of seeing or walking,"[42] which makes it seem that I see or walk, then the statement is absolutely true and cannot be doubted. This is so because I am aware of the action of the soul or, perhaps better, *in* the action of the soul.

In *De anima* Aristotle defined the soul (*psychē*) in general as "the first actuality [*entelecheia*] of a natural body potentially possessing life," or, "of a natural body possessed of organs."[43] Soul and body are one, as wax and the impression it receives are one (Aristotle's metaphor for *aisthesis*, or apprehension by sense). That is, wax has the potential to receive impressions, and what is actual, and most significant, is the impression it does receive, or its actuality in that very reception, or in reception altogether. The soul may be said to be present in actual sensation or perception.

Descartes discussed this passage, which he remembered from the Schools, in his *Notae in Programma quoddam* (Comments on a certain broadsheet), which was written in part to separate his doctrines from the Cartesianism that had grown up around them, namely in the work of his disciple Henricus Regius. Descartes understood Regius to have argued that the soul was in effect another organ of an organic body. If this were so, Descartes claimed, we could not explain how we use our intellects, how we clarify experience in the light of reason.[44] We have seen that Descartes maintained a version of Aristotle's argument that the soul is the form of the body, also stated at the beginning of the second book of *De anima*. When Descartes turned to the nettlesome issue of "innate ideas," he again took up arguments very like Aristotle's. Aristotle compared *entelecheia* to the possession of knowledge, which we have when we simply know things but have differently when we do things knowledgeably. We must, however, have knowledge in order to use it, and so potential must be prior to use. If the soul actually exists in its activity, it does so *with* the organic, sentient body as a whole, and awareness or consciousness (*egrēgopsis*) is the *entelecheia* in this higher, active sense.[45] For Descartes, the mind has the potential to make rational sense of the world, and

this potential must be "innate."[46] But the body also has the potential to respond to the world in determinate ways, and we are now in a position to make sense of another of Descartes's definitions of the passions: "the perceptions, or sensations, or emotions of the soul, *that may be referred only to it* [as embodied], and are caused, maintained and strengthened by certain movements of the spirits."[47] The passions vary with individual temperaments and experiences, but they are also innate, and immediate to consciousness.

Indirectness

Descartes was inspired to his vision of the human machine partly by the fountains he had seen as a young man in the grottoes of the royal gardens at Saint-Germain-en-Lay.[48] The "mere force" of released water in these automata was sufficient, through a system of tubes and reservoirs, to cause them to speak or play instruments. In Descartes's extraordinary analogy, the equivalent of objects of perception are the *viewers* of the automata, who, rather than being seen by sightless mechanical eyes, unknowingly step on a tile, initiating a process that ends when a bathing Diana has concealed herself in the reeds. She *seems* to see and hide from us, but really she "reacts" to the pressure exerted by our weight upon the tile, an event that might have been begun by anyone, by Actaeon or one of his dogs, for example.[49] This does not mean that no initiatory event occurred, or that you or I did not step on the tile, but it does mean that there is no simple image-relation between perception and its object.

Descartes carried the principle of indirect perception vividly illustrated by this example to truly radical lengths, arguing that light itself is a force different from our perception of it;[50] he began his treatise on optics with the example of walking in the dark with the help of a stick, comparing the judgments of vision to those made by the blind on the basis of touch. He scoffed at the traditional idea that the sense of sight, and thus the mind, somehow grasps "little images of things flitting through the air."[51] Visual perception — a process he compared to a painterly print or to reading, in both of which marks or signs occasion all kinds of meanings and imaginings — occurs not at the retina but at the inner end of the optic nerve, and in the mind itself. Like language and painting, sight teaches us to sense one thing and think something quite different. We must always interpret and shape external events, which are never self-evident. (It is, as we shall see, also necessary that we continually imagine ourselves.) Descartes's epoch-making doubt might thus be seen as the first great attempt to come to grips with the indirectness of perception entailed by physiological mechanism. The world in such terms is not a fable (as the inscription on one of Descartes's portraits reads), but there is also no question of a "mirror of nature."[52]

Indirectness gave an entirely new dimension to skepticism. The old quandaries of oars appearing bent in the water, or square towers appearing round at a distance, the ancient paradigms of the unreliability of sense, which Descartes repeated in his turn, only hinted at broader systematic problems

and at a vast, still continuing project. The ancient "fallacies of sight" settled into the stream of all experience *for a subject.* Augustine had argued against the Academics, the Platonist skeptics of his day, that he himself must exist in order to be deceived; but the completeness of the mechanical mediation of externality to the mind or soul implied that the bare awareness of one's existence had to be adapted and expanded to become the counterpart to all of one's experience, relative to which reality is constituted by reaction, distinction, and interpretation; mind and body reveal themselves as the capacities to react in appropriate ways, to distinguish and interpret.

Descartes's account of sight had the most fundamental of implications. If we think of the senses in terms of passivity, then the nervous system is the organ of the sense of touch, under which Descartes had, in effect, subsumed vision. Visual sensation is bodily, both its impressions and their accompanying passions joining the array before consciousness of other "feelings" and "sentiments." The general notion of the body as a responsive mechanism, and the centralization of its responses, may thus be seen to involve not only indirectness but the unification or reduction of the senses to touch. The sense of sight itself has become a kind of touch at a distance, to be distinguished from the "sight" of the mind's eye.

The Judgments of the Body

In the last of his *Meditationes,* in which he set out to demonstrate the existence of material things and the distinction between soul and body, Descartes put forth an argument that will repay close and careful paraphrase:[53] I have a clear and distinct idea of myself as a thinking thing, and I have a clear and distinct idea of my body. The first idea is higher. How might these two be put together? I find in myself faculties of thought of a very particular kind, but distinct from myself—that is, as a thinking thing—namely, imagination and sensation. I can think of myself without imagination and sensation, but I cannot think of imagination and sensation without myself. And yet there is an intellectual act included in their essential definitions; they must then be distinct from mind in the way that accidents (for example, changes in shape and movement) are distinct from the substance of physical bodies. Moreover, I find in myself a certain *passive faculty* of sensing, of receiving, or knowing the ideas of sensible things; but this faculty would be useless to me, and serve no purpose, if there were not in me, or in another, an *active* faculty, capable of forming or producing these ideas. Descartes then offers a peculiar spin on the idea of the givenness of sensation. The actions that yield my ideas cannot come from me, insofar as I am a thinking thing, since they not only presuppose no thought on my part, but are often represented to me without any contribution on my part, and even sometimes against my will. The counterparts to my ideas must therefore exist in some substance different from myself. There are two possibilities, nature (or body, extension) and God. Since God is good, and would not deceive us, and has moreover given us a strong inclination to assume the existence of the external world, corporeal things exist, even

if they are not always what they seem, and even if we may form mistaken (but useful and correctable) judgments about them. This conclusion has a simple and fundamental consequence: not only does the corporeal world exist, but sense and imagination equip us to live in it and deal with it—and so do the passions.[54]

The passions, far from being merely illusory, have a kind of infallibility "We cannot be misled…regarding the passions, in that they are so close and so internal to our soul that it cannot feel them unless they are truly as it feels them to be." Disturbances of blood and spirits corresponding to certain perceptions remain "present to our mind in the same way as the objects of the senses are present to it while they are acting upon our sense organs," and strong feelings, which Descartes compared to thunder or a fire burning the hand, are infallibly present until the disturbances subside.[55] Perceptions are passionate, and passions are really perceived.

The conditional vindication of sense, imagination, and passion brings us to the question of "clear and distinct knowledge" and its counterpart, the "obscure and confused." This juxtaposition was ancient, but in Descartes's hands it assumed quite a different meaning.[56] The confused was always associated with the "data" of sensation and did not imply being muddled or fuzzy. Perceptions are "confused" retroactively, so to speak, as if they had awaited the analysis and definition to which they are always potentially subject. Modern epistemological concern with the clear and distinct (in which Descartes as a mathematician and natural philosopher was also most interested) conceals the fact that we conduct much the greater part of our lives in terms of obscure and confused perceptions, which is not to say that we live our lives in ignorance, but rather that we live them largely pre-analytically. And, although reason may amend our perceptions, it is not possible and by no means desirable that all experience be made distinct.[57]

Descartes juxtaposed imagination and reason as proper to body and mind, respectively. Obscure and confused ideas are *by* the body (that is, by the organs of sense and the nervous system, hence their coupling with passions) and *of* the body (that is, they are not only external but also internal). To be sure, we "pervert and confound the order of nature" if we assent to appearances and conclude space to be empty, the sun to be the size it appears, or external objects to exist as they seem to. But we really possess the "sensations or perceptions of sense" upon which such mistaken judgments may be made "in order to signify to the mind [*esprit*] which things are beneficial or harmful to the union [*composé*] of which it is part, and *to that extent they are sufficiently clear and distinct*."[58] What Descartes called "imagination" is partly compounded of the passions; it makes and executes judgments concerning the beneficial and harmful with "sufficient" clarity and distinctness, as if rationally, but without the intervention of reason. "Imagination" is a kind of particular intellect, the indispensable means by which we deal with things as they come to hand, gain experience, and make most of the myriad judgments of our lives.[59] If we perceived distinctly, and saw chiliagons as such rather than

as shapes with indefinite numbers of sides, then we would be entirely unable to cope with the vast and ongoing *reality* of particular things and situations *represented* to us by imagination (and passion). Not only might we go mad trying to think of our bodies as pure extension in an ever changing relation to other bodies in Cartesian coordinate space, but were we successfully to do so, we would also be vitally unaware of the particular circumstances in which we find ourselves. And, as I shall argue in the last section, the "obscure and confused" is not simply the realm of the aesthetic (as it was to become), it is, among other things, the proper realm of practical reason

The Primitive Passions

Descartes's six "primitive" passions—of which the "innumerable" other passions are all subspecies[60]—are wonder, love, hatred, joy, sadness, and desire (*l'admiration, l'amour, la haine, la joie, la tristesse, la désir*).[61] Love and hatred, joy and sadness, are opposites; wonder and desire, however, have no opposites. *L'admiration* recalls the *thauma*, which incites the desire for knowledge, of the opening lines of Aristotle's *Metaphysics*.[62] Unlike *thauma*, however, *l'admiration* is not only prerational (predistinct) but it is prepassionate—*l'admiration* is apprehension of the given prior to perception for individual purpose. As *dispassionate*, wonder is appropriately first in Descartes's list, but it is also defined negatively with respect to the other five passions, just as desire is consequent to them. Wonder happens when we encounter something so novel (or perhaps the particular as such) that we can neither love nor hate it, that it can give us neither joy nor sadness. It is an element of most passions (presumably because situations are always to some extent unique), and it lends the force and persistence of passion to new sensations, not only fixing them in memory but locking the muscles and the organs of sense on them.[63] If novel things astonish us, literally stop us in our tracks, then wonder is bad; but if they excite curiosity and so stimulate the desire to learn, then they are good.[64]

At the other end of the list is the passion of desire, which "disposes the soul to wish, in the future, for the things it represents to itself as agreeable."[65] Desire predisposes the body to the satisfaction of lack, making it (and the soul) *want* things. Frightened, we "want" to run; courageous, we "want" to stand our ground; in love, we "want" to possess the beloved.[66]

The passion of desire has no opposite because, in seeking the good, the final end of our desiring, we necessarily avoid the bad. Love and hatred fit into this scheme as, respectively, dispositions to unite with and distance ourselves from an object. The many kinds of love are distinguished by their relative concern with either simple possession (as, say, in the case of greed or lust) or with the object of love itself (as in the case of affection, friendship, or devotion).

Love and hatred are alike in that their objects may be represented to the soul by external sense, internal sense (sensation plus passion), or by "its own reason." Something is "good" or "evil" if internal sense or reason judges it either "agreeable or contrary to our nature," and something is "beautiful" or

"ugly" if similarly judged by external sense, especially sight. *L'agrément* (to that which is fundamentally like us, harmonious with our nature), like its counterpart *l'horreur* (to that which is fundamentally unlike us and therefore threatening), is deeply personal, obscure, and corporeal; these are the most violent passions of love and hatred "because what enters the soul through sense touches it more strongly than what is represented to it by its reason."[67]

We are attracted to the beautiful and the good and repelled by the ugly and the evil; these "violent" and "most deceptive" passions are related to the deepest preservative function of the passions taken altogether, at the same time that they are not necessarily attached to the qualities of any object. Thus, although attraction and repulsion seem like love and hatred, they are not opposites. The object of attraction seems to be "the greatest of all goods imaginable," resulting in the keenest desire, and we take the highest pleasure in sexual union, which at a certain point in our lives dominates our imaginations.[68] Repulsion "is ordained by nature to represent to the soul a sudden and unexpected death." Perhaps because it is the physiological response to mortal threat, repulsion is easily triggered, as if our primitive nature were always to be on guard. But the simple touch of an earthworm, the rustling of a leaf, or a shadow, according to Descartes, may precipitate repulsion, together with the powerful desire and predisposition to turn away.[69]

As these examples suggest, relations among the "primitive" passions soon turn out to be not simple at all. Moreover, the boundary between pain and pleasure is always shifting. "Titillation of the senses [*le chatouillement des sens*]" is experienced as joy, and pain as sadness (*la douleur*).[70] "Titillation" (which is more like our "stimulation," or even "irritability," and is the general term for pleasure corresponding to pain), is that by which "the soul is immediately advised about things useful to the body." Pain causes the passion (that is, the reaction) of sadness, "then hatred of what causes the pain, and finally the desire to get rid of it."[71] And because it is more important to reject and avoid the harmful than to obtain things that are pleasant, "sadness is in some way…more necessary than joy, and hatred more necessary than love."[72] Presumably repulsion is also more necessary than attraction.

Titillation and pain are so closely allied that we may sometimes suffer pains with joy, and titillation with displeasure. From this, Descartes drew the conclusion that stimulation produces movement in the nerves that would harm them if they were not sufficiently strong to resist or, if in general, the body were not in a strong and healthy condition. The soul experiences this strength and resistance as joy or, more properly, is joyful at the strength of the apparatus of its embodiment—the soul considers it good to be united to the body.[73]

Imagination

Descartes argued that the soul is similar to the body *as a unity*.[74] In being one, it is like the organically interdependent whole of the body. The pineal gland, lodged deep in the brain, in the traditional location of the common sense, is

one in contrast to the double organs of sense.[75] The origin and destination of the nervous system of the bilaterally symmetrical human body, this slight common ground of body and soul, presumably offers a kind of image of both body and soul in its tiny centrality, deep within the brain.

"Nature...teaches me, by [internal] sensations...that I am very closely joined and, as it were, intermingled with [my body], so that I and the body form a unit."[76] One thing—the soul—wills, understands, imagines, and has sensory perceptions, and from this a conclusion follows: the soul must have an *image* of its body as a whole. When amputees report pain in missing members (a frequent example of Descartes's), such misapprehensions may be explained as the result of impulses reaching the brain from the transmitting nerves rather than from the limb itself.[77] But whether or not such experiences are illusory, the implication is the same: the soul knows and remembers its body as a whole from internal sensations. Like all bodies, the soul's own may be regarded clearly and distinctly as pure extension; but it is critically important that it is not known as pure extension in the first instance.

In *La dioptrique* (The optics), Descartes explained that the retinal image, still fairly resemblant, initiates a patterned impulse through the optic nerve to the brain. We perceive the orientation of the parts of external objects relative to the body by sight, just as we do by touch. We apprehend the surface of the object through the surface of the organ of sense, which must always be in some actual relation to the object. In the pineal gland, where infinite responses may be made to differences registered by the senses, a change occurs whenever there is a change in the position of the limbs in which the nerves are embedded. Nature has enabled the soul not only to know the place occupied by each part of the body it animates, relative to all the others, but also to shift attention from these places "to any of those lying on the straight lines which we can imagine to be drawn from the extremity of each part and extended to infinity."[78] The soul "knows" where its body is, effectively but not distinctly.

To return to the passions, as Descartes's arguments proceed, the passions become compounds of the "primitive" passions at the same time that they become more social, therefore moral and ethical. But if we are selfish while also being aware of ourselves, that is, if our sensations and passions make us represent ourselves to ourselves as primarily conscious of our own bodies, and also of our interests as embodied, how do we relate to other people?

In the third part of his treatise, Descartes attempted to establish a basis for intersubjectivity by returning to wonder, alone among the "primitive" passions in being dispassionate. Although wonder has no opposite of its own, it gives rise to very important opposites—esteem and contempt, generosity and pride, humility and abjectness. We arrive at such distinctions because, more than simply wondering at novelty, we wonder at greatness or insignificance.[79] Usually esteem and contempt refer to our passionless opinions about the worth of things, and since such judgments often provoke passions for which no names exist, Descartes adapted them to his purpose. Esteem "is the soul's inclination to present to itself the value of the object...caused by a special

movement of the spirits which are so directed in the brain that they strengthen the impressions having this effect." We may regard anything with esteem (or disdain), but these passions are most noteworthy "when we refer them to ourselves" and to our own merit.[80] It is visible in our whole mien and behavior when we are feeling good about ourselves, which presumably brings self-esteem close to joy.[81]

But Descartes clearly meant to shift his treatment of self-satisfaction to a level higher than that found in the soul's occasional delight in its union with the body; he stated that we may justly esteem ourselves most highly when we "exercise the free will and control we have over the passions." To do so "renders us in a certain way like God by making us masters of ourselves."[82] The free exercise of the highest human virtue manifests itself as *generosity*. Those who are generous are inclined to esteem others as they esteem themselves, anticipating such realization of virtue in others. Ultimately, generosity is not just a virtue but also a passion, although it is not a "primitive" passion. Generosity is justified high self-esteem, and it is compounded of the movements of wonder, joy, and love, both self-love and whatever external cause contributes to our self-esteem.

For Aristotle, friendship (*philia*) is a broad category, in principle universal and in a sense preceding justice; all the feelings constituting friendship for others are "an extension of regard for self."[83] Self-love by a good person is not only right but is itself a fulfillment of goodness. And, Aristotle argued, just as we are by nature conscious of our own sensations and activities, and therefore take pleasure in our own lives as a good, so we may feel the life, sensations, and thoughts of another. This is the basis for friendship, and it follows in Aristotelian fashion that the best friends are the best people, those who have best realized their humanity.

I am suggesting that Aristotle's idea of *philia*, based on self-consciousness as a common sensation and the affirmation of one's own life as such, is a major precedent for Descartes's idea of generosity. It is true that Aristotle's ideal is aristocratic in its highest form—that is, only some had the freedom and leisure to become fully human—and that Descartes adapted a contemporary ideal of aristocratic behavior to his purposes.[84] The common basis in embodied self-awareness and self-affirmation, however, is potentially much less contextual, much more embracing. If *generosity* is taken back to its roots, *gens* or *genus*, then it means something very similar to *kindness*, to treat someone as being like oneself, in kind or nature.

Wonder is basic to generosity because generosity entails encounter with an individual, who, moreover, must act freely and unpredictably in every situation. In his definition of the "primitive" passions, Descartes moved directly from wonder to love, which impels the soul willingly to unite itself to an object.[85] Having defined *love*, Descartes again turned to wonder in order to distinguish kinds of love according to the *esteem* with which we regard the object of love, *in comparison to ourselves*. We feel affection for objects less than ourselves (flowers, birds, horses), and we feel friendship for objects

equal to ourselves (people): "They are so truly the objects of this passion that there is no person so imperfect that we could not have...a very perfect friendship, given that we believe ourselves loved by him and that we have a truly noble and generous soul." Devotion, the third form of love, is love for an object higher than ourselves, principally God.[86]

Sexual attraction is defined in related terms; it comes from the perfections that one imagines in a person who one thinks may become another self (*un autre soi-même*). When we experience ourselves as half a whole, "the acquisition of this |other| half is confusedly represented by nature as the greatest of all imaginable goods." Descartes compared sexual attraction to that which ends in seeing or eating, though the sexual attraction is much more powerful and irresistible. "The other half" is also a second self, and, we must conclude, sexual attraction is actually complementary to horror, as the continuation of oneself complements the avoidance of death.[87]

Sexual attraction involves the imagination of the other, but it raises problems as it does so. Our apprehension of the other as ourself is obscure to the point of impossibility, and the essential narcissism of the relation conceals the other person. Only relations based on self-affirmation (rather than lack) are not narcissistic. That is, by affirming ourselves as individually living and embodied, not under the threat of death, we understand those other persons — represented (as we are represented to ourselves), but present as external — as like ourselves in being self-affirming, or at least potentially self-affirming.

Descartes returned from time to time to the example of fiction, especially theater. This spectatorial metaphor — and attitude — is in fact fundamental; when we represent ourselves and *imagine* ourselves, we "see" ourselves, as it were, at a distance, or, as like our representations of others. At the same time, this distance touches the absolute basis of both passion and self. As we have seen, when stimulus is so strong as to threaten harm, but the body is able to resist, the soul feels joy, and it affirms its union with the body. Experience of passion at a distance may also yield "intellectual joy," a kind of satisfaction peculiar to the human soul itself. This is like our enjoyment of fiction: "we naturally take pleasure in feeling ourselves aroused to all sorts of passions — even to sadness and hatred — when these passions are caused merely by the strange happenings we see presented on the stage, or by other such things which, being incapable of harming us in any way, seem to stimulate our soul in titillating it."[88] We take the most basic pleasure in seeing passions enacted by others from a position of non-involvement, much as we enjoy "thrills" in circumstances that are not really dangerous. In the dramatic distance of fiction, it is as if we are put outside the incessant play of the passions, though we may still observe them. But in such states of titillation, we must inevitably not only *see* the passions of others but we must compare our own state of removed well-being to theirs — we must compare our sense of ourselves, and our *image* of ourselves, to theirs.

Descartes's treatise on the passions of the soul is best known to art historians as a major source for the seventeenth-century painter Charles Le Brun's famous neoclassical masks of facial expressions.[89] Descartes observed that, in general, facial expressions are most often used to conceal our passions rather than to reveal them, and this follows from his insistence upon our essential freedom in relation to the passions. Dissimulation of course implies recognition, but Le Brun's masks are more strictly theatrical, and the important consequence of Descartes's argument is to separate facial expression from inwardness or at least to complicate this relation greatly. In this short study I have been concerned with broader issues. Descartes was the first thinker to gather the implications of the mediations entailed by the assumption that the human body is a complex mechanism, part of the larger mechanism of nature: perception never occurs without the mediations of passion, which must arise in the transmission of external force, so that perception is most comparable to reading, in which the least signs trigger not only recognition but floods of individual feelings, fantasies, and memories, themselves more or less tinged with feelings.[90] Thus *representations* of the passions are also inevitably *expressions* of the passions — expressions of the one who represents, not so much of what is represented. This is an assumption about art that was to become as deep and commonplace as the supporting assumption of mechanism itself.

Although Descartes's mechanical nature stands at the beginning of the formation of modern, Western "common sense," the other "mechanisms" of history, economy, culture, and language, which have come to explain human behavior, all lay in his cultural-historical future. Through the centuries, the nominalist reduction initiated by Descartes's "primitive" passions has continued. The seventeenth-century philosopher Baruch Spinoza reduced them to still more basic motive forces: the avoidance of pain and the pursuit of pleasure, self-preservation, and self-interest.[91] Thomas Hobbes would base his political theory on a comparable analysis,[92] and Sigmund Freud's notions of sexuality represent a vastly influential culmination of the attempt to find a psychological prime mover, a single and basic counterforce.

If Descartes's psychology marks the emergence of such possibilities and choices, his analysis of the passions was meant to provide the basis for an ethics, a project cut short together with his fairly brief philosophical career. Descartes was not in a position to understand the complexity of the subjectivity he had begun to define, that is, how it would be accommodated or exploited by technologies and institutions. But I have argued that he did see something like empathy as the consequence of the same emergence of self-image, the consequence of the simultaneous mechanization and embodiment of the human thing that thinks.

Notes

1. Thomas Hobbes, *Leviathan,* ed. Richard Tuck (Cambridge: Cambridge Univ. Press, 1996), 15.

2. Hobbes, *Leviathan* (note 1), 13–14. According to Katharine Park and Eckhard Kessler in Charles B. Schmitt, gen. ed., *The Cambridge History of Renaissance Philosophy* (Cambridge: Cambridge Univ. Press, 1988), whose three chapters on psychology (pp. 455–534) provide an excellent introduction to what had become the Aristotelian *koine,* in terms of which Descartes wrote, the word *psychology* was first used in 1575. See also Gary Hatfield, "Descartes' Physiology and Its Relation to His Psychology," in John Cottingham, ed., *The Cambridge Companion to Descartes* (Cambridge: Cambridge Univ. Press, 1992), 337.

3. René Descartes, *The Passions of the Soul,* trans. Robert Stoothoff, in idem, *The Philosophical Writings of Descartes,* ed. John Cottingham, Robert Stoothoff, and Dugald Murdoch (Cambridge: Cambridge Univ. Press, 1985), 1:325–404, esp. 327. First published in French as *Les passions de l'âme* (Amsterdam: Elzevier, 1649). Subsequent references are to Descartes's numbered sections of the text, as established in René Descartes, *Oeuvres de Descartes,* ed. Charles Adam and Paul Tannery (Paris: Léopold Cerf, 1909), 11:291–497. See also Geneviève Rodis-Lewis, *Les passions de l'âme* (Paris: J. Vrin, 1970), for valuable historical background and commentary.

4. Descartes, *Passions* (note 3), §2.

5. Aristotle, *Metaphysics,* trans. Hugh Tredennick (Cambridge: Harvard Univ. Press, 1980), 1021a14–19. The connection to Aristotle is pointed out by Harry Austryn Wolfson, *The Philosophy of Spinoza: Unfolding the Latent Processes of His Reasoning* (Cambridge: Harvard Univ. Press, 1934), 185–95. This is an excellent brief review of Descartes's treatise. See also Aristotle, *On the Soul,* trans. W. S. Hett (Cambridge: Harvard Univ. Press, 1957), 417a15–417b28.

6. Descartes, *Passions* (note 3), §2.

7. Roger Ariew and Marjorie Grene, "The Cartesian Destiny of Form and Matter," in Roger Ariew, *Descartes and the Last Scholastics* (Ithaca: Cornell Univ. Press, 1999), 77–96.

8. Ariew and Grene, "Cartesian Destiny" (note 7), 89.

9. John F. Wippel, "Essence and Existence," in Norman Kretzmann, Anthony Kenny, and Jan Pinborg, eds., *The Cambridge History of Later Medieval Philosophy: From the Rediscovery of Aristotle to the Disintegration of Scholasticism, 1100–1600* (Cambridge: Cambridge Univ. Press, 1982), 385–410. See, for example, Descartes's "Sixth Meditation," where he refers to "the composite, that is, the mind united with this body"; see René Descartes, *Meditations on First Philosophy,* trans. John Cottingham, in idem, *The Philosophical Writings of Descartes,* ed. John Cottingham, Robert Stoothoff, and Dugald Murdoch (Cambridge: Cambridge Univ. Press, 1985), 2:59. First published in Latin as *Meditationes de Prima Philosophiae* (Paris: Michel Soly, 1641). The theological stakes in this usage are high, and Aquinas maintained that Aristotle's arguments were compatible with the immortality of the soul and the resurrection of the body; see Stephen Gaukroger, *Descartes: An Intellectual Biography* (Oxford: Clarendon, 1995), 388–94; Stephen Gaukroger, "Descartes' Theory of the Passions," in John Cottingham, ed., *Descartes* (Oxford: Oxford Univ. Press, 1998), 211–24; Roger Ariew,

Descartes and the Last Scholastics (Ithaca: Cornell Univ. Press, 1999), 15; and David Summers, *The Judgment of Sense: Renaissance Naturalism and the Rise of Aesthetics* (Cambridge: Cambridge Univ. Press, 1987), 216–27.

10. René Descartes, "To Princess Elizabeth, 21 May 1643" (letter), trans. John Cottingham, in idem, *The Philosophical Writings of Descartes*, ed. John Cottingham, Robert Stoothoff, and Dugald Murdoch (Cambridge: Cambridge Univ. Press, 1985), 3:219.

11. Gaukroger, *An Intellectual Biography* (note 9), 384–88; and Thomas E. Wartenberg, "Descartes's Mood: The Question of Feminism in the Correspondence with Elizabeth," in Susan Bordo, ed., *Feminist Interpretations of René Descartes* (University Park: Pennsylvania State Univ. Press, 1999), 190–212. Correspondence with the intellectually precocious Elizabeth played a decisive role in the formulation of Descartes's treatise, turning his last thought in the direction of the practical and ethical. Elizabeth may also have wished to understand her own melancholia.

12. René Descartes, *Discourse on the Method...*, trans. Robert Stoothoff, in idem, *The Philosophical Writings of Descartes*, ed. John Cottingham, Robert Stoothoff, and Dugald Murdoch (Cambridge: Cambridge Univ. Press, 1985), 1:141. First published in French as *Discours de la méthode...* (Leiden: n.p., 1637). The reference to the soul as a helmsman, which echoed in Descartes's mind, refers at some distance to Aristotle, *On the Soul* (note 5), 413a7–9. On the *hegemonikon* (ruling faculty), see Summers, *Judgment of Sense* (note 9), 92 n. 21 and passim. See also Richard B. Onians, *The Origins of European Thought about the Body, the Mind, the Soul, the World, Time and Fate* (Cambridge: Cambridge Univ. Press, 1951), 115.

13. Plato, *Republic*, trans. Paul Shorey (Cambridge: Harvard Univ. Press, 1937), 436A–441C. Aristotle, *Nicomachean Ethics*, trans. H. Rackham (Cambridge: Harvard Univ. Press, 1982), 1102b29–1103a1, wrote of the soul as double: a vegetative soul, which is irrational, and an appetitive soul, which is rational in the sense that it is subject to reason, as a child to an adult. For a diagram of the then traditional view of the soul, see Katharine Park, "The Organic Soul," in Charles B. Schmitt, gen. ed., *The Cambridge History of Renaissance Philosophy* (Cambridge: Cambridge Univ. Press, 1988), 466. Descartes specifically rejects the idea of vegetative and animal souls; see René Descartes, *Treatise on Man*, trans. Robert Stoothoff, in idem, *The Philosophical Writings of Descartes*, ed. John Cottingham, Robert Stoothoff, and Dugald Murdoch (Cambridge: Cambridge Univ. Press, 1985), 1:108. First published in French as *L'homme* (Paris: Charles Angot, 1664). After the Council of Trent, the Jesuits denied the multiplicity of souls in men and animals; see Ariew, *Descartes and the Last Scholastics* (note 9).

14. Descartes, *Passions* (note 3), §§47, 68.

15. Descartes, *Passions* (note 3), §§5, 6, 7.

16. Descartes, *Treatise on Man* (note 13), 1:108; and Descartes, *Discourse on the Method* (note 12), 1:139–41. On the internal senses, see Summers, *Judgment of Sense* (note 9).

17. Descartes, *Passions* (note 3), §§38, 13, 16; and Descartes, *Discourse on the Method* (note 12), 1:139. See also Lorraine Daston and Katharine Park, *Wonders and the Order of Nature, 1150–1750* (New York: Zone, 1998), 292–93.

18. René Descartes, *Principles of Philosophy,* trans. John Cottingham, in idem, *The Philosophical Writings of Descartes,* ed. John Cottingham, Robert Stoothoff, and Dugald Murdoch (Cambridge: Cambridge Univ. Press, 1985), 1:288. First published in Latin as *Principia Philosophiae* (Amsterdam: Elzevier, 1644). On nature as an artisan, see Daston and Park, *Wonders* (note 17); and David Summers, "Pandora's Crown: On Wonder, Imitation, and Mechanism in Western Art," in Peter G. Platt, ed., *Wonders, Marvels, and Monsters in Early Modern Culture* (Newark: Univ. of Delaware Press, 1999), 45–77.

19. Descartes, *Meditations on First Philosophy* (note 9), 2:58.

20. Descartes, *Passions* (note 3), §50; on the central pineal gland, see Descartes, *Passions* (note 3), §§31–32.

21. Descartes, *Passions* (note 3), §§7, 10 and passim. For an introduction to the tradition of pneumatology out of which Descartes is writing, see Summers, *Judgment of Sense* (note 9), 110–24. See Descartes, *Treatise on Man* (note 13), 1:100, 100 n. 2, where animal spirits are identified as a very "*subtil*" wind (that is, "composed of very small, fast-moving particles"), or "a very lively and pure flame"; and the preface to René Descartes, "Description of the Human Body and of All Its Functions," trans. John Cottingham, in idem, *The Philosophical Writings of Descartes,* ed. John Cottingham, Robert Stoothoff, and Dugald Murdoch (Cambridge: Cambridge Univ. Press, 1985), 1:314–16. First published in French as *La Description du corps humain* (Paris: Charles Angot, 1664). See also Descartes, *Passions* (note 3), §7. This is certainly related to the discussion of light and fire at the beginning of *The World;* see René Descartes, *The World or Treatise on Light,* trans. John Cottingham, in idem, *The Philosophical Writings of Descartes,* ed. John Cottingham, Robert Stoothoff, and Dugald Murdoch (Cambridge: Cambridge Univ. Press, 1985), 1:81–84. First published in French as *Le Monde de M. Descartes ou le Traité de la Lumiére* (Paris: Iacques le Gras, 1664). On the element of fire, quintessence, and animation, see David Summers, "Form and Gender," *New Literary History* 24 (1993): 243–71.

22. Descartes, *Passions* (note 3), §47 (translation modified). Does Descartes mean that the soul reacts to movement as such?

23. Descartes, *Passions* (note 3), §138; irrational animals lead their lives solely in terms of corporeal movements, "similar to those movements which in us usually follow [the passions], which incite our soul to consent to such movements" but which we are free not to follow (translation modified). Plato was mistaken in describing moral conflict as a *psychomachia* in which higher and lower "personages," as Descartes calls them — apparently referring to the long tradition of Christian iconography in which virtues and vices were personified combatants — struggle for dominion; see Descartes, *Passions* (note 3), §47. Plato famously compared the soul to a team of good and bad horses steered by reason; see Plato, *Phaedrus,* trans. Harold North Fowler (Cambridge: Harvard Univ. Press, 1914), 247c–248e. On the *Psychomachia* of Prudentius and its iconographic tradition, see Adolf Katzenellenbogen, *Allegories of the Virtues and Vices in Mediaeval Art from Early Christian Times to the Thirteenth Century,* trans. Alan J. P. Crick (New York: W. W. Norton, 1964).

24. Descartes, *Principles of Philosophy* (note 18), 1:224.

25. Descartes, *Passions* (note 3), §17 (translation modified); see Amélie Oksenberg

Rorty, "Descartes on Thinking with the Body," in John Cottingham, ed., *The Cambridge Companion to Descartes* (Cambridge: Cambridge Univ. Press, 1992), 371–92.

26. Descartes, *Passions* (note 3), §74.

27. Descartes, *Passions* (note 3), §52 (translation modified).

28. Descartes, *Passions* (note 3), §74.

29. Descartes, *Passions* (note 3), §51.

30. Descartes, *Passions* (note 3), §136.

31. Descartes, *Passions* (note 3), §138.

32. Descartes, *Passions* (note 3), §26. Descartes notes that, normally, impressions, both external and internal, received through the nerves are more vivid than those resulting from the movements of the spirits alone. The latter "are like the shadow or painting [*sont comme l'ombre ou la peinture*]" of the former; see Descartes, *Passions* (note 3), §21 (translation modified).

33. Descartes, *Passions* (note 3), §107.

34. Descartes, *Passions* (note 3), §§50, 211.

35. Descartes, *Passions* (note 3), §§107–11.

36. Descartes, *Principles of Philosophy* (note 18), 1:209.

37. Descartes, *Passions* (note 3), §19.

38. Aristotle, *Nicomachean Ethics* (note 13), 1170a–b.

39. Aristotle, *Parva naturalia,* trans. W. S. Hett (Cambridge: Harvard Univ. Press, 1957), 455a (translation modified).

40. Aristotle, *On the Soul* (note 5), 434b9–24.

41. Aristotle, *Nicomachean Ethics* (note 13), 1171b29–1172a16.

42. Descartes, *Principles of Philosophy* (note 18), 1:195.

43. Aristotle, *On the Soul* (note 5), 412a28–29, 412b5–6.

44. René Descartes, *Comments on a Certain Broadsheet,* trans. Dugald Murdoch, in idem, *The Philosophical Writings of Descartes,* ed. John Cottingham, Robert Stoothoff, and Dugald Murdoch (Cambridge: Cambridge Univ. Press, 1985), 1:302–3. First published in Latin as *Notae in Programma quoddam* (Amsterdam: Elzevier, 1648).

45. Aristotle, *On the Soul* (note 5), 412b18.

46. Descartes, *Comments* (note 44), 1:304.

47. Descartes, *Passions* (note 3), §27 (translation modified).

48. Gaukroger, An *Intellectual Biography* (note 9), 62–67.

49. Descartes, *Treatise on Man* (note 13), 1:100–101. The viewer might also be challenged by a Neptune. The rational soul is like the fountain-keeper who may change movements by changing the flow of water. If the viewer is an imaginary Actaeon, the reference is to Ovid, *Metamorphoses,* trans. Frank Justus Miller (Cambridge: Harvard Univ. Press, 1977), 3.174.

50. Descartes, *The World* (note 21), 1:81–82.

51. Descartes, *Discourse on the Method* (note 12), 1:152–55.

52. This portrait is reproduced on the cover of Cottingham, ed., *The Cambridge Companion to Descartes* (note 2). See Richard Rorty, *Philosophy and the Mirror of Nature* (Princeton: Princeton Univ. Press, 1979), where he argues that Descartes's "idea" is dominated by the ancient tradition of the ocular metaphor. Although Rorty provides a useful history of such metaphors, the thesis is much too simple, and one

must agree instead with Dalia Judovitz, "Vision, Representation, and Technology in Descartes," in David Michael Levin, ed., *Modernity and the Hegemony of Vision* (Berkeley: Univ. of California Press, 1993), 63–86, that "Descartes's inquiry into the nature of vision leads to an exploration of optics that displaces both the priority of the eye and the centrality of vision" (p. 69). See also the excellent article by Stephen Houlgate, "Vision, Reflection, and Openness: The 'Hegemony of Vision' from a Hegelian Point of View," in David Michael Levin, ed., *Modernity and the Hegemony of Vision* (Berkeley: Univ. of California Press, 1993), 87–123, where he rightly observes that Descartes's arguments about vision are in fact "proto-Rortian" (p. 103). These readings of Descartes must also qualify the status of the camera obscura as the paradigm for intellection before the nineteenth century, on which see Jonathan Crary, *Techniques of the Observer: On Vision and Modernity in the Nineteenth Century* (Cambridge: MIT Press, 1990).

53. Descartes, *Meditations on First Philosophy* (note 9), 2:50–62.

54. Descartes, *Meditations on First Philosophy* (note 9), 2:54–55.

55. Descartes, *Passions* (note 3), §§26, 46.

56. On clear and distinct, and obscure and confused, see Summers, *Judgment of Sense* (note 9), 182–97.

57. At the beginning of the *Principia Philosophiae,* Descartes remarks that, although we should doubt everything the least bit uncertain, even to the point of considering it false, "as far as ordinary life is concerned, the chance for action would frequently pass us by if we waited until we could free ourselves from our doubts, and so we are often compelled to accept what is merely probable"; see Descartes, *Principles of Philosophy* (note 18), 1:193. At the end of the *Principia,* Descartes writes that his principles of explanation of the natural world have more than "moral certainty" because the more a principle explains, the less likely it is to be false; see Descartes, *Principles of Philosophy* (note 18), 1:289–90. These arguments do not discredit moral certainty, or probability, but rather distinguish it from the kind of certainty he is setting out.

58. Descartes, *Meditations on First Philosophy* (note 9), 2:57 (translation modified).

59. In the early *Rules for the Direction of the Mind* (*ingenium,* something like native intelligence), Descartes closely links the "corporeal imagination" with common sense, following the older pattern of the internal senses; see Descartes, *Discourse on the Method* (note 12), 1:41–43. Descartes could argue that the particular intellect is in fact the individual human soul (see note 9 above), the "divine spark" evident not only in pure intellect but also in the practice of arts and skills; see René Descartes, *Rules for the Direction of the Mind,* trans. Dugald Murdoch, in idem, *The Philosophical Writings of Descartes,* ed. John Cottingham, Robert Stoothoff, and Dugald Murdoch (Cambridge: Cambridge Univ. Press, 1985), 1:17, 35. First written in Latin around 1628 as *Regulae ad Directionem Ingeni.*

60. Descartes, *Passions* (note 3), §149.

61. Descartes, *Passions* (note 3), §69. Descartes's "primitive" passions are an adaptation of the older "concupiscent" passions (love, hate, desire, aversion, pleasure, and pain). See Gaukroger, *An Intellectual Biography* (note 9), 403.

62. Aristotle, *Metaphysics* (note 5), 982b11–983a21.

63. Descartes, *Passions* (note 3), §70.

64. Descartes, *Passions* (note 3), §72.

65. Descartes, *Passions* (note 3), §86.

66. Descartes, *Passions* (note 3), §52. See Rorty, "Descartes on Thinking with the Body" (note 25), 382.

67. Descartes, *Passions* (note 3), §85 (translation modified).

68. Descartes, *Passions* (note 3), §90.

69. Descartes, *Passions* (note 3), §89.

70. Descartes, *Passions* (note 3), §94.

71. Descartes, *Passions* (note 3), §137.

72. Descartes, *Passions* (note 3), §137.

73. Descartes, *Passions* (note 3), §94.

74. Descartes, *Passions* (note 3), §30.

75. On common sense, see Summers, *Judgment of Sense* (note 9); and Descartes, *Treatise on Man* (note 13), 1:100, 106, where Descartes identifies the pineal gland with the common sense and imagination. The pineal gland can be moved by the spirits "in as many different ways as there are perceptible differences in the objects," and the soul is such that it may receive as many different perceptions as there are movements in the gland; see Descartes, *Passions* (note 3), §34. The gland may also receive movements from the soul and, hence, transmit them to the nerves and muscles.

76. Descartes, *Meditations on First Philosophy* (note 9), 2:56; and Descartes, *Passions* (note 3), §30.

77. Descartes, *Meditations on First Philosophy* (note 9), 2:61.

78. Descartes, *Discourse on the Method* (note 12), 1:169.

79. Descartes, *Passions* (note 3), §150.

80. Descartes, *Passions* (note 3), §§149–51.

81. Descartes, *Passions* (note 3), §151.

82. Descartes, *Passions* (note 3), §152 (translation modified).

83. Aristotle, *Nicomachean Ethics* (note 13), 1168b5–7.

84. Charles Taylor, *Sources of the Self: The Making of the Modern Identity* (Cambridge: Harvard Univ. Press, 1989), 154; see also John Marshall, *Descartes's Moral Theory* (Ithaca: Cornell Univ. Press, 1998), 96–141, 150 n. 4.

85. Descartes, *Passions* (note 3), §84.

86. Descartes, *Passions* (note 3), §83.

87. Descartes, *Passions* (note 3), §90 (translation modified). Descartes argues that the good father regards his children as better parts of himself; Descartes, *Passions* (note 3), §82.

88. Descartes, *Passions* (note 3), §94.

89. See Jennifer Montagu, *The Expression of the Passions: The Origin and Influence of Charles Le Brun's* Conférence sur l'expression générale et particulière (New Haven: Yale Univ. Press, 1994). Le Brun also drew on a number of earlier writers, as well as the study of classical sculpture, and he devised a scheme according to which the rise or fall of the eyebrows or corners of the mouth, relative to the fixed point of the pineal gland, expressed good or bad reactions.

90. See David Summers, "Representation," in Robert S. Nelson and Richard Shiff, eds., *Critical Terms for Art History* (Chicago: Univ. of Chicago Press, 1996), 3–16.

91. Spinoza subordinated the passions to the *conatus,* the will of living things to persist in their existence; see Wolfson, *Philosophy of Spinoza* (note 5), 207.

92. Hobbes considered the modern understanding of the passions to provide a better guide to the "blotted and confounded" human heart than that provided by the construal of conscious "designs," and thus a better guide both for political theory and actual rule; see Hobbes, *Leviathan* (note 1), 2.

Music and the Order of the Passions
Martha Feldman

The Force of Sound in alarming the Passions is prodigious.

— Charles Avison[1]

First Thoughts

Recently I was asked a question that has stuck with me ever since: "Was there a template for the passions in eighteenth-century music?" Was there a *template* for the passions? In a time bent on categorizing the passions, laying them out in neat classifications, ordering them in hierarchies, and pitting them in relations of enmity and sympathy, I wondered how any single passion could have served as a template for all the others, and indeed what a template could mean. I thought of the eighteenth-century German composer and theorist Johann Mattheson, whose Cartesian taxonomy aligned various passions with baroque dances, and of the kaleidoscope of discrete passions heard successively in the arias of an opera seria. But was there a *superpassion* that framed or made possible all the others, a sort of passion of passions?

This essay has come from thinking about these questions. On one level its claim is simple: music in the seventeenth and eighteenth centuries played a striking role in the modeling of the passions, as it was continually called on by theorists and composers to help valorize certain passions and censure others and to inculcate their respective virtues and perils in listeners. The changing relationship between music and the passions has much to reveal about changing attitudes toward the passions during this period. Throughout the sunnier part of the Enlightenment, the passion of joy — along with its various aliases: contentment, delight, pleasure — was celebrated but still always tensed in a counterpoise with the Cartesian passion of wonder. Around the mid-eighteenth century, wonder and its miraculous manifestations were largely expunged or forced underground as unseemly rivals of reason, beauty, and regularity. No sooner, however, had wonder been banished from the blaring spectacles of the court and the public square, the halls of the opera house, and the annals of aesthetic philosophy than it came creeping back under the darker guise of the sublime — a sublime that exalted pathos and ended finally by unloosing the hegemony of any single passion.

Such are my broad claims, but beneath them lies a messier set of realities. Bound up with a social order in flux, conceptions and reconceptions of the passions — which were most prized, how so, what categories they belonged to,

and what functions they served—occurred fitfully across time and place. Not only did changing valuations of the passions signal new and often contradictory attitudes toward human feeling, sensation, and cognition but they also involved shifting ideas about how meaning should be signified, how human nature should be displayed, how feeling should be manifested and exchanged between parties, and where authority was vested. In the final analysis, then, the offices of the passions cannot be characterized through the metaphor of the *template*. What was at stake were changes in the very foundations of beliefs about the self and the world. This essay is an attempt to point out some of the most salient implications of those changes.

Wonder

In the seventeenth century, before the tyrannies of reason forced their way into the salon and the opera house, music was often put in the service of the fantastic and the wondrous. Outdoors, shawms, cornets, fifes, and drums accompanied a variety of spectacles, from fire-breathing dragons to jousting horsemen and flag acrobats. Indoors, opera orchestras played to the sight of Apollo being spirited heavenwards in a horse-drawn chariot, or Dawn chasing away the nighttime stars. In the *tragédies en musique* that were staged in Louis XIV's Versailles and Paris beginning in 1674, the music was paralleled visually by dazzling stage machines. And in the most magnificent of the public theaters then multiplying throughout Italy, huge numbers of horses, triumphs, and soldiers thronged onstage during opere serie, while parterres and stage floors were transformed into lavish ballrooms on gala nights. Music in this baldly material world seemed by its very immaterial nature to distill the quintessence of wondrous possibility.

In the imagination of the time, the arts of the fantastic sprang from the magical abundance and virtue imputed to the monarch, who, in the seventeenth century, still signified the miraculous point of convergence between the divine and the human. As the ultimate human referent of wonder, the monarch was symbolized politically in public spectacles that levied the intangibility of sound as a warrant of his divine powers, which were repeatedly celebrated to propose him as opera's main hero and figurative author. But as the eighteenth century wore on, the public's faith in a mysteriously sacred sovereign, with its implications of an ultimately unknowable state of nature, came under attack throughout Europe, and opera became part of the problem. Already bound up with suspicions that led to these attacks, opera became a kind of last bastion in the wider symbolic system that had embraced the monarch as the fount of wonder and marvels.

We should recall that the idea of wonder as the primary passion was consolidated philosophically at the height of princely spectacle in Europe. René Descartes, in *Les passions de l'âme* (1649), placed wonder first under the heading of "The order and enumeration of the Passions." "When the first encounter with some object surprises us," he calculated, "this makes us wonder and be astonished at it. And since this can happen before we know in the

least whether this object is suitable to us or not, it seems to me that Wonder is the first of all the passions. It has no opposite, because if the object presented has nothing in it that surprises us, we are not in the least moved by it and regard it without passion."[2] Implicitly, it seems, no passion was possible for Descartes without wonder as its prerequisite. Standing alone with no contrary, wonder is the wellspring of inquiry about nature and the passions taken together. Though wonder threatened to cause unreason and undue emotion, the human subject could use it to comprehend sensuality and magic, master their consequences, and channel them into beneficial pathways.

Lorraine Daston and Katharine Park have shown recently how the Cartesian conception of wonder had roots in the Renaissance, when *states* of wonder came to be newly allied with natural objects of curiosity and pleasure — "wonders."[3] In the same way, wonder *at* musical wonders became the catalyst for collecting, making, and classifying music in an endless variety of genres and forms. A striking manifestation of this phenomenon came as late as 1739 with Mattheson's *Der vollkommene Capellmeister* (The perfect chapel master), which scrutinized the passions in a trickle-down version of Cartesianism in order to produce taxonomies for every musical genre. For Mattheson, for example, the serenade was marked by tenderness, purity, and kindheartedness, the *balletto* by joy and delight. Mattheson associated different dances with different affects: the minuet with moderate gaiety, the gavotte with jubilation, the bourrée with calm contentment, the *anglaise* with stubbornness, the sarabande with feelings of ambition. Mattheson sometimes struggled to fabricate these associations and occasionally even justified them through putative associations with local colors and pedigrees: hence, the jaunty rigaudon derived from the sailors of Provence, or possibly from Italy (both Mediterranean), the gavotte, from goatherding mountain peoples.[4]

The urge to rationalize the passions by explaining their roots in the musical and dance traditions of different cultures bespeaks the kind of taxonomic impulse that Descartes saw as handmaiden to wonder. But the wonder/wonders kinship in music was far older than Mattheson's writings. It emerged not only in spectacles but in numerous productions of musical oddities by composers and publishers trying to satisfy the public's thirst for curiosities. In the early years of the eighteenth century, for instance, the Dutch composer Johannes Schenck composed *Les fantaisies bisarres de la goutte* (Bizarre fantasies on gout) for viola da gamba; and in 1737, Jean-Féry Rebel wrote *Les élémens,* an eccentric, choreographed symphony that offered various representations of creation — chaos followed by earth, and so on, in order of occurrence.[5]

Still more strikingly, wonder was conveyed through idiosyncratic musical collections depicting wondrous things, unique in nature or uniquely varied. François Couperin's suite-like *ordres* for harpsichord mixed French and Italian styles to produce lively character portraits of friends and patrons. Couperin's first *ordre* of 1713 is especially notable for its length and eccentricity.[6] Marin Marais's quirky, sprawling fourth book of viola da gamba pieces

from 1717 includes nine dance sets scattered with *fantaisies, boutades,* cha-connes, rondeaux, and *caprices* in and among the standard baroque dances, as well as an astonishing *Suite d'un goût étranger* (Suite in a strange taste), composed of no less than thirty-two pieces characterizing everything from a labyrinth to an asthmatic and gathered together with a *marche tartare,* an *arabesque,* a *pièce luthée* (styled after lute playing), a *caprice ou sonate,* a *ron-deau le bijou,* and two smaller suites *within* the suite.[7] Marais's book worked like a cabinet of curiosities that buyers could survey and sample. Accordingly, in the *Avertissement* to the reader, Marais noted that in part two of the book (including the *Suite d'un goût étranger*), one could find a number of character pieces that would "give pleasure when one masters their style and spirit, *for they do not have an obvious melodic line,*" while other pieces "overlooked the 'ordinary rules' of voice-leading in four-part counterpoint."[8] Marais's col-lection encouraged players to pick and choose, to substitute one rondeau refrain for another, to select pieces of varying difficulty, or to use different instruments from those designated—in the *Avertissement,* Marais suggested violins, treble viols, or even treble flutes in place of violas da gamba.[9] In effect, players could satisfy their pleasures, skills, and interests like shoppers in a crammed boutique.

Joy

Collections like Marais's placed conventional pieces side by side with eccen-tricities of kind, maintaining a tension between the unique and the conven-tional that marked the whole seventeenth and earlier eighteenth centuries. In music, the passion of wonder generated an unruly riot of delightful sights and objects, from the strange and terrible to the peaceful and rational "belle nature."[10] Yet as conflicts between passion and reason heightened in the sober aesthetic, moral, and natural philosophy of the Enlightenment, the legitimacy and propriety of musical wonders, and especially operatic ones, were increas-ingly called into question. Wonder, once overtly valorized because it could inspire reason and covertly prized because it made assertions of virtue and power axiomatic, now came to be disdained as vulgar and feared as a threat to good judgment and morals.[11] In a quintessentially eighteenth-century effort to reconcile paradoxes, Mattheson distilled the issue into a single axiom: "nothing can move us that cannot be understood."[12]

Within the new logic of the Enlightenment, reason was called upon to tem-per expression and understanding, with a consequent deepening of the rift between rationalism and sensuality. In eighteenth-century dramaturgy, for instance, a new equanimity of human emotion was expressed in the continual resolution of disquieting passions into happy endings. Joy could keep com-pany with wonder, but, not surprisingly, wonder's links to the monstrous, grotesque, incomprehensible, and fearsome, whether manifest in the tempests of Neptune or the furies of Hades, made it ever more suspect. This was espe-cially the case for theorists of Italian opera, who led the way in revising the stage according to the French neoclassical principles of decorum and dignity

that obtained for spoken drama.[13] Hence the Roman Accademia dell'Arcadia, patronized by Queen Christina of Sweden in the 1690s, set out to purge Italian opera of spectacular machines, multiple subplots and intrigues, and comic episodes.

New rules mandated that plots edify viewers through the use of the pastoral and most especially through histories of ancient heroes and rulers which emphasized serious moral and sentimental dilemmas. By the time Pietro Metastasio began composing his opera seria librettos in the 1720s, the genre had been strictly codified as a three-act structure, with six to seven characters, arias consistently placed at the ends of scenes, and stagings that replaced magical machines, previously used to signify pagan gods, with verisimilar representations of triumphs, processions, and battles. An infatuation with the wondrous remained, but increasingly, opera composers tried to mesmerize listeners through the vocal prowess of singers.

Meanwhile, emerging aesthetic philosophies that worked to codify the fine arts gave tighter form to the long-standing rhetorical bases of music, pressing against the validity of wonder in musical compositions. Music was to move listeners to its sway, matching every expression to its object and eliciting no emotion that would not ultimately console or mollify. In the edition of 1740 of his influential *Réflexions critiques sur la poésie et sur la peinture* (1719), the abbé Jean-Baptiste Dubos, a historian and theorist, stressed the need to correlate musical styles and subjects and to temper the intensity of expression. Music was expected to realize classical rhetorical ideals as a healing force — thus Dubos's praise for the passage in act 5 of Jean-Baptiste Lully's *tragédie en musique, Roland* (1685), in which the eponymous hero is restored to his senses. Dubos compared this passage to the languorous bedtime music of the ancients, who themselves used music to calm their imaginations:

> The symphony in the opera of Rowland...plays its part very well in the action where it is introduced. The action of the fifth act, where it is placed, consists in restoring Rowland to his senses, who went off the stage quite raving mad at the end of the fourth act. This delightful music gives us an idea of those symphonies which Cicero and Quintilian say the Pythagoreans made use of, to calm, before they went to bed, the tumultuous ideas which the bustle of the day had left in their imaginations; in the same manner as they employed symphonies of an opposite nature, to put the spirits in motion when they awaked, in order to render themselves fitter for application.[14]

Like other early Enlightenment thinkers of an empiricist, sensist, and pragmatic bent, Dubos took pains to reconcile the continued fact of operatic marvels with the requirement that music lead to good feelings. "We commend the symphony of the tomb of Amadis," he wrote, "and that of the opera of Issé, by saying the imitation is very natural, tho' we have never beheld nature in the circumstances in which those symphonies pretend to copy it."[15] Though mere fancy, marvels of nonnature were justifiable when they resembled nature, and

the music accompanying such spectacles had the power to move audiences all the more.[16]

But increasingly, French aestheticians pushed upstream against the marvelous in opera to insist that verisimilitude and a close unity of words and music were necessary in order to harness musical powers for the common good. According to this view, beauty and regularity were indispensable moral tools for touching off the correct sympathies in listeners. Yves Marie André argued in his *Essai sur le beau* (1741) that reason and beauty could not be denied their deserved status because the soul grants them such importance — hence ugly dissonance was acceptable only for violent expression, as a necessary evil. Once reason and beauty were accommodated, André claimed, music was able to realize its moral destiny. For André, music was superior even to painting, since nature had imbued music with authenticity, immediacy, and temporality.[17]

The beneficent sensory effects that André elucidated led him to conclude that all musical works would end by reaffirming the passion of joy. Similarly, in the much reprinted *Les beaux-arts réduits à un même principe*, first published in Paris in 1746, André's contemporary Charles Batteux called music and other fine arts "the fruits of joy."[18] Batteux cautioned that if music were to exceed "clearly defined limits," it would threaten a loss of self-control in the listener, resulting in "chaos, not order" and "horror rather than pleasure."[19]

One challenge to achieving these ideals was the fact that, although music was viewed as a prime *mover* of the passions, it was but a secondary *sign* of them. To compensate for this, Batteux, Dubos, Mattheson, and many others turned to well-wrought poetry. Music without words, they claimed, had no means of mediating between itself and objects or of otherwise referring to the material world.[20] This kind of rhetorical thinking was virtually universal throughout Europe at the time: an inclination to temper music with poetic verse in order to produce a mix of passions worthy of classical rhetoric was evident in numerous national traditions. For Italian literati like Metastasio and Pier Jacopo Martello, for instance, different verse types expressed different passions, but all *good* verse for music maintained decorum while urging virtue.[21] The inevitable happy ending of the Italian libretto affirmed the belief that music could only achieve collective moral force through a careful balance between the sways of passion and the triumphs of virtue.[22]

Yet hovering near the passion of joy were its main alter egos, fury and madness, forever threatening the classical ideas of reason, regularity, and beauty on which joy depended. Madness, paradoxically, was linked with magic, its ancient cure. Thus, in the first half of the eighteenth century, musical drama often portrayed madness as a state to be overcome through miraculous interventions that would restore the senses to universal happiness. A prime example is George Frideric Handel's opera *Orlando* (London, 1732), which enlarged on Ludovico Ariosto's sixteenth-century poem *Orlando furioso*. Appended to its first printed libretto was an *argomento* that told readers of the "immoderate Passion that Orlando entertained for Angelica,

Queen of Catai, and which, in the end, totally deprived him of his Reason."[23] The story, it claimed, exemplified "the imperious Manner in which Love insinuates its Impressions into the Hearts of Persons of all Ranks; and likewise how a wise Man should be ever ready with his best Endeavours to reconduct into the Right Way, those who have been misguided from it by the Illusion of their Passions."[24]

In *Orlando,* passions are embodied in wondrous form: rage and madness as the love-crazed hero Orlando, with his baleful visions of the monster Cerberus; love as the blind Cupid, or a magic mountain where languishing heroes die; temperance as the magician Zoroastro; grief as the nightingale who weeps while singing of unrequited love. And, much as in seventeenth-century operas, *Orlando* elaborates a specific physiology of passion whereby motions that enter the heart disturb the passions by dividing the subject in two — the essential self is divided from the emotional state into which it is thrown. In act 1, scene 5, Angelica's lover Medoro declares, "My heart is divided from myself," and Orlando, as he descends into madness at the end of act 2, cries out, "I am my spirit, divided from myself."[25]

Often this type of division comes about when excessive passions cast mysterious magic spells on their victims. Again and again, the love-struck couple Medoro and Angelica declare that they are helpless in the face of love's potency. Love is a maddening force beyond reason that lies perilously outside the mechanical power of human resistance.[26] Yet in the enchanted world of *Orlando,* the dangers of love also have their salvation in magic. Hence beneficent effects are projected through the magician's music: Zoroastro's stately bass voice sounds reassuringly over a quasi-ground bass in his first, sumptuously orchestrated aria, "Lascia Amor, e siegui Marte," supported by limpid harmonies and steady rhythms.

Zoroastro's music could hardly contrast more with that of Orlando, whose mental state deteriorates in several arias across the first and second acts. In "Fammi combattere," Orlando embarks on a note of blustering heroism; in "É questa la mercede — Cielo!" his heroism swells into rage, and then finally into madness, a transition signaled by an overly long diminished chord on "Ciel." Yet both arias are only a preamble to Orlando's imminent collapse. At the end of act 2, Orlando loses his reason completely — his passions erupt in frantic succession, culminating in the famous mad scene, "Ah, stigie larve!" As Orlando imagines himself dead in act 2, scene 11, wandering among the shades of hell, the music breaks into radical disunity: abrupt shifts of harmony and tempo as he fends off specters and Stygian monsters; an off-balance passage in 5/8 time as he ploughs the waters in the guise of Charon; bizarre chromaticisms; and finally a childlike gavotte, "Vaghe pupille," wrenched abruptly into a repeated bass descent by semitones (a mad version of the passacaglia bass), only to return unexpectedly to the gavotte as Orlando begs the lovely Proserpina to weep no more.[27]

Orlando is an object lesson in how the spirit can be "divided from itself" through magic-induced unreason; hence, it is a lesson in the negative effects of

wondrous things. But the opera also shows how reason and joy prevail, as finally Orlando's senses are retrieved from the dispossession caused by love: in act 3, slumbering and dreaming in a field of poppies (prior to his soothing "Già l'ebro mio ciglio"), Orlando is healed by Morpheus, a muse conjured up by Zoroastro. The opera's metaphysics are thus a hybridized holdover of seventeenth-century magic and reason, extending Descartes's maxim of nearly a century earlier that "the exercise of virtue is a supreme remedy for the Passions."[28]

Given that early-eighteenth-century theories of imitation depended on words to mediate between sounds and thoughts, feelings and things—in short, to make moral sense of the world—instrumental music was often seen as unable to produce the equation of reason and joy that was the result of texted sound. Thus, the French scientist Bernard Le Bovier de Fontenelle's legendary quip, "Sonate, que me veux-tu?" (Sonata, what do you want from me?).[29] After all, if texted music signified reason in a system of signs in which music was secondary, merely imitating the words it attached to, then how could the *non-sense* of nonverbal music convey even so much as the plight of unreason? The abbé Noël-Antoine Pluche, in his *Spectacle de la nature* (1746), complained that it had become customary "for some centuries to do without vocal music and...amuse solely the ear, without presenting any thoughts to the mind;...to claim to satisfy men with a long series of sounds devoid of meaning...[is] directly contrary to the very nature of music, which is to imitate."[30]

Pluche's disparagement of wordless music was not shared by everyone, however, and it was neither desirable nor practicable to dismiss instrumental music altogether. Indeed, instrumental music was often rationalized into favor on the grounds that it conformed with the natural universe. The abbé Dubos, who hesitated to give instrumental music full legitimacy since it was non-semantic, nevertheless celebrated its capacity to access and represent the darker human passions, citing the famous *Tempest Symphony* from Marais's opera *Alcyone* (1706) as proof.[31] And the composer and theorist Jean-Philippe Rameau justified nonverbal music by identifying musical passions through the naturalist acoustics that underlay his outwardly mechanistic chordal theory, which proposed the *corps sonore*—the resonance of upper partial tones produced by various vibrating bodies—as a kind of primordial source of all musical harmony.[32]

In short, the question of music's capacity to signify, with or without words, became a lightning rod in discussions about which passions music should privilege, and how music could best express the passions all told. But attitudes toward music increasingly betrayed shifts in the subjective *experience* of the passions, in the very notion of what could constitute a passion, and on what the notion of a passion turned. As music became implicated in a growing attention to individual human feeling—what the contemporary critic Michael Chanan has called a new "economy of sentimentality"[33]—specific representations of words through notes seemed bound to limit, or at least undermine, the affective power of music. Hence, rising attacks on imitation

around midcentury debunked descriptive music as being trivial, claiming instead that music had direct force on listeners and did not require mediation by either words or nonverbal images. Jean-Jacques Rousseau, in the post-humous *Essai sur l'origine des langues,* wrote that music was no longer a secondary sign but an unmediated expression of the thing itself—not a repre-sentation, but a primary instantiation.[34] While Rousseau and his kind still preferred vocal music as the site of a primordial link to the emotions—his famous *cri animal de la nature*—they did not need instrumental music to be descriptive in order for it to be legitimate.[35]

In reality, of course, Rousseau was the baldest of idealists, refusing to admit that inherent in his notion of music was a universal conception of music. Still, Rousseau's thinking exemplifies a change in ideology in which music assumed a primary function rather than its secondary one as represen-tation. This new ideology is epitomized in the tender romance of Rousseau's popular *opéra comique Le devin du village* (1752). *Le devin* played a central part in the *Guerre des Bouffons,* the famous pamphlet war over the relative merits of French and Italian opera: the war raged between August 1752 and September 1753, during which time a troupe of Italian opera comedians took Paris by storm.[36] Hailed as natural and lyrical for their performances of the humble comic intermezzo, the Italians became mascots for Italophilic natural-ists, including Rousseau and the Encyclopedists, who cried out against the artifices of French *tragédie en musique*. The quarrel turned on a false compari-son, since logically it should have pitted French tragic opera against its Italian countertype in the realm of high-brow, lavish spectacle, namely opera seria, rather than against the lowly comic intermezzo. But the debate served the important function of heating up challenges to opera seria and the artificiality of virtuosic arias, most notably in the polemics of the Italian writer Francesco Algarotti and the Viennese composer Christoph Willibald Gluck.

Here again, the view that virtuosity was the stuff of cheap wonder and artifice was attached to long-standing suspicions of instrumental music. Conflated in some arguments with an expensive vocal wizardry—deemed errant and unnatural, and often identified with descriptive forms of imita-tion—instrumental music continued to battle at midcentury for theoretical legitimacy. Gradually, though, publics and critics came to accept instrumental music on its own terms and to invest it with powers that helped liberate music from text.[37] Let us now see where this semantic freedom took the musical passions.

Pathos (and Self)

Charles Avison, in his *Essay on Musical Expression* (1752), declared that the "peculiar and essential property [of music is] to divest the Soul of every unquiet Passion, to pour in upon the Mind, a silent and serene Joy, beyond the power of Words to express, and to fix the Heart in a rational, benevolent, and happy Tranquillity."[38] Joy was Avison's ultimate passion, and ultimately, for him, the musical passions were to have only beneficent, calming effects.[39] In

45

this, Avison echoed an old tradition of taming wild passions with music: as far back as the ancient tales of Orpheus, the taming of the passions was symbolized by humankind's special abilities to tame wild beasts.[40] But Avison also followed an encompassing Enlightenment logic that made this domesticating function axiomatic for *all* music, since for Avison, music was inherently civilized and thus capable of making its listeners sociable and, finally, happy.[41]

Yet Avison was something of a liminal thinker, whose ideas were situated midway between older allegiances to joy and pleasure, still tied to rhetorical imitation, and newer leanings toward expression freed of imitation and endowed with heightened emotional possibilities. The special work of music was its ability to touch the audience's sympathies, either by imitating sounds or, preferably, by what he vaguely referred to as "any other Method of Association."[42] With this elusive phrase, Avison betrayed a growing suspicion of the referential system of imitative aesthetics, championing instead a loosening of ties between musical effects and things, and a more general relationship of music to signs: not the contemptible barking of dogs he derided in Antonio Vivaldi's *Four Seasons* but something more ineffable.[43] Avison had his own solutions to the problem of signification in music. Among them was to relegate imitation in vocal pieces to instrumental accompaniments, as Handel had done in "Hush you pretty warbling quire" from *Acis and Galatea* (1718); in this aria, the voice was given nothing that could smack of an effort to imitate chirping birds.

As imitation became metaphysically suspect around midcentury, expression began to take priority. In music, this shift was a paradigmatic one, since the job of musical expression was no less than to mediate between the immaterial, irrational sphere of the passions and the soul, and the material, rational sphere of the mind.[44] The Scotsman Henry Home, the German Johann Nicolaus Forkel, the Frenchman Michel-Paul-Guy de Chabanon, and many other theorists continued to insist that music had its own means of representation and its own capacity to stir the passions, outside of any external system of reference.[45] For instance, Forkel, Johann Sebastian Bach's eighteenth-century biographer, wondered: "If music is a language of the passions and emotions, if not a single person's emotions exactly coincide with those of another, would it not then follow that, in default of suitable precepts and rules deduced from nature and from experience, art would have to be left to the caprice and wilfulness of each individual?"[46] Forkel concluded that this eventuality could only be avoided by a composer who was a "master spirit," who could achieve "maturity by dint of industry and unremitting study of nature's secrets" so that others would be able to "search out nature's hidden depth for the magic beauties of art."[47] Forkel and like-minded thinkers chased away old models, such as Mattheson's, which linked single movements or pieces with single affects. The passions were now to be spontaneous and ever changeable. Idealized in pluralities, they were to rise up in fluid succession, much as they did in the parodic pantomimes of operatic performances by Rameau's nephew, as represented in Denis Diderot's late work *Le neveu de Rameau*.

Given this new freedom and flexibility, the fact that music could no longer designate particular passions or restrict itself to any single passion did not pose a problem. Daniel Webb, an English writer, defined the new relation of music and affect in his *Observations on the Correspondence between Poetry and Music* (1769). Offering a general class theory of the passions in which music was denied specific referential powers, Webb explained

That, in music, we are *transported* by sudden transitions, by an impetuous reiteration of impressions.

That we are *delighted* by a placid succession of lengthened tones, which dwell on the sense, and insinuate themselves into our inmost feelings.

That a growth or climax in sounds *exalts* and *dilates* the spirits, and is therefore a constant source of the *sublime*.

[And that i]f an ascent of notes be in accord with the sublime, then their descent must be in unison with those passions which *depress* the spirits.[48]

From these observations Webb deduced that "[a]ll musical impressions, which have any correspondence with the passions, may...be reduced under one or other of...four classes."[49] Each class ended respectively in the transport, delight, exaltation, or depression of the spirits, and each class was prompted by movements of the spirit made by sounds associated not with one but with several passions, which collectively made up a "general class":

If they agitate the nerves with violence, the spirits are hurried into the movements of anger, courage, indignation, and the like.

The more gentle and placid vibrations shall be in unison with love, friendship, and benevolence.

If the spirits are exalted or dilated, they rise into accord with pride, glory, and emulation.

If the nerves are relaxed, the spirits subside into the languid movements of sorrow.[50]

Webb concluded that "it is evident that music cannot, of itself, *specify* any particular passion, since the movements of every class must be in accord with all the passions of that class. For instance, the tender and melting tones which may be expressive of the passion of love will be equally in unison with the collateral feelings of benevolence, friendship, and pity; and so on through the other classes."[51]

Others may have disagreed with Webb's groupings, but not with his impulse to diminish the specificity of musical reference. Far from being seen as a loss, relinquishing old referential habits was done gladly once the triumphant

mechanism of the human imagination was vested with an almost boundless power. For Webb, Diderot, the Swiss theorist Johann Georg Sulzer, and others, exaggerated imitation became stifling, while imagination became the pride and distinction of the sentient subject.[52]

Along with many other works, Avison's concerti grossi of 1744 — arranged after Domenico Scarlatti's harpsichord sonatas — gave musical form to theories like Webb's. Avison recast Scarlatti's pantomimetic sonatas as concertos, thus framing the gestural and highly subjective material produced by the soloist in a collective musical discourse.[53] Referentially ambiguous but emotionally strong, these concerti resonate with later critiques of opera. In Diderot's *Encyclopédie* (1751–72), Charles de Saint-Évremond (quoted in the Chevalier de Jaucourt's article on opera) and the baron Friedrich Melchior Grimm (in his article "Poème lyrique") both claimed that opera became a monster, unnatural and false, when it put obvious awareness of representation before the spectator's eyes. Far from distilling the passions into discrete categories as earlier theorists had, Saint-Évremond's and Grimm's instincts were to avert disorder by having the spectator be touched instead of dazzled or delighted.[54]

Exit the fantastic and with it the possibility of an unembarrassed joy; enter the new valorization of the sentimental and the pathetic. Jean Le Rond d'Alembert, a mathematician and also an editor of the *Encyclopédie*, captured the new pathos with a polemical bluntness in "De la liberté de la musique" (1759): "let us leave to the common crowd the ridiculous prejudice of believing that music is suited only to the expression of gaiety; experience teaches us daily that it is no less susceptible to expressions of tenderness and grief."[55] Crudely opposing here the joyful and the pathetic, D'Alembert was spurred by a desire to shoo away varieties of aesthetics that made no significant place for sorrow in music and that could not accommodate the full spectrum of emotions necessary to guarantee emotional authenticity on an illusionistic stage. His remarks fell in with a growing sentiment that understood pathos as essential to creating illusion. But, more importantly, the eventual victory of the pathetic was implicated in shifting views in two other domains — representation and metaphysics, and specifically the epistemological status of the subject. As Downing Thomas recently observed, "In place of a metaphysical bond between the object and our representations of that object, guaranteed by the existence of God, . . . a new series of connections were formed, based on the increasing importance of *sensibilité*."[56] Sensibility signified refinement through emotion, whereby feeling was elevated over cognition as a means to understanding and awareness, and the capacity to be moved by pathos to compassion was prized above all else.

Signs of sensibility, unmediated by representations of external objects, were strenuously pursued in music, and especially in the opera house. In 1772, in a pointed elaboration of this phenomenon, the Neapolitan Antonio Planelli published a harangue against magic (read: wonder) that condemned divas and the composers who accommodated them; the harangue culminated in a

panegyric on the pathetic.[57] Planelli warned that listeners were being wooed by the stunning instrumental feats of virtuosi. Deprived of the chance to follow the meanings and moods of characters, the audience could not experience verisimilitude through the performers' singing.[58] One diva proficient in the "marvelous," Planelli charged, referring obliquely to the famous soprano Caterina Gabrielli, "has made our composers delirious. Since she began to appear … everything in theaters has turned into a trill. Entranced by this novel musical spell, audiences were convinced they were hearing for the first time the only style truly worthy of operatic music. The *maestri di cappella,* similarly touched by such magic, imagined that they were entering a new musical world. Setting foot in that enchanted land … they blessed the heavens."[59]

Planelli's critique collapsed vocal artifice into the mystifying powers of magic, much as earlier reformers like Algarotti, Pietro Verri, and others had done,[60] though their writings called for nothing as restrictive as Planelli's prescription for a pathetic style. His first "law" of theatrical singing was that it have "few notes."[61] Too many notes made for artifice, and too much artifice destroyed the pathetic — that emblem of authentic emotion. In order to achieve greater emotional depth, operatic singing was to favor a middling path, with music limited in pitch range, expressive tone, style, and sheer number of notes. Yet his new version of the pathetic was decidedly different from the grandiose tragic style conceived in rhetorical tradition: Planelli's second "law" stated that theatrical music "abhors tones that are too high and too low" because "[p]athos consists of a just medium."[62]

Planelli's solution for keeping virtuosity from becoming a commodity resonates with the many pathetic idioms that were starting to turn opera in the direction of a naturalistic musical sentimentality from about 1760 onward, when opera seria was more and more seen as a holdout against naturalism and authentic emotion.[63] Perhaps the most striking, if eccentric, musical manifestation of this new sensibility was the north German aesthetic of *Empfindsamkeit,* roughly "sensibility." Cultivated at the Berlin court of Frederick the Great, its most famous practitioner was Carl Philipp Emanuel Bach, whose *Empfindsamer Stil* absorbed into an intense instrumental idiom the earlier operatic styles of the Italianized German opera composers Johann Adolf Hasse, famed throughout Europe, and Carl Heinrich Graun, the court Kapellmeister under Frederick beginning in 1741 and the composer of the classic exemplum of *Empfindsamkeit,* the Passion cantata *Der Tod Jesu* (1755).

Bach's influential *Versuch über die wahre Art das Clavier zu spielen* (Essay on the true art of keyboard playing) of 1753 made the operatic genealogy of the *Empfindsamer Stil* obvious by insisting that knowledge of vocal styles was imperative for keyboardists, whom he advised to study voice and listen closely to good singers.[64] Many keyboardists, he noted, could astound listeners yet not touch their hearts (as the best singing could do): "More often than not, one meets technicians … who … astound us [lit. 'fix our countenances in Wonderment'] with their prowess without ever touching our sensibilities.

They overwhelm our hearing without satisfying it and stun the mind without moving it."[65] To demonstrate his principles, Bach published six sonatas with the *Versuch:* each sonata exploded with excess before being wrestled into moderation, thus showcasing the keyboardist's virtuosity while also putting his own impulsive passions, and ability to master them, on display. In this way, Bach's music nearly broke down the barrier between the old stoical value of passion harnessed by self-control, a legacy from neoclassical aesthetics, and the late-eighteenth-century value of pervasive subjectivism.[66]

It was particularly in the moody fantasia—freely formed to convey the fancy of the composer or performer—that Bach concentrated the new sensibility most intensely, with abrupt shifts of key and tempo, remote modulations, and other startling departures, meticulously notated to mimic the heightened oratorical delivery of an actor's pacing and hesitations.[67] And, like an actor, the performer of the fantasia was to take stock of his audience, helping it understand the affects conveyed in the piece by wearing expressions on his or her own face: "It is principally in improvisations or fantasias that the keyboardist can best master the feelings of his audience. Those who maintain that all of this can be accomplished without gesture will retract their words when...they find themselves obliged to sit like a statue before their instrument. Ugly grimaces are, of course, inappropriate and harmful; but fitting expressions help the listener to understand our meaning."[68]

Implicit in this claim was the idea that the performer should express feelings that were "real." While not brand new, this idea ran contrary to the opinion of French aestheticians of the first half of the eighteenth century, like Batteux and André, and also to a seemingly reactionary critique of acting that Diderot began writing around 1770, *Paradoxe sur le comédien,* in which he claimed that, since acting was contrivance, the actor need not feel the part.[69] For Bach it was just the opposite: the performer was not merely to enact but to embody the content of what was to move the audience, inhabiting the right mood and constantly varying the passions expressed as his or her inner feelings changed.[70] Bach's stance resonates with Charles Burney's description, in *An Eighteenth-Century Musical Tour in Central Europe and the Netherlands* (1773), of Bach's own improvisations at the keyboard:

> After dinner...I prevailed upon him to sit down again to a clavichord...and he played, with little intermission, till near eleven o'clock at night. During this time, he grew so animated and *possessed,* that he not only played, but looked like one inspired. His eyes were fixed, his under lip fell, and drops of effervescence distilled from his countenance. He said, if he were to be set to work frequently, in this manner, he should grow young again. His performance to-day convinced me...that he is not only one of the greatest composers that ever existed, for keyed instruments, but the best player, in point of *expression.*[71]

Here, the performer assumes the body and personhood of the one now regarded as the principal feeling subject, namely, the composer—often, but

often not, the same person, and the only one who could "effectively express what he himself keenly feels," as Sulzer later put it.[72] Passion was externalized as the fruit of a primary creator. Whatever skepticism we may bring to these tokens of authenticity, and the emerging cult of the author that accompanied them, the new culture of sensibility perceived outward expressions of emotion by the performers as musical gateways to human sympathy, extending the interests of Avison in line with those of philosophers like Francis Hutcheson and, most famously, David Hume.[73]

In *A Treatise of Human Nature* (1739), Hume had explained that impressions alike to the self could generate sentiments through resemblance, helped by causation and contiguity. In this construction, the passions could be seen as dynamic instruments of human sympathy.[74] And from this point, it was a small step to understanding that the operation of the passions in music took place as feeling was transacted between performers and spectators, the latter scrutinizing human character for signs of truth through a combination of sound and sight. Where once, heightened emotion had frightened commentators on the passions, now Sulzer, Grimm, and many others became entranced with musical representations that showed strong emotions.[75] In the new science of emotion, existing under the name *aesthetics*, music became a space of affective signs that could be examined in order to understand human pathos. At the same time, *sympathy* became the new catchword, in near-Stanislavskian terms, of how acting engages the hearts of its viewers.

At work here is a tentative rejoining of body and soul, which previously had suffered a philosophical split at the hands of Descartes. With Étienne Bonnot de Condillac's *Essai sur l'origine des connaissances humaines* (1746) and Julien Offroy de La Mettrie's *Histoire naturelle de l'âme* (1747), sensation and thought had already begun to move closer together. Music was advanced as a natural sign of the passions, prior to language yet ideally able to represent them. The new bond between sensation and thought took root in essays such as Diderot's "Lettre sur les sourds et les muets" (1751; Letter on the deaf and dumb), which looked at the connection of music and sensibility in aesthetic-philosophical terms.[76] By the time Sulzer published his article "Musik" in 1777, the connection could be framed as a simple item of faith: "Nature has established a direct link between the ear and the heart; each emotion is expressed by particular sounds, each of which awakens in the listener's heart the original experience that gave rise to it."[77]

It is not surprising that this new physiological aesthetics expressed itself in a sort of *hyperpassion*. Reciprocally negotiated between actors and viewers, this hyperpassion privileged uncontainable emotion signified by the nonverbal — silence, interruption, ellipses, parataxis, and the physical expressions of sighs, tears, throbbing hearts, and beating breasts. Such moments define what Stefano Castelvecchi has dubbed "sentimental opera," a "third" operatic genre lying between comedy and tragedy, and pitched at the growing bourgeoisie who thronged to performances of the works of Niccolò Piccinni,

Pierre-Alexandre Monsigny, Giovanni Paisiello, and others after 1760.[78] These composers dispensed with the restraints of the classical pathetic found in *tragédies en musique* by composers such as Lully and Rameau, or in early opere serie by Neapolitan composers such as Giovanni Battista Pergolesi, whose "Se cerca, se dice" from Metastasio's *L'Olimpiade* (1733) epitomized the tender pathetic. Where formerly the pathetic was used to contrast with but always resolve narratively into joy, now the pathetic was deployed across larger narratives and was made efficacious in their endings.

But theorists argued that pathos, in order to succeed in the theater, needed an illusionistic setting. In an essay from 1787, Jean-François Marmontel claimed that actors and audiences experienced a performance on split levels — the reality of the hall and the illusion of the action — and that such a split had to be emphasized in order to make illusions "convincing."[79] Marmontel's proposals correspond to those of many other late-eighteenth-century Frenchmen, such as Jean-Georges Noverre and Charles Nicolas Cochin, who agitated both for continuity in dramaturgical forms and for an illusionistic stage — less light in the auditorium, more curtain falls to hide scene changes, naturalistic action and acting techniques, realistic scenic pictures, oblique perspectival sets, more singing in midstage, animation of side stages and wings, and historical costumes and scenery.

Simultaneously, the argument for illusion was echoed by Planelli, who vaunted Aristotle's dramatic theory in the *Poetics* for its elevation of the passions of terror and compassion.[80] Planelli renamed opera seria *tragèdia musicàle* in a move that anticipates the much later recasting of *dramma per música* as *tragèdia per música* in printed libretti. From a kind of negative morality in which characters die, which he saw as having been forced on ancient viewers, Planelli idealized the best modern theater as one in which virtuous heroes, whether of high or middling class, compelled the audience's affections and then rewarded it with a happy ending. For Planelli, good acting by singers was necessary because it enabled a performance to sustain illusions of verisimilitude.[81]

I single out this theater of illusion because it seems to have had the capacity to undergird the pathetic by creating the belief that an exchange of emotion was in play between parties, putting the individual feelings of actors and viewers on display for inspection and authentication. But it also escalated a political battle that had long been fought on the French stage between codes of *sensibility* and codes of *taste*. As Anne Vincent-Buffault has argued in her *History of Tears*, sensibility in this battle was implicitly aligned with the natural emotions of non-nobles, while taste was aligned with the learned judgments and artifice of the aristocracy.[82] For Vincent-Buffault, the first French theatrical genre to strike a direct hit against *bon goût* as a privileged category of discrimination was the spoken *comédie larmoyante* (sentimental or tearful comedy) in vogue after 1730. Along with the opéras comiques on the lyric stage starting in the 1760s, the *comédies larmoyantes* consistently represented love as a condition capable of triumphing over the hardened prejudices of

class—and it was particularly through music that love could project individual feelings in a moving form. This was precisely Diderot's point in his satirical dialogue *Le neveu de Rameau* when he had the character of Lui praise the expression of the miser's plaint in Egidio Duni's opéra comique *L'isle des foux* (1760) and the young girl's beating heart in François-André Danican Philidor's opéra comique *Le maréchal ferrant* (1761). Through this dialogue, Diderot argued that the new opéras comiques deserved a special hearing for their masterful control of human emotion: "Go and listen to the piece when the young man, feeling himself on the point of death, cries: *Mon coeur s'en va.*"[83]

Unlike in earlier decades, opera and spoken theater in the later eighteenth-century began to produce these heightened sensibilities, not only for private individuals but for individuals in public spaces. With this shift came floods of tears, which both tested social ties and marked new views of human virtue, figured through the colloquial, self-reflexive, and melancholy nature of the works themselves, as well as the pathos with which they were delivered and observed. A few, namely Rousseau and Diderot, doubted whether the new collectivity of tears was authentic and signaled true virtue.[84] But for some time, writers, composers, actors, and viewers all colluded in making pathos a guarantee of spontaneity and sincerity. We might ask whether these collective tears were the affidavit of a new subjectivity and a new sociability; whether they were a hedge against the loneliness of an illusionistic theater; and whether they portended the alienation of the modern subject, who longed to be rejoined affectively to the wider world that was quickly fading with the decline of the old order. If I have only broached these questions here, it should nevertheless be clear that they were crucial to the Enlightenment individual's assumption across Europe of a new role in his or her own manufacture, authorization, and self-promotion.[85]

A Provisional Ending

Because critical theories about music and the passions thrived in the habitat of a rhetorical tradition, they necessarily formed part of a collective discourse and also a discourse about the collective.[86] Indeed, the predicament of the individual subject in navigating the precipitous terrain of the passions was at times barely audible in these discourses. Throughout the eighteenth century, the role of the individual increasingly came to the fore, but it was only after the passions ceased to underpin discussions about music and affect that analyses of them could be framed in new ways: as expression, emotion, pity, pathos, class struggles, and the aspirations of individuals. And once that happened, the passions began to see the end of their days as a discursive category.

Musically, it was in the theater that the biggest blow was dealt to discourses of the passions, since it was there that relations between individuals and social groups were dramatized onstage and off and were, finally, transformed. In particular, the ascendancy of an illusionistic theater around 1760

brought with it a new listening subject whose inner self was stirred by its perception of others' emotions. Yet, paradoxically, it was through the solitary, existential act of absorbed spectating that the listener was now expected to be animated emotionally.

What begins as a discourse on the passions, oriented to collective affect, becomes, then, a discourse on expression, oriented to the individual. And in the course of this transition, sites of authority undergo momentous shifts as well. With wonder, authority was perceived in the miraculous monarch, who represented the fount of marvels.[87] With joy, authority was identified in star performers, who, because of the roles they played and the unprecedented fees and status they commanded, were themselves turned into ambiguous substitutes for the monarch in the new public sphere of commodities. With the pathetic, finally, authority was seen to reside principally in the composer, whose intentions were increasingly inscribed in notational details that pulled at the performer like a puppeteer. In this way, the composer (as primary creator) became a proxy for the new self-determining, autonomous subject. Given these shifting relations between authority and affect, new claims on behalf of pathos in the second half of the eighteenth century must be understood as political: to feel an emotion in a particular way was to make a moral, political, and cultural claim, and to make such a claim was to reproduce and also challenge social institutions and the values that informed them.[88] In these latter operations, music played a remarkable role—all the more so because largely tacit.

Notes

This essay was written for Patricia.

I would like to thank the Getty Research Institute for inviting me to participate as a Getty Scholar in the 1998/1999 Scholar Year "Representing the Passions." In particular I would like to thank the former director, Salvatore Settis, the former associate director, Michael S. Roth, and the rest of my stimulating colleagues there. I am also much indebted to my seminar "Music and the Passions" (University of Chicago, Winter 2000) for helping shape this essay: Lyndal Andrews, Donald Chae, Yoonjeong Choi, Jeffers Engelhardt, Peter Martens, Ryan Minor, Joti Rockwell, and especially my advisee Catherine Cole all gave me invaluable feedback on the initial text of this essay—as did my colleagues Thomas Christensen, Berthold Hoeckner, and David Levin, and the editor of this volume, Richard Meyer. Finally, a special thanks to Mary Springfels for bringing her ideas about the passions to life in a delightful performance of George Frideric Handel's *Orlando* at the Getty Center in 1999.

1. Charles Avison, *An Essay on Musical Expression* (London: C. Davis, 1752), 3. The passage continues: "Thus, the Noise of Thunder, the Shouts of War, the Uproar of an enraged Ocean, strike us with Terror: So again, there are certain sounds natural to Joy, others to Grief, or Despondency, others to Tenderness and Love; and by hearing *these*, we naturally sympathize with those who either *enjoy* or *suffer*" (pp. 3–4).

2. René Descartes, *The Passions of the Soul*, trans. Stephen H. Voss (Indianapolis:

Hackett, 1989), 52. For the original, see René Descartes, *Les passions de l'âme* (1649), ed. Jean Maurice Monnoyer (Paris: Gallimard, 1988), §53:

> Lorsque la première rencontre de quelque objet nous surprend, et que nous le jugeons être nouveau, ou fort différent de ce que nous connaissions auparavant ou bien de ce que nous supposions qu'il devait être, cela fait que nous l'admirons et en sommes étonnés. Et parce que cela peut arriver avant que nous connaissions aucunement si cet objet nous est convenable, ou s'il ne l'est pas, il me semble que l'admiration est la première de toutes les passions. Et elle n'a point de contraire, à cause que, si l'objet qui se présente n'a rien en soi qui nous surprenne, nous n'en sommes aucunement émus, et nous le considérons sans passions.

3. See Lorraine Daston and Katharine Park, *Wonders and the Order of Nature, 1150–1750* (New York: Zone, 1998).

4. See Johann Mattheson, *Johann Mattheson's* Der vollkommene Capellmeister: *A Revised Translation with Critical Commentary,* trans. Ernest C. Harriss (Ann Arbor, Mich.: UMI Research Press, 1981), pt. 2, chap. 13, §§41–42 (on the serenade), §44 (on the *balletto*), §§81–86 (on the minuet), §§87–89 (on the gavotte), §§90–94 (on the bourrée), §§109–12 (on the *anglaise*), §§118–20 (on the sarabande), §§93–94 (on the rigaudon). For the original, see Johann Mattheson, *Der vollkommene Capellmeister* (Hamburg: Christian Herold, 1739; reprint, Kassel: Bärenreiter, 1995).

5. Johannes Schenck lived from circa 1660 until after 1712; only the basso continuo part of *Les fantaisies bisarres de la goutte,* op. 10, survives. With *Les élémens,* Jean-Féry Rebel included an article explaining that the first sound in the first movement, "Le chaos," was expressed through the simultaneous attack of every note in the D-minor harmonic scale, a chord that then resolved to a single pitch to represent earth. Another example of such musical curiosities is the *Canone infinito gradato a 4 voci sopra 'A solis ortus cardine'* for keyboard by Johann Gottfried Walther (1684–1748); see the music as given in Philipp Spitta, *Johann Sebastian Bach: His Work and Influence on the Music of Germany, 1685–1750,* trans. Clara Bell and J. A. Fuller-Maitland (New York: Dover, 1951), 1:384 n. 56. I am grateful to Mary Springfels for bringing these works to my attention.

6. After 1713, François Couperin's *ordres* became increasingly regularized, with greater homogeneity of mood and less than half as many pieces included.

7. Marin Marais, *The Instrumental Works,* vol. 4, *Pièces à une et à trois violes: Quatrième livre (1717),* ed. John Hsu (New York: Broude Trust, 1998). Marais also included in the fourth book his *Tableau de l'opération de la taille,* a piece characterizing the stages of a gallstone operation with accompanying programmatic text (for example, "L'aspect de l'apereil," or "Fremissement en le voyant").

8. Marais, *The Instrumental Works* (note 7), 196–97 (emphasis added). Marais gave as an example of rules he overlooked the parallel fifths and octaves on the downbeats of measures 18 and 19 of no. 80.

9. Marais, *The Instrumental Works* (note 7), 196–97.

10. Some writers have lamented a putative metaphysical split implied by such music. Reviewing French justifications of the operatic marvelous, Catherine Kintzler, *Poétique de l'opéra français de Corneille à Rousseau* (Paris: Minerve, 1991), 371,

describes the wondrously "real power of mechanical excitation" by which spectacles could arouse emotions sympathetically. Gary Tomlinson's recent *Metaphysical Song: An Essay on Opera* (Princeton: Princeton Univ. Press, 1999) assigns early modern opera a new re-*presentation*al semantic function in which meaning is expressed as a mere secondary effect.

On "la belle nature," an ideology that elevated harmonious nature to a universal paradigm, see Jean Ehrard, *L'idée de nature en France dans la première moitié du XVIII^e siècle* (Paris: Albin Michel, 1994), esp. pt. 2, "La nature humaine et ses lois," including chap. 5, "Nature et beauté," and chap. 6, sec. 3, "Les 'passions' et l'ordre du monde."

11. See Daston and Park, *Wonders and the Order of Nature* (note 3), esp. chaps. 8–9.

12. Quoted in George J. Buelow, "Johann Mattheson and the Invention of the *Affektenlehre*," in George J. Buelow and Hans Joachim Marx, eds., *New Mattheson Studies* (Cambridge: Cambridge Univ. Press, 1983), 394.

13. See Robert S. Freeman, *Opera without Drama: Currents of Change in Italian Opera, 1675–1725* (Ann Arbor, Mich.: UMI Research Press, 1981).

14. Jean-Baptiste Dubos, *Critical Reflections on Poetry, Painting, and Music; with an Inquiry into the Rise and Progress of the Theatrical Entertainments of the Ancients*, trans. Thomas Nugent, 5th ed., rev. (London: John Nourse, 1748; reprint, New York: AMS, 1978), 1:368–69; for the original, see Jean-Baptiste Dubos, *Réflexions critiques sur la poésie et sur la peinture*, 4th ed., rev., corr. and enl. (Paris: Chez Pierre-Jean Mariette, 1740), 1:446–47:

> La symphonie de l'Opera de Roland … joüe très-bien son rôle dans l'action où elle est introduite. L'action du cinquiéme acte où elle est placée, consiste à rendre la raison à Roland, qui est sorti furieux de la Scene à la fin du quatriéme acte. Cette belle symphonie donne même l'idée de celles dont Ciceron et Quintilien disent que les Pythagoriciens se servoient pour appaiser, avant que de mettre la tête sur le chevet, les idées tumultueuses que les mouvemens de la journée laissent dans l'imagination, de même qu'ils emploïoient des symphonies d'un caractere opposé, pour mieux mettre les esprits en mouvement, lorsqu'ils s'éveilloient, et pour se rendre ainsi plus propres à l'application.

Instructive on the codification of the fine arts in the eighteenth century, and its relation to changing ideals of style and expression, is Enrico Fubini, "Introduction," in idem, ed., *Music and Culture in Eighteenth-Century Europe: A Source Book*, trans. Wolfgang Freis, Lisa Gasbarrone, and Michael Louis Leone, trans. ed. Bonnie J. Blackburn (Chicago: Univ. of Chicago Press, 1994), 1–34; for the original, see Enrico Fubini, ed., *Gli enciclopedisti e la musica* (Turin: Einaudi, 1971). See also Enrico Fubini, ed., *Gli illuministi e la musica: Scritti scelti* (Milan: Principiato, 1969).

15. Dubos, *Critical Reflections* (note 14), 1:371 = Dubos, *Réflexions* (note 14), 1:449–50: "Ou loüe celle du tombeau d'Amadis, et celle de l'Opera d'Issé, en disant qu'elles imitent bien le naturel, quoiqu'on n'ait jamais vu la nature dans les conconstances où ces symphonies prétendent la copier." The opera that Dubos refers to is *Issé* by André Cardinal Destouches, a *pastorale héroïque* performed at court in Paris in 1697.

16. See Dubos, *Réflexions* (note 14), 1:450 = Dubos, *Critical Reflections* (note 14), 1:371:

> Par exemple, les accens funèbres de la symphonie que Monsieur de Lulli a placez dans la scène de l'Opera d'Amadis, où l'Ombre d'Ardan sort du tombeau, font autant d'impression sur nostre oreille que le spectacle et la déclamation en font sur nos yeux. Nôtre imagination...est beacoup plus émuë de l'apparition de l'Ombre que si nos yeux seuls étaient séduits.
>
> (For example, the funeral accents of the symphony, which Lulli has inserted in the scene of the opera of Amadis (act 3), where the ghost of Ardan comes out of his tomb, make as great an impression upon our ear, as the show and representation have upon our eyes. Our imagination...is much more moved with the apparition of the ghost, than if only our eyes were deluded.)

On the relationship between French opera and nature, I have learned a great deal from Catherine Cole's "Mediating Belief: Images and Ideologies of Nature on the French Lyric Stage, 1750–79" (Ph.D. diss., University of Chicago, in progress).

17. See Yves Marie André, *Essai sur le beau*, rev. ed. (Paris: Chez Crapart, 1770). André claimed that "la fin de la Musique est double, comme son objet, elle veut plaire à l'oreille, qui est son juge naturel: elle veut plaire à la raison, qui préside essentiellement aux jugemens de l'oreille; et par le plaisir qu'elle cause à l'une et à l'autre, elle veut exciter dans l'ame les mouvemens les plus capables de ravir toutes les facultés" (p. 141). For André's comparison of musical beauty with painting, see page 193.

18. Batteux argues that music, along with poetry, painting, sculpture and the arts of gesture and dance, are fine arts and arts of pleasure. See Charles Batteux, *Les beaux-arts réduits à un même principe*, in Peter le Huray and James Day, eds., *Music and Aesthetics in the Eighteenth and Early-Nineteenth Centuries* (Cambridge: Cambridge Univ. Press, 1981), 44; for the original, see Charles Batteux, *Les beaux-arts réduits à un même principe*, ed. Jean-Rémy Mantion (Paris: Aux Amateurs de Livres, 1989), 82.

19. See Batteux, *Les beaux-arts*, ed. Le Huray and Day (note 18), 45 = Batteux, *Les beaux-arts*, ed. Mantion (note 18), 85. For Batteux, fine arts were distinct from utilitarian mechanical arts and from the arts of eloquence and architecture, which served both pleasure and utility.

20. See, for instance, Mattheson, *Johann Mattheson's* Der vollkommene Capellmeister (note 4), pt. 2, chap. 12, esp. §§4–8, 30–31 47–51; Batteux, *Les beaux-arts*, ed. Le Huray and Day (note 18), 47–51 = Batteux, *Les beaux-arts*, ed. Mantion (note 18), 239–42; and Dubos, *Critical Reflections* (note 14), 1:360–75 = Dubos, *Réflexions* (note 14), 1:446. See also Jean Le Rond d'Alembert's famous remarks in his *Discours préliminaire de l'Encyclopédie* of 1751, which is virtually the manifesto of Enlightenment ideals: "Any music that does not portray something is only noise; and without that force of habit which denatures everything, it would hardly create more pleasure than a sequence of harmonious and sonorous words stripped of order and connection"; Jean Le Rond d'Alembert, *Preliminary Discourse to the Encyclopedia of Diderot*, trans. Richard N. Schwab, with Walter E. Rex (Chicago: Univ. of Chicago Press, 1995), 39.

21. See Piero Weiss, "Pier Jacopo Martello on Opera (1715): An Annotated Translation," *Musical Quarterly* 66 (1980): 378–403; for the original, see Pier Jacopo

Martello, *Della tragedia antica e moderna* (1715; Bologna: Lelio dalla Volpe, 1735), §5 (dialogo), 114–53; and the letters of Metastasio as published in *Tutte le opere di Pietro Metastasio*, ed. Bruno Brunelli (Milan: Mondadori, 1943–54), vols. 3–5. This principle of decorum finds company as well in north German writers—for instance, the response published in 1738 by Johann Abraham Birnbaum to the assault on Johann Sebastian Bach by Johann Adolf Scheibe argued (contra Scheibe's *galant* bias) that music must obey the rhetorical precept of variety in order to express passion. The underlying assumption of Birnbaum's claim is that variety is the basis for moderation, and that both variety and moderation are essential for expressing and inspiring states of passion; see Johann Abraham Birnbaum, *Impartial Remarks on a Dubious Passage in the Sixth Issue of* Der critische Musikus, in Enrico Fubini, ed., *Music and Culture in Eighteenth-Century Europe: A Source Book*, trans. Wolfgang Freis, Lisa Gasbarrone, and Michael Louis Leone, trans. ed. Bonnie J. Blackburn (Chicago: Univ. of Chicago Press, 1994), 273–77.

22. This belief is distilled in Aminta's aria "Siam navi all'onde algenti," from Metastasio's libretto *L'Olimpiade* (Vienna, 1733), act 2, scene 5, as cited in Metastasio, *Tutte le opere* (note 21), 1:602:

> Siam navi all'onde algenti
> Lasciate in abbandono:
> Impetuosi venti
> I nostri affetti sono:
> Ogni diletto è scoglio:
> Tutta la vita è mar.
> Ben, qual nocchiero, in noi
> Veglia la ragion; ma poi
> Pur dall'ondoso orgoglio
> Si lascia trasportar.
>
> (We are ships abandoned to the freezing seas. Our passions are impetuous winds. Every pleasure is a reef, all life a sea. // Like a good helmsman, reason keeps watch in us; but then it lets us be carried away by turbulent pride.)

Bruce Alan Brown (private communication, February 1999) has observed that the aria resonates with Metastasio's own comments on the passions in *Estratto dell'*Arte poetica *d'Aristotile e considerazioni su la medesima*, in which he argued against Aristotle's claim in the *Poetics* that tragedy should be restricted to fear and compassion: "Human passions are the necessary winds with which we navigate this sea that is life; and in order that our travels be prosperous, it is not fitting that we set ourselves the impossible task of extinguishing them." Extending the metaphor of the helmsman, Metastasio goes on to say that, in addition to terror and compassion, the winds of passions include "admiration, glory, aversion, friendship, love, envy, emulation, avid ambition to acquire, anxious fear of loss, and a thousand others that are made up from the combination and mixture of these," all of which must be governed in order to obtain public and private tranquillity; for the original Italian, see Metastasio, *Tutte le opere* (note 21), 2:1031–32:

Son pur le umane passioni i necessari venti co'quali si naviga per questo mar della vita; e perché sien prosperi i viaggi non convien già proporsi l'arte impossibile d'estinguerli; ma quella bensì di utilmente valersene, restringendo ad allargando le vele ora a questo ora a quello, a misura della loro giovevole o dannosa efficacia nel condurci al dritto cammino o nel deviarcene. Or gli affetti nostri non si restringono al solo terrore ed alla sola compassione: l'ammirazione, la gloria, l'avversione, l'amicizia, l'amore, la gelosia, l'invidia, l'emulazione, l'avida ambizione degli acquisti, l'ansioso timor delle perdite, e mille e mille altri che si compongono dal concorso e dalla mistura di questi, son pure ah'essi fra quei venti che si spingono ad operare e che conviene imparare a reggere, se si vuol procurare la nostra privata e la pubblica tranquillità.

23. See George Frideric Handel, *Orlando: Drama, da rappresentarsi nel regio-teatro d'Haymarket*, trans. Samuel Humphreys (London: T. Wood, 1732; reprint, [New York]: printed for the Carnegie Hall Corporation, 1984), 2.

24. Handel, *Orlando* (note 23), 2.

25. Handel, *Orlando* (note 23), 10 (Medoro, "E il mio core da me diviso," act 1, scene 5); 30 (Orlando, "Sono lo spirto mio de me diviso," act 2, scene 11).

26. In act 2, scene 6 of *Orlando*, Angelica laments her ingratitude to Orlando, to whom she owes her life, but nevertheless breaks out into an aria that begins "Non potrà dirmi ingrata, / Perchè restai piagata / Da un così vago stral" (He cannot call me an ingrate / because I was wounded / by such a lovely dart). London audiences, however, had in hand the *en face* translation of *Orlando*, where the text — rendered so freely as to be almost independent of the original — hardened the opposition of love and reason: "Had Reason Power to rule his Hate, / He ne'er could call me an Ingrate; / Because my soft, resistless Heart / Was pierc'd by such a lovely Dart"; see Handel, *Orlando* (note 23), 26–27.

Similarly, in act 3, scene 1, Medoro claims that he cannot give his heart to Dorinda because it is not his; in act 3, scene 4, Angelica again says that love is fate, not choice; and in act 3, scene 5, Dorinda calls love a wind that turns the mind.

27. On madness in opera, see Ellen Rosand, "Operatic Madness: A Challenge to Convention," in Steven Paul Scher, ed., *Music and Text: Critical Inquiries* (Cambridge: Cambridge Univ. Press, 1992), 241–87.

28. Descartes, *The Passions of the Soul* (note 2), 101 = Descartes, *Les passions de l'âme* (note 2), §148: "Que l'exercice de la vertu est un souverain remède contre les passions."

29. See Peter le Huray and James Day, "Introduction," in idem, eds., *Music and Aesthetics in the Eighteenth and Early-Nineteenth Centuries* (Cambridge: Cambridge Univ. Press, 1981), 4, on Rousseau's use of Fontenelle's remark for the *Encyclopédie*; and see Jean Le Rond d'Alembert, "On the Freedom of Music," in Enrico Fubini, ed., *Music and Culture in Eighteenth-Century Europe: A Source Book*, trans. Wolfgang Freis, Lisa Gasbarrone, and Michael Louis Leone, trans. ed. Bonnie J. Blackburn (Chicago: Univ. of Chicago Press, 1994), 90, for a quotation of the quip by d'Alembert in his essay "De la liberté de la musique" of 1759.

30. See Noël-Antoine Pluche, *The Spectacle of Nature*, in Enrico Fubini, ed., *Music and Culture in Eighteenth-Century Europe: A Source Book*, trans. Wolfgang Freis, Lisa

Gasbarrone, and Michael Louis Leone, trans. ed. Bonnie J. Blackburn (Chicago: Univ. of Chicago Press, 1994), 81; for the original, see Noël-Antoine Pluche, *Le spectacle de la nature; ou, Entretiens sur les particularités de l'histoire naturelle…* (Paris: Chez les frères Estienne, 1755–64), 7:111: "C'est l'usage qui s'est extrêmement étendu depuis quelques siècles, de se passer de la musique vocale et de s'appliquer uniquement à amuser l'oreille sans présenter à l'ésprit aucune pensée; en un mot de prétendre contenter l'homme par une longue suite de sons destitués de sens: ce qui est directement contraire à la nature même de la musique, qui est d'imiter, come font tous les beaux arts, l'image et le sentiment qui occupent l'esprit."

31. Dubos argued that "symphonies" — instrumental numbers — in dramatic works can display a "true imitation of nature" since they echo sounds in nature and therefore can produce great effects when heard "seasonably in the scenes of a dramatic piece." Their veracity then depends, according to Dubos, on "the resemblance with the sounds they are intended to imitate. There is truth in a symphony composed for the imitation of a tempest, when the modulation, harmony, and *rhythmus* convey to our ear a sound like the blustering of the winds in the air, and the bellowing of the waves, which dash impetuous against one another, or break against the rocks. Such is the symphony which imitates a tempest in the opera of Alcione by Monsieur Marais." Such pieces don't produce "articulate" sounds but rather help "engage us to the action, by making almost the same impression upon us, as would arise from the very sound they imitate, were we to hear it under the same circumstances as the symphony." See Dubos, *Reflections* (note 14), 1:363–64 = Dubos, *Réflexions* (note 14), 1:439–40.

32. For a fine account of Rameau's ideas, see Thomas Christensen, *Rameau and Musical Thought in the Enlightenment* (Cambridge: Cambridge Univ. Press, 1993), esp. chaps. 6 and 10, and the explanation on page 293 of the frontispiece to Rameau's *Code de musique* (1760), where three muses allegorize Rameau's theory of the *corps sonore:* one plucks a lyre, another writes down music using the proportions of the overtones of the *corps sonore,* and a third measures the proportions on a monochord — all three personify music in its pure originary form.

33. See Michael Chanan, *From Handel to Hendrix: The Composer in the Public Sphere* (London: Verso, 1999), chap. 2.

34. See Jean-Jacques Rousseau, *Essay on the Origin of Languages and Writings Related to Music,* trans. and ed. John T. Scott, vol. 7 of idem, *The Collected Writings of Rousseau,* ed. Roger D. Masters and Christopher Kelly (Hanover: Univ. Press of New England, 1998), 289–332; for the original, see Jean-Jacques Rousseau, *Oeuvres complètes* (Paris: NRF Éditions de la Pleiade, 1959–95), 5:371–429. Rousseau first hinted at this in his *Lettre sur la musique française* (1752), though his essential argument there hinged on the matter of the best language for text setting — not French, but Italian — with only an underlying suggestion that Italian was primordial and constituted a kind of music in itself. Rousseau developed the latter idea fully in *Essai sur l'origine des langues,* which is usually dated to 1761 though it was not published in his lifetime. On the contents and dating of Rousseau's musical writings, see John Scott's introduction to Rousseau's *Essay on the Origin of Languages,* xiii–xlii.

35. A similar view informed Étienne Bonnot de Condillac's *Essai sur l'origine des connaissances humaines* (Paris: Lecointe & Durey, 1822).

36. See Rousseau, *Essay on the Origin of Languages* (note 34), xix–xxiv.

37. See Mattheson, *Johann Mattheson's* Der vollkommene Capellmeister (note 4), pt. 2, chap. 12, where Mattheson argued that the passions were more elusive in instrumental music, since its melodies were inherently more showy (with leaps and dotted rhythms) than those of vocal music and thus apt to become shapeless, even when enticing. A larger treatment of the rhetorical issues vis à vis changing attitudes toward instrumental music is given in Mark Evan Bonds, *Wordless Rhetoric: Musical Form and the Metaphor of the Oration* (Cambridge: Harvard Univ. Press, 1991).

38. Avison, *An Essay on Musical Expression* (note 1), 3.

39. See Avison, *An Essay on Musical Expression* (note 1), 2–8.

40. The fable of Saint Jerome taming the lion had long served as a symbol for the taming of wild human passions. For a synopsis of how seventeenth-century conceptions of the passions relate to biblical, classical, and medieval traditions, see Stephen Gaukroger, ed., *The Soft Underbelly of Reason: The Passions in the Seventeenth Century* (London: Routledge, 1998), 1–14.

41. See Avison, *An Essay on Musical Expression* (note 1), 5: "But beyond this, I think we may venture to assert, that it is the peculiar Quality of Music to raise the *sociable and happy Passions*, and to *subdue* the *contrary ones.*"

42. See Avison, *An Essay on Musical Expression* (note 1), 4.

43. See Avison, *An Essay on Musical Expression* (note 1), 91 n. Hence, too, da capo arias that move from anger to reconcilement and back to anger in their A sections are odious to Avison. Why, he wonders (p. 71 n), couldn't an aria progress naturally to love and reconcilement in the B section ("the second") and then end there?

44. For Avison, in *An Essay on Musical Expression* (note 1), musical imitation was to raise corresponding affections in the soul, resulting in a direct correspondence between object and expression that he called a "Similitude" (p. 58). Such imitation of natural objects had to be "temperate and chastised" (p. 61) in order that it bring the object before the hearer, without insisting on a direct correspondence between itself and the music. Avison's idealized example of this, which first appears in the revised edition of *An Essay on Musical Expression* (1753), is Handel's "Hide Me from Day's Garish Eye" from *L'allegro, il Penseroso ed il Moderato;* see Enrico Fubini, ed., *Music and Culture in Eighteenth-Century Europe: A Source Book*, trans. Wolfgang Freis, Lisa Gasbarrone, and Michael Louis Leone, trans. ed. Bonnie J. Blackburn (Chicago: Univ. of Chicago Press, 1994), 313 n. 8. I am grateful to my student Jeffers Engelhardt for an illuminating analysis connecting Avison's theories to this aria.

45. See, for instance, the excerpt from Henry Home, Lord Kames, *Elements of Criticism*, 6th ed. (Edinburgh: printed for J. Bell and W. Creech [etc.], 1672), quoted in Peter le Huray and James Day, eds., *Music and Aesthetics in the Eighteenth and Early-Nineteenth Centuries* (Cambridge: Cambridge Univ. Press, 1981), 76–81. Kames's work was first published in 1762.

46. For the English, see Johann Nicolaus Forkel, *Ueber die Theorie der Musik, insofern sie Liebhabern und Kennern der Kunst notwendig und nützlich ist,* in Peter le Huray and James Day, eds., *Music and Aesthetics in the Eighteenth and Early-Nineteenth Centuries* (Cambridge: Cambridge Univ. Press, 1981), 176; for the original, see Johann Nicolaus Forkel, *Ueber die Theorie der Musik, insofern sie Liebhabern*

und Kennern der Kunst nothwendig und nützlich ist (Göttingen: Wittwe Vanderhück, 1777), 4: "Wenn Musik eine Sprache der Empfindungen und Leidenschaften ist, — wenn die Empfindungen keines einzigen Menschen, mit den Empfindungen eines andern Vollkommen übereinstimmen; würder dann nicht folgen, daß in Ermangelung gehöriger Vorschiften und aus Natur und Erfahrung abgeleiteten Regeln, die Kunst dem Eigensinn und der Willführ eines jeden insbesondere überlassen seyn mußte?"

47. See Forkel, *Ueber die Theorie der Musik*, ed. Le Huray and Day (note 46), 178 = Forkel, *Ueber die Theorie der Musik* (note 46), 7.

48. Daniel Webb, *Observations on the Correspondence between Poetry and Music* (London: J. Dodsley, 1769; reprint, New York: Garland, 1970), 8–9 (emphasis added).

49. Webb, *Observations* (note 48), 9.

50. Webb, *Observations* (note 48), 9–10.

51. Webb, *Observations* (note 48), 10–11 (emphasis added). Webb went on to say that

> On hearing an overture by Iomelli, or a concerto by Geminiani, we are, in turn, transported, exalted, delighted; the impetuous, the sublime, the tender, take possession of the sense at the will of the composer. In these moments, it must be confessed, we have no determinate idea of any agreement or imitation; and the reason of this is, that we have no fixed idea of the passion to which this reason is referred. But, let eloquence co-operate with music, and specify the motive of each particular impression, while we feel an agreement in the sound and motion of the sentiment, song takes possession of the soul, and general impressions become specific indications of the manners and the passions (pp. 11–12).

52. See Johann Georg Sulzer, "Leidenschaften" (Emotions), in Peter le Huray and James Day, eds., *Music and Aesthetics in the Eighteenth and Early-Nineteenth Centuries* (Cambridge: Cambridge Univ. Press, 1981), 124: "The imagination...must make the greatest contribution to emotion, for when a strong emotion is felt it is the imagination that gives birth to the great mass of simultaneously associated images." Hence the object to be imitated should remain ambiguous in music or, more radically, should not be conjured up at all; rather, music should call forth feelings that might allow listeners to make objective associations on an individual basis. For the original, see Johann Georg Sulzer, *Allgemeine Theorie der schönen Künste in einzeln...* (Leipzig: M. G. Weidemann, 1771), 693, col. 2–694, col. 1: "Darum muss die Einbildungskraft das meiste zur Leidenschaft beytragen. Denn von ihr kommt es, dass bey jeder gegenwärtigen etwas lebhaften Empfindung eine grosse Menge andrer damit verbundener Vorstellungen zugleich rege werden."

53. See especially the second and third movements of Avison's Concerto in D Minor, no. 10.

54. See Downing A. Thomas, *Music and the Origins of Language: Theories from the French Enlightenment* (Cambridge: Cambridge Univ. Press, 1995), 160.

55. D'Alembert, "On the Freedom of Music" (note 29), 88. For the original, see Jean Le Rond d'Alembert, *Mélanges de littérature, d'histoire, et de philosophie...*, rev. ed. (Amsterdam: Zacharie Chatelain, 1759), 4:sec. 13; reprinted in Denise Launay, *La Querelle des Bouffons: Texte des pamphlets avec introduction, commentaires et index*

(Geneva: Minkoff Reprint, 1973), 3:2224–25: "laissons au vulgaire ce préjugé ridicule, de croire que la Musique ne soit propre qu'à exprimer la gaieté; l'expérience nous prouve tous les jours qu'elle n'est pas moins susceptible d'une expression tendre et douloureuse."

56. Thomas, *Music and the Origins of Language* (note 54), 149. Thomas cites Jean-Pierre de Crousaz's *Traité du beau; ou, L'on montre en quoi consiste ce que l'on nomme ainsi...*, rev. ed. (Amsterdam: L'Honoré & Chatelain, 1724), 1:75, for having made the metaphysical connection between objects and their representation explicit.

57. See Antonio Planelli, *Opera*, in Enrico Fubini, ed., *Music and Culture in Eighteenth-Century Europe: A Source Book*, trans. Wolfgang Freis, Lisa Gasbarrone, and Michael Louis Leone, trans. ed. Bonnie J. Blackburn (Chicago: Univ. of Chicago Press, 1994), 244; for the original, see Antonio Planelli, *Dell'opera in musica* (Naples: D. Campo, 1772), sec. 3, chap. 1, pt. 4: "Altra differenza tra la musica antica e la moderna." In the pathetic, Planelli found a tragic loss of originary musical passion through the loss of modal ethos that came about because of the fact that in his day a given aria text could be set in many different keys.

58. Arguments favoring verisimilitude were long-standing in Italian operatic polemics; see, for example, the moralist diatribes of Ludovico Antonio Muratori, *Della perfetta poesia italiana*, ed. Ada Ruschioni (Milan: Marzorati, 1971–72).

59. See Planelli, *Opera* (note 57), 250–51 = Planelli, *Dell'opera in musica* (note 57), sec. 3, chap. 2 ("Stile della musica teatrale"), pt. 3 ("Terza legge: *Lo stil teatrale ama il canto parlante, non quello di gorgheggio*").

60. Planelli echoed Algarotti, Verri, and others in rebuking divas and composers as commercialists, fearing that they made music a matter of profiteering and would turn emotion into a mere commodity to be bought and sold. See Francesco Algarotti, *Saggio sopra l'opera in musica: Le edizioni di Venezia (1755) e di Livorno (1763)*, ed. Annalisa Bini (Lucca: Libreria Musicale Italiana, 1989); and Pietro Verri, "La musica," in Enrico Fubini, ed., *Music and Culture in Eighteenth-Century Europe: A Source Book*, trans. Wolfgang Freis, Lisa Gasbarrone, and Michael Louis Leone, trans. ed. Bonnie J. Blackburn (Chicago: Univ. of Chicago Press, 1994), 333–38.

61. See Planelli, *Opera* (note 57), 248–49 = Planelli, *Dell'opera in musica* (note 57), sec. 3, chap. 2, pt. 1.

62. See Planelli, *Opera* (note 57), 249–50 = Planelli, *Dell'opera in musica* (note 57), sec. 3, chap. 2, pt. 2.

63. On these developments, see Stefano Castelvecchi, *Sentimental Opera: The Emergence of a Genre, 1760–1790* (Ann Arbor, Mich.: University Microfilms, 1996).

64. See Carl Philipp Emanuel Bach, *Essay on the True Art of Playing Keyboard Instruments*, ed. and trans. William J. Mitchell (New York: W. W. Norton, 1949), 39: "The whole approach to performance will be greatly aided and simplified by the supplementary study of voice wherever possible and by listening closely to good singers"; for the original, see Carl Philipp Emanuel Bach, *Versuch über die wahre Art das Clavier zu spielen* (Berlin: Christian Friedrich Henning, 1753; reprint, Leipzig: Breitkopf & Härtel, 1957), 13: "Einen grossen Nutzen und Erleichterung in die ganze Spiel-Art wird derjenige spüren, welcher zu gleicher Zeit Gelegenheit hat, die Singe-kunst zu lernen, und gute Sänger fleißig zu hören."

65. Bach, *Essay on the True Art* (note 64), 147 = Bach, *Versuch über die wahre Art* (note 64), 115: "Die Erfahrung lehret es mehr als zu oft, wie die Treffer und geschwinden Spieler von Profeßion nichts weniger als diese Eigenschaften besitzen, wie sie zwar durch die Finger das Gesicht in Verwunderung setzen, der empfindlichen Seele eines Zuhörers aber gar nichts zu thun geben. Sie überraschen das Ohr, ohne es zu vergnügen, und betäuben den Verstand, ohn ihm genung zu thun." This point was also made by Johann Joachim Quantz, a flute teacher to Frederick the Great and a composer at Frederick's court; see Johann Joachim Quantz, *On Playing the Flute,* trans. Edward R. Reilly (Boston: Northeastern Univ. Press, 2001); for the original, see Johann Joachim Quantz, *Versuch einer Anweisung die Flöte traversiere zu spielen* (Berlin: J. F. Voss, 1752).

66. When the sixth sonata begins "Allegro di molto," for instance, the spectator almost immediately confronts a belaboring body, with crossed hands that push the figure over the top of the instrument and effectively shorten the arms. Afterward the opening movement shifts impetuously from figurative work to suspended passages, and then, in the middle movement, to highly affective ornamented passagework. In the final movement, "Fantasia—Allegro moderato," recitative-like passages alternate with passages of surprising metric dissonance. Similarly, Bach's *Württemberg* sonata starts with a series of diminished sevenths interspliced with piano-dotted rhythms and melodic sevenths—though before the first double bar it becomes typically *galant,* even while maintaining gestural and rhythmic continuities with the opening.

67. For a new reading of Bach's fantasias and related developments, see Annette Richards, *The Free Fantasia and the Musical Picturesque* (Cambridge: Cambridge Univ. Press, 2001).

68. Bach, *Essay on the True Art* (note 64), 152 = Bach, *Versuch über die wahre Art* (note 64), 122–23: "Besonders aber kan ein Clavieriste vorzüglich auf allerley Art sich der Gemüther seiner Zuhörer durch Fantasien aus dem Kopfe bemeistern. Daß alles dieses ohne die geringsten Gebehrden abgehen könne, wird derjenige bloß läugnen, welche durch seine Unempfindlichkeit genöthigt ist, wie ein geschnitztes Bild vor dem Instrumente zu sitzen. So unanständig und schädlich heßliche Gebährden sind: so nützlich sind die guten, indem sie unsern Absichten bey den Zuhöhrern zu hülfe kommen."

69. Batteux wrote in 1746 that "if it sometimes happens that the musician or dancer is involved in the actual passion that he is expressing this is entirely accidental and it has nothing to do with the purpose of the art"; see Batteux, *Les beaux-arts,* ed. Le Huray and Day (note 18), 48 = Batteux, *Les beaux-arts,* ed. Mantion (note 18), pt. 3, sec. 3, chap. 3, p. 239: "Si quelquefois il arrive que le musicien, ou le danseur, soient réellement dans le sentiment qu'ils expriment, c'est une circonstance accidentelle qui n'est point du dessein de l'art." Diderot, by contrast, in a treatise that he continued to revise until his death in 1784, was reacting against what by then he saw as a widespread naiveté that bought into the quest for authentic emotion on the stage—a state he claimed was a contradiction; see Denis Diderot, *The Paradox of the Actor,* in idem, *Selected Writings on Art and Literature,* trans. Geoffrey Bremner (London: Penguin, 1994), 100–58; for the original, see Denis Diderot, *Paradoxe sur le comédien,* ed. Joël Dupas (Paris: L'École des Loisirs, 1994).

70. See Bach, *Essay on the True Art* (note 64), 152–53, 160–61 = Bach, *Versuch über die wahre Art* (note 64), 122–24, 129.

71. Charles Burney, *An Eighteenth-Century Musical Tour in Central Europe and the Netherlands...*, ed. Percy A. Scholes (London: Oxford Univ. Press, 1959), 219 (emphasis added).

72. Bach's rhetorical subjectivism became gospel in the writings of that later Berlin resident, Sulzer, specifically in his idea that without "expression" music becomes a "pleasant toy," but with it, music is an "overwhelmingly powerful language which engulfs the heart" and "compels us in turn to tenderness, resolution, courage." Sulzer also insisted, in line with Bach's comments, that the composer could only "effectively express what he himself keenly feels." Later Sulzer said that the composer can best sustain a given character if he puts himself "into the emotional state that he wishes others to experience," ideally by imagining some dramatic situation that will "naturally induce the kind of state that he has in mind," with everything kept in "character." For these excerpts, see Johann Georg Sulzer, "Ausdruck in der Musik" (Expression in music), in Peter le Huray and James Day, eds., *Music and Aesthetics in the Eighteenth and Early-Nineteenth Centuries* (Cambridge: Cambridge Univ. Press, 1981), 124–27 passim = Sulzer, *Allgemeine Theorie der schönen Künste* (note 52):

> Der Ausdruk ist die Seele der Musik: ohne ihn ist sie blos ein angenehmes Spielwerk; durch ihn wird sie zur nachdrüklichsten Rede, die unwiderstehlich auf unser Herz würket. Sie zwingt uns, ist zärtlich, denn beherzt und standhaft zu seyn. Bald reizet sie uns zum Mitleiden, bald zur Bewundrung. Einmal stärket und erhöher sie unsre Seelenkräfte; und ein andermal fesielt sie alle, daß sie in ein weichliches Gefühl zerfließen (109, col. 2).

> [W]ie erlangt der Tonsetzer diese Zauberkraft, so gewaltig über unser Herz zu herrschen? Die Natur muß den Grund zu dieser Herrschaft in seiner Seele gelegt haben. Diese muß sich selbst zu allen Arten der Empfindungen und Leidenschaften stimmen können. Denn nur dasjenige, was er selbst lebhaft fühlt, wird er glücklich ausdrücken (109, col. 2–110, col. 1).

> Hat er den Character des Stücks festgesetz, so muß er sich selbst in die Enpfindung setzen, die er in andern hervor bringen will. Das beste ist, daß er sich eine Handlung, eine Begenbenheit, einen Zustand vorstelle, im welchem sich dieselbe natürlicher Weise in dem Lichte zeigt, worin er sie vortragen will; und wenn seine Einbildungskraft daben in das nöthige Feuer gesetzt worden, alsdenn arbeite er, und hüte sich irgend eine Periode, ode eine Figur einzumischen, die außer dem Character seines Stücks liegt (111, col. 2).

See also Thomas, *Music and the Origins of Language* (note 54), 154–56, who discerns a similar view in Jean-Baptiste Joseph Lallemant's *Essai sur le mécanisme des passions en général* (Paris: Le Preur, 1751). Thomas suggests that Lallemant saw music as the strongest vehicle of the passions and stressed that their experience correlated strongly with how others perceived their representations. Yet, Lallemant did not insist that the passions being represented *had* to be experienced or embodied by their actor or maker, only that they should be perceived as legible signs by viewers and listeners.

73. For Hutcheson, and many others, the human voice occupied an unequaled place as an instrument of sympathy; see Francis Hutcheson, *An Essay on the Nature and Conduct of the Passions and Affections* (London: A. Ward, 1742; reprint, Gainesville, Fla.: Scholars' Facsimiles and Reprints, 1969).

74. David Hume, *A Treatise of Human Nature*, ed. L. A. Selby-Bigge, 2d ed., rev. P. H. Nidditch (Oxford: Clarendon, 1978), 317–22, 340, 359, 365, 368–71, 576.

75. See Thomas, *Music and the Origins of Language* (note 54), chap. 5, esp. 164–65 on Lacépède.

76. Thomas argues that this already happens in La Mettrie, for whom the activity and sensibility of the mind are continuous; see Thomas, *Music and the Origins of Language* (note 54), 151–58.

77. Johann Georg Sulzer, "Musik," in Peter le Huray and James Day, eds., *Music and Aesthetics in the Eighteenth and Early-Nineteenth Centuries* (Cambridge: Cambridge Univ. Press, 1981), 133; for the original, see Sulzer, *Allgemeine Theorie der schönen Künste* (note 52), 781, col. 1: "Die Natur hat eine ganz unmittelbare Verbindung zwischen dem Gehör und dem Herzen gestiftet; jede Leidenschaft kündiget sich durch eigene Töne an, und eben diese Töne erweken in dem Herzen dessen, der sie vernihmt, die leidenschaftliche Empfindung, aus welcher sie enstanden sind." Sulzer goes on to say that

> The cruder senses—smell, touch and taste—affect the body, not the soul; they arouse nothing but blind pleasure or displeasure; their energies are absorbed in enjoyment or revulsion. The visual and aural senses, however, affect the spirit and the heart. In these two senses lie the mainsprings of rational and moral behaviour. The aural sense is certainly the more powerful of the two.
>
> (Die gröberen Sinnen, der Gerusch, der Geschmack und das Gefühl, können nichts als blinde Lust, oderlinlust erwecken; die sich selbst, jene durch den Genuß, diese durch Abschen, verzehren, ohne einige Würkung auf die Erhöhung der Seele zu haben; ihr Zweck geht blos auf den Körper. Aber das, was das Gehör und das Gesicht und empfinden lassen, zielet auf die Würksamkeit des Geistes und des Herzens ab; und in diesen beyden Sinnen liegen Triebfedern der verständigen und sittlichen Handlungen. Von diesen beyden edlen Sinnen aber hat das Gehör weit die stärkere Kraft.)

78. See Stefano Castelvecchi, "From *Nina* to *Nina*: Psychodrama, Absorption, and Sentiment in the 1780s," *Cambridge Opera Journal* 8 (1996): 91–112; and Castelvecchi, *Sentimental Opera* (note 63). Sentimental tropes also infected tragedy and comedy, both spoken and sung, a famous example of the latter being Mozart's tender-hearted hero Belmonte from *Die Entführung aus dem Serail* (1782).

79. See Jean-François Marmontel, "Entr'acte," in idem, *Élémens de littérature*, rev. ed. (Paris: Née de la Rochelle, 1787), 3:216–17. See also Gösta Bergman, *Lighting in the Theatre*, trans. N. Stedt (Stockholm: Almqvist & Wiksell, 1977), 175–95, which explores the issue of illusion in the theater with respect to lighting. Cf. Metastasio's comments against Aristotle's confining of passions to fear and compassion, cited in note 22.

80. See Planelli, *Dell'opera in musica* (note 57), sec. 2, chap. 4, pp. 72–74.

81. This verisimilitude in turn is only possible with operas shaped on the musical terms of Gluck's reforms: fewer notes sung in small ranges to approximate speech, a parlante rather than melismatic style, a dearth of ornaments, an overture meaningfully connected to the drama, and sections of music organized in continuous tableaux.

82. See Anne Vincent-Buffault, *The History of Tears: Sensibility and Sentimentality in France,* trans. Teresa Bridgeman (New York: St. Martin's, 1991), chap. 4.

83. Quoted in Denis Diderot, Rameau's Nephew *and* D'Alembert's Dream, trans. Leonard Tancock (Harmondsworth, England: Penguin, 1966), 98.

84. Rousseau challenged the new theater of sensibility to produce a truly impassioned public. For him, the teary theater of illusion could not underpin a real social contract because it promoted false illusions of collective feeling and virtue, as if viewers had *really* carried out virtuous action; see Vincent-Buffault, *The History of Tears* (note 82), 71–72. Of course, anxieties over the authenticity of emotional response to staged pathos were inherent and ongoing since any pathos staged was pathos faked, and any tears shed over faked pathos were fake tears. Furthermore, if pathos could be faked, its effects could be challenged. This was one of the reasons why Diderot, when he wrote his late work *Paradoxe sur le comédien* (note 69), wanted to blow the cover on staged "feeling" and explode the myth of sensibility.

85. Related to the cult of sentimentality was the cult of the sublime. Ryan Minor, in his typescript "Sublimating the Sublime: Communal Passions and the Founding of the German Choral Movement" (May 2000) for my seminar "Music and the Passions" (University of Chicago, Winter 2000), argues that Sulzer, Kant, and the early-nineteenth-century musical philosopher Christian Friedrich Michaelis all struggled to comprehend the vast incomprehensibility of human emotion known as the sublime. Minor touches on Sulzer's attempts to contain and measure the sublime, Kant's attempts to scrutinize and master the sublime through reason, and Michaelis's attempts to allow musical manifestations of the sublime their wondrousness beyond measurement and reason.

86. See Thomas, *Music and the Origins of Language* (note 54), chap. 5, esp. 169–72.

87. See Georges Bataille, *The Accursed Share: An Essay on General Economy,* vol. 3, *On Sovereignty,* trans. Robert Hurley (New York: Zone, 1991).

88. See, for example, Catherine Lutz, *Unnatural Emotions: Everyday Sentiments on a Micronesian Atoll and Their Challenge to Western Theory* (Chicago: Univ. of Chicago Press, 1988); and Rom Harré, ed., *The Social Construction of Emotions* (Oxford: Basil Blackwell, 1986).

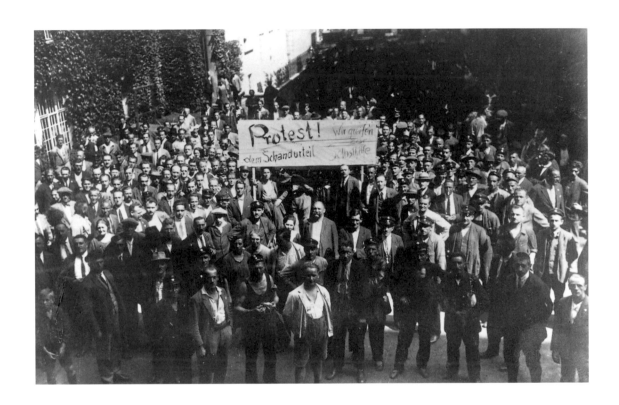

Fig. 1. Early morning—workers demonstrating against the Schattendorf verdict, 15 July 1927

Masses, Mind, Matter: Political Passions and Collective Violence in Post-Imperial Austria

Stefan Jonsson

Good citizens are rare.

— Baruch Spinoza[1]

At eight o'clock in the morning on 15 July 1927, Vienna's electricity workers switched off the gas and electricity supplies to the city. Public transportation, communication, and industrial production came to a complete halt. It was a signal: people left their workplaces and living quarters, and they began marching toward the parliament building (fig. 1). Joining them halfway was Elias Canetti, who would become one of Austria's most distinguished writers. "During that brightly illuminated, dreadful day," he wrote later, "I gained the true picture of what, as a crowd, fills our century."[2]

The impetus for the march was a killing that had occurred six months earlier in Schattendorf, a village in Austria's Burgenland, near the Hungarian border.[3] A group of social democrats had marched through town. Throughout the 1920s, such manifestations took place almost every Sunday in nearly every town and village in Austria, a country split between the socialist movement and a radical-conservative front that supported the governing coalition and that was often organized in the Heimwehr, the local defense corps. As the Schattendorf social democrats passed the tavern of Josef Tscharmann, the watering hole for a gang of right-wing vigilantes called the Frontkämpfer (front fighters), rifles were fired from a window. Matthias Csmarits, a worker and war veteran, and Josef Grössing, an eight-year-old boy, were shot in their backs and killed.

On 14 July, the jury of the district court in Vienna delivered its verdict. The accused were the innkeeper's two sons, Josef and Hieronymus Tscharmann, and their brother-in-law, Johann Pinter — all were members of the Frontkämpfer. It was incontestable that they had fired at the demonstrators. They had confessed to this themselves. It was incontestable that two persons had died. The verdict of the jury was "not guilty."

"A Clear Verdict," declared the *Reichspost*, the organ of the governing party, the following morning. "The Murderers of the Workers Acquitted," ran the front-page headline of the *Arbeiter-Zeitung*, the major social-democratic newspaper, which published a fuming editorial by Friedrich Austerlitz: "The bourgeois world is constantly warning of a civil war; but is not this blatant,

this provocative acquittal of people who have killed workers, for the reason that they were workers, already by itself a civil war?"[4]

Austerlitz's editorial captured the sentiments of the working classes in Vienna: on 15 July, they acted in accord with their passions. The demonstration was not preceded by planning or announcements—it caught the leaders of all political parties off guard. The immediate goal of the workers was to voice their dissent in front of the parliament building. Before reaching their destination, however, they were struck down by mounted police. Many began to arm themselves with rocks and sticks. The police responded by making arrests, bringing the captured to the police building on Lichtenfelsgasse. In an effort to force the release of the detained, demonstrators overpowered the police and set the police building on fire. Meanwhile, the police had lined up outside the nearby Justizpalast (palace of justice), the symbolic seat of law. Attacking the police chain, the demonstrators besieged the Justizpalast and forced their way into the building, some carrying containers with gasoline.

At 12:28, the fire department received the first emergency call from the Justizpalast. Fire engines were promptly dispatched, but the crowd—its number now exceeding two hundred thousand—refused to let the vehicles pass (fig. 2). Chancellor Ignaz Seipel and the chief of police, Johann Schober, decided to arm six hundred officers with rifles and gave them orders to march toward the turmoil. Around half past two, just as the demonstrators had yielded way to the fire engines, the police started shooting. By this time, Otto Bauer, a leading theorist of Austro-Marxism and chairman of the Sozialdemokratische Arbeiterpartei (Social Democratic Party), had reached the site:

> I and some of my friends saw the following. A lineup of security officers progressed from the direction of the opera toward the parliament building, a true lineup, one man beside the other separated by one to two-and-a-half steps. At this time Ringstrasse was empty and only at the other side of Ringstrasse a couple of hundred people were standing, not demonstrators but curious onlookers who had been watching the burning Justizpalast. Among them were women, girls, and children. Then one unit approached, I saw them move forward, rifles in hand, persons who for the most part had not learned to shoot, even when firing they leaned the butt against their belly and fired left and right, and if they saw any people—there was a small group in front of the building of the school council and a larger one in the direction of the parliament building—then they fired at them. The people were seized by frantic fear; for the most part, they had not even seen the unit. We saw people running away in blind fear, while the guards were shooting at them from behind.[5]

Gerhard Botz, the principal historian of the July events in Vienna, speaks of a "shooting psychosis."[6] The police shot demonstrators, spectators, and their own. They fired at men and women, at children and the elderly, at fire engines and ambulances. When calm was restored, eighty-five civilians and

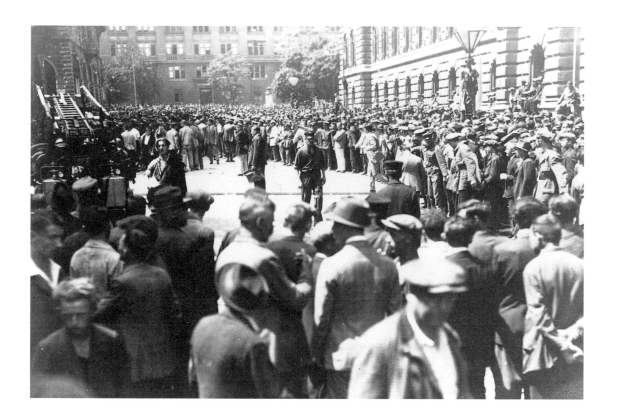

Fig. 2. Late morning—demonstrators and onlookers gathering outside the Justizpalast, 15 July 1927

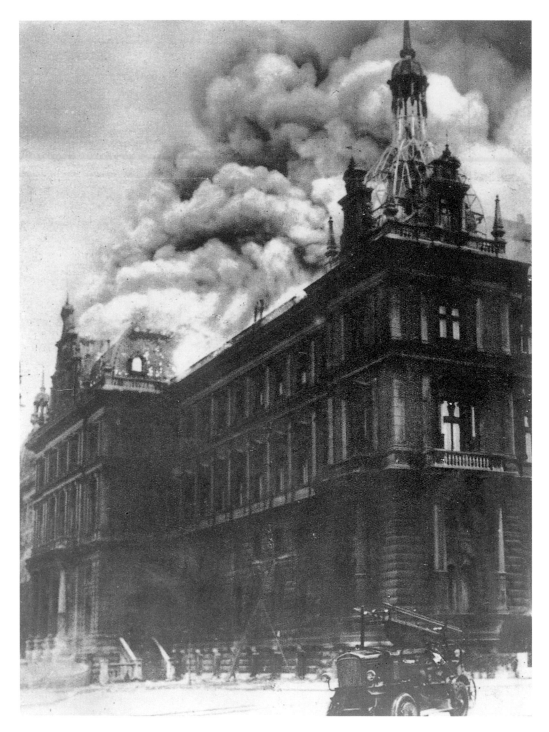

Fig. 3. E. Seebald
Der brennende Justizpalast
From *Interessantes Blatt* (Vienna), 21 July 1927, Kalender, 4

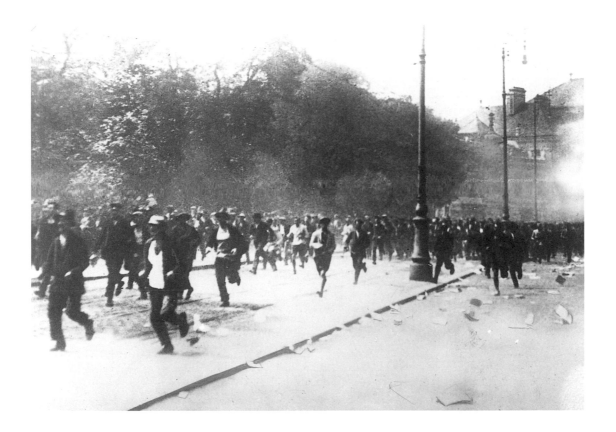

Fig. 4. Afternoon—panic-stricken demonstrators and onlookers
fleeing from police gunfire outside the Justizpalast, 15 July 1927

four police officers had been killed, and more than one thousand combined were injured. One of the responsible officials, Vice Chancellor Karl Hartleb, admitted that the scene sometimes looked like a rabbit hunt.[7] It was soon revealed that the ammunition distributed to the officers consisted of so-called dumdum bullets, which are designed to expand upon contact with the target. The doctors attending to the wounded in Vienna's hospitals related horrendous sights of bodies with wounds that appeared to have been inflicted from distances of less than one meter.

To the bourgeois establishment, the bloodshed was a price worth paying for the restoration of order: the Automobile Club of Austria expressed its gratitude by donating five thousand schillings to the police; the Association of Bankers, the Central Association of Industry, and the Chamber of Commerce likewise gave money to the police department; and the Grand Hotel in Vienna reassured potential guests that the "unfortunate events…instigated by communists" would in no way affect their comfort.[8] Dozens of police officers were decorated with medals of honor, tokens with which the upper classes encouraged the force that had protected their idea of society.[9] Meanwhile, communists and left-wing social democrats believed that the events of 15 July signaled an imminent revolutionary situation that would allow them to realize *their* idea of society.

The fifteenth of July saw the breakdown of the democratic forms that had contained the political passions of Austria's post-imperial society. Created by the decree of the victors of World War I, the young republic was ruled by a conservative Christian government that had barely managed to stake a course through the postwar chaos. Thanks to the parliamentary cooperation of the social democrats, the government had resolved the crises caused by the destruction of the Austro-Hungarian empire, thereby establishing between the working classes and the bourgeoisie a precarious equilibrium that gave the democratic institutions room to maneuver. July 1927 changed all that. After July, the upper classes would associate the workers' idea of a good society with the raging masses or the Bolshevik revolution; the working classes would associate the burghers' idea of a good society with the flashing muzzle of a gun.

Yet, what emerged from this class struggle was a political force that triumphed over both socialists and conservatives—a fascist front, better than the socialists at mobilizing the people and better than the conservatives at maintaining social order. The only true beneficiary of the July events was the Heimwehr movement; after July, Austrian authorities, private donors, and the fascist governments of Italy and Hungary all increased their financial and political support of this paramilitary force in order to consolidate the regime against the socialist threat. The Heimwehr thus grew into a political force that could gradually realize its ideal of an Austria purged of communists and Jews. In sum, 15 July 1927 was a turning point in Austria's history.

On Stadiongasse he jumped up on the heap of stones, which was there at the time, opened his coat, stretched out his arms widely, and shouted to charging security forces: "Shoot here, if you dare to!" And the unthinkable happened.[10]

"Fifty-three years have passed, and the agitation of that day is still in my bones," Elias Canetti remarks in his memoir: "It was the closest thing to a revolution that I have physically experienced. Since then, I have known quite precisely that I would not have to read a single word about the storming of the Bastille."[11] Canetti was so influenced by this experience that he spent the rest of his life investigating the behavior of the so-called masses. As Gerald Stieg has discussed, several Austrian writers and politicians realized that July 1927 epitomized the political and cultural substance of Austria's first republic.[12] In this essay, I will analyze how some of these writers understood the violent force of the political passions that erupted "during that brightly illuminated, dreadful day." My subjects are Karl Kraus (1874–1936), Heimito von Doderer (1896–1966), and to a lesser extent Canetti (1905–94), whose writings deserve a separate study.

Between 1918 and 1933, from the socialist revolutions in the wake of World War I to the Nazi victory, German and Austrian culture and politics were dominated by competing efforts to apprehend and control the social and political passions that erupted in clashes between the working classes, the fascist militias, and the apparatus of state violence. These efforts gave a central role to a political agent that intellectuals and politicians from the French Revolution until our day have called "the masses." As early as the 1890s, an entire scholarly discourse—mass psychology—crystallized around the efforts to understand this agent. Mass psychology drew on many sources: Hippolyte Taine's positivist and profoundly conservative history of modern France; Jean-Martin Charcot's studies of insanity; Émile Zola's naturalist inventory of the mores of the working classes; and Gabriel Tarde's, Alfred Victor Espinas's, and Henri Fournial's sociological theories, all of which evolved in connection with the criminal anthropology of Italian social scientists like Scipio Sighele.[13] The discourse of mass psychology was codified by Gustave Le Bon's enormously successful *Psychologie des foules* (1895; *The Crowd: A Study of the Popular Mind*, 1896). Mediated by Le Bon, mass psychology deeply influenced all the social sciences, contributing not only to the subdiscipline of social psychology—as in William McDougall's *The Group Mind* (1908) and Sigmund Freud's *Massenpsychologie und Ich-Analyse* (1921; *Group Psychology and the Analysis of the Ego*, 1922)—but also to German sociology and social philosophy, from where, and always with or against Nietzsche's proverbial declaration of war against the masses, it bifurcated into the political strategies of fascism, on the one hand, and the left-wing critiques of fascist ideology, on the other. Along with the discourse of mass psychology came an array of terms and opinions that journalists, writers, and the educated classes appropriated and made part of their political worldview, especially their understanding of the lower classes.

It is against this backdrop that the intellectual reactions to 15 July 1927 are best understood. Conversely, the reactions of Canetti, Kraus, and Doderer enable a better understanding of the epistemological foundations and ideological limitations of the discourse of mass psychology itself. As I shall argue, the masses is a fantasy that the discourse of mass psychology projects onto the social landscape. My hypothesis is that this projection is a product of the specific ways in which socially significant passions have been represented—politically and intellectually—throughout the modern period. By socially significant passions, I mean the affective aspects of human labor and the libidinal need for social recognition that form the binding medium of society. The act of representing such passions, I want to suggest, structures the social field by instituting a distinction between representatives and the represented. This distinction entails a distribution of power and knowledge, determining who will be included in the political and cultural institutions, and hence able to ascend to the position of society's political and cultural representatives, and who will be excluded from those institutions, and hence subsumed under the notion of "the people."

In Europe, at the end of the nineteenth century and through the first decades of the twentieth, distribution of power tended to generate a distinction between the masses and individual citizens: the masses were defined, typically, as a social matter characterized by passions; the individual citizen, by contrast, as a mind characterized by reason and thus capable of executing power by rationally representing the passions of the masses. The act of representing socially significant passions can therefore be seen as an originary mechanism of politics, as the source of power. The masses that intellectuals and politicians have struggled to represent throughout modernity, are, it will turn out, fabricated by their own acts of representation.

This argument does not imply that the masses are an effect of discourse or a historical construction. But nor does it imply that the masses are a reality. The masses can be understood as an "effect of representation," with the proviso that this representation occurs on several social levels, some of which are palpably concrete: The representation may be discursive, as in scientific and literary accounts *about* the masses. The representation may also be political, as in the system of representative democracy at the beginning of the twentieth century. The representation may, moreover, be economic, as in the capitalist mode of production in which labor is represented in the form of surplus value extracted by the capitalist.

These modes of representation are not necessarily congruous. For instance, a theoretical representation of society may contradict the institutions of political representation or the economic system in which labor is socially represented as exchange value. Germanic languages are able to distinguish these modes of representation either as forms of *Darstellung,* speaking *about* someone or something, or as forms of *Vertretung,* speaking *for* or *on behalf of* someone or something.[14] English is deprived of the possibility to clearly signal the difference between the two but, in return, is able to mark that the two are

often interconnected. For there are cases where discursive, political, and economic systems of representation are aligned to contribute to one and the same effect. One such case is the production of a phenomenon called "the masses." This explains why the masses are always construed as absolutely peripheral in relation to positions of centrality that accumulate not only political power but also aesthetic, intellectual, ethical, and economic values.[15]

———————————

A mounted policeman stormed up on the sidewalk, blocked the doorway with the body of his horse and bestially beat down with his sabre on the young girls who pleaded for mercy with their out-stretched hands, until they fell to the ground in a pool of blood.

———————————

The question of the masses is directly linked to the question of the social itself—how, and by whom, is society represented? Until quite recently, our concepts of society have been associated with the nation-state. Now, however, according to numerous social scientists, we are entering an era in which political, social, cultural, and economic activities are no longer structured primarily by either nation or state.[16] Global economic and technological changes have discredited not only the ideology of universal progress that characterized the labor movement but also the ideology of the homogeneous nation-state according to which all co-nationals partake in a single community, share the same history, and move toward a common destiny. As the integrative capacity of class and nation dwindles, the labor movement and the nation-state are transformed into containers of divergent political projects and disoriented populations who often reorganize themselves along ethnic or religious lines. Today, class, nation, and state—three categories that once governed the historian and social scientist—have thus lost a great deal of their explanatory power. "Society" again strikes us as an abstract and enigmatic idea. What content does it have when its reference to the nation-state is removed?

The search for answers to such questions is transforming the field of the humanities and the social sciences. This transformation is evident in the return to the intellectual agenda of two discourses that last flourished after World War I: geopolitics and mass psychology. The geopolitical interest now reappears under the rubric of globalization, and it is driven by the desire to analyze how long-standing national, territorial, class-based, and governmental supports of society are eroded by the macrodynamics of the world system as such, the newly discovered sphere of the "global." The renewed interest in mass psychology, in turn, is apparently motivated by the desire not only to describe the social and psychic consequences of this disintegration but also to reexamine how collective life is still sustained. Increasingly, scholars and theorists are focusing on the microdynamics of concrete human affairs, rediscovering the realms of civil society and communitarian behavior, as well as exploring emergent social movements centered around religion and ethnicity.[17]

This, then, is the context in which the passions have regained status as a theoretical category — the passions offer a working hypothesis for social theorists who seek new answers to the first problems of sociology: Why, and how, do human beings unite in collectives? How do we explain our ability to weave a communal fabric from which we continue to manufacture our fates, even after the collapse of those political authorities and social structures that have for so long been seen as the indispensable pillars of society? Answers to these questions take many different forms. Consider, for example, Gilles Deleuze's and Félix Guattari's definition of desire as the basic force of social production; or Martha Nussbaum's reconquest of love as a social category; or communitarian accounts of how civil society is tied together by bonds of loyalty and trust; or studies on the resurgence of ethnonationalism and religious fundamentalism; or, finally, Peter Sloterdijk's recent account of modernity as the deplorable result of the masses' corrosion of social hierarchies.[18] Notwithstanding their differences, these lines of research are united by a common interest in the passions as underpinnings of social institutions and also as generators of political change. Hence, Serge Moscovici's argument that "[s]ociety springs from within us, as passions arising from each of us":

> Under a society made up of institutions, so real and visible, in which we live, [the first sociologists] caught a glimpse of, and sought to explore, a society made up of the passions that flow through our lives. Who could doubt that these passions act as a stimulus to the great inventions of politics and religion, and are generally a sign of cultural innovation?... Our primal links between one another, much more than a blend of interests and thoughts, are the movements of the passions. These are what cause people to participate in that phenomenon, which in the end remains a mystery, called a collectivity.[19]

Moscovici's claim is a radical one because it calls into question a number of influential social theories. The basis of society would be neither a social contract that balances the self-interests of individuals (liberalism) nor the imposition of law by a sovereign (conservatism or religion); neither the necessity of collaborative production (historical materialism) nor the communicative capacity of human beings (structuralism and semiotics). Rather, for Moscovici, the basis of society is the libidinal process that he links to the passions, an irreducible and indestructible element of sociality present in each human subject. A concept of society that is based on law, social contract, shared culture, or units of material production can be defined theoretically and codified constitutionally. But if such phenomena are but temporary crystallizations of a more essential social reality constituted by "the passions that flow through our lives," how is this level of reality to be defined? How is it to be represented legitimately by political institutions? Such questions alone justify a reinterpretation of mass psychology, for the discourse of mass psychology assumes that there is one phenomenon in which socially significant passions may be examined in pure form: the masses.

In the afternoon on the 15th of July, Rudolf Kreuzer and his wife walked across Ringstrasse in the direction of the Schiller monument. The street was calm with only a handful of peaceful pedestrians. Suddenly, a volley was fired near the Schiller monument. The couple ran toward the opera. There came another volley. One shot hit the woman in her neck and injured her spinal column, causing a general paralysis

The positivist sociologists of the late nineteenth century who first sketched a coherent theory of mass psychology defined the masses in much the same way as their colleagues in the natural sciences defined a physical mass. Both sociologists and natural scientists postulated the existence of an undifferentiated matter which, under the right conditions, could be converted into energy. This energy could be harnessed for constructive purposes—the result being what social scientists called civilization—or it could explode—the result being a riot, even a revolution.

To define the masses as undifferentiated matter implies that they lack formation and individuation, and it suggests that the masses are commanded by the parts of the psyche that are universal, that is, by unconscious instincts and passions. According to Le Bon, the principal characteristics of the individual who joins a crowd are "the disappearance of the conscious personality, the predominance of the unconscious personality, the turning by means of suggestion and contagion of feelings and ideas in an identical direction, the tendency to immediately transform the suggested ideas into acts"; as a result, the individual "is no longer himself, but has become an automaton who has ceased to be guided by his will."[20] The individual thus becomes an organ stirred by the passions circulating in the larger social body of which he or she is now a function. These passions thus amount to something like a control system for the social body—Le Bon's "collective mind"[21]—which governs the actions of all members of the crowd.

The first key term in Le Bon's analysis is *contagion*, for which he drew on Gabriel Tarde's theory of imitation. According to Tarde, who sought to account for the cohesion of a social group, people imitate one another and sometimes become so similar that they all start to think, feel, and act in the same way, the result being the formation of a collective mind.[22] Le Bon's second key term is *suggestion*, for which he drew on Jean-Martin Charcot's research on hypnosis. Charcot described how the process of contagion was activated by an external agent who exercised a power of suggestion over the collective. Le Bon described the process as "collective hypnosis." His notion of the masses thus presupposes the existence of another agent, in the role of the hypnotist. This agent is "the leader." The one cannot be understood without the other: only the suggestion of the leader can fuse individuals into a crowd.

In other words, mass psychology construes the masses as a political problem. The leader enters as a solution, transforming the formless matter of the masses into an organized crowd. For Le Bon, this transformation marks the

birth of social order: the volatile passions of the masses are tamed and put to constructive use — like the Furies are suppressed by Athena.

Mass psychology thus explains the processes by which leaders mobilize the masses to support certain political goals, but it offers no judgment on the goals as such. So, Hitler whipping up enthusiasm for the annihilation of Jews, or Gandhi exhorting India's poor to rise against British injustice, or Revlon promoting a new eyeliner are all, under the rubric of mass psychology, comparable phenomena. In all three cases, a leader directs the masses' desire toward a certain objective; and the fact that the objective can vary between such extremes only confirms another basic assumption of the crowd psychologist: that the masses cannot think, that they can be led to do anything. It is no coincidence that Le Bon's work was, and continues to be, preferred reading for statesmen around the world, from Theodore Roosevelt to Adolf Hitler. "I have read all his works," Benito Mussolini once confessed, "and I don't know how many times I have re-read his *Psychologie des Foules.*"[23] Mass psychology thus not only explains *how* power is exercised — through the hypnotic ability of the charismatic leader — but it also asserts that power *must* be exercised, because otherwise the lower classes would be led astray by their passions. Constitutively ambiguous, mass psychology is at once an ideological theory and a theory of ideology. The discourse supplies both a manual on the art of manipulation and a critical analysis of that art.[24]

Le Bon never provided a proper definition of the masses. Sometimes the masses are associated with a past reality — the French Revolution, the Paris Commune — and other times with a threatening future — equality, universal suffrage. In Le Bon's historical present, however, the masses names an unknown social antagonist. The masses serves well as a representation of this faceless antagonist, because, as we have seen, the term can be analytically defined only as undifferentiated social matter. Yet, the term serves this purpose only as long as the antagonist remains faceless, that is, only as long as the social scientist is so far removed from the human collectives that he perceives them as undifferentiated. The masses therefore cannot be a theoretical concept, for it is always marked by a certain perspective. The farther removed the theoretical gaze is from a given society, the more likely it is that this society will appear as a mass.

Such is the first conceptual shortcoming of mass psychology's representation of social passions. In order to grasp its object theoretically, mass psychology must not attempt to close in on it empirically, lest it dissolve into distinguishable persons. This is the reason why historians have been reluctant to accept the explanations of mass psychology.[25]

———————

Just as she was kneeling down over the wounded, the fatal bullet was fired and crushed the back of her head.

———————

Can mass psychology explain the collective violence of 15 July? By 1927, there were a number of causes of discontent among Austria's workers. While the upper and middle classes and even the rural population had begun to benefit from the severe economic measures undertaken by the government after World War I, the working classes, by contrast, were facing unemployment of over 10 percent—in the Vienna region it was as high as 30 percent.[26] Legal discrimination was also an inflammatory issue: on at least four occasions, social democrats had been killed or injured in clashes with right-wing radicals, and, in all cases, the perpetrators had walked away unpunished.[27] The frustration that the unemployment and the legal discrimination generated among the workers was further increased by the fact that they had reason to expect that empowerment and equality were within reach. The unions and the Sozialdemokratische Arbeiterpartei controlled the material and institutional infrastructure of Vienna, and, because the support of the party had increased from election to election, the socialists hoped that they would soon rule by absolute majority. Yet, in 1927, expectations of empowerment remained unrealized, in no small part because the Christian conservatives, noting the growth of the social democratic electorate, became increasingly unpliant.

This class tension was, in turn, a legacy of Austria's defeat in World War I and the subsequent destruction of the Austro-Hungarian empire. After the war, the political, administrative, and economic apparatus broke down, so much so that with the Treaty of Saint Germain in 1919, "the whole *raison d'être* of Austria…seemed to have been irrevocably destroyed."[28] Historical and literary documents suggest that the citizens of the truncated state experienced the postwar years as a collective trauma.[29] Large parts of the population no longer trusted the state to be their representative. All sides reserved the right to arm themselves for future contingencies, conjuring up the specter of civil war as a pretext. Wealthy estate owners financed private armies. The right had the Heimwehr, while the social democrats had their own paramilitary wing in the Schutzbund. On 2 March 1927, the conservative government attempted to disarm the Schutzbund, provoking a brief crisis that further increased the social democrats' distrust of the authorities.[30]

Thus, the general political background of the demonstration of 15 July is a panorama of interlinked minor and major causes and motivations. The complexity and variety of these causes and motivations preclude a unified explanation of the violent event itself. Yet, the absence of a simple, causal explanation of the events of 15 July 1927 is precisely the reason why intellectuals and politicians have been tempted to posit the agency of a collective mind as an explanatory model: only a homogeneous and unidirected force of that kind, they seem to say, would have such a massive impact.

The line that separates a psychology of the crowd from a metaphysics of the crowd is thus often a thin one. When stating that the crowd acts as one being, mass psychologists deliver not a substantiated social theory but something analogous to the kind of explanation we find in mythology, where giant events are interpreted as acts of giants. Consider Canetti's description of the crowd:

"it wants to consist of *more* people: the urge to grow is the first and supreme attribute of the crowd. It wants to seize everyone within reach; anything shaped like a human being can join it."[31] To mass psychologists, whether Canetti, Le Bon, Tarde, Freud, or Sloterdijk, social agency ceases to be *he, she,* or *they.* Instead, social agency becomes *it,* which is strangely plural.

———————

The mob that heaved itself around the Justizpalast, howling and eager to loot, had transformed itself into a swarm of hatred. Its rage had turned into the fear of the weak, its demand for revenge into cowardice. It crawled away into the alleys to take cover.

———————

The collective soul is thus a "representation," conjured up by the social scientist in order to explain an effect, the immensity of which far exceeds the combined agency of the innumerable persons and circumstances that caused it. Experiencing the July events, Canetti and others believed they saw a collective mind in action. "I became a part of the crowd," Canetti recalls, "I fully dissolved in it, I did not feel the slightest resistance to what the crowd was doing."[32] Yet, like all accounts, Canetti's is a reconstruction, noted down in afterthought by an individual working through his memories and ideas.

Canetti's first ideas about the masses came to him as an "illumination" on a solitary walk through Vienna in the winter of 1924–25:

> It was night; in the sky, I noticed the red reflection of the city, and I craned my neck to look up at it. I paid no attention to where I was walking. I tripped several times, and in such an instant of stumbling, while craning my neck, gazing at the red sky, which I didn't really like, it suddenly flashed through my mind: I realized that there is such a thing as a crowd instinct, which is always in conflict with the personality instinct, and that the struggle between the two of them can explain the course of human history.[33]

This flash of inspiration, Canetti asserts, propelled him to devote thirty-five years to the study of the crowd. In his memoirs, Canetti relates how he set out on this lonely journey: to find out what a crowd really was, he isolated himself in a farmer's house in the Alps. The first morning, he sat at a table in the garden with the only book he had brought along, Freud's *Massenpsychologie und Ich-Analyse.* Embarking on a revision of Freud's theory, the twenty-year-old Canetti replaced Freud's sexual drive with another drive, the *Massentrieb,* or "crowd instinct." Freud and Le Bon had been blind, he believed. Neither thinker had known the crowd from the inside. As for himself, Canetti writes, "I had never forgotten how *gladly* one falls prey to the crowd…. I saw crowds around me, but I also saw crowds within me."[34]

Yet Canetti's intention to represent the crowd from within, as an experiential phenomenon, is called into question by his account of his own intel-

lectual procedure. "I had made up my mind," he writes, to "have the crowd before me as a pure, untouched mountain, which I would be the first to climb without prejudices."[35] Canetti here figuratively replicates the mental distancing that he had belittled in his adversaries, Le Bon and Freud—Canetti's theory, too, presupposes a separation of the rational mind from the passionate masses. Interestingly, Canetti states that it was during these days of hard discipline, divided between Freud and solitary mountain hikes, that he "struggled for and attained...independence as a person."[36] Quite literally, Canetti gains mastery as an individual by intellectually conquering the masses.

To be sure, Canetti's mature analysis is far more complex than these comments suggest. Yet it is enlightening to see how his first youthful attempts to analyze the crowd are predetermined by a certain conceptual structure. As a consequence, the crowd comes across less as a transparently described actuality than as a reflection of the conceptual limitations that govern the analysis. I have already mentioned the most obvious instance of these limitations—the way in which mass psychology must keep itself at a distance from its object, the masses—and Canetti's description reveals a second as well: the notion of the masses is always constituted in opposition to the notion of individual reason.

Take, for example, the following statement by Le Bon: "the substitution of the unconscious action of crowds for the conscious activity of individuals is one of the principal characteristics of the present age."[37] That is to say, the individual is to the crowd as conscious activity is to unconscious action. The basis for such a characterization is the Cartesian concept of the individual as defined by consciousness. For Descartes, the opposite of consciousness was the passions.[38] The crowd psychologists repeat this distinction. Assuming that the individual is characterized by consciousness, and that the crowd is the opposite of the individual, they conclude that the crowd must be characterized by the opposite of consciousness, that is, by unconscious passions.

To put it another way, the definition of the masses as a matter characterized by passions is an inverted mirror image of the definition of the individual as a mind characterized by reason. In the modern period, the crowd therefore occupies a position analogous to that of the primitive, the feminine, and the barbarian, all instances of the Other of Western rationality, and all linked by a common definiens: the passions. From Le Bon to Sloterdijk, the masses is a category pressed into service to address social processes that seem to erode differences, challenge authorities, and unmake rational distinctions. The mass is always the eclipse of reason and the enemy of the well-ordered polis. As Theodor Adorno states, "the mass is always the others."[39]

So it is that most efforts to analyze the masses are intrinsically linked to the problem of representing the passions. As a site of malleable passions, the crowd cannot represent itself coherently. It calls for representation by someone who can grasp its true nature and present it in intelligible form, namely, the intellectual. Moreover, the crowd calls for political representation by

someone who can speak on its behalf and convert its passions into political demands, namely, the leader, *Führer,* or party.

———————————

This achievement, which cannot be highly enough estimated ... can also be attributed to the fact that the Police Department of Vienna once again has proved itself to be the most steadfast protector of the order of the state.

———————————

Barely had the corpses been removed from Ringstrasse when Chancellor Seipel issued an official statement in which he praised the police department as "the most steadfast protector of the order of the state." Liberal and conservative newspapers alike — *Neue Freie Presse, Reichspost, Wiener Neueste Nachrichten, Neues Wiener Journal, Wiener Allgemeine Zeitung* — rapidly established this view of 15 July as the truth.

The writer and satirist Karl Kraus, in a series of essays published in his journal, *Die Fackel,* condemned the establishment for its silence and for its support of the chief of police, Schober. The citizens of Vienna had witnessed the slaughter of eighty-five innocent civilians without raising their voices. Even worse, they believed that it was reasonable to murder in order to protect the republic.

Since *Die Fackel*'s founding in 1899, Kraus had used the journal as a tribunal, with himself as the incorruptible judge of humankind. With his inimitable satire, Kraus took on slack common sense, political mediocrity, and corrupted language. The July events infused his satire with a primordial rage. Kraus mustered all his intellectual powers to expose what he saw as the truth about Austria's celebrated bulwark of republican liberty and justice — a legal system that acquitted murderers and murdered those who dared to protest. Worse still, Kraus believed, no one seemed to mind: "No one in this society, not a single person, has felt himself called to stand up and confess: the red flames on the sky over Vienna on July 15 must fade before the shame over the deeds and the cannibalistic well-being of a governmental authority and a bourgeois public whose sole concern at the moment was the negative impact on tourism."[40] As a measure of the times, Kraus observed with regard to Schober that "just days after Vienna has been turned into a *Nadererhölle* it is still possible for a liberal power-licker to editorialize about 'this distinguished, earnest Man, this good-hearted, this the most humanitarian of all chiefs of police.'"[41]

The July events fueled a campaign that Kraus had already begun against Schober and Vienna's press.[42] On 17 September 1927, Kraus put up posters all over Vienna, signed with his own name and addressed to Schober, demanding that the chief of police resign (fig. 5). In his memoirs, Canetti describes how he walked from one poster to the next, feeling "as if all the justice on earth had entered the letters of Kraus's name."[43] This poster was only the first in a series of public assaults that Kraus made on Schober, culminating with the

An den Polizeipräsidenten von Wien
JOHANN SCHOBER

Ich fordere Sie auf, abzutreten.

KARL KRAUS
Herausgeber der Fackel

Druck von Jahoda & Siegel, Verlag „Die Fackel",
verantwortlich für den Inhalt Karl Kraus,
sämtlich Wien, III. Hintere Zollamtsstr. 3

Fig. 5. Karl Kraus (Austrian, 1874–1936)
An den Polizeipräsidenten von Wien Johann Schober Ich fordere Sie auf, abzutreten, 1927,
poster, 83 × 53 cm (32⅝ × 20⅞ in.)
Vienna, Wiener Stadt- und Landesbibliothek

satirical drama of 1928, *Die Unüberwindlichen* (The invincibles), which ruined Schober's record for all posterity.

The efficiency of Kraus's tribunal depended entirely on his satirical genius. Like all true satirists, Kraus was an authoritarian who rested his authority on a utopian ethos. Kraus condemned the biased justice of Austria in the name of a higher justice, and he impeached the alleged impartiality of the Austrian press in the name of a higher impartiality. In doing so, Kraus exposed the seemingly sober common sense of the upper classes as a mere disguise for their self-interest, their prejudices, and their irrational "fear of the elements"[44]—a fear that prevented the bourgeoisie from seeing society clearly. By revealing the passions that underlay the Viennese establishment's support of the authorities, Kraus also robbed the discourse of mass psychology of its seeming neutrality. He set forth that the opposite of the rioting masses was not rationality or justice but the political passions of those who governed and those who benefited from the government. It was a simple but crucial discovery: the masses is a category that is always embedded in the field of power.

The symbolic tribunal of *Die Fackel* thus accomplished two related ends. First, it delegitimized the legal and political representatives of the young republic: the system of justice had ceased to represent the law, and the government had ceased to represent the people. Second, it broke up the ideological and epistemological monopoly of the press and the civil authorities. Through an act of discursive emancipation, Kraus freed the protesters from the stereotypes that had enabled the government, the police, and the press to mistake them for criminal elements, to confront them with excessive violence, and then to justify such repressive measures by continuing to refer to them as the masses. Against this story about Order's defeat of Anarchy, Kraus mobilized another stylistic skill that he had developed into an art form. He broke down the allegedly homogeneous opponents in the struggle into their constituent elements, unfolding before the public an extensive montage of eyewitness accounts, testimonials, and citations. Of the ninety-two pages of Karl Kraus's first essay on the July events, "Der Hort der Republik" (The bulwark of the republic), the first forty-eight consist entirely of quotations, the multiplicity and heterogeneity of which demonstrate the utter inadequacy of the masses as a descriptive category for the demonstration.

According to Gerald Stieg, Kraus's montage constitutes an intermediary stage between the political event and a full literary rendering of it, such as that in *Die Unüberwindlichen*.[45] The pages of *Die Fackel* thus allow a glimpse of history in the process of becoming representation, or fiction. However, Kraus's technique also moves in the opposite direction, working through an already fictionalized representation produced by the Viennese press and the government, thus bringing the reader face-to-face with the primary sources as well. Informed by ideas similar to those of Bertolt Brecht, Walter Benjamin, and the constructivists, Kraus's montage subverted the dominant fiction about the dangerous masses and the steadfast police, prompting instead a fresh look at the facts and contradictions that had been weeded out

in the official investigations. The news media and the government construed the July events as an act caused by one homogeneous agent, the masses; Kraus construed this agent as multiple individuals, and he attributed the cause of the violence to the uniform ruthlessness of the authorities, embodied by the chief of police. Schober's achievement was a magnificent one, Kraus concluded. He protected the glory of the republic by massacring its citizens.[46]

The management of the Gleichenberg Health Resort offers healing cures to the security forces without payment, a number of hotel owners and innkeepers have pledged to provide police officers with complimentary meals and lodging. The Chief of Police has accepted the offer.

Heimito von Doderer saw the violence on 15 July as an apocalypse. In the words of the narrator of Doderer's novel *Die Dämonen* (1956; *The Demons*, 1961), it was "the Cannae of Austrian freedom."[47] Along with Kraus and Canetti, Doderer is the other great chronicler of the burning of the Justizpalast. His contribution is an excellent example of a genre that is rare indeed: a bourgeois collective novel.

Conceived in 1927 but not finished until 1956, *Die Dämonen* introduces a multitude of characters, relating their lives and relationships over the space of more than thirteen hundred pages. What links one person to the next is not so much a conventional plot but a detailed account of emotional bonds, social rituals, ties of kinship, financial debts and credits, cultural values, and political opinions, all of which, when taken together with their correlative contexts — bank, opera, café, restaurant, university, salon, library, boudoir — make up an identifiable social class: the Viennese bourgeoisie of 1926 and 1927.

In Doderer's novel, the July demonstration constitutes the outside, the dangerous wilderness against which this world and class delimit themselves. This narratological organization corresponds to the grand philosophical theme that marks Doderer's oeuvre in general: the distinction between what Doderer calls "actual reality" and what he calls "second reality." For Doderer, "second reality" indicates a realm of ideological fantasy and psychological obsession that, in private life, results in perverse behavior. In *Die Dämonen*, the primary manifestation of this is Kajetan von Schlaggenberg, a writer with anarchic leanings who hungers for fat, middle-aged women, the sizes and looks of whom he catalogs with the rigor of a racial scientist. In public life, the belief in a "second reality" expresses itself mainly as political radicalism. "That man becomes a revolutionary," says Doderer's narrator, who "perceives realities too vaguely because of his own poor eyesight."[48]

In contradistinction to such delusions, Doderer reclaims the legacy of personal cultivation, the virtuous path toward self-transformation that is at one with a harmonious adjustment to "the order of the world." Doderer's narrative marshals the humanist credo of Giovanni Pico della Mirandola; the hero

of *Die Dämonen*, Leonhard Kakabsa, happens upon a Latin text by this Renaissance scholar, whose rendering of God's command to Adam may be taken as the central message of the novel: "you will define your own nature.... You can descend to the depths of brute creation or rise to the heights of the divine, according to the decision of your own soul." In *Die Dämonen*, Mirandola's credo entails a ban on collective undertakings. Doderer voices this individualistic message through one of the few workers included in the novel: "In our party newspaper," an obvious reference to the *Arbeiter-Zeitung*, "all I ever read is 'the people,' 'the masses,' and always 'the masses.' It's the masses that matter, the masses that count. But I'm not the masses, I'm a human being by myself. And that don't mean a thing to them."[49]

Leonhard bears out the central credo through fantastic individual achievements. At first an uneducated worker who seeks comfort with prostitutes, Leonhard one day happens upon Scheindler's *Latin Grammar for Schools*. Within a year, he is fluent in Latin. Leonhard's scholarly aspirations gain him access to the salons of the bourgeoisie, where he meets the love of his life. His efforts also bring material success: after a wealthy prince hires him as librarian of his book collection, Leonhard leaves his factory job for a career as a scholar. With undisguised devotion, the narrator chronicles how Leonhard is "transformed step by step from a crude and lawless barbarian into the equivalent of a rational and logical citizen of the Roman world."[50]

The narrative of *Die Dämonen* culminates on 15 July, and it is through Leonhard's eyes that we first see the demonstration: "an immense crowd of people ... like a moving wall" approaches the university library where the former night shift worker studies. Among the demonstrators are Leonhard's old comrades, but he has no wish to join them as they pose a menace to his newly won independence. "It might be sensible to lock up," he tells the doorkeeper of the library, lapsing into "disjunct fragments of thought": "The library — such treasures — Pico della Mirandola..."[51]

Die Dämonen seems to offer a pluralistic representation of the demonstration. It is viewed by different characters from several vantage points — street corners, windows, balconies. The best is reserved for the narrator, who is posted, field glasses in hand, in an apartment facing the Justizpalast: "We no longer saw only the fleeing people; in running, the crowd dissolved into innumerable individual dots; the scene became 'pointillistic,' and the intensely glaring sunshine emphasized that illusion. Now too we caught sight of the first victims; suddenly the square was spotted here and there with them, dark bundles in the sunlight."[52]

A second perspective belongs to the novel's fascist characters, who judge the violent disorder as confirmation of the urgent need for their own political order: "let them knock each other's heads in. All the better for us." A third, and dominant, perspective belongs to the many characters who are utterly indifferent to what is happening around them: they see no relation between their own lives and the "bundles" on Schmerlingplatz: "'Why, is there shooting...?' Quapp asked, wide-eyed.... 'Why — what has happened...?' she

burst out. 'I'll tell you all about it some other time, Quappchen. Salvos in honor of a dead boy.'"[53] Indeed, the majority of Doderer's characters experience the event only as an absence of trams in the street or as an inconvenience when trying to switch on their lamps and coffeemakers.

On closer consideration, the ostensibly pluralistic representation of the demonstration is constrained by the philosophical thematic that separates "actual reality" from "secondary reality." The characters who actively participate in the demonstration are without exception those who indulge in a "second reality." They are portrayed either as criminals or as deluded fanatics, and they are embodied ultimately by the most despicable character in the novel, the murderer Meisgeier. A rat from the netherworld, Meisgeier ascends from the sewers to Schmerlingplatz in front of the Justizpalast, motivated only by his lust to kill.

The multiplicity of perspectives thus turns out to be a narrative illusion. The reader inevitably identifies with the onlookers, who do not sacrifice their individuality. Another such point of view belongs to a young historian named René von Stangeler. Watching the demonstration, Stangeler sees a chaotic mass of people living out their ideological delusions. Being imprisoned in "the rigid, isolated second reality," both the demonstrators and the police act with ruthless intolerance, both knowing "precisely how things should be and whom they ought to shoot at, and why."[54]

A biographical reading would show that the narrative perspectives that govern the representation of 15 July can be traced to the political views that Doderer himself embraced variously during the twenty-five years that he worked on the novel.[55] In the mid-1930s, for example, when Doderer was a convinced Nazi, he planned to use 15 July to illustrate the pernicious influence of the Jews. By the early 1940s, Doderer had converted to Catholicism and had come to embrace an explicitly antipolitical and archconservative attitude. Thus 15 July emerged as a regrettable example of the ways in which men and women are blinded by ideologies.

Still, on the surface, *Die Dämonen* pretends to embrace a truly pluralistic and diversified chronicle of political events. The novel succeeds in creating this impression because it announces itself as a "diary of a collective entity,"[56] incorporating and exhibiting the psychology, values, attitudes, and everyday habits of an entire class. The representatives of this group have, to be sure, some sense of community. At the beginning of the novel they even refer to themselves as *die Unsrigen,* or "our crowd." Yet, paradoxically, what distinguishes this collective entity is that its members do not see themselves as a "we," and much less as a class, but as individuals. Hence, *Die Dämonen* is not just a collective novel but a collective novel of apprenticeship, a bildungsroman of a group. At the outset, Doderer's characters seek comfort in one another, in the "second reality" of their own group. The novel chronicles how they evolve from this stage to a higher level of existence, where they all—at least the successful ones—realize that they carry the key to happiness and freedom within their own individuality.

Doderer's program of personal cultivation, however, is superior only in contrast to the more primitive stage that it surpasses. This is why 15 July is so central to *Die Dämonen;* the demonstration represents precisely the primitive stage of the masses, blinded by ideology, confined to a second-rate reality:

> They did not march because the murderers of a child and war veteran were getting off scot-free, but because the child had been a worker's child and the veteran a worker. The "masses" were demanding class justice, against which their leaders had so often cried out. The people stormed against the verdict of a people's court, against their own verdict. That broke the backbone of freedom; from that point it was maintained in Austria for only a short time, and artificially. The so-called masses have always been fond of settling in a compact group upon the branches of the tree of liberty which tower into infinity. But they must saw off these branches; they cannot help themselves; and then the whole crown of the tree collapses. Sit where he will, the man who listens to the "masses" has already lost his freedom.[57]

To be sure, *Die Dämonen* is pervaded by a fear of the masses. As Claudio Magris has suggested, it may even be marked by a fear of history.[58] That being said, the novel's depiction of social reality is so comprehensive, almost exhaustive, that it cannot help but present its ideal of an antipolitical individualism as being in itself a political choice, the choice of a particular class. Thus, in fact, *Die Dämonen* explains the collective violence of 15 July — not in the way that its author and narrator explain it, but in the way that it inadvertently exposes the values and ideas that predisposed a large part of Vienna's citizens to experience the workers as a palpable menace, to misidentify them as a raging mob that must be suppressed. When read in this way, Doderer's novel exposes the July violence as the outcome not of any mass insanity but of what Charles Baudelaire once called the madness of the bourgeoisie.

If we compare *Die Dämonen* to Canetti's and Kraus's works, we notice that Doderer is alone in framing the masses as he does. Canetti's novel *Die Blendung* (1935; *Auto-da-fé,* 1946), conceived like *Die Dämonen* under the influence of the July events, does not view the masses from afar. For Canetti, the mass is one with the individual, for it exists within each individual:

> We wage the so-called war of existence for the destruction of the mass-soul in ourselves, no less than for hunger and love. In certain circumstances it can become so strong as to force the individual to selfless acts or even acts contrary to his own interests. "Mankind" has existed as a mass for long before it was conceived of and watered down into an idea. It foams, a huge, wild, full-blooded, warm animal in all of us, very deep, far deeper than the maternal.[59]

It was this mass, intrinsic to the human subject and anterior to individuality, that Canetti examined in his dramatic works, *Hochzeit* (1932; *The Wedding,* 1986) and *Komödie der Eitelkeit* (1933; *Comedy of Vanity,* 1983), and above all in his magnum opus *Masse und Macht* (1960; *Crowds and Power,* 1962).

In each of these, Canetti traced the forms of appearance and modes of formation of the mass throughout human history.

For Canetti, the mass equals the social instinct: individuals who attempt to repress the mass by taking shelter in their individuality will always find that the mass returns to haunt them. This is precisely what happens to the hero of *Die Blendung*, the bookworm Peter Kien. Like Doderer's characters, Kien believes himself to be securely separated from the masses by virtue of his immense erudition. However, as Canetti's narrator puts it, education is merely a *"cordon sanitaire* for the individual against the mass in his own soul."[60] Kien's individuality, constructed as an absolute value in opposition to the mass, results ultimately in self-destructive paranoia: in a great fire, Kien is consumed together with his library, just as the Justizpalast, the symbol of a system erected in opposition to the people, was consumed in July 1927. Where Canetti lets Kien's bourgeois apartment go up in flames together with the librarian himself, Doderer keeps his librarian, the ex-proletarian Leonhard Kakabsa, at a safe distance, watching the burning Justizpalast from his terrace. For Canetti, the human subject is both individual and mass; there is no choosing one over the other. For Doderer, the human subject must choose.

I went up to the commander and yelled: "for God's sake, at least avoid shooting at the ambulances! Not even during the war did anyone shoot at the Red Cross!" The police officer replied: "With your permission, I'm shooting at the Red Cross!"

"Our concept of the mass is derived from the standpoint of the individual," Bertolt Brecht wrote in the late 1920s: "The bourgeoisie has no understanding of the mass. It always just separates the individual and the mass."[61]

As codified by Le Bon in the nineteenth century, and perpetuated by Sloterdijk into the twenty-first century, mass psychology is a sterile discourse. Given the definition of the masses as the antithesis of individuality, and given the view of individuality as the anchor of rationality, it automatically follows that mass psychology represents the crowd as disorderly and destructive, an agent of leveling passions that must be raised up by education, struck down by suppression, or cleansed by fascist pedagogics.

Typically, the masses in Vienna were represented in keeping with this cliché. However, the mechanisms of representation in the accounts of Canetti, Kraus, and Doderer disclose a more intriguing logic. As we have seen, the meanings they give to the notions of the masses and the individual differ depending not only on how the writer situates himself as a representative of the political passions of 15 July but also on the narrative form that he uses to represent those passions. The act of representation thus precedes and produces the phenomena that are represented, or it redefines how others have construed these phenomena.

Let me clarify this argument by focusing on the political representation of the passions. What is suggested by 15 July 1927 is that the state, as a framework for the protection of individual rights and liberties, exists in contradiction to the masses. Under peaceful social conditions, this contradiction assumes a state of equilibrium. As Étienne Balibar and Cornelius Castoriadis have emphasized, however, the contradiction remains at the heart of every political system because the state always constitutes and defines itself in opposition to "the people," or "the masses."[62] In this view, the latent or actual contradiction between the state and the people is the vestige of an originary structuring of the social field—that is, the institution of political power as such, or, the act of political representation whereby one person becomes the representative of others, thus instituting a distinction between representative and represented, between sovereign and people, government and subject, ruler and ruled.

When the discourse of mass psychology analyzes the crowd in relation to the leader, it pretends to represent an existing social reality. At a deeper level, however, mass psychology's *theoretical* representations merely repeat and confirm the originary execution of power—the act of politically representing the passions—which divides society into rulers and the ruled. In mass psychology, this division manifests itself precisely as a distinction between individuals and the masses.

Yet this division is never quite stabilized; it must always be managed, controlled, and reasserted through the rituals of power. The accounts of Canetti, Kraus, and Doderer demonstrate how, in times of crisis, the same division materializes in violent confrontations. Doderer and Kraus also disclose, though in opposite ways, the social and material factors that determine the manner in which the population is divided between the two poles of the rulers and the ruled. Those who consent to or collaborate with the ruling regime will be situated as individuals in relation to the ruling power. Those who resist or turn their backs on the ruling power, that is, those who are external to its hegemony, will be situated as the masses, a denomination that justifies whatever programs of education, persuasion, or domination the state finds appropriate in its effort to preserve and extend its hegemony.[63] The discourse of mass psychology has fulfilled a crucial role in this execution of power; it has served as a virtual guide to the art of government, a twentieth-century counterpart to Machiavelli's *The Prince,* advising leaders how to rule by channeling the passions of the crowd.

There were forty-eight dead there, among them a single woman. This woman was my wife. There I finally found her, there I found the terrible truth.

In the 1920s, a number of writers revised the view of the masses that had been disseminated by Taine, Tarde, Fournial, Sighele, and Le Bon. Two important

revisions were Freud's *Massenpsychologie und Ich-Analyse* and Canetti's *Masse und Macht* (begun in the early 1920s but not completed until 1960). Freud and Canetti dismissed Le Bon's general social theory but salvaged some of his insights, namely, the idea that individual identities are unimportant in the crowd. As both Freud and Canetti noted, however, the crowd does not just deprive the subject of individual identity but it also constitutes a situation in which the subject reenacts the formation of identity. In other words, the crowd presents a social situation in which the human subject reexperiences the entire course of socialization and individuation, sensing both what it is like to lose one's individuality by becoming part of the collective and what it is like to shape one's identity by adapting to, or deviating from, the norms and forms of the collective.

Freud saw the crowd as wholly mediated by a leader, a group ego that serves as the ego ideal of each person. Canetti, by contrast, argued that the crowd needs no leader since it is mediated by drives intrinsic to each human subject.[64] Canetti went on to argue that the crowd allows for a glimpse of society at the stage where human passions are not yet frozen into institutions or representatives—a stage where power does not yet exist, a society degree zero constituted by human subjects whose identities are momentarily suspended and rebuilt.[65] In this view, the masses do not signify a fall from social organization to disorder; rather, they signify an ongoing reorganization of social passions.

Freud's and Canetti's distinctive reconceptualizations of mass psychology share one fundamental presupposition. Neither construes the masses as a negation or antithesis of individual rationality: to the contrary, both posit that the mass embraces individual rationality as one of its manifestations. Thus, both embrace an epistemology in which the notion of individual rationality is no longer the basis for the production of interpretation and knowledge.

From the 1920s on, the discourse of crowd psychology therefore evolves along two distinct lines. One line, taking its cue from Freud, led to what may be termed *theories of ideology*. Figures such as Wilhelm Reich, Erich Fromm, Adorno, and Max Horkheimer sought to analyze and explain the passions and identifications that bind individuals together into a uniform, if sometimes irrational, historical subject.[66] Typically, their theories focused on the family as the origin of the imaginary identifications that make individuals submit to symbolic father figures. In this way, mass psychology came to address directly the politics of fascism, shedding light on its internal mechanisms in the hope of helping men and women escape its spell.

The other line leads in the opposite direction, to what may be termed *ideological theory*. Because this strain of mass psychology retained the epistemological basis that Le Bon had built on, it remained convinced of the irrationality of the crowd and, thus, of the need for strong leadership. The eventual direction of this kind of thinking, of course, is toward fascist theory, for fascism too develops a certain doxa about the masses as it seeks to explain and manipulate social passions.

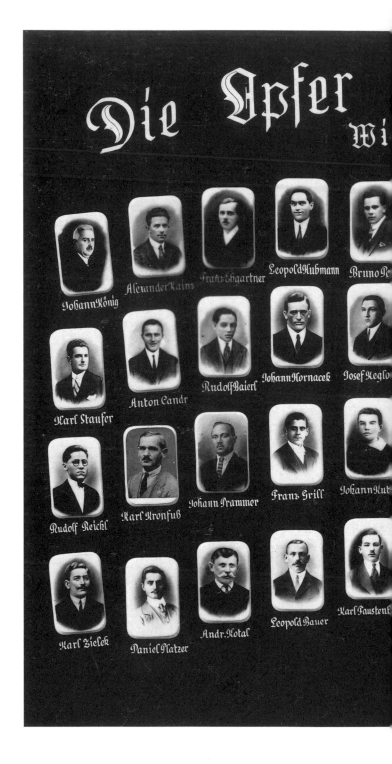

Fig. 6. Fotograf Wilhem Müller
Die Opfer der Schreckenstage, Wien 15. und
16. Juli 1927, 1927, postcard, 8.8 × 13.2
cm (3⁷⁄₁₆ × 5³⁄₁₆ in.)
Stockholm, private collection

As Klaus Theweleit has argued, while the politics of fascism seek to mobilize the masses, it is at the same time driven by a fear of the masses. This seeming paradox exists, Theweleit maintains, because fascism actually operates with two contradictory notions of the masses.[67] The mass that is mobilized is organized: its passions are represented completely by the leader, and all emotions are contained. It is an armored mass, drilled and disciplined, violently cut to shape in order to fit the representative units of the soldier, the army, the race, the nation, and *das Volk,* through which the leader exhibits his power. The mass that is held in contempt, by contrast, appears always with the attributes of the floating, the swampy, the swarming. It is a mass not yet disciplined and whose presence threatens to dissolve the units of the fascist hierarchy. It is the Jewish mass and the Gypsy mass, hysteric females and irremediable communists—all associated with miscegenation, transgression, and egalitarianism. Thus, fascism absolutizes Le Bon's distinction between the individual and the masses, transforming it into the rigid relation between *Führer* and *Volk,* the latter purged of all signs of difference. An avid reader of Le Bon, Joseph Goebbels explained the relationship between the two: "Leader and mass, that's no more of a problem than painter and paint. To form a mass into a people and the people into a state has always been the deepest meaning of true politics."[68]

Drawing on Deleuze and Guattari, Theweleit calls fascism a "molar" mobilization of the masses.[69] The goal of fascism is to purify passions, so that each subject is converted into a clean and uniform unit that can be assembled with other such units into larger entities—the result being the enormous blocks of bodies that parade endlessly before the party elite in Leni Riefenstahl's *Triumph des Willens* (1935). In contradistinction to this, Deleuze and Guattari suggest the idea of a "molecular" mass, characterized by an infinite multiplicity of plural agents whose heterogeneous flow of passions forms rhizomic webs that transgress all boundaries.[70]

Deleuze and Guattari's influential distinction between the molar and the molecular organization of society would thus correspond to the two extreme alternatives available for representing the passions. A molar politics is one where a single political agent represents all socially significant passions. A molecular politics is one where the passions are not represented at all. A society based on a molecular politics would be without political representation—there would be neither individuals nor masses, only singular human beings. Many political thinkers have defined utopia in exactly this way, describing a society that would follow the withering away of the state, as Karl Marx wrote, or, the disappearance of political representation, the end of power as such.

Then they started firing their guns into the City Hall, because a few people behind the gate had shouted "Pfui!"

96

At eight o'clock in the morning on 15 July 1927, the electricity workers switched off the gas and electricity. They interrupted not only public transportation and energy supplies but the whole machinery of communication and representation by which the Austrian government wielded its power. It was a spontaneous display of political passions. On this day, these passions did not recognize any representative. The initial signal was issued by the electricity workers, to be sure. But once set in motion, the demonstration had no leaders, no guiding slogans, not even any firm demands. There was only a passionate wish to turn the city into an arena in which the workers could enact their anger, disappointment, solidarity, and desire for justice. The demonstrators' actions short-circuited the institutionalized structure of political representation; consequently, the demonstration lacked unity and order, because unity and order can only be brought about by representing the passions in specific forms. Vienna's masses chose every form. Anger and self-interest easily blended with the passion for justice. Solidarity and gasoline entered the Justizpalast side by side. In brief, the events of 15 July were a realization of a molecular mass politics.

Singular human beings who use their own bodily presence to represent their own social passions are always the principal enemies of the state, writes Giorgio Agamben: whenever and wherever such manifestations take place, one may be sure that, sooner or later, "the tanks will appear."[71] From this angle, 15 July was also a realization of a molar mass politics, a rehearsal of the violent suppression of social passions that would soon be realized under fascism. The motivation of Vienna's authorities can be compared with the vision of the rightist militias who curbed workers' republics and uprisings all over Germany during the winter of 1918 and 1919. This force kept a strong presence throughout the interwar period in both Germany and Austria, contributing to the fall of the two young democratic republics. As Theweleit discusses, those warriors saw the restless proletariat as pure formlessness, in relation to which they construed their own masculine individuality. Here is how the writer Ernst von Salomon perceived the revolting masses: "the face of the mass, rolling sluggishly onward, prepared to suck anything that offered no resistance into its mucous whirlpool. I had no wish to succumb to the maelstrom. I stiffened and thought 'scoundrels' and 'rabble' and 'pack' and 'mob,' narrowed my eyes to scrutinize their mouldering, emaciated figures. Like rats, I thought, wearing the dirt of the gutter on their backs, scrabbling and grey with beady, red-rimmed eyes."[72] In 1918, as in 1927, the phantom face of the mass called for retaliation: "If the troops don't fire at precisely the right moment, if the troops lose their nerve, they are crushed and trampled within seconds. In this case, the troops did fire, the demonstration was broken apart."[73]

Of all the details registered in the eyewitness accounts of 15 July, the sounds of the day seem to have made the strongest impression. The noises record the emotions circulating within the social collective, tracing a curve from the molecular display of passions to the molar display of force. In the first hours of the morning, the disordered cacophony of the masses: "Pfui!

Booh! Shame!" After noon, the stunned silence of hundreds of thousands of people watching justice be reborn in the flames from the Justizpalast. Then, as evening drew near, the rifles' call to order: "This sound was like a sharp line, the snap of a lash."[74]

Notes

1. Baruch Spinoza, "Tractatus Politicus," in idem, *Sämtliche werke in sieben Bänden*, ed. Carl Gebhardt (Hamburg: Felix Meiner, 1977), 5:92.

2. Elias Canetti, *The Torch in My Ear*, trans. Joachim Neugroschel (New York: Farrar, Straus & Giroux, 1982), 252; for the original, see Elias Canetti, *Die Fackel im Ohr: Lebensgeschichte 1921–1931* (1980; Munich: Carl Hanser, 1993), 237.

3. My account of 15 July is based in part on archival sources at the Verein für Geschichte der Arbeiterbewegung in Vienna — which has preserved a wealth of newspapers, magazines, pamphlets, posters, Social Democratic party records, and photographic material — and in part on previous research: Rudolf Neck and Adam Wandruszka, eds., *Die Ereignisse des 15. Juli 1927: Protokoll des Symposiums in Wien am 15. Juni 1977* (Munich: R. Oldenbourg, 1979); Ludwig Jedlicka and Rudolf Neck, eds., *Österreich 1927 bis 1938: Protokoll des Symposiums in Wien, 23. bis 28. Oktober 1972* (Munich: R. Oldenbourg, 1973); Gerhard Botz, *Gewalt in der Politik: Attentate, Zusammenstösse, Putschversuche, Unruhen in Österreich 1918 bis 1938* (Munich: Wilhelm Fink, 1983); Anson Rabinbach, *The Crisis of Austrian Socialism: From Red Vienna to Civil War, 1927–1934* (Chicago: Univ. of Chicago Press, 1983); Ernst Fischer, *Erinnerungen und Reflexionen* (Reinbek bei Hamburg: Rowohlt, 1969); Robert Danneberg, *Die Wahrheit über die "Polizeiaktion" am 15. Juli* (Vienna: Wiener Volksbuchhandlung, 1927); Hellmut Andics, *Österreich 1804–1975: Österreichische Geschichte von der Gründung des Kaiserstaates bis zur Gegenwart in vier Bänden*, vol. 3, *Der Staat, den keiner wollte: Österreich von der Gründung der Republik bis zur Moskauer Deklaration* (Vienna: Molden-Taschenbuch-Verlag, 1976); Ernst Hanisch, *1890–1990: Der lange Schatten des Staates: Österreichische Gesellschaftsgeschichte im 20. Jahrhundert* (Vienna: Überreuter, 1998); and Gerald Stieg, *Frucht des Feuers: Canetti, Doderer, Kraus und der Justizpalastbrand* (Vienna: Falter im ÖBV, 1990).

4. Friedrich Austerlitz, "Die Arbeitermörder freigesprochen: Der Bluttag von Schattendorf ungesühnt," *Arbeiter-Zeitung*, 15 July 1927, 1.

5. Otto Bauer, quoted in Karl Kraus, ed., "Der Hort der Republik," *Die Fackel* 29, nos. 766–70 (1927): 2. This and all subsequent translations from *Die Fackel* are mine.

6. Gerhard Botz, "Der '15. Juli 1927,' seine Ursachen und Folgen," in *Österreich 1927 bis 1938: Protokoll des Symposiums in Wien, 23. bis 28. Oktober 1972* (Munich: R. Oldenbourg, 1973), 141–60.

7. Quoted in Botz, *Gewalt in der Politik* (note 3), 151.

8. See Kraus, "Der Hort" (note 5), 30–38.

9. See Kraus, "Der Hort" (note 5), 40.

10. This and the following vignettes are from the montage of eyewitness accounts and reports that Karl Kraus collected and published in the October 1927 issue entitled "Der Hort der Republik," of *Die Fackel*; see Kraus, "Der Hort" (note 5), 1–48.

11. Canetti, *The Torch in My Ear* (note 2), 245 = Canetti, *Die Fackel im Ohr* (note 2), 231.

12. See Stieg, *Frucht des Feuers* (note 3). The present essay covers some of the same ground as Stieg's excellent book. Stieg's objective, however, is to trace the repercussions of the event in Austria's literature. My objective is to contrast representations of the event with the more general discourse of mass psychology. For this reason, Stieg's conclusions concerning Kraus and Doderer are rather different from mine.

13. On the origins of mass psychology, see Susanna Barrows, *Distorting Mirrors: Visions of the Crowd in Late Nineteenth-Century France* (New Haven: Yale Univ. Press, 1981); and Robert A. Nye, *The Origins of Crowd Psychology: Gustave Le Bon and the Crisis of Mass Democracy in the Third Republic* (London: Sage, 1975).

14. See Hasso Hofmann, *Repräsentation: Studien zur Wort- und Begriffsgeschichte von der Antike bis ins 19. Jahrhundert* (Berlin: Duncker & Humblot, 1974), 15–37, 406–62.

15. My argument about the effects of, and relations between, theoretical, political, and economic representations of society draws on the rich theoretical exchange on the relation of politics and ideology — the former being a matter of representation in the sense of *Vertretung*, the latter a matter of representation in the sense of *Darstellung* — that departs from Marx's *The Eighteenth Brumaire of Louis Bonaparte* and Lukács's *History and Class Consciousness*. For recent contributions to this discussion, see Gayatri Chakravorty Spivak, "Can the Subaltern Speak?" in Cary Nelson and Lawrence Grossberg, eds., *Marxism and the Interpretation of Culture* (Urbana: Univ. of Illinois Press, 1988), 271–313; Jacques Derrida, *Spectres of Marx: The State of the Debt, the Work of Mourning, and the New International*, trans. Peggy Kamuf (New York: Routledge, 1994); and Étienne Balibar, *Masses, Classes, Ideas: Studies on Politics and Philosophy Before and After Marx*, trans. James Swenson (New York: Routledge, 1994), 87–149.

16. See the contributions in Ulrich Beck, ed., *Perspektiven der Weltgesellschaft* (Frankfurt: Suhrkamp, 1998). For a comprehensive analysis, see Manuel Castells, *The Power of Identity* (Oxford: Blackwell, 1997), 243–353; and Manuel Castells, *End of Millennium* (Oxford: Blackwell, 1998), 206–354.

17. See Jean L. Cohen and Andrew Arato, *Civil Society and Political Theory* (Cambridge: MIT Press, 1992); Robert D. Putnam, with Robert Leonardi and Raffaella Nanetti, *Making Democracy Work. Civic Traditions in Modern Italy* (Princeton: Princeton Univ. Press, 1993); and Amitai Etzioni, *The Spirit of Community: Rights, Responsibilities, and the Communitarian Agenda* (New York: Crown, 1993).

18. Gilles Deleuze and Félix Guattari, *Anti-Oedipus: Capitalism and Schizophrenia*, trans. Robert Hurley, Helen R. Lane, and Mark Seem (New York: Viking, 1977); Martha C. Nussbaum, *Love's Knowledge: Essays on Philosophy and Literature* (New York: Oxford Univ. Press, 1990); Terence Irwin and Martha C. Nussbaum, eds., *Virtue, Love, and Form: Essays in Memory of Gregory Vlastos* (Edmonton: Academic Printing & Publishing, 1994). On communitarian virtues and passions, see Amitai Etzioni, ed., *The Essential Communitarian Reader* (Lanham, Md.: Rowman & Littlefield, 1998); and Francis Fukuyama, *Trust: Social Virtues and the Creation of Prosperity* (New York: Free Press, 1995). On ethnonationalist passions, see Slavoj Zizek, *For They Know Not What They Do: Enjoyment as a Political Factor* (London:

Verso, 1991); Stanley J. Tambiah, *Leveling Crowds: Ethnonationalist Conflicts and Collective Violence in South Asia* (Berkeley: Univ. of California Press, 1996); and Martin Riesebrodt, *Pious Passion: The Emergence of Modern Fundamentalism in the United States and Iran,* trans. Don Reneau (Berkeley: Univ. of California Press, 1993). Peter Sloterdijk's recent work is entitled *Die Verachtung der Massen: Versuch über Kulturkämpfe in der modernen Gesellschaft* (Frankfurt: Suhrkamp, 2000).

19. Serge Moscovici, *The Invention of Society: Psychological Explanations for Social Phenomena,* trans. W. D. Halls (Cambridge: Polity, 1993), 20–21. First published in French as *La machine à faire des dieux* (Paris: Librairie Arthème Fayard, 1988).

20. Gustave Le Bon, *The Crowd: A Study of the Popular Mind,* 2d ed. (Dunwoody, Ga.: N. S. Berg, 1968; reprint, Atlanta: Cherokee, 1982), 12. First published in French as *La psychologie des foules* (Paris: Félix Alcan, 1895).

21. Le Bon, *The Crowd* (note 20), 5.

22. See Gabriel Tarde, *Les lois de l'imitation* (Paris: Félix Alcan, 1890).

23. Pierre Chanlaine, *Les horizons de la science: Entretiens avec les notabilités du monde politique, religieux et scientifique* (Paris: E. Flammarion, 1928), 17; quoted in Nye, *The Origins of Crowd Psychology* (note 13), 178. On the influence of Le Bon's book on Hitler's *Mein Kampf,* see Alfred Stein, "Adolf Hitler und Gustave Le Bon," *Geschichte in Wissenschaft und Unterricht* 6 (1955): 362–68.

24. This ambiguity is discussed in depth by Serge Moscovici, *The Age of the Crowd: A Historical Treatise on Mass Psychology,* trans. J. C. Whitehouse (Cambridge: Cambridge Univ. Press, 1985), 24–45.

25. See George Rudé, *The Crowd in History: A Study of Popular Disturbances in France and England, 1730–1848,* rev. ed. (London: Serif, 1995), 3–16, 195–213.

26. See Botz, *Gewalt in der Politik* (note 3), 143. See also Gerhard Botz, "Die 'Juli-Demonstranten,' ihre Motive und die quantifizierbaren Ursachen des '15. Juli 1927,'" in Rudolf Neck and Adam Wandruszka, eds., *Die Ereignisse des 15. Juli 1927: Protokoll des Symposiums in Wien am 15. Juni 1977,* Wissenschaftliche Kommission des Theodor-Körner-Stiftungsfonds und des Leopold-Kunschak-Preises zur Erforschung der österreichischen Geschichte der Jahre 1918 bis 1938, vol. 5 (Munich: R. Oldenbourg, 1979), 29.

27. See Fischer, *Erinnerungen und Reflexionen* (note 3), 162–64; and Botz, *Gewalt in der Politik* (note 3), 142–43.

28. Frank Field, *The Last Days of Mankind: Karl Kraus and His Vienna* (New York: St. Martin's, 1967), 139.

29. See Stefan Jonsson, *Subject without Nation: Robert Musil and the History of Modern Identity* (Durham: Duke Univ. Press, 2000), chap. 5.

30. See Andics, *Österreich 1804–1975* (note 3), 3:122–24.

31. Elias Canetti, *Crowds and Power,* trans. Carol Stewart (New York: Farrar, Straus & Giroux, 1984), 16; for the original, see Elias Canetti, *Masse und Macht,* in idem, *Werke* (Munich: Carl Hanser, 1980), 15.

32. Canetti, *The Torch in My Ear* (note 2), 245 = Canetti, *Die Fackel im Ohr* (note 2), 231.

33. Canetti, *The Torch in My Ear* (note 2), 123 = Canetti, *Die Fackel im Ohr* (note 2), 119.

34. Canetti, *The Torch in My Ear* (note 2), 148–49 = Canetti, *Die Fackel im Ohr* (note 2), 143–44.

35. Canetti, *The Torch in My Ear* (note 2), 142 = Canetti, *Die Fackel im Ohr* (note 2), 136–37.

36. Canetti, *The Torch in My Ear* (note 2), 149 (translation modified) = Canetti, *Die Fackel im Ohr* (note 2), 144.

37. Le Bon, *The Crowd* (note 20), v.

38. See René Descartes, *Les passions de l'âme* (1649; Paris: Librairie Générale Française, 1990), 57–74.

39. Institut für Sozialforschung (Frankfurt am Main), *Aspects of Sociology*, trans. John Viertel (London: Heinemann Educational, 1973), 73.

40. Kraus, "Der Hort" (note 5), 52.

41. Kraus, "Der Hort" (note 5), 62. Naderer was a conservative journalist.

42. See Hans Weigel, *Karl Kraus, oder die Macht der Ohnmacht* (Vienna: Fritz Molden, 1968), 271–94.

43. Canetti, *The Torch in My Ear* (note 2), 246 = Canetti, *Die Fackel im Ohr* (note 2), 232.

44. Kraus, "Der Hort" (note 5), 70.

45. See Stieg, *Frucht des Feuers* (note 3), 102.

46. Kraus, "Der Hort" (note 5), 69.

47. Heimito von Doderer, *The Demons*, trans. Richard and Clara Winston (New York: Alfred A. Knopf, 1961), 1311; for the original, see Heimito von Doderer, *Die Dämonen: Roman: Nach der Chronik des Sektionsrates Geyrenhoff* (Munich: Biederstein, 1956), 1328.

48. Doderer, *The Demons* (note 47), 492 = Doderer, *Die Dämonen* (note 47), 486.

49. Doderer, *The Demons* (note 47), 672, 582–83 = Doderer, *Die Dämonen* (note 47), 658, 572.

50. Doderer, *The Demons* (note 47), 601 = Doderer, *Die Dämonen* (note 47), 590.

51. Doderer, *The Demons* (note 47), 1212–13 = Doderer, *Die Dämonen* (note 47), 1224–27.

52. Doderer, *The Demons* (note 47), 1262 = Doderer, *Die Dämonen* (note 47), 1270.

53. Doderer, *The Demons* (note 47), 1307, 1249 = Doderer, *Die Dämonen* (note 47), 1323, 1264.

54. Doderer, *The Demons* (note 47), 1237 = Doderer, *Die Dämonen* (note 47), 1252.

55. See Elizabeth C. Hesson, *Twentieth-Century Odyssey: A Study of Heimito von Doderer's* Die Dämonen (Columbia, S.C.: Camden House, 1982), 20–53.

56. Doderer, *The Demons* (note 47), 6 = Doderer, *Die Dämonen* (note 47), 9.

57. Doderer, *The Demons* (note 47), 637 = Doderer, *Die Dämonen* (note 47), 624.

58. See Claudio Magris, *Der habsburgische Mythos in der österreichischen Literatur*, trans. Madeleine von Pásztory (Salzburg: Otto Müller, 1966), 299–304.

59. Elias Canetti, *Auto-da-fé,* trans. C. V. Wedgwood (New York: Farrar, Straus & Giroux, 1984), 411 (translation modified); for the original, see Elias Canetti, *Die Blendung* (1935; Munich: Carl Hanser, 1992), 449.

60. Canetti, *Auto-da-fé* (note 59), 411 = Canetti, *Die Blendung* (note 59), 449.

61. Bertolt Brecht, "[Notizen über] Individuum und Masse," in idem, *Gesammelte Werke*, ed. Elisabeth Hauptmann (Frankfurt: Suhrkamp, 1967), 20:60.

62. See Étienne Balibar, *Masses, Classes, Ideas* (note 15), 3–37. Cornelius Castoriadis describes the relation of state and people as follows: "The state is an entity separated from the collectivity and instituted in such a manner as to secure the permanence of that separation"; see Cornelius Castoriadis, "Pouvoir, politique, autonomie," in idem, *Le monde morcelé* (Paris: Éditions du Seuil, 1990), 124.

63. On this point, see Ranajit Guha, *Dominance without Hegemony: History and Power in Colonial India* (Cambridge: Harvard Univ. Press, 1997), 1–125.

64. For Canetti's views on Freud, see his interview of Adorno in *Die gespaltene Zukunft: Aufsätze und Gespräche* (Munich: Carl Hanser, 1972), 66–92.

65. Canetti, *Crowds and Power* (note 31), 15–90.

66. Some important works are Wilhelm Reich, *Massenpsychologie des Faschismus: Zur Sexualökonomie der politischen Reaktion und zur proletarischen Sexualpolitik* (Copenhagen: Verlag für Sexualpolitik, 1933), translated by Vincent R. Carfagno as *The Mass Psychology of Fascism* (New York: Farrar, Straus & Giroux, 1970); Erich Fromm, "Autorität und Familie: Sozialpsychologischer Teil," in Max Horkheimer, ed., *Studien über Autorität und Familie* (Paris: Félix Alcan, 1936), 77–135; and Max Horkheimer and Theodor Adorno, *Dialektik der Aufklärung: Philosophische Fragmente* [1947], in Max Horkheimer, *Dialektik der Aufklärung und Schriften, 1940–1950*, ed. Gunzelin Schmid Noerr, vol. 5 of idem, *Gesammelte Schriften*, eds. Alfred Schmidt and Gunzelin Schmid Noerr (Frankfurt: Fischer, 1987), translated by John Cumming as *Dialectic of Enlightenment* (London: Verso, 1979).

67. See Klaus Theweleit, *Male Fantasies*, vol. 2, *Male Bodies: Psychoanalyzing the White Terror,* trans. Stephan Conway, Erica Carter, and Chris Turner (Minneapolis: Univ. of Minnesota Press, 1989), 3–4. First published in German as *Männerphantasien*, vol. 2, *Männerkörper: Zur psychoanalyse des weißen Terrors* (Frankfurt am Main: Roter Stern, 1978).

68. Joseph Goebbels, *Michael: Ein deutsches Schicksal in Tagebuchblättern* (Munich: F. Eher, 1929), 21; quoted in Theweleit, *Male Fantasies* (note 67), 2:94 (translation modified).

69. See Theweleit, *Male Fantasies* (note 67), 2:75–76.

70. Deleuze and Guattari, *Anti-Oedipus* (note 18), 340–41.

71. Giorgio Agamben, *The Coming Community,* trans. Michael Hardt (Minneapolis: Univ. of Minnesota Press, 1993), 86.

72. Ernst von Salomon, "Die Geächteten," in Ernst Jünger, ed., *Der Kampf um das Reich* (Essen: Deutsche Vertriebsstelle "Rhein und Ruhr," 1930), 10; quoted in Theweleit, *Male Fantasies* (note 67), 2:4 (translation modified).

73. Ernst von Salomon, "Hexenkessel Deutschland," in Ernst Jünger, ed., *Der Kampf um das Reich* (Essen: Deutsche Vertriebsstelle "Rhein und Ruhr," 1930), 19; quoted in Theweleit, *Male Fantasies* (note 67), 2:33.

74. Doderer, *The Demons* (note 47), 1274 = Doderer, *Die Dämonen* (note 47), 1291.

Observations on the
Natural History of the Web
Horst Bredekamp

Programming of Vision

Since 1993, when the first graphical Web browser made it a commonplace to send and receive digital images, the fantastic growth of the Internet as a medium of information exchange, amusement, and advertising has been accompanied by an iconization of knowledge that is tantamount to a kind of programming of vision.[1] The World Wide Web is now a colossal machine for the transmission of images; as such, it ideally serves the purposes of art history. Certainly, few other disciplines in the humanities are so well represented on the Web. Increasingly, the contents of numerous museums and archives are finding their way onto the Web, often in images of astonishing technical quality.[2] The question of whether the Internet can be a tool of art history now has its answer. However, another question remains: Should the Internet also be an object of art historical study?

In its modern form, starting with the works of Alois Riegl (1858–1905) and Aby Warburg (1866–1929), if not before that, art history has encompassed the widest possible range of subject matter; as a result, the record of the discipline of art history as a science of images lends credence to the belief that old and new media can shed light on each other. The reach of art history seems all the more expansive now that such alternative disciplines as semiotics, visual studies, and film studies — for all their successes in the analysis of visual information — have proved so oddly inconclusive. With some exceptions, these disciplines appear unresponsive to the long-term continuity of the history of form, its ability to outlast even the worldly and artistic crises of the twentieth century.

From Mother Nature to Father State

The Internet is a topic of choice for art history, not only because it serves as a storage and transit system for images but also because it yields a new answer to a question that was first raised in antiquity: Given the imperfection of all earthly things, is it for nature to create a new human race, or for the human race to create a new nature? At the risk of a disconcerting shift into narrative overdrive, the contours of this double-edged question shall be traced from the Middle Ages onward. One of the earliest anthropomorphic images of nature appears in a mid-thirteenth-century illuminated manuscript of Alain de Lille's allegorical poem, *Anticlaudian* (1181–83). An angry and sorrowful goddess,

Fig. 1. Natura with the head of the new man
From Alain de Lille, *Anticlaudian*, 1300s, Codice CCLI, fol. 4r
Verona, Biblioteca Capitolare

Fig. 2. Philips Galle (Dutch, 1537–1612), after Maarten van Heemskerck (Dutch, 1498–1574)
The Reward of Labor and Diligence: Man Born to Toil, 1572, engraving, 21.1 × 24.9 cm (8¼ × 9¾ in.)
New York, Metropolitan Museum of Art

Fig. 3. Matthäus Merian (Swiss, 1593–1650)
Integrae Naturae Speculum Artisque Imago
From Robert Fludd, *Utriusque Cosmi Maioris Scilicet et Minoris Metaphysica,
Physica atque Technica Historia*, vol. 1 (Oppenheim, Germany: Aere Johan-
Theodori de Bry, Typis Hieronymi Galleri, 1617), 4–5

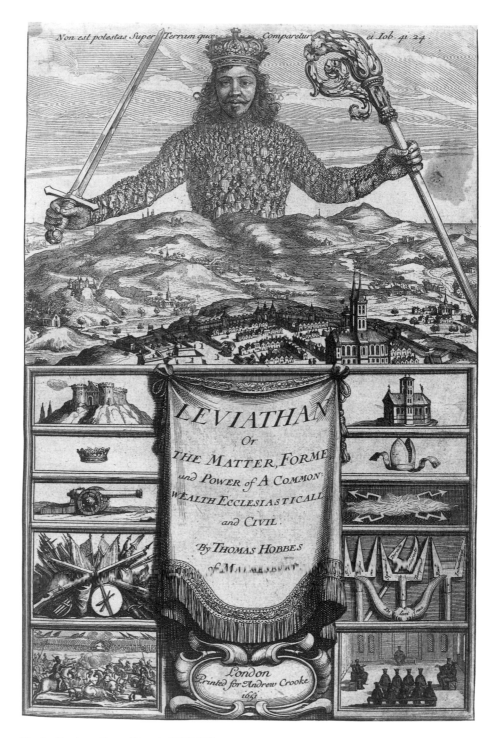

Fig. 4. Abraham Bosse (French, 1602–76)
Leviathan
From Thomas Hobbes, *Leviathan; or, The Matter, Forme and Power of a Commonwealth Ecclesiasticall and Civil* (London: Andrew Crooke, 1651), title page

Natura, threatens to turn her back on the human race, to create a new species, *homo novus et perfectus*. She poses with the head of this new being, who will be both god and man (fig. 1).[3]

The wrath of Natura remained a potent image until the Renaissance, when it was superseded by images of a bountiful earth and a maternal nature. A holistic notion of concordance between man and nature put an end to the goddess's denunciation of man; it now appeared that Natura freely offered man the means of transforming natural evolution into technological progress.[4] In an engraving by Philips Galle from 1572, after a drawing by Maarten van Heemskerck, Natura lactans appears together with a cosmos, hanging aloft, to which are attached the appliances of technology (fig. 2).[5] While the cosmos floats at a distance from the earth, many-breasted Natura appears as the giver of technology—and thus of the means of her own subjugation.[6]

Nearly half a century later, in 1617, Matthäus Merian's image of the cosmos shows the artificial product of this naturalized technology. Natura holds a chain, at the end of which is an ape, representing human art; the ape marks off a diminutive globe with dividers, in a gesture inherited from the outworn imagery of God as the Supreme Architect (fig. 3).[7]

The significance of this image of a new cosmic order must not be underestimated. It is more than likely that Thomas Hobbes, the founder of modern political theory, was familiar with Merian's engraving. In his *Leviathan* (1651), Hobbes wrote of the long succession of human actions as "a continuall chain, (whose first link is in the hand of God...)," a reference to Merian's literal chain of the ape, Natura, and the hand from the clouds.[8] And in his account of the natural bounty of the earth, Hobbes makes an obvious allusion to Merian's iconography of Natura: "As for the Plenty of Matter," Hobbes wrote, it is dispensed "from (the two breasts of our common Mother) Land, and Sea."[9]

In Hobbes's view, nature had committed the signal error of giving birth to man as a wolf. Where de Lille had assigned to Natura the task of creating a new species, Hobbes, who lived in an age of technological optimism, now assigned the same task to man himself. It was for man to produce a new artificial being who would transcend the bounds of organic life and embody the living divine image of a mortal god—this was "that great LEVIATHAN called a COMMONWEALTH, or STATE" (fig. 4).[10] In the ongoing question of whether nature must create a new humanity, or humanity a new nature, Hobbes thus introduced an intermediate scenario, in which nature made use of man to create a tremendous being who would cast off the likeness of the wolf.

Networking Leviathan

Modern conceptions of the state continue to be nourished by Hobbes's. As one writer recently observed, "Constitutional theory has been as preoccupied with the mystery of Leviathan as art history with that of *Mona Lisa*."[11] Currently, in the wake of globalization, there are competing prophecies of the demise of the state and of its revitalization.[12] Both schools of thought look to

the Internet for support of their claims. For George Dyson, whose *Darwin among the Machines* (1997) — like its namesake, Samuel Butler's essay of 1863 — examines the relationship between man and technology, the Web constitutes the first real and material incarnation of Leviathan.[13] Dyson points, with some justification, to the first paragraph of Hobbes's work, in which this artificial giant is described as a rational, biomechanical organism of communication.[14] Yet, as many have done, it can be asserted with equal justification that the Internet marks the end of Leviathan, and thus the demise of the state.

One way to understand these contradictory notions about the Internet is through its material makeup. Leviathan stands erect, a compact visual metaphor of the revitalized state. The Internet, by contrast, sprawls laterally, in a distributed state — yet since it is largely coextensive with the supply of electric current, an image of the world at night gives form to its outline (fig. 5).[15]

It is well known by now that the Internet started life as a survival stratagem. The first computer network was devised in the late 1960s by the Advanced Research Projects Agency (ARPA), an agency that had been formed by the Department of Defense in the wake of the shock of the first Sputnik satellite. ARPANET, as the network was called, was seen as a means of securing the continued viability of command structures in the event of an ICBM strike by the Soviets.[16] A hierarchic, branching system could have been taken out by strikes directed at its centers. The flexible connections of a web, however, would continue to function even when parts of it were ruptured. Ironically, the Pentagon thus played a central role in the genesis of the quasi-anarchistic communications system that is the Internet.[17] A further irony is that, now that the Internet is open to the world, it shows no respect for the frontiers of the state. Despite all assertions to the contrary, the Internet cannot effectively be supervised.

The means devised for the defense of the state are thus transforming themselves into a medium of its radical subversion; the most telling signs of this phenomenon are to be found in the political propaganda and pornography that are ubiquitous on the Web. In the mid-1990s, early censorship attempts stimulated lively debate, but when it dawned on the participants that they were being manipulated by the Christian Right in the United States, the debate largely died down. In a Cassandra-like fashion, advocates of total freedom of speech tend to regard the obsessive focus on political propaganda and pornography as counterproductive.[18] It is therefore worth emphasizing that what follows is not a plea for censorship but rather an acknowledgment of the fact that censorship on the Internet is a practical impossibility.[19]

Logically enough, the tolerant Internet transmits some opinions that are the very opposite of tolerant. The best-known example of this, the Web site of the German-Canadian neo-Nazi Ernst Zündel hails from the early days of the Web. The Zündel site gives currency to the revisionist dogma that the Holocaust was a Zionist horror tale. While Zündel was being prosecuted in Canada in 1998 for spreading hatred on the Internet, his site was hosted by Radio Islam, through which it could be visited from anywhere in the world.

Fig. 5. George V. Kelvin
The impact of human beings on the earth, as seen at night by satellite
Painting for the cover of *Scientific American*, September 1989 (special issue, "Managing Planet Earth")

The Zündel site's German counterpart, Thule-Netz, systematically encodes all incoming emails, so that communications remain secret even if they are monitored. Thule-Netz contains links to other neo-Nazi sites, including one to a site called Stormfront (fig. 6), which offers downloads of all the National Socialist insignia (illegal in Germany), along with other material that is illegal in many countries. Of course, even when it is illegal, this material is widely available in books and pamphlets; but—at least theoretically—in printed form, there is a chance that it will be found and seized. On the global Internet, however, even this theoretical possibility does not exist.

The other area of the Internet that has disturbing implications for the domain of jurisprudence is pornography. The most extensive study to date, carried out in 1995, concluded that more than 80 percent of all images on the Internet could be described as pornographic.[20] This figure has been questioned, with some reason,[21] but even a considerably lower percentage would not minimize the theoretical issues raised by the homepages of just two sites.

The first, Bizarre and Ultimate Perversion, has a disarming, tongue-in-cheek warning screen.[22] Its homepage shows a Luca Signorelli-like image of figures from hell (fig. 7), the message of which soon wipes the smile off the visitor's face. So unendurable are the images on this sector of the Internet that police investigators who work with them frequently need psychological counseling.

At the time of the writing of this essay, in spring 1999, the second site was accessed by entering "Catholic guilt" in the search window on the Yahoo! search engine (fig. 8). On German television, after eleven at night, this site would hardly raise an eyebrow, but in other countries—and certainly in the United States—it would not be permitted on any public channel at any time. However, presumably thousands of visitors to Yahoo! had clicked on this site, because there it was, two clicks away from the search window. The grounds for this apparent inconsistency lie in the distinction between things shown on public television, which are there for all to see, and things shown on the Internet, which are there for the individual to choose to see. Any intervention, any hint of censorship (even supposing such a thing were possible), would be construed—and consequently condemned—not as an attack on a mass medium but as an attack on individual freedom of choice.

Theoretically, the Internet is the individual's to use, as he or she wishes, and this is precisely why every debate on censorship to date has petered out. It is for the privately owned search engines, if for anyone, to filter out undesirable images. In 1997, a Supreme Court decision forbade any censorship on the Internet, at least in the United States.[23] The Court's concession to the pro-censorship camp was to oblige tens of thousands of pornography providers to ask visitors for their credit card numbers—the (faulty) logic being that only adults have credit cards. The Internet thus became an engine of addiction, in which money is siphoned off in return for direct access to the user's id. It is one of the mysteries of contemporary psychoanalysis that it has yet seen fit to exploit the Internet as a primary source of raw material: the Web is surely the most comprehensive and protean repository of the images of taboo desires.

Fig. 6. <u>National Socialist graphics</u> page from Stormfront Web site
From http://www.stormfront.org/gns.html (March 1999)

Fig. 7. Homepage for Bizarre and Ultimate Perversion Web site
From http://www.perversion.net/home.html (March 1999)

Fig. 8. Catholic Guilt's modified Japanese wooden pony
From http://www.dungeonslave.com/samples/index.html (March 1999)

It may be the mark of an enlightened society to be broadly tolerant of pornography, and, to be sure, on the Internet there are currently quantities of well-nigh unimaginable images that would be subject to criminal penalties were they to appear anywhere else. Yet the mechanisms that govern the Internet are different from those that govern political action and political symbolism, and it is this very disparity that makes the Internet so invaluable. The forbidden images of the Internet give us occasion to reflect on issues of governance on a cosmic scale. And while there is no immediate prospect of formulating any cosmic theory, one aspect of the immense value of Internet images — in all their cruelty and dangerousness — is that they will impinge on any such theory when it comes.[24] Internet imagery artificially creates the condition of life that de Lille's new and perfect man and Hobbes's Leviathan were intended to counter. The World Wide Web creates a new nature, which, through the power of its technological and economic expansion, revives the dream of a life divorced from the state.[25]

Artificial Nature

It is indeed ironic that the Internet feeds the old hope of creating a second nature. What is at work here is a tendency that has been characteristic of the computer ever since it acquired its first graphic interface, namely, the tendency to equate image and reality. On the assumption that nature would ascend to a higher plane were it to become pure image, countless users are deserting the passivity of television for the interactivity of the Internet. In this migration, a number of artists operate as recruiters.

To create an alternative nature in the world of images, one must first generate thousands of species. The English artist Jane Prophet does this through the agency of visitors to her TechnoSphere site, a three-dimensional world populated by artificial life-forms (fig. 9).[26] TechnoSphere allows participants "to create their own creatures and to observe their development and eventual death. Through the World Wide Web interface, new life-forms can be created and recorded on the system, and data concerning these life-forms can be retrieved."[27] In a mountainous landscape, herbivores and carnivores meet; new participants add new species to both categories; and the resulting creatures reproduce spontaneously, handing down their creators' names to their progeny. TechnoSphere has some one hundred thousand participants around the world, of whom some forty thousand make approximately seven hundred and fifty thousand interventions within an average ten-day period.

This enthusiasm might be a sign of a growing infantilism, but the Techno-Sphere experience is altogether too technoid to be dismissed entirely as a variant of the cuddly-toy fixation. The TechnoSphere creatures possess neuronal networks of up to one thousand nodes, and they are seemingly capable of learning; they may develop either into good guys, the Norns, who can then be traded and used for breeding, or into bad guys, the Grendels, who can of course also be traded.

In most of these artificial worlds, an inexorable Darwinism rules. Internecine

Fig. 9. Jane Prophet (English, b. 1964) and Gordon Selley (English, b. 1964)
Inside TechnoSphere: No. 4, 1997, Internet art
From http://www.technosphere.org.uk/pic4.htm (March 1999)

Fig. 10. Bruce Damer (American, b. 1962)
Nerve Garden I: Plant Models Generated by the Germinator, 1997, Internet art
From http://www.biota.org/papers/ngalife.htm (March 1999)

battles are part of the charm of Internet worlds, both those set in nature and in city domains. In AlphaWorld, the first collaborative world on the Web, your avatar, or digital alter ego, will be murdered unless you hire a bodyguard. There are now real-life individuals who offer, for a fee, to keep your digital bodyguards alive, so that the virtual you can survive while the real you sleeps.

According to one's viewpoint, these technological life-forms (fig. 10)[28] can be seen as cold compensation for the extinction of the species; or as subtle feelers sent out by power companies, with the ultimate aim of making the user dependent on a world of electronic illusion; or as a fulfillment of neobaroque desires of a life beyond the dusty *vanitas* of material existence; or, finally, as a logical consequence of what Hans Belting has described as contemporary art's "de-framing."[29] Presumably, there is some truth in all of these. The Internet reflects the human face in a multitude of ways.

Net Art

There are numerous artists and groups of artists who take these reflections as their subjects, seeking to cast light on them, either through distortion or intensification.[30] For instance, there are crash sites, such as jodi.org, which simulate catastrophic system crashes without doing any real damage.[31] Ironic paths to concrete poetry and designer semiotics may be pursued at sites such as Äbsurd Örg, which extends sign play into a kinetic form in which monstrous forms gorge and disgorge icons (fig. 11).[32]

Finally, there are the aspects of image-use that we set out to trace in the first place: the artistic creation of a new man, a new state, and a new nature. The NSDAP Web site is devoted to an ironic form of anarchism (fig. 12). The initials stand, in this instance, for the New School of Design, Art, and Performance.[33] NSDAP campaigns for total censorship of the Internet on the grounds that worldwide freedom of information is the work of a "telecommunist conspiracy," which, like all liberation movements, will ultimately lead to totalitarianism. What they propose instead is an anti-imperialist Museum of Freedom, the "Wilhelm Reichstag," with a Wilhelm Reich Stadium that will hold 350,000 people.

The artist Ingo Günther, based in Cologne and New York, has developed a countermovement. He imagines the inauguration of a new state, the Refugee Republic, to be made up of all the world's refugees and displaced persons (fig. 13).[34] Administered through the Web, the Refugee Republic would be one of the earth's largest nations. Perhaps never has the problem of the future of Leviathan been more clearly stated than in this conceptual art project.

By contrast, Christa Sommerer and Laurent Mignonneau—like Jane Prophet and other artists—create digital worlds set in nature. Their *Life Spacies* may be regarded as an experiment in replicating an active state of nature. *Life Spacies* "enables visitors to integrate themselves into a three-dimensional complex virtual world of artificial life organisms that react to the visitors' body movement, motion and gestures. The artificial life creatures

Fig. 11. Cörê?mêlt page from Äbsurd Örg Web site
From http://www.absurd.org/(((((((/clxkemall/f2.html (March 1999)

Fig. 12. Dada Vin©i
Wilhelm Reich Memorial: Anti-Imperialist Peace Museum, 1995, Internet art
From http://www.agit.com/imagine/ars/index.html (March 1999)

Fig. 13. Ingo Günther (German, b. 1957)
Refugee Republic Insignia, 1993, Internet art
From http://www.refugee.net/products.html (March 1999)

Fig. 14. Christa Sommerer (Austrian, b. 1964) and Laurent Mignonneau (French, b. 1967)
Life Spacies: Christa Sommerer Interacting with the Creatures, 1997, Internet art
From http://www.ntticc.or.jp/~lifespacies/link5.html (March 1999)

also communicate with each other and so create an artificial universe, where real and artificial life are closely interrelated through interaction and exchange" (fig. 14).[35] Surrounded by her creatures, Sommerer turns into a latter-day version of de Lille's Natura (see fig. 1).

Do any of these efforts, however, satisfy the definition of *art* as a semantic transgression of factual form? This question cannot as yet be answered in the affirmative, but neither can it be answered in the negative.[36] Take, for example, the thirteenth-century figure of Natura: it is of questionable artistic value, but its art historical value is of the greatest importance.

The verdict hangs in the balance. By now it should be clear which passions have driven the *iconic turn,* a move created in the thin light of our longings for a state of nature that would transcend both the political state and the constraints of nature itself. Insofar as such longings express themselves through images, they bear on the theoretical question of whether man imitates created nature (*natura naturata*) or man is the creative force itself (*natura naturans*). The discipline of art history may be used to remind us of the longevity of the central issues involved and also to allow us to judge more dispassionately the disparate passions that fuel and occupy the Internet. And you would be wise, dear reader, to apply this detachment to the activities of the Internet-struck art historian as well.

Notes

This essay was composed in spring 1999. At that time, all the references to Internet sites and statistics were accurate. Subsequently, some of the sites have changed, relocated, or ceased to exist — many of these sites, however, can be found as they were in spring 1999 on archive sites such as http://www.archive.org.

1. For a discussion of the growth of the Internet, see Rainer Rilling, "Auf dem Weg zur Cyberdemokratie," *Telepolis, magazin der netzkultur,* 5 February 1997, http://www.ix.de/tp/deutsch/special/pol/8001/1.html (1 March 2002). For a discussion of the concept of programming of vision, see André Reifenrath, "Die Geschichte der Simulation: Überlegungen zur Genese des Bildes am Computerbildschirm" (Ph.D. diss., Universität Berlin, 1999), 191.

2. See, for example, the databases of the Bildarchiv Foto Marburg, 1995, http://www.fotomr.uni-marburg.de/vb.htm (1 March 2002).

3. Mechthild Modersohn, *Natura als Göttin im Mittelalter: Ikonographische Studien zu Darstellungen der personifizierten Natur* (Berlin: Akademie, 1997), 27–28.

4. Modersohn, *Natura als Göttin im Mittelalter* (note 3).

5. Hans-Martin Kaulbach and Reinhart Schleier, *Der Welt Lauf: Allegorische Graphikserien des Manierismus,* exh. cat. (Ostfildern-Ruit, Germany: Verlag Gerd Hatje, 1997), 59–60.

6. Horst Bredekamp, "Der Mensch als Mörder der Natur: Das 'Iudicium Iovis' von Paulus Niavis und die Leibmetaphorik," *Vestigia Bibliae* 6 (1984): 261–83; see esp. 269, for Nature's indictment of man, as formulated by the German humanist Paulus Niavis.

7. Bredekamp, "Der Mensch als Mörder der Natur" (note 6), 272–73.

8. See Thomas Hobbes, *Leviathan*, ed. Richard Tuck (1651; Cambridge: Cambridge Univ. Press, 1991), 146: "Liberty and Necessity are consistent; as in the water, that hath not only liberty, but a necessity of descending by the Channel; so likewise in the Actions which men voluntarily doe: which, because they proceed from their will, proceed from liberty, and yet, because every act of man's will, and every desire, and inclination proceedeth from some cause, and that from another cause, in a continuall chain, (whose first link is in the hand of God, the first of all causes,) they proceed from necessity."

9. See Hobbes, *Leviathan* (note 8), 170: "As for the Plenty of Matter, it is a thing limited by Nature, to those commodities, which from (the two breasts of our common Mother) Land, and Sea, God usually either freely giveth, or for labour selleth to mankind."

10. Hobbes, *Leviathan* (note 8), 9; and Horst Bredekamp, *Thomas Hobbes visuelle Strategien: Der Leviathan: Urbild des modernen Staates* (Berlin: Akademie, 1999), 56–57.

11. Thomas Darnstädt, "Leviathans Ende," *Der Spiegel*, 3 March 1999, 42.

12. Martin van Creveld, *The Rise and Fall of the State* (Cambridge: Cambridge Univ. Press, 1999); and Wolfgang Reinhard, *Geschichte der Staatsgewalt: Eine vergleichende Verfassungsgeschichte Europas von den Anfängen bis zur Gegenwart* (Munich: Beck, 1999).

13. George Dyson, *Darwin among the Machines: The Evolution of Global Intelligence* (Reading, Mass.: Addison-Wesley, 1997), 10.

14. Hobbes, *Leviathan* (note 8), 9.

15. On the masthead of the September 1989 issue of *Scientific American* was the following caption for this image:

The cover painting depicts points of light that reflect the impact of human beings on the earth, as seen at night by satellite. The major sources of light are urban areas (especially in the Northern Hemisphere), slash-and-burn agriculture (in South America), grassland burning (in Africa), and natural-gas flares (in Siberia and the Persian Gulf). Floodlights, operated by fishing fleets to attract squid, illuminate the Sea of Japan; city lights trace the path of the Trans Siberian Railroad; and lights along the Nile River contrast with the virtually dark Sahara. Although these and other features are only approximations (fires vary seasonally, for example), they effectively portray patterns of human activity around the world. George V. Kelvin executed the painting with data provided by Woodruff Sullivan of the University of Washington. Sullivan has compiled a mosaic image, "The Earth at Night," from satellite photographs made by the Defense Meteorological Satellite Program of the U.S. Air Force.

16. See Jeffrey Hart, Robert Reed, and Francois Bar, "The Building of the Internet: Implications for the Future of Broadband Networks," *Telecommunications Policy* 16 (1992): 666–89; Howard Rheingold, *The Virtual Community: Homesteading on the Electronic Frontier* (New York: Harper Perennial, 1994); Edwin Diamond and Stephen Bates, "The Ancient History of the Internet," *American Heritage* 46, no. 6 (1995):

34–45; and Katie Hafner and Matthew Lyon, *Where Wizards Stay Up Late: The Origins of the Internet* (New York: Simon & Schuster, 1996).

17. See Robert Calliliau, "Zur Technikgeschichte des Internet: Stichworte eines Surf-Pioniers," in Claus Leggewie and Christa Maar, eds., *Internet und Politik: Von der Zusachauer- zur Beteiligungsdemokratie?* (Cologne: Bollmann, 1998), 76: "We do not believe in kings, presidents, or political elections. We believe in community and in the free flow of data."

18. See Eli Noam, "Anarchie in den Netzen?" in Claus Leggewie and Christa Maar, eds., *Internet und Politik: Von der Zuschauer- zur Beteiligungsdemokratie?* (Cologne: Bollmann, 1998), 151–52.

19. See Spiros Simitis, "Ein Markt jenseits aller Kontrollen?" in Claus Leggewie and Christa Maar, eds., *Internet und Politik: Von der Zuschauer- zur Beteiligungs-demokratie?* (Cologne: Bollmann, 1998), 183–93. Simitis gives a concise history of censorship attempts, and he assesses the necessity of censorship measures and the incompatibility of national control mechanisms with the transnational organization of Web networks.

20. Marty Rimm, "Marketing Pornography on the Information Superhighway," *Georgetown Law Journal* 83 (1995): 1849.

21. To follow the extensive debate on the Web, search for "Marketing Pornography on the Information Superhighway." See also the overview by Florian Rötzer, 8 July 1999, http://www.heise.de/tp/deutsch/inhalt/te/5059/1.html (1 March 2002).

22. See Bizarre and Ultimate Perversion homepage, 6 December 1998, http://www.perversion.net (1 March 2002):

"Welcome TO HELL!! . . . WARNING!! WARNING!! WARNING!!

The following site contains VERY EXPLICIT & BIZARRE adult related material! We urge you not to underestimate the EXTREME nature of this site. Words cannot describe the unimaginable things that are waiting for you inside!!! If you have a weak heart, you are urged to go else ware [*sic*].

This site may cause INTENSE RECURRING Nightmares!! . . . YOU HAVE BEEN OFFI-CIALLY FOREWARNED. If you proceed to ignore these warnings you will be fully responsible for your own actions. If you are under 18 years of age and view any of our material, you will be committing a crime and YOU WILL GO BLIND!!! THIS IS YOUR FINAL WARNING TO LEAVE!!"

23. The first court cases were in 1996. The Communications Decency Act was enacted by the United States Congress in that same year. In 1997, however, the act was declared unconstitutional by the United States Supreme Court on the grounds of the priority of freedom of expression. Justice Stevens wrote in the seven to two decision that "No single organization controls any membership in the Web, nor is there any centralized point from which individual Web sites or services can be blocked from the Web"; and furthermore that "The interest in encouraging freedom of expression in a democratic society outweighs any theoretical but unproven benefit of censorship"; see *Reno, Attorney General of the United States et al. v. American Civil Liberties Union et al.*, The American Civil Liberties Union Freedom Network, 11 July 1997, http://www.aclu.org/court/renovacludec.html (1 March 2002).

24. See Horst Bredekamp, "Demokratie und Medien" in *Bürger und Staat in der*

Informationsgesellschaft: Enquête-Kommission "Zukunft der Medien in Wirtschaft und Gesellschaft, Deutschlands Weg in die Informationsgesellschaft" (Bonn: Deutscher Bundestag, 1998), 188–94.

25. For an unsurpassed formulation of this utopian concept, see Esther Dyson et al., "Cyberspace and the American Dream: A Magna Carta for the Knowledge Age," *The Progress and Freedom Foundation,* 22 August 1994, http://www.pff.org/position. html (1 March 2002); on this essay, see Horst Bredekamp, "Politische Theorien des Cyberspace," in Ralf Konersmann, ed., *Kritik des Sehens* (Leipzig: Reclam, 1997), 320–39.

26. Jane Prophet, TechnoSphere homepage, 1995, http://www.technosphere.org/ uk (1 March 2002).

27. Gordon Selley, Rycharde Hawkes, and Jane Prophet, "TechnoSphere," *Ars Electronica,* 1996, http://www.aec.at/prix/1997/97azW-technosh.html (1 March 2002).

28. Bruce Damer, Nerve Garden: A Virtual Terrarium homepage, 1997, http:// www.biota.org (1 March 2002).

29. See Hans Belting, *Das Ende der Kunstgeschichte? Eine Revision nach zehn Jahren* (Munich: C. H. Beck, 1995), 21–22.

30. For an early encounter between art history and Internet art, see the special issue of the periodical *Kritische Berichte* 26, no. 1 (1998). For an anthology of analyses of Internet art, see Gottfried Kerscher, *Net.art,* 1999, http://www.rz.uni-frankfurt.de/ ~kerscher/netart.html (1 March 2002).

31. Jodi.org homepage, 1998, http://www.jodi.org (1 March 2002). See also Tilman Baumgärtel, "'We Love Your Computer': Ein Interview mit Jodi," *Kritische Berichte* 26, no. 1 (1998): 17–25.

32. Äbsurd Örg homepage, 1997, http://www.absurd.org (1 March 2002). Oddly enough, Äbsurd Örg now simulates a system crash, while jodi.org is a series of interactive Internet art images.

33. New School of Design, Art and Performance homepage, 1995, http://www. agit.com/imagine/2nsdap.html (1 March 2002).

34. Ingo Günther, Refugee Republic homepage, 1993, http://www.refugee.net (1 March 2002). See also Dieter Daniels, "'Refugee Republic' von Ingo Günther," *Kritische Berichte* 26, no. 1 (1998): 26–28.

35. Christa Sommerer and Laurent Mignonneau, *Life Spacies,* 1997, http:// www.mic.atr.co.jp/~christa/WORKS/CONCEPTS/LifeConcept.html (1 March 2002). See also Christa Sommerer and Laurent Mignonneau, "Art as a Living System," in idem, eds., *Art@Science* (Vienna: Springer, 1998), 148–61.

36. Reifenrath, "Die Geschichte der Simulation" (note 1), 213, denies that computer images can ever be art.

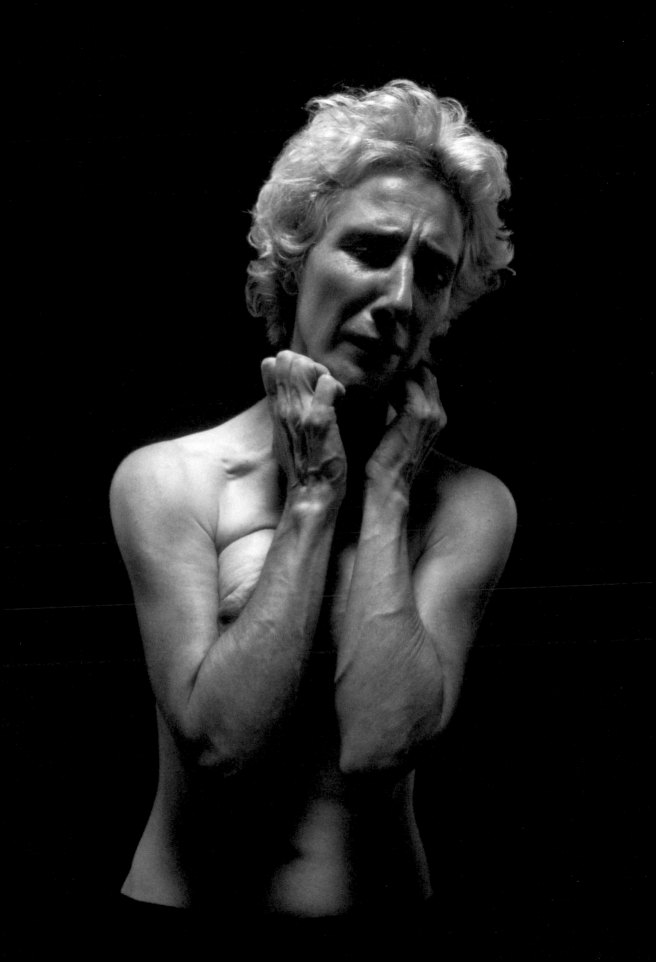

"Spiritual experience is nothing more than pain elevated
to a level above that of mere sensation." D.T. Suzuki

Description of a woman possessed to perform the Eight Stations of
the Cross through bodily gestures alone:

"Without uttering a single word or moving her mouth, she made
different gestures and external movements to summon the
spirit's different thoughts and acts which would provoke the said
movements of the body. Sometimes she cried or was very gay,
sometimes she sighed or raised her eyes to the heavens, sometimes
she intimated fear or made a visible effort to calm herself."

Francisco de Mosón Lisbon 1563

"Visionary ecstasy is the experiencing of an image that
takes over the body of the seer." Victor Stoichita

IMAGE / BODY

UNITY of EMOTIONS - "Deposition" type grouping of figures.

The large group shot is about reacting to a force on the camera (viewer) side -
unseen. There is a wave of pressure/disturbance that comes over them
and evokes different visible reactions of anguish, sorrow, anger, fear, grief
and intense stress. There is no relief at the end — only the aftermath
of the force, a wake of diminishing intensity and forms.

 The wall of suffering where Sorrow, Fear, Anger, Pain, Anguish,
 Grief, Anxiety, Bewilderment meet.

* Try with single
person studies first.

The World of Appearances swirling all around me like the
night sea —— the beautiful reflections, the pretty colors, the flickering
smile, the tearful confession, the accusing glance.... It is a new
palette, one that is both controllable and uncontrolled.

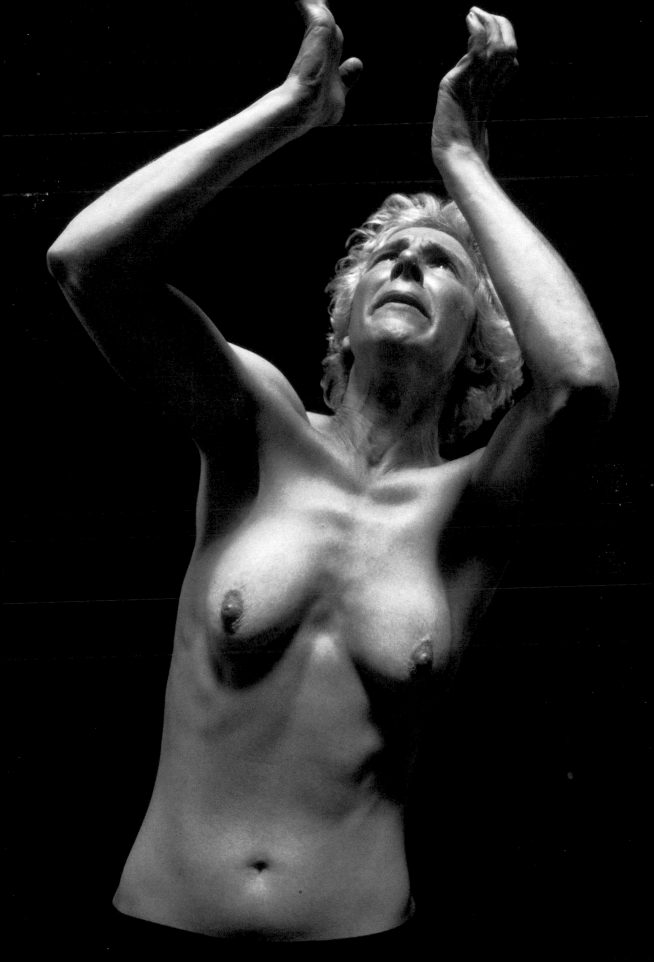

" Break the front door if you want to enter your home."

Zen Master DOGEN 1226

A trip to the subterranean level of the Norton Simon Museum may be in order to revisit the Asian collection as a guide to avoid the pitfalls of mere resemblance, likeness, and optical correspondance.

"Nirvana, a Sanskrit word, originally means 'putting out the fire', which points to a state where there is freedom from burning desire, anxiety, or the enslavement of passion."

Kazuaki Tanahashi

This morning, getting the kids ready for school, I yelled at my older son. Everyone had been up way too late the night before, and by breakfast it all broke down. After the first few volleys, I got drawn in, and then exploded, just like my father. I screamed at the top of my lungs, violently — and the whole family was stunned. He was startled, shocked, and in tears. I felt terrible afterwards, as I do now 30 minutes later sitting in my study with my stomach still in a knot. Then I returned to my work on the Bosch picture — 'Christ Mocked' — with its controlled bitterness and hatred. The faces are extraordinary, but contained — this is not the mob in a blind rage and fiery emotion. It is masterly in color and composition, but it is not Passion itself. How can I represent this? This was the central theme for the Representing the Passions year at the Getty in '98, but in fact it was never achieved. My passions that year occured completely outside the seminar situation, and in moments that had nothing to do with answering questions, measured analysis or posing problems. So, I don't know where this passion space is, but I sense that it has to do with the Balinese drama I witnessed years ago, and all shamanic practices where actors become possessed and entered by an external spirit agent or power — losing themselves completely. Look to Being, not Knowledge for answers.

Bodies

Unspeakable Passions: The Civil and Savage Lessons of Early Modern Animal Representation

Elizabeth Liebman

Monkeys may be born free, but they have been everywhere in chains in visual representation.[1] From Konrad Gesner's sixteenth-century scientific illustration of the cercopithecoid monkey (fig. 1) to the twentieth-century film image of King Kong (fig. 2), the portrayal of the enchained primate—the being that most resembles the human in material form and substance—has signaled a tenuously bound animal passion. The animals in these images do not wear the collar of the organ grinder's gentle companion; rather, they are masculine brutes, shackled at the pelvis in order to restrain the impulses of a body bereft of reason. Human observers, male and female, might respond to such images with feelings of curiosity, astonishment, sympathy, revulsion, remorse, or horror—the emotions known through most of Western history as the passions of the soul.

King Kong is a modern fable of passion run amok in both distant jungles and the most civilized city in the world. The still frame of Kong in irons is a visual catalog of emotion, an iconography of passion. Around the terrified and terrible beast stand the avaricious promoters of the living "Eighth Wonder of the World," rows of paying spectators who buzz with covetous curiosity, and the beautiful Ann Darrow (Fay Wray), who arouses in Kong the masculine passions of desire and aggression. In the film's final scene, after the death of Kong, it is Ann who bears the moral responsibility for Kong's inappropriate and outsized desire: "It was Beauty killed the Beast," announces the greedy impresario.[2] Even in the context of late-sixteenth-century humanist scholarship, when the depiction of the cercopithecoid monkey inspired the comparatively innocent passion of wonder—a mixture of curiosity and desire that pervaded Gesner's illustrated work the *Historiae Animalium*[3]—images such as Gesner's also delivered a similar lesson on passion: the chain that appears so near the organs of sexual reproduction reminds the viewer that animal passion is characteristically in need of external restraint.

My aim in this essay is to show how and at what moment in history new emotions came to be associated with the representation of nonhuman primates. I will focus on a particular discovery—the recognition of the ape as a new species of primate—first made in the seventeenth century and still occupying scholars today in the intertwined, specialized practices of biological and social research. The discovery of the ape required adjustments to the systematic

Fig. 1. *De Cercopitheco*
From Konrad Gesner, *Historiae Animalium: Liber I, De Quadrupedibus Viuiparis*, 2d ed. (Frankfurt: in Bibliopolio Cambieriano, 1603), 856

Fig. 2. King Kong in chains
Film still from *King Kong*, dir. Merian C. Cooper and Ernest B. Schoedsack, RKO Pictures, 1933

naming and picturing of primates. Taxonomic and iconographic changes coincided with and influenced the study of the passions in the developing ideology of the French Enlightenment. My claim is that, within the Enlightenment's self-conscious program of scientific and intellectual ambition, the figure of the primate aroused troubling and occasionally unspeakable emotions that reason neither explained nor contained: these primal desires and fears were sexual, and they challenged the ideals of knowledge and progress, reason and liberty, and, more urgently, the grounds of biological and social organization in the early modern world.

Though Gesner's image of the cercopithecoid monkey and the movie image of Kong were created almost four hundred years apart, for scientific purposes and popular entertainment respectively, both are part of a tradition in which animals serve as symbols and allegories of human conduct and as expressions of historically specific cultural attitudes. Eighteenth-century representations of monkeys and apes addressed two prominent gaps in the state of knowledge of the material world: the precise operations of sexual reproduction and the mechanisms of human emotion. The intractable enigma of human origins perplexed Enlightenment thinkers, with their spirit of scientific optimism, and it posed a fundamental threat to individual identity and to the nobility of family, class, race, and species. Without demonstrable scientific laws for sex and love, the unexplained biological status of the monkey revived the ancient fear of exogamy — the union of unlike entities, specifically, mating outside of a recognized group. In social and biological spheres, and in an increasingly diverse and mobile population, exogamy threatened Enlightenment aspirations for collective and individual perfection.

As if in response to the questions and anxieties provoked by the nascent understanding of primates and their relationship to humans, the image of the monkey became a means of dispensing moral instruction. Commercial print makers renovated the religious and emblematic symbolism of monkeys for use in popular fables and natural history texts. Naturalists, moralists, and artists alike used primate representations to administer lessons in human behavior and human nature. The twofold duty of the primate image yoked scientific representation and moral instruction. The mixture appealed to both reason and emotion, and it charged the monkey image with paradox and irony, the features of eighteenth-century *esprit,* wit, or "ingenious reason."[4]

Eighteenth-century efforts to understand and describe the ambiguous relationship between reason and passion have compelled the interest of historians throughout the twentieth century. Peter Gay has written that the "impotence of reason" before passion was a theme that "haunted" the Enlightenment.[5] For Michel Foucault, the problem of emotion lay in the eighteenth-century curiosity about sex and the interchange of knowledge and pleasure that put passion "at the center of a formidable petition to know."[6] And Norbert Elias, followed by Joan DeJean, has described the role of passion in the civilizing project of the Enlightenment. What Elias called a growing "compulsion to self-control" began in the period roughly following the appearance of Gesner's

enchained monkey. This active, civic compulsion for control or restraint of one's emotions reflected a departure from the archaic interpretation of the passions as uncontrollable, occult phenomena.[7] Studies such as these affirm the imbrication of reason and passion in the early modern life sciences, and they underscore the Enlightenment desire to explain the individual and the social in terms of the natural. Eighteenth-century French definitions of *sauvage* and *civil* developed in language that described phenomena in the organic world. *Sauvage* modified ferocious animals, in contrast to domestic animals. In botanical terminology, *sauvage* denoted uncultivated, natural plants. *Sauvage* modified or defined the particular, isolated individual (human or other), while *civil* modified the collective interests of a group. The concept of civilization was tied to the natural world through the assumption of collective culture or cultivation, a common ground rendered fertile at the expense of the modified *sauvage*.[8] Thus the placement of the shackles on the cercopithecoid monkey (and later on Kong) rendered the animal isolated and infertile, its passion impotent, its civilization and its liberty simultaneously tethered.

Aside from the depictions of the cercopithecoid monkey and King Kong, the images in this essay range from the first systematic description of the chimpanzee in 1699 through representations of primates in pre–French Revolution fiction and natural history texts. The selection reveals a persistent anxiety about the figure of the monkey in two epistemological frameworks. In the first, the natural philosophy of seventeenth-century Cartesian mechanism governed the interpretation of physical and emotional phenomena, allowing the safely confined monkey to perform as a mechanical actor. In the second, the art and literature of the mid-eighteenth century reflected the rise of empiricism and the materialist insistence on physical engagement with the world, implicating the monkey in the erotic, sensual representation of nature. It has been traditional to identify this segment of the "long eighteenth century" with the emergence of the human individual from established social institutions. But the price for that liberation was a release into the larger and disorganized conditions of material and emotional existence, the new categories of identity and experience.

While monkeys had been found commonly in Europe for centuries, true apes were extremely rare until the second half of the eighteenth century. Early accounts of the new primate attempted to give shape to an experience that was authentically phantasmal. Unknown and unidentified monkeys and apes slipped between the orders of human and animal, fact and fiction, and fell easily into the class of genies, fairies, enchantments, and metamorphoses, the familiar roles and devices of ancient fiction and popular tales. The peculiar new ape resembled the human, and by projection it bore the mien of the polymorphous and irrational gods of antiquity who sojourned on earth, frequently to couple with mortals.[9] Thus early modern life scientists and social theorists were confronted with the task of rescuing the monkey from the realm of mythology. Jean-Jacques Rousseau, for one, understood that euhemerism, the

tendency to interpret mythology as actual history, was a circular process that obstructed the progress of science and anthropology. In his reconstruction of the "natural man" for the "Discours sur l'origine et les fondements de l'inégalité parmi les hommes" (1755), Rousseau recognized that taxonomies of modern primates had identified the large humanlike monkeys—*Pongos,* mandrills, and Orang-outangs—with the divinities that the ancients called satyrs, fauns, and sylvans.[10] Consequently, mythic passions and appetites were attributed to the newly discovered animals.

Seventeenth-century knowledge of monkeys covered two general types: the familiar and social simian entertainer of the street and salon, Gesner's cercopithecoid monkey, and the spectral and solitary native of distant and exotic locales, the Orang-outang, from the Malay for "man of the woods," or *Homo sylvestris.* In his narrative of 1590, the English adventurer in Angola, Andrew Battell, provided the first field report of large, tail-less animals that walked upright—Battell called them "dangerous monsters."[11] Sensational and affecting, the dominant passion of Battell's account was wonder, the primitive, uninformed response to extraordinary and rare experiences. Battell's description of what was probably a chimpanzee appeared in specialized studies of apes published in the next two centuries, in every European language, and it was cited by both naturalists and social theorists. In 1693, the English naturalist and botanist John Ray gave the humanlike monkey the name Anthropomorpha, within the group *Simia.*[12] The Swedish botanist Carolus Linnaeus reclassified the order Primates and included the designation Homo sapiens in his 1758 edition of the *Systema Naturae.*[13] In the nineteenth century, the English biologist Thomas Henry Huxley named four distinct anthropoids, or "Great Apes": the gorilla, the chimpanzee, the Orang-outang, and the gibbon.[14] Today, the literature of primate classification and description remains under constant revision and dispute.

Eighteenth-century investigators perceived and rendered the anthropoid as a misshapen copy of the ideal human figure. For artists, the formal features of the ape differed even from the ideal animal form of the graceful cercopithecoid monkey and thus challenged rational delineation. Early reports indicated that the ape was bigger, stronger, and smarter than known monkeys but that it possessed the essential monkey nature: imitative, devious, sexually promiscuous, and deficient in the higher faculties of speech and reason. The ape aroused passionate interest not only as a public spectacle but also as an object of intellectual curiosity for the most prominent scientific and social thinkers of the Enlightenment. From the time of its discovery, the anthropoid ape figured in speculations on nature and culture, education and environment, and the essential perfectibility of the human species. Naturalists pursued primate physiology, but social thinkers like Rousseau, Voltaire, Denis Diderot, and Thomas Jefferson all used the monkey as a defining tool in their representations of human behavior and civilization: each of them exploited the range of passion, including sexual passion, that could be gathered from the symbolic history and material existence of the monkey.[15]

With the accumulation of scientific knowledge of the strange anthropomorphic animals came fantastic stories and images of Pygmies and Hottentots, mixed-race monkey men, stolen women, and children raised by monkeys. These stories combined the passions of awe, desire, and fear, in effect supporting a kind of mythology in an increasingly demythologized world.[16] But the continuing presence of fantastic tales also has been seen as an aspect of Enlightenment open-mindedness, a positive skepticism in which everything was possible, if unspeakable, especially the implausible.[17]

The modern investigation of passion began with the publication of René Descartes's last work, *Les passions de l'âme* (1649). Together, the natural philosophy of Cartesian mechanism and orthodox religious theory excluded animals from the science of emotion. Animals lacked not only a unique and animating soul, which moved spirits throughout the body, but also the facial anatomy that could reveal the activity of the soul in legible form. By the institutional doctrines of science and religion, the animal could neither feel nor communicate the nuances of human sentiments such as grief, anxiety, envy, or regret. But common familiarity with animals confirmed that they possessed the two "primitive" instincts of survival, concupiscence and irascibility (desire and fear), from which Descartes reasoned and defined all other human emotions. The paradoxical readmission of animals into the theory occurs with the emphasis on training: "For since with a little skill one can change the movements of the brain in animals bereft of reason, it is plain that one can do it even better in men, and that even those who have the weakest souls could acquire absolute dominion over all their passions if one employed enough skill in guiding them."[18] Descartes's treatise can be seen as a kind of therapeutic manual for the emotionally disordered, for those who lacked rational control over their animal passions; we might even say that it aimed for the domestication of passion.

Descartes's remedy underlies the lessons of Rousseau's *Émile; ou, De l'éducation* (1762), in which Rousseau defended the passions in the state of nature as instruments of freedom and preservation.[19] Rousseau's wholly positive view of passion belongs to the general and more moderate tendency in the Enlightenment to re-situate the passions within the context of modern science and art. If the emotions defied physiological explanation, they could nonetheless be redefined and purposefully inclined in the direction of human perfection.[20] The formerly negative, passive desires of wonder and curiosity became positive, active, and useful under the rubric of *interest*. Diderot wrote in the *Encyclopédie* (1751–72) that the virtue of interest and its role in art lay in its power to reveal the *enchaînement* of incidents, characters, and likenesses.[21] Later, the French writer Jean-François Marmontel described interest as an affection of the soul for objects and images that offer the possibility of individual identification.[22] For Marmontel, the degree to which a work of art is *of interest* is directly related to its capacity to resemble and influence, its capacity to throw light on the human condition or exert moral sway regarding ideas of good and evil, desire and fear.

With its uncanny human resemblance, the simian form amply satisfied the Enlightenment appetite for *interest*. Now a compelling object of interest in scientific inquiry and representation, the monkey figure shed the passive and symbolic role assigned it in Christian art and iconography of the Middle Ages.[23] The medieval images of the distorted monkey form embodied evil and the Devil, inspiring fear as they also represented degraded, postlapsarian man. Fear and desire fused in the monkey to symbolize human vice and appetite. Contempt motivated the use of the monkey in a visual attack on popery, the disparagement of Roman Catholicism that originated in the Protestant north, most prominently in Britain and the Dutch Republic. In Catholic, monarchical France, the monkey image joined with the visual traditions and characters of the commedia dell'arte for the Enlightenment satires on intellectual pretense and aristocratic manners.[24] By the eighteenth century, the critique of religious authority was manifest in the popular secular satires that cast the monkey in everyday scenes of moral and political wrongdoing and social misconduct. The targets of these new burlesque travesties were bourgeois bureaucrats: lawyers, schoolmasters, and military officials. As new primate species were presented to private and public audiences, the ancient symbolism of the monkey mingled with the images of discovery, producing new allegories and fables, new lessons for the modern age.

In the academic training of artists, there was an association of pedagogy and passion. The academy cultivated art and public morality by prioritizing the *grand genre* (history painting) and human achievement, but it also dictated the conduct of artists by directing the passionate, untamed imagination of the individual toward the interests of the state. The institutionalized union of emotion and professional artistic practice culminated in the doctrine of the Académie royale de peinture et de sculpture, specifically in Charles Le Brun's lecture on expression of 1688, which incorporated aspects of Descartes's treatise on the passions.[25] Le Brun's illustrations for these lectures were meant to instruct artists in the systematic visual representation of human emotion so that their *grand genre* paintings would convey truth. Le Brun's lectures, however, succeeded in expanding the discourse of emotion and expression to all genres of painting: portraiture, landscape, still life, and specialized animal painting. Artists of these *lower* genres were designated "apes of nature"; their occupational identification with the monkey was proclaimed in the academic motto *ars simia naturae* (art imitates nature, or, art the ape of nature), and their training consisted of the servile copying of ideal models.[26] Their ranks produced images of primates that were used in the rational proceedings of scientific inquiry and in popular ribald stories — the monkey satires that expressed and aroused both curiosity and the hostility of ridicule.

In 1699, at the height of Cartesian influence in natural philosophy, the English anatomist Edward Tyson published the first illustrated scientific monograph on the animal we now know as the African chimpanzee (figs. 3, 4).[27] The modern study of apes and monkeys and the science of comparative anatomy began with Tyson. His descriptions, methods, and illustrations

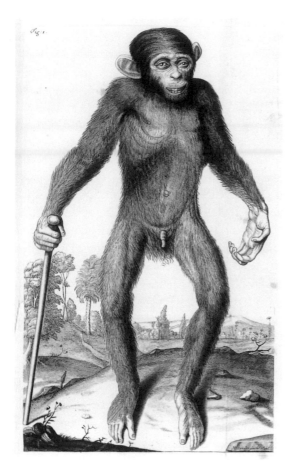

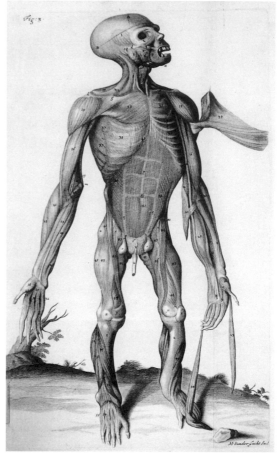

Fig. 3. Michael van der Gucht (Flemish, 1660–1725), after William Cowper (British, 1666–1709)
Portrait of Edward Tyson's "Pygmie"
From Edward Tyson, *Orang-outang, sive Homo Sylvestris; or, The Anatomy of a Pygmie Compared with That of a Monkey, an Ape, and a Man . . .* (London: printed for Thomas Bennet & Daniel Brown, 1699), fig. 1

Fig. 4. Michael van der Gucht (Flemish, 1660–1725), after William Cowper (British, 1666–1709)
Edward Tyson's "Pygmie" anatomized
From Edward Tyson, *Orang-outang, sive Homo Sylvestris; or, The Anatomy of a Pygmie Compared with That of a Monkey, an Ape, and a Man . . .* (London: printed for Thomas Bennet & Daniel Brown, 1699), fig. 3

became the models for study until late in the nineteenth century. The full title of Tyson's book outlines its contents and ambition: *Orang-outang, sive Homo Sylvestris; or, The Anatomy of a Pygmie Compared with That of a Monkey, an Ape, and a Man, to Which Is Added a Philological Essay Concerning the Pygmies, the Cynocephali, the Satyrs, and Sphinges of the Ancients, Wherein It Will Appear That They Are All Either Apes or Monkeys, and Not Men, as Formerly Pretended.* The anatomist and artist William Cowper collaborated with Tyson on the illustrations, and the plates were engraved by Michael van der Gucht. Tyson's specimen was a juvenile that he had seen alive only briefly. He had no secure knowledge of the animal in its natural state nor, for that matter, of the human races of Africa. A significant but only partially accomplished goal of his anatomical study was to expunge from modern science the myths of antiquity that allowed for speculation on intermediate beings. Tyson demonstrated convincingly that his "Pygmie," of the group Orang-outang, was not the satyr of the ancients. If that mythical beast, euhemerised by Pliny and others, were another kind of animal or pure fabrication, he could not say.[28]

Through systematic dissection and description, Tyson compared the features of his new ape to those of humans and monkeys. Remarkably, as far as he could tell, the organs of speech and the brain were identical in the ape and in the human. In the context of Cartesian epistemology and Christian theology, this discovery of organic similarity was problematic: the presence of unexpected and inexplicable perfection in animals deeply threatened not only the Cartesian conclusion that the noble, higher faculties of speech and thought were functions of the uniquely human and immaterial soul but also the basic Christian assumption of human privilege.[29] Within the general class of animals to which the human certainly belonged, there was now an urgent need to establish distinctions between the unique rational animal and the lower forms of beast and brute.

Tyson delivered a lesson in reason through the techniques of comparative anatomy, but his treatise offered another lesson that was visual and emotional. Cowper's original drawings of the animal were beautifully executed on the sixteenth-century anatomist Andreas Vesalius's model of human posture and anatomy.[30] The first image of the ape creates a shock of recognition in face and figure, inducing a consciousness of kind. For the early modern viewer the effect was perhaps unwelcome and may have been intensified by the accompanying text which gave more detailed anatomical evidence against human uniqueness. But through a defensive maneuver of perception and psychology, the image could be seen as irrational, a comic deformation of ideal human proportion and line.

Comparison was the basic tool not only of the anatomist but also of the early caricaturist. The *Encyclopédie* traced the roots of the genre of caricature to the grotesque characters of Italian Rennaissance art and theater and the deformation of known features that "charged" an image with great psychological power.[31] The French words *charger* and *caricature* derive from the

Italian *carricare* (to load, or weight). In French art of the eighteenth century, the heavy, deformed Italian grotesque became an undulating, linear caprice. The sinuous rococo grotesque linked incongruous organic and organismal forms and often included the expressive curves of the monkey body.[32] The express purpose of the caricature, according to the *Encyclopédie*, was amusement and laughter, and its success relied on the comparison of a natural or ideal form with a charged revision. Into the developing theory and practice of caricature and the grotesque came the reality of the anthropoid ape. For Tyson, the comparison of ape and human revealed similarity and difference in anatomical structure; for the image makers, Cowper and van der Gucht, the comparison produced not only likeness and equivalence but also caricature through the conscious or unconscious deformation of recognizable features.[33] As a caricature, Tyson's Pygmie was a revolting, desiccated, hairy little man, a degradation of the perfect original; its emotional impact turned revulsion into amusement, into the kind of laughter that Thomas Hobbes described, often as sign of pusillanimity, at "the apprehension of some deformed thing."[34] The laughter elicited by the monkey image in the seventeenth century was not an expression of delight but of fear or cowardice.

The likeness of the upright ape to the human form riled human vanity. Under the heading of "Vanity" in his *Pensées* (1659), Blaise Pascal identified comparison as the engine of laughter: "Two faces are alike; neither is funny by itself, but side by side their likeness makes us laugh."[35] The theory of caricature, Cartesian mechanics, and Pascal's observation on vanity and comparison were fused in Henri Bergson's turn-of-the-century essay on laughter; and Bergson and Pascal would in turn inform Sigmund Freud's theory of laughter, which sheds light on the mixed emotional response to new primate images in the eighteenth century. Freud explained that every new experience demands "a definite amount of expenditure from our understanding."[36] When the new experience resembles the old, the effort or surplus of unspent expectation is discharged in laughter. Thus, in the case of Tyson's new primate illustration, the viewer might have expected or hoped to find a greater difference in the comparison of animal and human features. Finding instead a very close resemblance, the viewer's unspent expectation and disappointment could be discharged in laughter. Moreover, Freud assigned to humor "the task of removing a possible emotional development which would form a hindrance to the pleasurable effect."[37] In early modern primate imagery, the emotional development was a gradual and painful confrontation with the probability of a close biological relationship between humans and apes. Humor restored a small, if temporary, degree of distance between the closely related species. The decades following the publication of Tyson's scientific monograph saw a peak in the popularity of the genre of humorous monkey imagery, the didactic and entertaining paintings and printed books of French *singerie* or the Dutch equivalent, *apenspel* (monkey play).

Tyson's chimpanzee was a scientific specimen — not a comic actor from the travesty world of *singerie*. The animal was safe, deceased, and immature; its

scientific realism and explicit conventional frontality canceled the pleasure that might have been expected in the obscene.[38] The anatomical figures of the humanlike ape may have aroused unconscious sexual fear or fantasy, but they certainly provoked rational conscious thought on the generation and production of species. In 1699, this process was still a scientific mystery; knowledge of generative methods was only conjectural, and *reproduction* was an unknown term. Earlier in the century, the English physician and anatomist William Harvey had proposed the existence of the ovum in the female organs of generation, and the Dutch naturalist Antoine van Leeuwenhoek had identified the "animalcules" of spermatozoa.[39] The production of a new individual was thought to be the result of the mingling of material form and immaterial spirits, and breeding and hybridization were understood in terms of animal husbandry, but generation was in theory lawless and therefore dangerous. Generation was thus particularly worrisome in a period of social reorganization that allowed for the creation of "New Men" and nobility based on criteria other than blood.[40]

If the similarity between apes and humans in the organs of speech and thought troubled anatomists, the similarity of reproductive organs gave rise to even more alarming concerns. What unspeakable possibilities suggested themselves to naturalists who puzzled over the mysteries of anatomy, heredity, and hybridization? The only certainty about generation was that the new form developed inside the female body, the incontestable site of mixture and production. One of the two theories that competed for acceptance in the eighteenth century was preformation, which posited the emergence of the homunculus, the fully formed individual, from the complete but microscopic germ. The other, epigenesis, focused on the developmental process by which disorganized matter gradually takes on its full potential.[41] Both theories allowed for accidents of creation or development, for the appearance of monsters.

Notions of monstrosity, of improper mixture and mixed offspring, haunted the realms of eighteenth-century natural philosophy, theology, morality, social identity, and in visual representation in the composition of the grotesque.[42] Arguments on the production of monsters aligned with hypotheses of generation. Was monstrosity due to the nature and creation of the egg, the preformationist view, or to the circumstances of development and the processes of epigenesis? Defined in *Le dictionnaire de l'Académie francaise* (1694) and later in the *Encyclopédie*, the monster took on both savage and civil forms.[43] Monstrosity was first a natural, zoological phenomenon: an animal that possessed at birth a form contrary to the order of nature, either a surplus (a two-headed kitten) or a deficiency (a limbless kitten). Monstrosity also pertained to moral conduct, to the excessive passions of desire (appetite and avarice) and the vices of absence (ingratitude or cowardice). The monstrous was in every case impure and irrational. It was bestial and inherently sexual as the result of unbridled desire and the possible consequence of unnatural union or exogamy. Monstrosity was a singular event, the creation of an original entity,

and explanations of monstrosity varied among Enlightenment thinkers: in his *Dictionnaire philosophique,* Voltaire suggested that the category of monstrosity entailed questionable and prejudiced evidence and that the classification itself was aesthetic and relative. He attributed the intellectual impulse to contain the monstrous to the lack of knowledge of generation and to the emotional need to secure a boundary between the human and the animal.[44]

In the early modern literary and visual imagination, suspicions of animal and human familiarity seemed increasingly possible on a scientific level. Such suppositions were fueled by the empiricist study of the passions within natural phenomena, the knowledge of anthropoid apes, and the expanding public demand for printed books and art. One of Andrew Battell's most commonly repeated stories was of a human child kidnapped and kept by apes.[45] This tale figured in early debates on education and environment, and it has remained a fixture of Western philosophy and popular imagination. The anecdote combines sexual inference with familial associations and resemblances—the monstrous kidnappers themselves were thought to be the product of unnatural mixture. The amateur naturalist Pons Augustin Alletz entertained the idea of the Orang-outang as the product of a woman and a monkey in his *Histoire des singes* (1752), a successful work of entertainment that also found a place in libraries of science.[46]

The hint of physical intimacy between the species also appeared in the darkly satiric fable "The Monkey Who Had Seen the World," by the English poet and playwright John Gay. The animal painter John Wootton illustrated the edition of 1729 (fig. 5), and his designs were engraved by Gerard van der Gucht (a relative of Michael van der Gucht, who produced the figures of Tyson's Pygmie). "The Monkey Who Had Seen the World" entertained an audience of educated English adults with a monkey parody of French affectations and libertinage. Continental readers apparently took no offense: Gay's fable appeared immediately in translation and remained in print for the rest of the century, and, according to a French edition of 1802, it delighted all classes of society.[47] In the fable, a monkey driven by its natural curiosity determines to see the world. He is captured and sold as a pet, in which capacity his instinctual lewdness makes him a witty and refined imitator, a monkey suitor held captive in a lady's boudoir:

> Proud as a lover of his chains,
> He day by day her favour gains.
> .
> He twirls her knots, he cracks her fan,
> Like any other gentleman.

Finally, the clever beast breaks the chains and returns to reform his monkey society, "like Orpheus, burnt with public zeal, / To civilize the public weal."[48]

Wootton represented the moment of the monkey's homecoming in the woods where, still fashionably dressed, he imparts to "hairy sylvans" the lessons

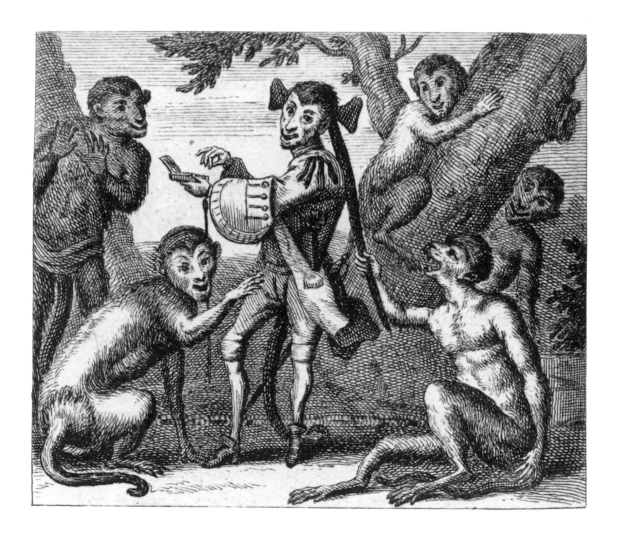

Fig. 5. Gerard van der Gucht (British, 1696–1776), after John Wootton (British, ca. 1682–1765)
Vignette for "Fable XIV. The Monkey Who Had Seen the World"
From John Gay, *Fables*, 3d ed. (London: J. Tonson & J. Watts, 1729), 52

of courtly arts and mannered life. The monkey's audience, "warm with mal-
ice, envy, spite," becomes a mischievous and biting copy of human society, the
civilized savages.[49] The illustration is not a simple costume travesty. It draws
an equivalence between the sexual conduct of monkeys and that of the human
upper class. Wootton freely deployed the phallic symbolism of the humanlike
long plait of hair in the center of the image: it recurs in the tail and sword that
hang from the monkey's stylish breeches and also in the stick suspended from
his wrist. The other monkeys grasp and gesture at these *bâtons;* their paws
explore and groom the strange animal in the center of the picture. The active,
probing hands unify the group on the eighteenth-century visual principle of
enchaînement, the linking of individuals within a group by gaze, glance, and
gesture. Yet the link is only interspecies, as Gay's apologue ultimately confines
the group within the hierarchy of the primate: "Weigh your own worth; sup-
port your place, / The next in rank to human race."[50]

The image of the fettered, captive monkey appeared in a range of sophisti-
cated urban entertainments: in fables and adventure stories, published natural
history texts, as an element of chinoiserie decor, as a feature of the private
menagerie, and in street performance. But the monkey and the ape also
belonged in the realm of the scientific, namely, the discovery of a real new
world that was both exotic and erotic to the Western imagination. The Enligh-
tenment survey of authentic, savage nature was no more free from emotional
bias than were literary and artistic representations of possible worlds. Roy
Porter has written of the eighteenth-century infatuation with erotic paradises,
past and present—the imagined isle of Cythera and the revelation of Tahiti—
and also of the moral determinism that underlay the perception of non-
Western human sexuality as savage or civilized, natural or degraded.[51] That
determinism surfaced in early ethnographic and zoological studies of Africa,
South America, and the Far East—the places of origin for imported monkeys—
where naturalists proposed climatological and environmental explanations for
human behavior. Monkeys in general, and the anthropoid ape in particular,
fit easily into the established modes of ideological, intellectual, and aesthetic
speculation. If modern, Western primatology began with Tyson, it subse-
quently incorporated the assumptions, distortions, and projections repre-
sented by the exotic/erotic East, resulting in what Donna Haraway has called
"simian orientalism."[52]

Twentieth-century simian entertainment has preserved the early coupling
of the exotic and the erotic in the resounding euphonic harmony of "Orang-
outang" and "King Kong." The auditory, however, is only one sensory link
between early and late modern "jungle dramas." Cynthia Erb, with Haraway,
has suggested that in these dramas "touch becomes a sign of the genre's over-
all investment in images of contact, usually between representatives of 'civi-
lization' and 'nature,' or Western and non-Western worlds."[53] John Wootton's
image of the grasping, hairy sylvans acknowledges the role of touch in extra-
linguistic communication. The image of the woman in the hairy hand of Kong
embodies the eighteenth-century relationship between passion and the senses:

the successful effect of the dramatic and visual representation of passion results in the experience of having been "touched."

Tales of Oriental sensuality, sexual passion, availability, and conquest were the stuff of early modern best-sellers such as Antoine Galland's *Les mille et une nuits, contes arabes traduits en français* (1704–10), Claude Prosper Jolyot de Crébillon's *La Sopha* (1742), and Diderot's *Les bijoux indiscrets* (1748).[54] But domestic, European nature also provided a background for erotic passion in eighteenth-century art, in the open-air scenes of *fêtes-galantes* by Jean-Antoine Watteau, in the gardens created for lovers by Jean-Honoré Fragonard, and in the theatrical pastorals and idylls of François Boucher. Images of rosy-cheeked shepherdesses and rosy-bottomed nymphs, the objects of satyrs' affection, crowded private and public salons and circulated in prints and published tales. Invariably personified as female, the figure of sensuous, fecund, and erotic Nature coexisted with depictions of savage, violent nature in allegories of *vanitas* and power in the genre of the hunt and in the animals and carcasses of the still life. Love and learning moved together out-of-doors, where the female students of the scientist and man of letters Bernard Le Bovier de Fontenelle and the abbé Nöel-Antoine Pluche—along with the most famous pupil of the eighteenth century, Rousseau's Emile—took their lessons.

In chapter 16 of *Candide; ou, L'optimisme* (1759), Voltaire's ur-fable on the theme of impotent reason before passion (including simian passion), Candide and his companion Cacambo pause in flight across the frontier of Paraguay. At rest in a beautiful meadow, they are alarmed (aroused) by human cries and discover two naked girls pursued by two monkeys who are nibbling at their buttocks. The innocent Candide shoots the monkeys dead, believing that he has rescued the girls. He then discovers that the monkeys were the girls' lovers and that his emotional act of sympathy has backfired. To Candide's astonishment, upon discovering the truth of the relationship, Cacambo explains: "you're always surprised by everything. Why do you find it so strange that in some countries monkeys should enjoy the favours of the ladies? They're a quarter human, just as I am a quarter Spanish." Candide recalls his tutor Dr. Pangloss's explanations of such "accidents," the couplings that produced centaurs, fauns, and satyrs. "Well, you ought to be convinced now that it's true," Cacambo tells him, "You see how people behave when they haven't had a bit of education."[55] Voltaire is here characteristically critical and ironic on the subject of formal learning, but nevertheless he makes a claim for intellectual openness in the face of astonishing implausibilities. The monkey lovers are in the company of many other interracial couplings and conflicts that occur in the story, the mingling of princes and slaves, Germans, Spaniards, Jews, Jesuits, Muslims, Bulgars, Africans, Incas, and mulattos. Throughout the wars, murders, slavery, and sexual abuses of *Candide*, Voltaire's lesson is constant: the savagery of civilization, the violence of the civilizing process.

The scene of Voltaire's monkey lovers attracted two famous eighteenth-century print makers, both of whom were experienced with Voltaire and the imagery of the erotic print: Charles Monnet illustrated the compilation

Romans et contes of 1778 (fig. 6), and Jean-Michel Moreau, called Moreau le jeune, illustrated *Candide* for the first complete edition of Voltaire's work, the distinguished Kehl edition (fig. 7), released to subscribers from 1782 until 1789 with a separate folio of prints.[56] Their interpretations of the scene and their representations of passion show formal similarities and differences that make it possible to designate the images and their markets as civil or savage, designations that surely would have pleased Voltaire. The more economical Monnet edition was aimed at a broad readership, a civil market, while the Moreau edition was intended for private delectation, for a select clientele that included royalty — a sophisticated, cultivated audience that was, in the irony of Voltairean taxonomy, savage.

In both pictures, the nude women occupy the center of the image, with the smaller, armed figures of Candide and Cacambo in the background. Monnet's arrangement presages the "gun and camera" trope of the modern jungle adventure film, with the eye and gun of Candide aimed directly at the pubis of one of the women.[57] Both artists show the women in motion, running with arms upraised and legs parted in midstride. Monnet's version sets the monkey and human lovers in ideal nature, a shaded, Edenic bower, a cultivated European garden, while Moreau's scene aims for topographic accuracy in a setting that is savage and uncultivated, mountainous, vast and exposed, the post-Edenic New World. Both artists also took unusual care in the rendering of the simian faces, conforming to the conventions for the representation of passion and human facial expression based on Le Brun's seventeenth-century treatise: Monnet's animals have the upraised eyebrows and grins of happy, expectant lovers, while Moreau's satyrs display the furrowed brows of violent agitation, the appetite of desire gone to its gruesome, animal extreme.

Voltaire meant for this episode to be comic. And Monnet's civilized representation successfully captures the scene's intended comedy through the use of the comparative method. A pair of men and a pair of monkeys bracket the two women in a construction that allows the viewer to identify with either pair and partake in the pleasure. The choice poses a moral conundrum in which impulses oscillate between the savage and the civil. The similar, schematic arrangement of the bracketing pairs of amorous males forces a comparison between the two, and the resulting expenditure of expectation produces laughter. It is a comedy of both comparison and situation, a scene so implausibly arranged that it could not happen in a civilized, cultivated garden.

Moreau's rendering, by contrast, is chaotic, terrible, and incomparable to human experience. The women are not graceful nymphs but the objects of exogamous, bestial, sexual desire. The exoticism of the locale suggests that such horror could indeed happen there. The human males are small and impotent figures, dwarfed by the landscape and by the outsized passion that occurs before them. Where the paws of Monnet's apes lightly touch the feminine thigh, the muscled arms of Moreau's brutes encircle the bellies of both women. This contact emphasizes maternity and suggests a more significant drama: Voltaire had previously speculated on the subject of "ape-rape" in his

Fig 6. **Jeanne Deny (French, 1749–after 1815), after Charles Monnet (French, 1732–1816)**
Illustration for chapter 16 of *Candide; ou, L'optimisme*
From Voltaire, *Romans et contes* (Bouillon, Belgium: aux depens de La Société Typographique, 1778), vol. 2, after 122

Fig. 7. **Emmanuel Jean de Ghendt (Flemish, 1738–1815), after Jean-Michel Moreau le jeune (French, 1741–1814)**
Illustration for chapter 16 of *Candide; ou, L'optimisme*
From Voltaire, *Oeuvres complètes*, ed. Pierre-Augustin Caron de Beaumarchais ([Kehl, Germany]: Impr. de la Société Littéraire-Typographique, 1784–89)

Essai sur les moeurs et l'esprit des nations (1756). Subscribing to the climato-
logical theory of passion, Voltaire supported the probability that in hot coun-
tries monkeys had subjugated women; he presumed that "monstrous species
could be born from those abominable loves."[58]

A reversal of the sex roles in the pictured episode is impossible. Rational
man did not allow corporeal imagination to travel that far. It was unspeak-
able, if not unthinkable, to suggest that the eighteenth-century European male
would take a female monkey lover. This stricture found natural reinforcement
in the many notes on the modesty of female monkeys in the presence of
human observers, which appeared almost as frequently as descriptions of
ardent male monkeys toward women.[59] Furthermore, in the *Encyclopédie*
definitions of woman as a physical, anthropological, legal, and moral object,
certain parallels emerge between the woman and the monkey.[60] All the
Encyclopédie definitions hinge on the Enlightenment ideal of physical orga-
nization modified by education; thus, the natural or savage woman is con-
trasted with the woman in a state of civil domestication. Lieselotte Steinbrügge
has convincingly proposed that woman's sex-specific character in the Enlight-
enment was based on her closeness with nature, a fundamental emotional
"creatureliness" that escaped rationality.[61] Physically designed for the passion
of love, woman's essence and greatest power lay in the art of inspiring desire.
However, she shared with the monkey the problem of being another kind of
man, a smaller, inferior copy, curious and devious by nature. This was the
"coquette," the primitive and natural savage woman. The civilized, moral
woman was a result of perfection and modification through education. The
lovers of Voltaire's monkeys thus illustrate Cacambo's pronouncement that
they "haven't had a bit of education."

Rousseau described the state of nature and the uneducated, uncivilized
l'homme sauvage in his "Discours sur l'origine et les fondements de l'inégalité
parmi les hommes." Rousseau's stated ambition was to mark the moment
when "Nature was subjugated to Law," the point at which philosophers
"transferred to the state of Nature ideas they had taken from society"; the
point at which "they spoke of Savage Man and depicted Civil Man." His first
move, justly celebrated for its dramatic effect, was to "set aside the facts, and
speculate on what mankind might have become if it had remained abandoned
to itself."[62] Of course, Rousseau had all the facts, and they are presented
meticulously in his "Note X" to the description of the natural man. The note
summarizes the literature of primatology and considers in more depth the
possible relationship between the human and the ape. Beginning with the
satyrs of antiquity, Rousseau moves from Battell's early narrative to accounts
by contemporary travelers to the scientific studies of Tyson, Diderot, and the
naturalist Georges-Louis Leclerc, comte de Buffon. Rousseau objects to the
use of the term *monster* and to the bias of projection in Western observations
of monkeys. He concludes, contingent on further discovery, "that
the Monkey is not a variety of man; not only because it is deprived of the fac-
ulty of speaking, but especially because it is certain that this species lacks the

faculty of perfecting itself which is the specific characteristic of the human species." Yet Rousseau did not surrender entirely the idea that future experimental investigations might reveal a more particular relationship between humankind and the primate. Rousseau called these vaguely suggested experiments "impracticable," and to be sure they remain forbidden by clinical ethics today. Rousseau understood that the demonstration of perfectibility might require the observation of children in isolation, deprived of civil lessons, in order to test the efficacy of natural, solitary, savage lessons.[63]

Rousseau had read Buffon's natural history of man and animals, the initial three volumes of Buffon's massive *Histoire naturelle, générale et particulière* (1750–1804), a work that dominated continental science in the second half of the eighteenth century. But Rousseau had not seen Buffon's fourteenth volume (1766), which included essays on the nomenclature of monkeys and apes, descriptions and illustrations of individual species, anatomical figures, and a review of primatology literature from Pliny to Tyson. With regard to Battell's sixteenth-century claims of the monkey's amorous pursuit of females, humans included, Buffon was openly skeptical but chose to be inclusive in order to appeal to emotion and reason.[64] In his aim to cultivate a large audience for the modern science of nature, Buffon did not hesitate to capitalize on the passions of interest, wonder, desire, and fear in his full account of organic diversity and animal behavior. Certainly, the adventure stories of Battell and the anecdotes of Alletz had proven to be both titillating and marketable. Moreover, reports of the bizarre and the barbarous validated Buffon's overt anthropocentrism, his claims for the triumph of modern, European civilization over nature, for the beauty of "cultivated nature."[65]

Perhaps most important, Buffon sought to contest the idea, which he attributed to the vulgar masses and to the philosophes (Rousseau and the radical materialists), that the monkey, specifically the chimpanzee, called "Jocko" or Orang-outang, was difficult to classify. The Jocko, Buffon declared, was neither the last of animals nor the first of men, but pure animal under a human mask. Buffon confronted the anatomical features that had startled Tyson—the perfect structure of the brain and organs of speech—and, like Tyson, he concluded that the higher faculties were uniquely human. Buffon based this judgment on direct observations of simian dexterity and behavior and gave his eyewitness account of the Orang-outang's extraordinary imitative conduct at a tea party. Finally, Buffon insisted that the distinction between the animal and the human could not be made by the observation of form nor could it be discerned from conduct that was involuntary and purely imitative in monkeys, a faculty much overrated by the vulgar masses. In Buffon's enlightened ecological view, education was an observable environmental pressure, and perfectibility the essential characteristic of the human. The lower animal, the beast, was unperfectible owing to the conditions of its upbringing, the lessons unimparted and unlearned. Humanity was the result of organic and social perfection; it was possessed only by the reasoning animal. Education—civilizing lessons—modified human organs in order to

produce a state more favorable to thought and the fulfillment of human potential.[66] Buffon, in a demonstration of ingenious reason and paradox, posited education as a natural human instinct, a passion to know.

The first of the individual portraits of monkeys in Buffon's fourteenth volume is the Jocko, a flat-footed and passive brute at the limits of its animal sensibility (fig. 8). The drawing is an awkward, unclear mixture of human and animal features. But a remarkable transformation occurs when the artist, Jacques de Sève, inserts the Jocko figure into the headpiece vignette (fig. 9), a composition featuring all the various species pictured in the volume. The male Jocko becomes a female with plainly rounded breasts and belly, and he (now she) stands serenely, surrounded by smaller species cast as playful juveniles. She gazes toward the gesturing gibbon, the father figure, while her hand rests on the head of a crouching baboon, which in turn touches her maternal abdomen. Hers is a gentle, restraining, teaching hand, part of the complex *enchaînement* of the monkey figures into a hierarchical order, a chain of dependence. The scene is tender and sentimental, and it can be compared to the domestic and didactic family tableaux by the contemporary salon painters Jean-Baptiste Greuze and Jean-Baptiste-Siméon Chardin. Yet the animal family exists in confined isolation, caged within an unbroken hedge frame of architectural ornament and vegetation. This headpiece is unique among those of the original volumes of Buffon's *Histoire naturelle*. Unlike the others, it contains no putti, the supernatural human forms that typically help to display or restrain, by touch or by mechanical device, a group of animals. Without the putti to provide transitional bodies between the human and the animal, the monkey ensemble offers no opportunity for comparison with the human form; no cause for laughter by comparison and the ensuing discharge of expectation; and no objects or demonstrations of inappropriate passion or sexual desire. Buffon meant the scene to stand as a world apart, very much a planet of apes, complete but imperfect and unperfectible. In a supplemental volume of 1788, Buffon expanded his descriptions of apes to include New World monkeys, but he never altered his opinion on human perfection and the unbridgeable gap between the civilized animal and the savage beast.

The particular iconography and the attributes of the monkey image have changed over time, but notions of the civil and savage in contemporary animal representation remain largely those of the eighteenth century. As popular spectacle, nature continues to arouse passion in the genre of the wildlife documentary and, increasingly if somewhat alarmingly, in the representation of savage, rampaging animal behavior. The image of female creatureliness and affinity with nature persists in the figure of the celebrated female primatologist—Jane Goodall, Dian Fossey, and Birute Galdikas—and also in the critical studies of Donna Haraway.[67] Female sexuality sells exotic natural history in the film star Julia Roberts's true adventures among the Orang-outangs of modern Borneo.[68] *King Kong,* in its original and remade versions, is both popular entertainment and the proper subject of academic study. Tales of forbidden experiments and of wild children raised by monkeys thrive in the

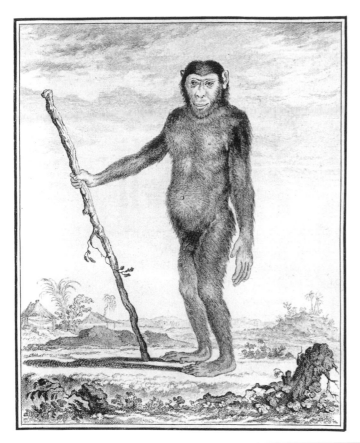

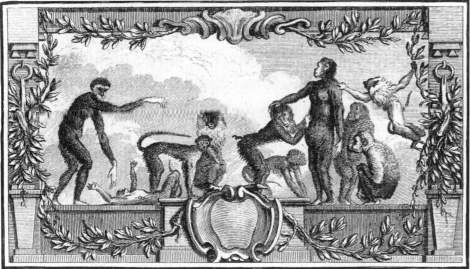

Fig. 8. Juste Chevillet (German, 1729–90), after Jacques de Sève (French, act. 1742–88)
Le Jocko
From Georges-Louis Leclerc, comte de Buffon, *Histoire naturelle, générale et particulière, avec la description du Cabinet du roi . . .* (Paris: Imprimerie Royale, 1750–1804), vol. 14, p. 82

Fig. 9. Louis-Claude Legrand (French, 1723–1807), after Jacques de Sève (French, act. 1742–88)
Vignette with primates
From Georges-Louis Leclerc, comte de Buffon, *Histoire naturelle, générale et particulière, avec la description du Cabinet du roi . . .* (Paris: Imprimerie Royale, 1750–1804), vol. 14, p. 1

supermarket tabloid, while in the mainstream press, scientific discovery takes the editorial page when the subject is evidence of primate culture, and the author, the distinguished professor of zoology Stephen Jay Gould, reproaches our emotional claim to a unique human status.[69] The comic comparison of humanity with "chimpunity" sustains the gentle travesty of television's "Chimp Channel" and the Swiftian satire of Will Self's novel, *Great Apes*.[70]

Although the century that followed Charles Darwin's great lesson yielded conclusive and specific data on the taxonomic group to which human beings belong, passion still haunts the dispassionate ideal of modern science. To the fear of exogamy and the uncertainty of corporeal boundaries have been added the reality of unanticipated biological mixtures in experimental organ transplants, genetic engineering, and the history and epidemiology of HIV. Our understanding of sexual reproduction and genetics has produced extraordinary technologies behind which our knowledge of the emotions lags. No less than in the seventeenth century we represent our emotions in terms of mechanical or social models. At the moment, the determinism of cognitive science and neurobiology appears to have displaced environmental behaviorism as the prevailing explanation for the source and movement of the emotions. In the tradition of animal representation, the monkey will continue to be a potent and exotic object, reflecting our fears and desires in lessons both savage and civil.

Notes

1. Cf. Jean-Jacques Rousseau, *Du contrat social*, in idem, *Oeuvres complètes* (Paris: Gallimard, 1964), 3:351: "L'homme est né libre, et par-tout il est dans les fers."

2. *King Kong*, dir. Merian C. Cooper and Ernest B. Schoedsack, RKO Pictures, 1933.

3. Konrad Gesner, *Historiae Animalium: Liber I*, 2nd ed. (Frankfurt: in Bibliopolio Cambieriano, 1604), 856.

4. Denis Diderot, ed., *Encyclopédie; ou, Dictionnaire raisonné, des sciences, des arts et des métiers* (Paris: Chez Briasson, 1751–80), 5:973, s.v. "Esprit." Available at http://www.lib.uchicago.edu/efts/ARTFL/projects/encyc (3 May 2002).

5. Peter Gay, *The Enlightenment: An Interpretation*, vol. 2, *The Science of Freedom* (New York: W. W. Norton, 1966), 188.

6. Michel Foucault, *The History of Sexuality*, vol. 1, *An Introduction*, trans. Robert Hurley (New York: Pantheon, 1978), 77–78.

7. Norbert Elias, *The Civilizing Process*, trans. Edmund Jephcott (Oxford: Blackwell, 1994), 496. See also Joan E. DeJean, "A Short History of the Human Heart," in idem, *Ancients Against Moderns: Culture Wars and the Making of a Fin de Siècle* (Chicago: Univ. of Chicago Press, 1997), 78–123.

8. DeJean, "A Short History of the Human Heart" (note 7), 127.

9. See Pons Augustin Alletz, *Histoire des singes, et autres animaux curieux, dont l'instinct et l'industrie excitent l'admiration des hommes, comme les éléphants, les castors, etc.* (Paris: Duchesne, 1752), 4; and Leonard Barkan, *The Gods Made Flesh: Metamorphosis and the Pursuit of Paganism* (New Haven: Yale Univ. Press, 1986),

12–15, 293 n. 30. See also Ashley Montagu, *Edward Tyson, M.D., F.R.S., 1650–1708, and the Rise of Human and Comparative Anatomy in England: A Study in the History of Science* (Philadelphia: American Philosophical Society, 1943), 400.

10. See Jean-Jacques Rousseau, "Discourse on the Origin and Foundations of Inequality Among Men [1755]," in idem, *The First and Second Discourses Together with the Replies to Critics and Essay on the Origin of Languages,* ed. and trans. Victor Gourevitch (New York: Harper & Row, 1990), 218.

11. Andrew Battell, *The Strange Adventures of Andrew Battell, of Leigh, in Angola and the Adjoining Regions,* ed. E. G. Ravenstein (London: Hakluyt Society, 1901; reprint, Nendeln, Liechtenstein: Kraus Reprint, 1967), 54.

12. On Ray's *Synopsis Methodica Animalium Quadrupedum et Serpentini Generis . . .* (1693), see Tore Frängsmyr, ed., *Linnaeus: The Man and His Work,* rev. ed. (Canton, Mass.: Science History Publications, 1994), 164 n. 17. For a brief history of primatology, see Daris R. Swindler, "Monkeys and Apes in History," in idem, *Introduction to the Primates* (Seattle: Univ. of Washington Press, 1998), 3–16. For eighteenth-century primatology, see Phillip Sloan, "The Gaze of Natural History," in Christopher Fox, Roy Porter, and Robert Wokler, eds., *Inventing Human Science: Eighteenth-Century Domains* (Berkeley: Univ. of California Press, 1995), 112–51; Gunnar Broberg, "Linnaeus's Classification of Man," in Tore Frängsmyr, ed., *Linnaeus: The Man and His Work,* rev. ed. (Canton, Mass.: Science History Publications, 1994), 156–94; and Robert Wokler, "Tyson and Buffon on the Orang-outang," *Studies on Voltaire and the Eighteenth Century* 155 (1976): 1–19.

13. Carolus Linnaeus, *Systema Naturæ per Regna Tria Naturæ, secundum Classes, Ordines, Genera, Species, cum Characteribus, Differentiis, Synonymis, Locis* (Stockholm: L. Salvii, 1758–59).

14. Thomas Henry Huxley, *Evidence as to Man's Place in Nature* (London: Williams & Norgate, 1863), 23.

15. Voltaire, *Essai sur les moeurs et l'esprit des nations . . . ,* in idem, *Oeuvres complètes de Voltaire* (Paris: Furne et cie, 1835–47), 3:1–610; Denis Diderot, "Paradoxe sur le comédien," in idem, *Oeuvres complètes,* ed. Herbert Dieckmann et al. (Paris: Hermann, 1975), 20:43–152; and Jefferson's speculation on the Orang-outang in "Query XIV: The Administration of Justice and Description of the Laws," in his *Notes on the State of Virginia* (London: J. Stockdale, 1787), as cited at http://www.yale.edu/lawweb/avalon/jevifram.htm (3 May 2002).

16. Allan Bloom, "Introduction," in Jean-Jacques Rousseau, *Emile; or, On Education,* trans. Allan Bloom (New York: Basic, 1979), 21.

17. See, for instance, Jacques Roger, *The Life Sciences in Eighteenth-Century French Thought,* ed. Keith R. Benson, trans. Robert Ellrich (Stanford: Stanford Univ. Press, 1997), 357.

18. René Descartes, *The Passions of the Soul,* trans. Stephen Voss (Indianapolis: Hackett, 1989), §50.

19. Rousseau, *Emile* (note 16), 212.

20. Diderot, *Encyclopédie* (note 4), 12:142–52, s.v. "Passions." See also Lorraine Daston and Katharine Park, *Wonders and the Order of Nature, 1150–1750* (New York: Zone, 1998), 303–28.

21. Diderot, *Encyclopédie* (note 4), 8:819, s.v. "Intérêt."

22. Jean-François Marmontel, "Eléments de littérature," quoted in Rémy G. Saisselin, *The Rule of Reason and the Ruses of the Heart: A Philosophical Dictionary of Classical French Criticism, Critics, and Aesthetic Issues* (Cleveland: Press of Case Western Reserve Univ., 1970), 113–15.

23. For a complete background on the development of early primate representation, see H. W. Janson, *Apes and Ape Lore in the Middle Ages and the Renaissance* (London: Warburg Institute, University of London, 1952).

24. See Margret Klinge, *David Teniers the Younger: Paintings, Drawings,* trans. David McLintock (Ghent: Snoeck-Ducaju & Zoon, 1991), 132.

25. Norman Bryson, *Word and Image: French Painting of the Ancien Régime* (Cambridge: Cambridge Univ. Press, 1981), 29–58. See also Jennifer Montagu, *The Expression of the Passions: The Origin and Influence of Charles Le Brun's* Conférence sur l'expression générale et particulière (New Haven: Yale Univ. Press, 1994).

26. For a history of the metaphor *ars simia naturae,* see Janson, *Apes and Ape Lore* (note 23), 287–325.

27. Edward Tyson, *Orang-outang, sive Homo Sylvestris; or, The Anatomy of a Pygmie Compared with That of a Monkey, an Ape, and a Man, to Which Is Added a Philological Essay Concerning the Pygmies, the Cynocephali, the Satyrs, and Sphinges of the Ancients, Wherein It Will Appear That They Are All Either Apes or Monkeys, and Not Men, as Formerly Pretended* (London: printed for Thomas Bennet & Daniel Brown, 1699).

28. Vernon Reynolds, *The Apes: The Gorilla, Chimpanzee, Orangutan, and Gibbon: Their History and Their World* (New York: E. P. Dutton, 1967), 48.

29. See Roger, *The Life Sciences* (note 17), 361.

30. See Sloan, "The Gaze of Natural History" (note 12), 119–20.

31. Diderot, *Encyclopédie* (note 4), 2:685, s.v. "Caricature." See also André Félibien, *Des principes de l'architecture, de la sculpture, de la peinture, et des autres arts qui en dependent,* 2 vols. (Paris: J. B. Coignard, 1676).

32. On the grotesque, see Barbara Maria Stafford, *Body Criticism: Imaging the Unseen in Enlightenment Art and Medicine* (Cambridge: MIT Press, 1991), 266–67; Barbara Maria Stafford, "Difficult Content, or the Pleasures of Viewing Pain," in idem, ed., *Good Looking: Essays on the Virtue of Images* (Cambridge: MIT Press, 1996), 170; and Diderot, *Encyclopédie* (note 4), 7:966, s.v. "Grotesques."

33. E. H. Gombrich, "The Experiment of Caricature," in idem, *Art and Illusion: A Study in the Psychology of Pictorial Representation,* 2d ed. (Princeton: Princeton Univ. Press, 1989), 342.

34. Thomas Hobbes, *Leviathan: Authoritative Text, Backgrounds, Interpretations,* eds. Richard E. Flathman and David Johnston (New York: W. W. Norton, 1997), 35.

35. Blaise Pascal, *Pensées,* trans. A. J. Krailsheimer (1659; Harmondsworth, England: Penguin, 1966), 34.

36. Henri Bergson, *Laughter: An Essay on the Meaning of the Comic,* trans. Cloudesley Brereton and Fred Rothwell (Copenhagen: Green Integer, 1999), 35–37; and Sigmund Freud, *Wit and Its Relation to the Unconscious,* trans. A. A. Brill (New York: Dover, 1993), 336–44.

37. Freud, *Wit and Its Relation* (note 36), 378.

38. Freud, *Wit and Its Relation* (note 36), 342.

39. On William Harvey's *De Generatione Animalium* (1651) and early embryology, see Richard S. Westfall, *The Construction of Modern Science: Mechanisms and Mechanics* (Cambridge: Cambridge Univ. Press, 1977), 97–98; and for an account of Leeuwenhoek's discovery of spermatoza and his formulation of a theory of generation, see Roger, *The Life Sciences* (note 17), 236–56.

40. Pierre Serna, "The Noble," in Michel Vovelle, ed., *Enlightenment Portraits*, trans. Lydia G. Cochrane (Chicago: Univ. of Chicago Press, 1997), 30–84.

41. Thomas L. Hankins, *Science and the Enlightenment* (Cambridge: Cambridge Univ. Press, 1985), 134.

42. Stafford, *Body Criticism* (note 32), 254–66.

43. Diderot, *Encyclopédie* (note 4), 10:671–72, s.v. "Monstre."

44. Voltaire, "Monstres," in idem, *Dictionnaire philosophique* [1764–70], in idem, *Oeuvres complètes,* ed. Louis Moland, 52 vols. (Paris: Chez Garnier, 1870–80), as posted at http://www.voltaire-integral.com/20/monstres (3 May 2002).

45. Battell, *Strange Adventures* (note 11), 55.

46. Alletz, *Histoire des singes* (note 9), 31.

47. John Gay, "The Monkey Who Had Seen the World," in idem, *Fables,* 3d ed. (London: J. Tonson & J. Watts, 1729), 52. See also John Gay, *Le fablier anglais: Fables choisies de Jean Gay, Moore, Wilkie, etc.,* trans. A. Amar du Rivier (Paris: Guilleminet, 1802), 8.

48. Gay, "The Monkey Who Had Seen the World" (note 47), ll. 11–22.

49. Gay, "The Monkey Who Had Seen the World" (note 47), l. 57.

50. Gay, "The Monkey Who Had Seen the World" (note 47), ll. 37–38.

51. Roy Porter, "The Exotic as Erotic: Captain Cook at Tahiti," in G. S. Rousseau and Roy Porter, eds., *Exoticism in the Enlightenment* (Manchester: Manchester Univ. Press, 1990), 117–44.

52. Donna Jeanne Haraway, *Primate Visions: Gender, Race, and Nature in the World of Modern Science* (New York: Routledge, 1989), 10.

53. Cynthia Erb, *Tracking King Kong: A Hollywood Icon in World Culture* (Detroit: Wayne State Univ. Press, 1998), 69. Erb also notes (p. 53) that the film title *King Kong* met with studio resistance for its "Chinese sound." See also Donna Jeanne Haraway, "Apes in Eden, Apes in Space: Mothering as a Scientist for National Geographic," in idem, *Primate Visions: Gender, Race, and Nature in the World of Modern Science* (New York: Routledge, 1989), 133–85.

54. Suzanne Rodin Pucci, "The Discrete Charms of the Exotic: Fictions of the Harem in Eighteenth-Century France," in G. S. Rousseau and Roy Porter, eds., *Exoticism in the Enlightenment* (Manchester: Manchester Univ. Press, 1990), 145–74.

55. Voltaire, *Candide and Other Stories,* trans. Roger Pearson (Oxford: Oxford Univ. Press, 1990), 40–43.

56. Gordon N. Ray, *The Art of the French Illustrated Book, 1700 to 1914* (New York: Pierpont Morgan Library, 1986), 70–72, 87–101.

57. Erb, *Tracking King Kong* (note 53), 73.

58. Voltaire, "Essai sur les moeurs" (note 15), 3:3.

59. See Georges-Louis Leclerc, comte de Buffon, *Histoire naturelle, générale et particulière, avec la description du Cabinet du roi* ... (Paris: Imprimerie Royale, 1750–1804), 14:45, s.v. "Les orang-outangs, ou le Pongo et le Jocko" (by Buffon).

60. Diderot, *Encyclopédie* (note 4), 6:468–76, s.v. "Femme."

61. Lieselotte Steinbrügge, *The Moral Sex: Woman's Nature in the French Enlightenment*, trans. Pamela E. Selwyn (New York: Oxford Univ. Press, 1995), 6. See also Dominique Godineau, "The Woman," in Michel Vovelle, ed., *Enlightenment Portraits*, trans. Lydia G. Cochrane (Chicago: Univ. of Chicago Press, 1997), 399.

62. See Rousseau, "Discourse on the Origin" (note 10), 139–40.

63. See Rousseau, "Discourse on the Origin" (note 10), 217.

64. Buffon, *Histoire naturelle* (note 59), 14:3, 31, s.v. "Nomenclature des singes" (by Buffon).

65. Buffon, *Histoire naturelle* (note 59), 12:xi–xiv, s.v. "De la nature, première vue."

66. Buffon, *Histoire naturelle* (note 59), 14:33–42, 43–71, s.vv. "Nomenclature des singes" (by Buffon), "Les orang-outangs, ou le Pongo et le Jocko" (by Buffon).

67. Richard Milner, "Ape Women, Leakey's Primate Field Observers," in idem, *The Encyclopedia of Evolution: Humanity's Search for Its Origins* (New York: Facts on File, 1990), 20–21; and Haraway, "Apes in Eden, Apes in Space" (note 53).

68. *In the Wild: Orangutans with Julia Roberts*, dir. Nigel Cole, Tigress Productions (ITV/BBC/WNET), 1997.

69. John Cooke, "Lost Jungle Boy Raised by Monkeys," *National Enquirer*, 6 April 1999, 35; and Stephen Jay Gould, "The Human Difference," *New York Times*, 2 July 1999, sec. 1, p. 19.

70. Will Self, *Great Apes* (New York: Grove, 1997).

The Afterlife of Sarah Siddons; or, The Archives of Performance

David Román

In 1999, the eighteenth-century British stage actress Sarah Siddons resurfaced in Southern California. Two exhibitions — *A Passion for Performance: Sarah Siddons and Her Portraitists,* held at the J. Paul Getty Museum, and *Cultivating Celebrity: Portraiture as Publicity in the Career of Sarah Siddons,* held at the Huntington Library, Art Collections, and Botanical Gardens — showcased the figure of Siddons as she was portrayed and publicized in late-eighteenth-century London. Prior to Siddons's resurfacing via these exhibitions and the media coverage they generated, I wonder whether the late-twentieth-century museum-going public was familiar with Siddons's name and achievements.[1] If Siddons escapes immediate recognition in our contemporary moment, it is perhaps because the genres that made her famous — tragic drama, portrait painting, and theater criticism — no longer carry the same cultural weight that they did in eighteenth-century England. Can we name, for instance, a contemporary stage actress whose fame is based upon the virtuosity of her stagecraft and who is known, as Siddons was, for portraying classic roles in theater?

Siddons's performances of famous women — Lady Macbeth, Queen Katharine, Queen Elizabeth, to name a few — made her one of the most talked-about women of her time. Yet we have no direct access to Sarah Siddons, the stage performer. We know Siddons today only as an image, or rather as a series of images and textual descriptions. The primary traces of Siddons's celebrated career are the visual likenesses of her captured by painters of her day and the firsthand accounts of her work and life by those who put them down in writing.[2] Siddons preceded the media on which celebrity now depends: photography, film, television, mass-market magazines, and, increasingly, the Internet.

I am less interested in reviving the celebrity of Sarah Siddons than in thinking through what her cultural afterlife might tell us about performance and its archives. The historical appearance, disappearance, and reappearance of Sarah Siddons beget a series of questions that I address in the following pages: How might performance enable the transmission of cultural memory from one historical moment to another? In what ways might contemporary performances re-embody once celebrated, though now obscure, moments in theatrical history? And what might this re-embodiment tell us about the relationship between the present and the historical past?

These are among the questions that guide Joseph Roach's influential study, *Cities of the Dead: Circum-Atlantic Performance* (1996), in which Roach touches on the different ways that ritual and performance serve as cultural memory. Roach writes that "[t]he social processes of memory and forgetting, familiarly known as culture, may be carried out by a variety of performance events, from stage plays to sacred rites, from carnivals to the invisible rituals of everyday life. To perform in this sense means to bring forth, to make manifest, and to transmit."[3] Roach's work informs my own exploration of memory and performance. And, as Roach makes clear, the idea of the archive is of central importance to this endeavor. Performance archives are generally assumed to be housed in museums or libraries. Roach, however, encourages theater and performance historians to broaden their understanding of the archive, to see that other cultural forms and practices might also connect us to the theatrical past. By examining a wide range of cultural practices, including theatrical and ritual performance, Roach demonstrates how such public events shape our sense of history and tradition. In doing so, he calls into question the power of the written word as the primary authority on, and documentary record of, the cultural past.

The two Los Angeles exhibitions mentioned above situated the figure of Sarah Siddons within the traditional archival settings of the museum and the library. Yet the very nature of Siddons's celebrity prompts us to look elsewhere as well: performance is this archival "elsewhere." While both of these exhibitions successfully showcased the visual and material culture of Siddons's historical period, they less successfully conveyed a sense of her theatrical achievements. The Getty seemed openly aware of the challenge and the desirability of capturing Siddons's brilliance as a performer; in an effort to meet this challenge, the museum commissioned a play on Siddons from the playwright Frank Dwyer.

The Affliction of Glory: A Comedy about Tragedy, which ran concurrently with *A Passion for Performance*, highlights the tensions between the historical past and the contemporary moment, though these tensions never quite resolve into a convincing drama. The play focuses on a young couple, an actress and her actor boyfriend, who are themselves staging a play about Siddons and Sir Joshua Reynolds, a friend and also the painter of Siddons's most famous portrait. Dwyer cast his actors as both the historical figures and the contemporary characters. In the program, Dwyer pondered the relationship between visual culture, lived experience, and the performing arts:

> We're all in motion—in play, as Sarah was—in alchemical process the opposite of Art, our Present becoming our Past. But tonight belongs to us, alive, our being alive heightened as we collaborate together at a play. In the theater we watch the Past become the Present as the Present becomes the Past; and perhaps, if we concentrate, Sarah Siddons may be lured out of her long retirement, may step down from one of her frames (which one, which is the best likeness?), and join us.[4]

Like the exhibition it accompanied, Dwyer's play reveals a great deal about Siddons and her milieu; Dwyer's comments in the program suggest that he, and presumably the Getty, hoped that the play might go further, that it might summon the individual magnetism and dramatic power of Siddons for a late-twentieth-century audience. Instead, *The Affliction of Glory* mainly offered another static representation of Siddons, albeit in a form different from that of the paintings in the Getty galleries. Yet even on the level of visual stage-craft, the play could not compete with the portraits of Siddons on display in the museum.

The primary means by which Siddons's celebrity persists is not theatrical productions such as Dwyer's but a Reynolds portrait of 1784 entitled *Sarah Siddons as the Tragic Muse* (fig. 1). The portrait presents Siddons, an actress who secured her reputation performing tragic roles, as Melpomene, the Tragic Muse of Greek myth. Melpomene is one of the nine Muses, the goddess daughters of Zeus, king of the gods, and Mnemosyne, the goddess of Memory.[5] The Muses presided over the arts and sciences, bestowing the gift of talent and inspiring artists to excel at their craft. In Reynolds's portrait, Siddons is at once the embodiment of Melpomene and also a contemporary materialization of the Tragic Muse. In other words, Siddons assumes the classical guise of the Tragic Muse, and then she herself becomes a muse, an inspiration for her contemporaries—including Reynolds—in both the visual and the performing arts.

If Reynolds is responsible in some measure for transforming Siddons into a muse in her own right, the presence of the painter's image in the portrait may be taken as a reference to this fact. The shadowy figure bearing a chalice to the right of Siddons is based on a prior study, now in the collection of the Tate Gallery, which Reynolds had made of his own face earlier the same year.[6] According to the art historian Jennifer Montagu, this figure recalls not only Reynolds's self-portrait but also the seventeenth-century French painter Charles Le Brun's drawing of the passion of fear, one of the two emotions, along with pity, that Aristotle had associated with tragedy in his *Poetics*.[7] Given the self-possessed, nearly affectless pose of Siddons, the fact that Reynolds would fashion his own likeness into a personification of fear is particularly striking. Certainly, the associative link between portrait and painter, between Siddons and Reynolds, increased their respective celebrity: after the painting was exhibited at the Royal Academy of Arts in London, interest in Siddons was routed through Reynolds, and vice versa.

The circuits of Siddons's celebrity—and, by extension, Reynolds's—are not confined to the museum, the rare-book library, or other repositories of elite culture. Siddons's celebrity also survives within the archives of popular culture. In 1957, for one night only, Bette Davis posed as the Tragic Muse at the thirty-fifth Pageant of the Masters in Laguna Beach, California (fig. 2). The pageant, which is still mounted on an annual basis, re-creates famous works of art as tableaux vivants—living pictures—with live actors onstage depicting famous figures and scenes from the history of Western art. In her

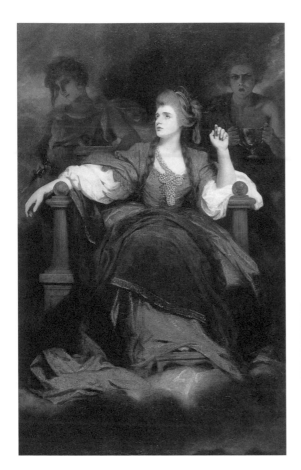

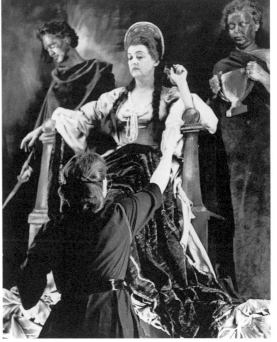

Fig. 1. **Joshua Reynolds (British, 1723–92)**
Sarah Siddons as the Tragic Muse, 1784, oil on canvas,
239.4 × 147.6 cm (94¼ × 58⅛ in.)
San Marino, California, Huntington Library, Art Collections,
and Botanical Gardens

Fig. 2. **Bette Davis as Sir Joshua Reynolds's *Tragic Muse*,
Thirty-fifth Pageant of the Masters, Laguna Beach,
California, 1957**

performance as the Tragic Muse, Davis did not impersonate Siddons, who Davis, of course, could never have met and whose performances Davis could never have seen. Instead, Davis impersonated the Reynolds's portrait of Sarah Siddons, the prior — and celebrated — embodiment of the Tragic Muse. Davis's staging suggests that the portrait no longer signified a personification of the Tragic Muse, a concept apparently lost on contemporary performers and audiences. In effect, Davis cited Siddons as a visual object, a painted portrait, which had become the latter's most famous "role."

The image of Bette Davis as *Sarah Siddons as the Tragic Muse* by Sir Joshua Reynolds calls attention to the various media involved in the cultivation of fame. If portrait painting was the primary means of capturing Siddons's celebrity, Davis's embodiment of Siddons's Tragic Muse reminds us that performance was what lay at the heart of Siddons's fame. That is to say, Siddons was an actress before she was the subject of a painting. But if, as various scholars have discussed, performances are ephemeral, where are we to find the archives of past performances?[8]

Davis's tableau vivant of 1957 sheds light on this very question since it brings to the fore both the archive of Siddons's celebrity and its intrinsic instability. While Davis embodied a painting rather than a theatrical role made famous by Siddons, Davis may have inadvertently impersonated an actual Sarah Siddons performance. Consider that in November 1785, as part of the Drury Lane revival of David Garrick's Shakespeare Jubilee (1769), Siddons herself staged a tableau vivant of Reynolds's portrait *Sarah Siddons as the Tragic Muse*.[9] Thus, at the Pageant of the Masters in 1957, Davis demonstrated how live performance remembers not only performances from an earlier historical moment but also the prior archives of those past performances. Rather than insisting on performance's ephemerality, then, we might want to consider the fact that contemporary performances revive past performances, while past performances are manifest in contemporary ones. In this way, performance serves as its own archive — performance is the means by which past performances are revived. In the case of Sarah Siddons, performance is the place where celebrity was first located and then subsequently preserved and even cultivated.

For fans of Bette Davis, the irony is that her portrayal of *Sarah Siddons as the Tragic Muse* cites not only a Siddons performance but also one of Davis's own prior performances, drawn from her own film archive. *All about Eve* (1950) stars Bette Davis as Margo Channing, a famous and accomplished stage actress who is ultimately supplanted by Eve Harrington, an aspiring and manipulative younger actress. In the process of paying tribute to Siddons, *All about Eve* demonstrates how celebrity is partially secured by the performative citation of already famous people. The movie begins and ends at an awards ceremony: Eve, played by Anne Baxter, is receiving the Sarah Siddons Award for Distinguished Achievement (fig. 3). The design of the Sarah Siddons Award (fig. 4), a statuette of Siddons in her pose as the Tragic Muse, at once memorializes and miniaturizes the Reynolds painting, adding yet another level to the citational dimension of the film.[10]

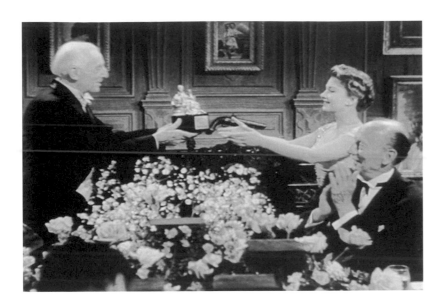

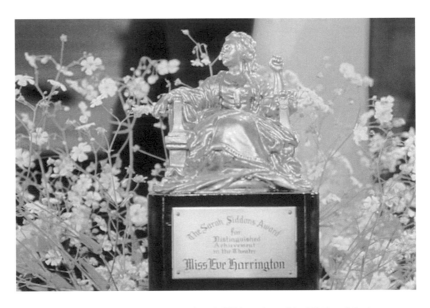

Fig. 3. Eve Harrington (Anne Baxter) receiving the Sarah Siddons Award for Distinguished Achievement
Film still from *All about Eve,* dir. Joseph L. Mankiewicz, Twentieth Century Fox, 1950

Fig. 4. Sarah Siddons Award for Distinguished Achievement
Film still from *All about Eve,* dir. Joseph L. Mankiewicz, Twentieth Century Fox, 1950

Eve begins as Margo's most devoted fan but soon becomes her assistant, then her understudy, and finally her rival. It is Eve who ultimately receives the Sarah Siddons Award. Yet it is Margo, Bette Davis's character, who holds the associative link with Siddons. Like Sarah Siddons, Margo Channing inspires fandom.[11] And both actresses signify artistic virtuosity. The film secures the link between Siddons and Channing in its famous party scene: while Eve plots to become Margo's understudy, Margo begins to realize the extent to which the world she has built in order to sustain her own celebrity—a world composed not only of her lover, friends, and assistants but also theater critics, producers, and agents—has been infiltrated by the younger actress. At precisely the moment in the narrative when Margo is most vulnerable, the film positions her physically in relation to Siddons (fig. 5), thus ensuring that we place Margo in a genealogy of theatrical celebrity. The very last shot in this scene is a close-up of the copy of *Sarah Siddons as the Tragic Muse* that adorns a wall in Margo's apartment (fig. 6). The presence of the Siddons portrait reveals Margo's own identification with the eighteenth-century actress, and it establishes Margo as Siddons's heir. And yet, Eve—what are we to make of Eve's impersonation of Margo, so successful that it allows Eve to usurp Margo's claim to the Sarah Siddons Award? *All about Eve* suggests that the key to celebrity is an impersonation of a star so aggressive that it ultimately becomes a violent displacement.

All about Eve is framed by Eve's moment of triumph as she receives the Sarah Siddons Award. Yet the film insists that we recognize this moment as an injustice to Margo Channing. While Eve displaces Margo within the narrative of the film, thus making it, at least on the level of the plot, all about Eve, Bette Davis lays claim to the role of legendary star, of diva, to which the name and portrait of Sarah Siddons refer in the film. To be sure, it is Bette Davis, not Anne Baxter, who is remembered for her performance in *All about Eve*, celebrated as an icon of her period, and now herself imitated by other performers.

If performance is its own kind of archive, where are the performances that cite Bette Davis's celebrity? And do these performances, like Eve's in *All about Eve*, aggressively displace the original star? With these questions in mind, I would like to consider another actor who contributed to the legacy of female celebrity and theatrical virtuosity—a performer who built a career on impersonating other stars, most notably Bette Davis. Charles Pierce, the most successful drag performer of his generation, considered himself a "male actress"— a man who performed female roles in the theater—rather than a female impersonator. Pierce performed his first female role in 1969, the year of the Stonewall rebellion, the New York City riot that marked the beginning of the modern gay and lesbian liberation movement.[12] Pierce was in his early forties at the time. Before Stonewall, Pierce wrote comic material for other performers and took male character parts at the Pasadena Playhouse in California, where he trained as an actor. In the early 1950s, he started performing his own stand-up comedy in gay clubs; by the end of the decade, Pierce's routine included lip-synching. In many ways, Pierce's career, which first took off in

Fig. 5. Margo Channing (Bette Davis) with Joshua Reynolds's *Sarah Siddons as the Tragic Muse*
Film still from *All about Eve,* dir. Joseph L. Mankiewicz, Twentieth Century Fox, 1950

Fig. 6. Joshua Reynolds's *Sarah Siddons as the Tragic Muse*
Film still from *All about Eve,* dir. Joseph L. Mankiewicz, Twentieth Century Fox, 1950

these nightclubs and bars, mirrored the gay subculture's own increasing visibility. Pierce worked the clubs of Miami and San Francisco, developing a repertoire of female impersonations and pantomimes, often with puppets. Pierce's over-the-top rendition of already outrageous female icons such as Mae West and Tallulah Bankhead established his cult status among his many gay fans. In the wake of Stonewall, and in the years before AIDS, Pierce's drag performances were legendary for their wit and virtuosity.

Pierce's most famous role, the role that secured his own reputation as a theatrical star, was that of Bette Davis. At the height of his career, in the early 1980s, Pierce performed his Davis impersonations—along with various renditions of other stars—at the prestigious Dorothy Chandler Pavilion at the Music Center in Los Angeles. The poster for the show, which was billed as *Charles Pierce: First Annual Farewell Performance*, featured a photo of Pierce, cigarette in hand, coiffed and posed in classic Bette Davis-style (fig. 7).[13] Shortly after this Los Angeles performance, Pierce starred in San Francisco as Margo Channing in *Applause*, the Broadway musical version of *All about Eve*.[14] Throughout his life and work, Pierce championed Bette Davis's career. His performances were a tribute to Davis's stardom, and, as such, they helped perpetuate Davis's own celebrity, much as hers had helped perpetuate Sarah Siddons's.

Charles Pierce died in 1999. He was seventy-two years old. In the obituaries published in the gay and mainstream press, Pierce was celebrated as a star, a person whose performances had achieved legendary status. Pierce's death begs the question I have been asking of previous stars such as Sarah Siddons and Bette Davis: how will his performance of celebrity be remembered and archived? Before Pierce died, he gathered together his scrapbooks, photographs, programs, recordings, and videotapes and shipped them to the New York Public Library for the Performing Arts at Lincoln Center. The staff completed cataloging Pierce's archive only weeks before his death. But if, as I have been arguing, performance can serve as its own archive, I wonder who has been studying his work and if it will be re-embodied in the future.

To recover the work of Charles Pierce through the available documentation of his career—a set of flyers and reviews, some press photographs and playbills, a few bootleg videotapes—would certainly prove to be a challenge. No less difficult, it seems to me, would be the attempt to recover the theatrical performances of Sarah Siddons by viewing her painted portraits. Yet despite this challenge, nearly two years after his death Charles Pierce resurfaced in Los Angeles; like Sarah Siddons before him, whose Southern California revival nearly coincided with the date of Pierce's death, Pierce was the subject of an exhibition. *Satirist in Sequins: The World of Charles Pierce* helped launch the ONE Institute and Archives at the University of Southern California; the institute houses an extensive collection of art, ephemera, books, manuscripts, and archival materials documenting the lives of gay, lesbian, bisexual, and transgendered people. *Satirist in Sequins* displayed a selection of Pierce's costumes, promotional photographs, program books, and other theater paraphernalia

Fig. 7. Advertisement for the show *Charles Pierce: First Annual Farewell Performance* at the Dorothy Chandler Pavilion, Los Angeles, 1983

Fig. 8. Charles Pierce memorabilia at *Satirist in Sequins: The World of Charles Pierce,* ONE Institute and Archives, Los Angeles, 2001

related to his career (fig. 8). In an adjacent room, a videotape of Pierce in performance — as Bette Davis, Tallulah Bankhead, Joan Crawford, and Mae West, among others — ran on a continuous loop.

During the opening festivities of the ONE Institute, various friends and fans of Pierce gathered at the exhibition to share stories and recollections of his artistic life. The exhibition enabled these friends and fans to reenact their memories of Pierce. But it also invited those who had never seen Pierce onstage to revel in his theatrical persona and achievements. This essay has been an attempt to propose that theatrical performance survives not only in the memory of those who witness it but also in the re-embodiment of it by other actors for other audiences. Such performances help shape a history that exceeds the traditional archival system of the museum, the library, and the university — a history that endures and is passed on through performances that archive the past even as they restage it.

Notes

A version of this essay was first presented at a panel on celebrity culture at the J. Paul Getty Museum in fall 1999. My thanks to Leo Braudy, Nancy Troy, and Richard Meyer for various forms of intellectual engagement and support.

1. Christine Nipe provides a very helpful survey of the Sarah Siddons exhibitions and the other cultural events surrounding them in "Mrs. Siddons' Currency," *Theatre Survey* 40, no. 2 (1999): 70–77.

2. For a bibliography on Sarah Siddons, see Shearer West, "The Public and Private Roles of Sarah Siddons," and Robyn Asleson, "'She Was Tragedy Personified': Crafting the Siddons Legend in Art and Life," both in Robyn Asleson, ed., *A Passion for Performance: Sarah Siddons and Her Portraitists*, exh. cat. (Los Angeles: J. Paul Getty Museum, 1999), 1–39, 41–95. See also Ellen Donkin's interesting work on Siddons and her reception among eighteenth-century theater audiences, "Mrs. Siddons Looks Back in Anger: Feminist Historiography for Eighteenth-Century British Theater," in Janelle G. Reinelt and Joseph R. Roach, eds., *Critical Theory and Performance* (Ann Arbor: Univ. of Michigan Press, 1992), 276–90.

3. Joseph Roach, *Cities of the Dead: Circum-Atlantic Performance* (New York: Columbia Univ. Press, 1996), xi.

4. Frank Dwyer, "Searching for Sarah," published in the program for *The Affliction of Glory: A Comedy about Tragedy*, a play written by Frank Dwyer and directed by Corey Madden, produced by the J. Paul Getty Museum and the Center Theatre Group/Mark Taper Forum, Harold M. Williams Auditorium, Getty Center, Los Angeles, California, 14 August–5 September 1999, 3.

5. "In ancient Greek myth, Mnemosyne (Memory), the mother of the Muses, is said to know everything, past, present, and future. She is the Memory that is the basis of all life and creativity. Forgetting the true order and origin of things is often tantamount to death (as in the case of Lethe, the river of death in Greek mythology, which destroys memory)"; see *Encyclopedia Britannica Online*, s.v. "myth," http://search.eb.com/bol/topic?eu=115608&sctn=36&pm=1 (27 March 2002).

6. See Jennifer Montagu, *The Expression of the Passions: The Origin and Influence of Charles Le Brun's* Conférence sur l'expression générale et particulière (New Haven: Yale Univ. Press, 1994), 90, 210 n. 17.

7. Montagu, *The Expression of the Passions* (note 6), 90.

8. See Peggy Phelan, *Unmarked: The Politics of Performance* (New York: Routledge, 1993).

9. See Robyn Asleson, "A Sarah Siddons Chronology," in idem, ed., *A Passion for Performance: Sarah Siddons and Her Portraitists,* exh. cat. (Los Angeles: J. Paul Getty Museum, 1999), xv: "1785, 18 December: Drury Lane revives Garrick's Shakespeare Jubilee. Siddons, eight months pregnant, appears as the Tragic Muse in a re-creation of Reynolds's painting."

10. *All about Eve*'s attention to Siddons inspired a group of theater aficionados in Chicago to establish a Sarah Siddons Society. The society grants an annual award to an outstanding stage actress. Helen Hayes was the first to receive the award for her 1952 performance in *Mrs. McThing.*

11. On Siddons and her fans, see West, "The Public and Private Roles" (note 2), 17–20; West describes the behavior of Siddons's audiences, especially women spectators, and the consumer culture around souvenirs, especially Siddons miniatures, that stemmed from her performances.

12. For a fascinating study of the Stonewall riots, see Martin Duberman, *Stonewall* (New York: Dutton, 1993).

13. The Playboy Channel televised a one-hour version of Charles Pierce's show called *Legends of the Silver Screen.*

14. *Applause,* with a book by Betty Comden and Adolph Green, music by Charles Strause, and lyrics by Lee Adams opened on Broadway at the Palace Theatre in March 1970; the play starred Lauren Bacall as Margo Channing. *Applause* won four of its eleven Tony Award nominations, including Best Musical and Best Actress. *Applause* had a very successful 896-performance run on Broadway. When Bacall left the Broadway cast to launch the North American tour, the producers cast Anne Baxter, who played Eve Harrington in *All about Eve,* as her replacement. For a fascinating account of the making of *Applause* as well as the film *All about Eve,* see Sam Staggs, *All about All about Eve: The Complete Behind-the-Scenes Story of the Bitchiest Film Ever Made* (New York: St. Martin's, 2000).

Pulling Ribbons from Mouths:
Roland Barthes's Umbilical Referent
Carol Mavor

The subject of nostalgia comes into the picture: it belongs to the precarious hold that a person may have on the inner representation of a lost object.

— D. W. Winnicott[1]

Now I was no longer separated from her; the barriers were down; an exquisite thread united us. Besides, that was not all: for surely Mamma would come.

— Marcel Proust[2]

On 7 January 1977 Roland Barthes gave his inaugural lecture at the Collège de France in Paris. The scene: a jam-packed hall with people filling the seats, sitting on the floor, and even spilling out into the halls.[3] All wanted a glimpse of Barthes. All wanted the satisfaction of hearing his velvety voice, "resonant and what the French call *chantante*."[4] "Suddenly the noise died down and Roland came from the back of the hall and walked towards the platform, [his mother] Henriette on his arm as if a marriage was about to take place. Henriette took her seat in the front row while her son took his place behind the microphone on the platform."[5] ("I have never seen a finer love," Barthes's friend and fellow theorist Algirdas Julien Greimas would later claim.)[6] Among the ribbons of infra-language that Barthes pulled from his mouth that day, I am touched by these: "I should therefore like the speaking and the listening that will be interwoven here to resemble the comings and goings of a child playing beside his mother, leaving her, returning to bring her a pebble, a piece of string, and thereby tracing around a calm center a whole locus of play."[7]

Like Proust (whom Walter Benjamin described as "that aged child"),[8] Barthes was a boyish man, forever tied to his mother in both his writings and his day-to-day life. Coming and going, Barthes would always return to her with his own pebbles and string. She was the peaceful center of his life. Even after he was grown, Barthes would come home for lunch (almost every day) by climbing down from his upstairs Paris apartment through a trapdoor to his mother's apartment below.[9] A gay man, Barthes fulfilled the stereotype of being too passionately close to the mother. To be "tied to the apron strings (of a mother)," so says the *Oxford English Dictionary,* is to be "wholly under her influence."[10] Barthes played best (perhaps even solely) with his mother:

When I was a child, we lived in a neighborhood called Marac; this neighborhood was full of houses being built, and the children played in the building sites; huge holes had been dug in the loamy soil for the foundations of the houses, and one day when we had been playing in one of these, all the children climbed out except me — I couldn't make it. From the brink up above, they teased me: lost! alone! spied on! excluded! (to be excluded is not to be outside, it is to be *alone in the hole,* imprisoned under the open sky: *precluded*); then I saw my mother running up; she pulled me out of there and took me far away from the children — against them.[11]

"The writer is someone who plays with his mother's body," Barthes famously claims in *The Pleasure of the Text* (1975; originally published as *Le plaisir du texte,* 1973).[12] The critic Susan Suleiman suggests persuasively that Barthes closes off the mother from the space of playing.[13] I am choosing to see Barthes's mother as playing *outside* of his games (literature, theory, semiotics, etc.) — but always in a shared space, "far away from the children — against them."

Barthes's playful words at his inaugural Collège de France lecture, his description of "the comings and goings of a child playing beside his mother, leaving her, returning to bring her a pebble, a piece of string, and thereby tracing around a calm center a whole locus of play," mirror the mise-en-scène of the British psychoanalyst D. W. Winnicott's "good-enough mother": the mother who gives both herself and her child independence, sitting peacefully with her own work, perhaps reading or knitting, while the child plays in the light of her enveloping (not smothering) nurture. Winnicott's most famous essay, "Transitional Objects and Transitional Phenomena" (1953), focuses not only on the "good-enough mother" but also, as the title makes clear, on the "transitional object": a child's blanket, doll, teddy bear, or even cooing song — something given to the child to stand in for the lost or missing mother. It is significant that, for Winnicott, the infant's act of vesting the transitional object with meaning is the beginning of creative life, the first instance of making art. Mother is not only at the heart of art but also care, which is never far from Winnicott's particular vision of cure. In Winnicott's own words, "I believe cure at its root means care."[14] For Winnicott, the model for both psychoanalytic practice and creative life is a gift given to us by our mothers at the start of our lives, like a package tied with string. String *joins,* like the umbilical cord between a mother and an infant. String *holds* unintegrated material together: "String can be looked upon as an extension of all other techniques of communication ... [it] helps in the wrapping."[15]

Barthes's inaugural lecture was a "foretaste of the book he had just completed and would publish three months later with the title *A Lover's Discourse,*"[16] a book that would draw a whole area of play around the mother, with references to Winnicott's work. The Winnicottian scene nourished Barthes — he was like a child still in touch with the presence of a "good-enough mother" — enabling him to weave the texture not only of his inaugural speech

and *A Lover's Discourse* (1978; originally published as *Fragments d'un discours amoureux,* 1977) but also, several years later, *Camera Lucida: Reflections on Photography* (1981; originally published as *La chambre claire: Note sur la photographie,* 1980). (One wonders what Henriette was doing, thinking, playing through her mind while she sat below the stage of her son's performance at the Collège de France.)

Barthes's longtime friend and frequent translator, Richard Howard, observed Barthes and his mother on a trip to New York in the mid-1960s: Henriette was wearing her traveling costume (evidence of the source of Barthes's own love of a "certain kind of 'British' tailoring").[17] Looking back, Howard recalled that "one saw from their way of being together, from an interest in each other quite without inquisitiveness, that this mother and this son were able—rarest of family rituals—to enjoy the world they shared. It was not necessarily his world (or hers)....My discovery that his mother did not read his books, and that Roland did not expect her to, eased some family tensions of my own; this was but one of many lessons my friend was to impart."[18] Barthes touches on this subject himself in *Camera Lucida:* "I never educated my mother, never converted her to anything at all: in a sense I never 'spoke' to her, never 'discoursed' in her presence, for her; we supposed, without saying anything of the kind to each other, that the frivolous insignificance of language, the suspension of images must be the very space of love, its music."[19] Henriette provided Barthes with something more honorable, more precious than semiotic squibbles or heavy cultural observations: a world partaken together, their world, out of this world.

Led out by his mother's hand (her apron strings), Barthes returned (as he would again and again) to Maman. ("From the brink up above, they teased me:...*alone in the hole,* imprisoned under the open sky: *precluded...* then I saw my mother running up; she pulled me out of there and took me far away from the children—against them.") In *The Pleasure of the Text,* Barthes paraphrases his boyish, indeed effeminate, arguably queer desire to be dependent: "The pleasure of the text is not necessarily of a triumphant, heroic muscular type. No need to throw out one's chest. My pleasure can very well take the form of a drift."[20] The pleasure of reading and writing becomes a drift, a cruise: "I must seek out this reader (must 'cruise' him) *without knowing where he is.* A site of bliss is then created [Ce lecteur, il faut que je la cherche (que je la "drague"), *sans savoir où il est.* Un espace de la jouissance est alors créé]."[21]

Henriette was Barthes's bliss, his *jouissance.*[22] His passion was for her. (It was not passion as in a passion for theater, Havana cigars, opera, a little Campari, film, Japanese meals, white peaches, too-cold beer, Pollock—other, smaller, passions of Barthes's.)[23] Barthes's maternal appetite was bodily and beyond language: "Pleasure can be expressed in words, bliss cannot. Bliss is unspeakable, inter-dicted."[24]

Yet, as Barthes tells us, bliss is not far from boredom. If boredom is desire for desire—Adam Phillips's attentive take on it[25]—then one must use the

body to crack, sever, fissure boredom's shell so as to come into the bliss (desire itself) that awaits us. (In Benjamin's eloquent words, "Boredom is the dream bird that hatches the egg of experience.")[26] For Barthes, when the body cuts into the text, in an involuntary act separate from one's intellectual pursuits, the "prattle-text" is transformed into exquisite sensation, into bliss: "If the prattle-text [*le texte-babil*] bores me personally, it is because in reality I do not like the demand. But what if I did like it (if I had some maternal appetite)? Boredom is not far from bliss: it is bliss seen from the shores of pleasure."[27] In other words, to be bored is to merely see pleasure, as one sees the shore of a utopic island from the mainland; and to see pleasure (to read it) is not necessarily to experience it: one must inhabit it. (The mother is not bored by the prattle of her child: spoken from a body that was once a graft upon herself, the words from the mouth of her now-detached little one caress her ears, a site of bliss is created—there is no distance here, no shore from the other side.) To experience pleasure as *of the body*—as opposed to merely seeing it, writing it, picturing it, speaking it, reading it from a distance—is to come into bliss, one might even say to suffer from it. "My body does not have the same ideas I do,"[28] writes Barthes. Overwhelmed with sensation—whether of the "composite odor" of his childhood summers in "Petit-Bayonne (the neighborhood between the Nive and the Adour)," with its smells of "the rope used by the sandal makers, the dim grocery shop, the wax of the old wood, the airless staircases, the black of the old Basque women...Spanish oil...the dust in the municipal library (where I learned about sexuality from Suetonius and Martial), the glue of pianos being repaired...chocolate,"[29] or whether of "the rumpled softness of [his mother's] crêpe de Chine and the perfume of her rice powder," awakened by an old photograph in which "she is hugging me, a child, against her"[30]—Barthes feels bodily desire as passionately at odds with consciousness.

One can, it seems, only *happen* upon this maternal appetite—it finds you. In *The Pleasure of the Text,* Barthes calls it *jouissance.* In *Á la recherche du temps perdu,* Proust expresses it as "une mémoire involuntaire."[31] (Whose writing did Barthes love more than Proust's?) The odor of Proust returns often in the textures of Barthes's perfume. When it finds you, this maternal appetite, then one can indulge in the taste of the madeleine. And whether this maternal appetite is an appetite *for* the mother or *of* the mother, Barthes is purposely ambiguous, although one feels relatively sure that it is both. In Barthes's hands, just like the pleasure *of* the text, the maternal becomes both the object and the subject of his bliss. To eat the madeleine cake is to eat the mother as well as to become her. Of the sensation of tasting his maternal madeleine, Proust writes, it "had the effect, which love has, of filling me with a precious essence;...not in me, it *was* me."[32] Tiny and almost impalpable, this maternal appetite is best evoked in Barthes's tender love for certain photographs, where the referent plays there and gone, hide and seek, just like a mother.

The Spool Hits His Heart: Camera Lucida

In *Camera Lucida* (the book that Barthes wrote after his mother's death and the last book that he would publish before his own death), the referent's "umbilical" connection to the actual photograph is a queer metaphor informed by Barthes's relationship to his mother. Just as Barthes's search for perfect lovers in *A Lover's Discourse* — and also in the posthumously published *Incidents* (1992; originally published in French in 1987) — often hinges on memories of, or experiences with, the mother, Barthes's search for the most meaningful, most moving, most touching, most poignant, most wounding photograph turns out to be a search for the perfect photograph of *her*, for *the* perfect photograph: "la Photographie du Jardin d'Hiver" (the Winter Garden Photograph), taken of Henriette at age five in 1898. Threading together incidents, anecdotes, and semiotic squibbles on the meaning of photography, *Camera Lucida*'s well-strung speech suspends Barthes and his stories like old-fashioned pearls, forever clasped around his mother's tender neck. For Barthes, the link of the photograph to its referent is maternal.

Camera Lucida developed quickly — between 15 April and 3 June 1979 — like a photograph. In fact, it developed extra quickly, like a Polaroid picture, like purple spring crocus, like a last breath before death. Barthes died in 1980, the year that *Camera Lucida* was published. Critically injured when "knocked down by a laundry truck while crossing the street in front of the Collège de France," Barthes lingered, as if toying with death, as if playing with the idea of going with his mother: "Though he recovered sufficiently to receive visitors, he died fours weeks later."[33] It has been suggested that he died of a broken heart, of broken heartstrings. In *Camera Lucida*, Barthes himself predicts his death by lethal sorrow: "Once she was dead I no longer had any reason to attune myself to the progress of the superior Life Force (the race, the species).... From now on I could no more than await my total, undialectical death."[34] In his last letter to Richard Howard, four months before the accident, the broken Barthes, bereft of desire, writes: "Don't think me indifferent or ungrateful — it's just that since Maman's death there has been a scission in my life, in my psyche, and I have less courage to undertake things. Don't hold it against me. *Ne m'en veuillez pas.*"[35]

Without his mother, Barthes fears that he will desire nothing, that he will no longer speak his mother tongue (*la langue maternelle*). He finds himself to be alone. As Barthes remarks in *S/Z* (1974; originally published in French in 1970), long before his loss of Maman: "When it is alone, the voice does no labor, transforms nothing: it [merely] *expresses;* but as soon as the hand intervenes to gather and intertwine the inert threads, there is labor, there is transformation."[36] For Barthes, the labor that comes from the body — the hand that intervenes — produces "*text, fabric, braid:* the same thing."[37] But without his mother, labor might no longer be possible: the braid (the umbilical cord) is under the dark shadow of the scissors. To be reduced to a "unity of meaning" is "to *cut the braid.*"[38]

The first page of *Camera Lucida* is not text, but just image, a just image.

Fig. 1. Daniel Boudinet (French, 1945–90)
Polaroïd
From Roland Barthes, *La chambre claire: Note sur la photographie*
(Paris: Gallimard, 1980), 9

Polaroïd, as it is called, is a photograph of a bed taken in 1979 by Daniel Boudinet (fig. 1). (We are born from mothers in bed. We die in bed. We have sex in bed. We write in bed. We eat in bed.) It is the only photograph in the book about which Barthes says nothing. For me, *Polaroïd* is the companion of the Winter Garden Photograph: the photograph that Barthes talks most about but never reproduces.[39] As he writes in *Camera Lucida,* "In front of the photograph of my mother as a child, I tell myself: she is going to die: I shudder, like Winnicott's psychotic patient, *over a catastrophe which has already occurred.*"[40] *Polaroïd* has no text: the Winter Garden Photograph has no image. They are a queer couple (not unlike Barthes and his mother).

Womblike, the light from *Polaroïd'*s window is diffused by gauzy curtains. Bits of light creep in through the loose weave of the fabric. Light leaks (where the curtains barely part, near the pillow) and drifts (through a small number of thin, select tears in the fabric). By invoking at once a watery membrane and aging sagging skin, the curtains pull at the delicate and somber texture of *Camera Lucida.* Soaked in precious robin's-egg blue, *Polaroïd* is the only color photograph among a total of twenty-five. The lovely color, a range of creamy green blues, gray green blues, and charcoal blues infused with flickers of white light, is a surprise. Barthes does not like color photographs. He writes in *Camera Lucida:* "I always feel ... that ... color is a coating applied *later on* to the original truth of the black-and-white photograph. For me, color is an artifice, a cosmetic (like the kind used to paint corpses)."[41]

Polaroïd is one of only two pictures in *Camera Lucida* without people — the other is Joseph Niépce's *The Dinner Table* (circa 1823). Barthes's words dress *Polaroïd* not only in death but also in the eyes of his mother. Searching through old photographs of Henriette, Barthes reminisces on the luminosity of her eyes: "For the moment it was a quite physical luminosity, the photographic trace of a color, the blue-green of her pupils."[42] As Diana Knight so cleverly points out: "This ... is the mediating light that will lead him at last to the essence of her face, a blue-green luminosity which is also that of the Boudinet polaroid."[43]

Polaroïd is both domestic and erotic. The late artist Félix González-Torres, himself a lover of Barthes (at least of his words), must have been inspired by Barthes's use of the Boudinet picture; González-Torres's own beautiful billboard of an empty bed is alive with crumpled sheets and the indexical remains of loss (fig. 2).[44] I am moved by the indentation, where a head once rested on the white, white pillows. (Now familiar with González-Torres's work and biography, I understand that it was the head of his lover Ross that left the trace in the pillow; but initially I could dream of who had been in his rumpled bed. Himself? An unnamed lover? His mother?) Barthes's use of Boudinet's picture also takes me back to Imogen Cunningham's *The Unmade Bed,* a portrait of an empty bed, save for a few hairpins which, despite their small size and their delicate being, take over the picture (fig. 3). The hairpins (a heavyset threesome and a lanky twosome) are the kind that women used to wear when it was popular, perhaps even necessary, to have long hair that could be pulled

Fig. 2. Félix González-Torres (Cuban-born American, 1957–96)
"Untitled," 1991, billboard
Installation at Bloomberg Offices, Finsbury Square, London

Fig. 3. Imogen Cunningham (American, 1883–1976)
The Unmade Bed, silver gelatin print from negative of 1957
Berkeley, Imogen Cunningham Trust

up in chignons or wrapped up in buns. They are evidence of hair taken down for its erotic effects. Forgotten in a bed, the hairpins become iconographic signs of something lost. Perhaps the braid has been cut; the hairpins are now catastrophic signs of remainder without return. (Is sex ever without loss?) Yet, the hairpins also stubbornly (and pleasurably) point back to a grandmother's white hair. (Mine bought these pins in silver, not black. They were hard to find.) The hairpins may poke at eroticism, but (for me at least) they also poke at a maternal, grandmotherly goodness which (rightly or wrongly) is not accustomed to traveling in erotic circles. Prosthetic tongues, these hairpins waver and bend their own secret letters, so as to sound out "mother" and "erotic" ("motherotic"), in an unfamiliar, if welcomed, mother tongue.

Camera Lucida is dark. The book, as if it were a night-blooming cereus, opens in darkness and then quickly fades. Barthes writes that he wants to "be a primitive, without culture,"[45] without light. His labor is to patch light leaks. Like the photographer who pulls a black cloth over his head in order to see the upside-down image reflected on the camera's back, Barthes can see better in darkness; this is his photopathy. "In order to see a photograph well, it is best to…close your eyes…. My stories are a way of shutting my eyes"[46] (fig. 4). He shuts his eyes and dreams about *her*. Barthes confesses: "I dream only about her."[47]

Barthes lives his mother's memory like a photograph: as both there and gone. Just as Sigmund Freud's young grandson Ernst invented a game in order to cope with his mother's absence, Barthes invents a game for reading photographs in order to cope with the loss of his mother. Ernst threw a wooden spool on a string-turned-toy, back and forth. When the spool was close to him, he said a happy *da* for *there,* and when the spool was away, he said a sorrowful *fort* for *gone*.[48] Barthes throws the contradictory *there-gone* condition of the photograph back and forth. All photographs play there and gone. But when a photograph specifically touches Barthes, moves him, wounds him, his "spool" hits his heart: "The text no longer has the sentence for its model [but the mother];… it is a powerful gush of words, a ribbon of infra-language."[49] Barthes discovers photographs which speak to him, which whisper *her* voice (*her* grain),[50] which awaken in him "the rumpled softness of her crêpe de Chine and the perfume of her rice powder."

In *Camera Lucida*, Barthes's mother becomes other than "mother," what Barthes calls elsewhere "family without the familialism."[51] When Barthes is caring for her at the end of her life, she becomes the child, his child, "his little girl." Barthes writes: "During her illness, I nursed her, held the bowl of tea she liked because it was easier to drink from than from a cup; she had become my little girl, uniting for me with that essential child she was in her first photograph."[52] Henriette is Barthes's Ariadne; she gives him the thread to photography (to life).

In the theater of *Camera Lucida*, Henriette plays not only mother-turned-daughter but also mother-turned-wife, as is dramatically implied by Barthes's caption for Félix Nadar's photograph of his wife Ernestine: "The Artist's

Like the beautiful bodies of those who died before growing old, sadly shut away in a sumptuous mausoleum, roses by the head, jasmine at the feet — so appear the longings that have passed without being satisfied, not one of them granted a single night of pleasure, or one of its radiant mornings. C. P. Cavafy

Fig. 4. Amos Badertscher (American, b. ca. 1940)
Untitled, 1975
From Amos Badertscher, *Baltimore Portraits* (Durham, N.C.: Duke Univ. Press, 1999), [77]

Fig. 5. Félix Nadar (French, 1820–1910)
Ernestine Nadar, modern print from negative of ca. 1890
Paris, Caisse Nationale des Monuments Historiques et des Sites

Mother (or Wife)" (fig. 5).[53] In Nadar's photograph, Ernestine is paralyzed, partially bedridden; her hair is soft, white, appealingly disheveled; she plays with our expectations, she (an old woman!) flirts with the camera, her husband *or* her son. Ernestine, whom Nadar called "Madame Bonne,"[54] sensually holds a bouquet of violets to her mouth, as if she were a young girl, as if she were Édouard Manet's *Street Singer*. When writing about Nadar's picture, Barthes compares the unknown photographer of the Winter Garden Photograph to Nadar, just as he compares the photograph of Henriette at age five (taken in 1898) to the photograph of the elderly Ernestine (taken in 1890): "The unknown photographer of Chennevières-sur-Marne [who took the Winter Garden Photograph] had been the mediator of a truth, as much as Nadar making of his mother (or of his wife — no one knows for certain) one of the loveliest photographs in the world; he had produced a supererogatory photograph which contained more than what the technical being of photography can reasonably offer."[55] Those familiar with the history of photography understand that Barthes is playing with the possibility that this late photograph of Nadar's could have been taken by his son Paul. But in Barthes's hands (the hands of an eternal boy-child), the picture plays with love between a grown son and his mother as erotic, as too close, as unnatural, as inverted — as many understood Barthes's relationship to his Maman, his Henriette, to be. (As Barthes writes of the mother in Bertolt Brecht's *The Mother:* "She is not the expected figure of maternal instinct, she is not the essential mother: her being is not on the level of the womb.")[56]

Tied to the Mother Tongue

As a sign for his utopic travels, which thrust him forward and backward at once (*fort/da*), Barthes metaphorically reunites with the maternal through the umbilical cord. Almost organ, but not, this strange form is exceptional: both sexes share it while still in the womb. Originally and always neither the child's nor the mother's, it dramatically connects to both *him* and *her,* maintaining (as Luce Irigaray celebrates in "(W)rest(l)ing with the Mother") an ethics of sexual difference through connection and nurturance.[57] Connecting mother to child and child to mother, the umbilical cord with its surreal "neither-nor" sex performs its beauty as *fort/da* toy. For Barthes, the umbilical cord doubles as a sign for his connection to his mother (both there and gone) and for the photograph's connection to its referent (both there and gone). Mother and photography owe their "genius" to their relation to the real: one is certain of having been there (in the mother's body), and one can also say for certain (at least Barthes can) that the person photographed was there. Barthes adheres to his Maman, just as the referent adheres to the photograph.

Barthes's love for his mother is the archetype not so much for the photograph but, rather, for *the condition of* photography.[58] Led by the thread of words, caught in a(maze)ment for her, Barthes's photographic discourse becomes the maternal body: a place that was always already there, a place where he was sure that he had once been, a place that he could never fully

leave … the maternal body as *the* place: "All the world's photographs formed a Labyrinth. I knew that at the center of this Labyrinth I would find nothing but this sole picture.… The Winter Garden Photograph was my Ariadne, not because it would help me discover a secret thing (monster or treasure), but because it would tell me what constituted that thread which drew me toward Photography."[59]

Confusingly, Barthes posits the Winter Garden Photograph as both monster ("at the center of this Labyrinth") and his Ariadne. As a result, Barthes's emphasis is less on the *real* maternal body represented in the Winter Garden Photograph (the presumed "secret thing") than on "that thread." (Barthes: "I cannot reproduce the Winter Garden Photograph. It exists only for me. For you, it would be nothing but an indifferent picture.")[60] Barthes gives us the thread (which in his hand is desire), but no "treasure." Following the thread is difficult, at times impossible. One gets so tangled, so tied up. Barthes writes: "I tie up my image-system (in order to protect myself and at the same time to offer myself)."[61] Barthes's web, full of desire, is as protective as it is generous. Barthes's connector thread travels toward meaning (the mother) without ever really getting there, just as the photograph travels endlessly toward the referent. Only Barthes can have *his* mother, *his* Maman.

Barthes's writing on the Winter Garden Photograph, with its emphasis on being within Mother, within language, is caught, like the photographic work of Lesley Dill, within a "kind of body language turned inside out" (fig. 6).[62] Barthes comes out with his mother's body on the tip of his tongue, his own "mother tongue." Dill opens up mouths to speak visible words that float like the precious letters shared between Virgin and angel in Simone Martini's and Lippo Memmi's *The Annunciation and Two Saints* or in Jan van Eyck's *The Annunciation* (fig. 7). Such images are especially lovely in that the words emanating from the angels' mouths give a sense of immediacy, of what Barthes might call "vocal writing."[63] The painted salutations from the angel that heat up the Virgin's ear "encourage viewers themselves to say the words aloud"[64] ("If it were possible to imagine an aesthetic of textual pleasure, it would have to include: *writing aloud* [W]hat it searches for (in a perspective of bliss) are the pulsional incidents, the language lined with flesh, a text where we can hear the grain of the throat, the patina of consonants."[65]

The ribbons of emanating speech in Dill's *A Mouthful of Words* imitate the banderoles of medieval and late gothic paintings—they are like the ribbons of letters that defy gravity, that have minds of their own, in Robert Campin's *The Nativity* (fig. 8): a young man with his mouth open (perhaps in song); his eyes cast upward (perhaps toward heaven); and barely legible Emily Dickinson poems issuing umbilically from his mouth. Letters are twisted, backward, reversed. Some are cutout paper letters strung together on thread, evoking the garlands of metallic cardboard letters that spell HAPPY NEW YEAR or HAPPY BIRTHDAY. And, much as in the full-page illumination from *Les heures de Rohan* (circa 1418, fig. 9), *Office of the Dead*—where a blue background is host to a wallpaper pattern of angels and stars in gold, where

Fig. 6. Lesley Dill (American, b. 1950)
A Mouthful of Words, 1997, charcoal and photography on
paper, 130.8 × 132.1 cm (51½ × 52 in.)
Toledo, Ohio, Toledo Museum of Art

Fig. 7. Jan van Eyck (Netherlandish, ca. 1390–1441)
The Annunciation (detail), ca. 1434/1436, oil on canvas
transferred from panel, painted surface: 90.2 × 34.1 cm
(35½ × 13⅜ in.)
Washington, D.C., National Gallery of Art

Fig. 8. Robert Campin (Netherlandish, ca. 1375–1444)
The Nativity, ca. 1420, oil on panel, 86 × 72 cm (33⅞ × 28⅜ in.)
Dijon, Musée des Beaux-Arts

Fig. 9. Master of the Rohan Hours (French, act. ca. 1410–40)
Office of the Dead
From Master of the Rohan Hours, *Les heures de Rohan,* ca. 1418, MS lat. 9471, fol. 159
Paris, Bibliothèque Nationale de France

text flows in ribbons from the dead man below and from God above, but also on God's gold-trimmed pink robe and moonlike halo, where the ground is littered with tiny bones that sometimes cross into Xs or curve into Cs, where the pattern of the blue cloth that the dead man lies on is evenly sprinkled with tiny circles that are also Os, where the rectangle of text begins with a violet D that is filled with a skull—there is not so much a tension between text and image in *A Mouthful of Words* as there is an emphasis on text *as* image.

The banderoles of Dill's *A Mouthful of Words* and the *Office of the Dead* speak the fetishistic language of *the condition of* the photograph: a moment forever lost (dead) and forever sustained (living). The photograph is life and death pictured *utopically*, at once. *A Mouthful of Words* speaks to the photograph's fragile (yet strong) umbilical link between life and death—the ribbons connect to the dead, perhaps to Dickinson herself, via the heavens of the earthling's directed gaze. In the *Office of the Dead*, there is no doubt that the banderole of the emaciated dead man is directed to God. The Latin on the phylactery emerging from his mouth is a "prayer for the dying" from Psalms 30:6: "In manus tuas, Domine, commendo spiritum meum; redemisti me Domine, Deus veritatis" (Into thy hands I commend my spirit; thou has redeemed me, O Lord, the God of truth).[66] God answers him in French verse, paraphrasing the words of Christ to the repentant thief: "Pour tes Péchés pénitence feras. Au jour du Jugement aveques mois seras" (For your sins you shall do penance. On Judgement Day you shall be with Me).[67]

Like a photograph, the *Office of the Dead* captures both death and life, making strange bedfellows out of emulsion and the love of God. The tiny soul of the dead man, represented in the form of a naked adolescent, is held momentarily by Satan while "the Archangel Michael hurls himself down with lifted sword to attack the devil, whom he seizes by the hair, and who is pierced by spears held by warriors of the heavenly host."[68] Only archangels, like Gabriel or Michael, are said to move between the mortal (the terrestrial) and the immortal (the heavenly). Like the umbilical cord, angels occupy the neuter, moving "between one order and another while being identified with neither."[69] The "shimmering, always moving being"[70] is the angelic texture of Barthes's most hedonistic texts. (For the cover of *A Lover's Discourse*, Barthes chose a fragment of *Tobias and the Angel*, a painting by a follower of Andrea del Verrocchio, featuring the laced arm of the archangel Raphael, disguised as a man, tenderly, lovingly, erotically, homoerotically holding the hand of Tobias. Unfortunately for English readers, Barthes's perfect choice of a visual image for *A Lover's Discourse* was not honored in its translation.) The *Office of the Dead*, like Barthes's *Camera Lucida*, like a photograph, like *A Mouthful of Words*, is an angel caught between life and death.

When the connection to a photograph is especially profound (as in Barthes's connection to his mother, as in his connection to the Winter Garden Photograph), Barthes experiences *punctum*, the moment when a piece, a fragment, a bit of the photograph punctuates, interrupts, wounds, "shoots out . . . like an arrow, and pierces" the viewer.[71] Like Marta Maria Pérez Bravo's photograph

Fig. 10. Marta Maria Pérez Bravo (Cuban, b. 1959)
Para Concebir #3, 1985–86, silver gelatin print, 40 × 50 cm (15¾ × 19¾ in.)
New York, Galeria Ramis Barquet

from her *Para Concebir* (To conceive) series (fig. 10), "Barthes's *punctum*-pictures pull at the beauty and the horror of all that is metaphorically implied by the small scar that cuts into the smoothness of all of our bellies, our navel: the irreducible mark of our birth and our guaranteed death. Our umbilical scar always pulls at the lost mother, just as photography pulls at its lost referent That is why (some) photographs *wound* Barthes: he feels it like a stab in the abdomen."[72]

Punctum is always personal (not universal like the *studium* of a photograph, which speaks clearly to a docile subject with intended meanings that are unproblematically discerned). *Punctum* comes unexpectedly, just as pleasure (*jouissance*) does in *The Pleasure of the Text*: "The *studium* is ultimately always coded, the *punctum* is not."[73] As a student once wrote in one of my courses: "For me, the text outside of the secretive punctuation is my *studium*, and what lay within, my *punctum*. While *Camera Lucida* can only be described as a personal journey, it is within the parentheses that I find the author.... They are the gaps in the text, where contradiction finds a home."[74] *Punctum* is bodily: it is as if one were being punctured and stitched, resewn to the mother's body. The umbilical cord becomes real/reel, a "carnal medium": "The photograph is literally an emanation of the referent. From a real body, which was there, proceed radiations which ultimately touch me, who am here; the duration of the transmission is insignificant; the photograph of the missing being, as Susan Sontag says, will touch me like the delayed rays of a star. A sort of *umbilical cord* links the body of the photographed thing to my gaze: light, though impalpable, is here a carnal medium, a skin I share."[75] And, "the air is the luminous shadow which accompanies the body; and if the photograph fails to show this air, then the body moves without a shadow, and once the shadow is severed, as in the myth of the Woman without a Shadow, there remains no more than a sterile body. It is by this tenuous *umbilical cord* that the photographer gives life; if he cannot, either by lack of talent or bad luck, supply the transparent soul its bright shadow, the subject dies forever."[76]

A photograph is but a shadow of what once was there but now is gone—not unlike the mother, whom we all have to live without, "sooner or later."[77] She comes and she goes.

Mother-Lover: Incidents *and* A Lover's Discourse

> Let the other appear, take me away, like a mother who comes looking for her child.
>
> —Roland Barthes[78]

The posthumous *Incidents* can make you twinge with embarrassment and even sadness for its strangely maternalized sexuality. There is the uneasiness one feels (along with Barthes) when he lies his head on his lover's shoulder, as if his lover were his "Mam": "in the elevator, I kissed him, rested my head on his shoulder; but whether this wasn't his sort of thing, or because of some

other reticence, he responded only vaguely."[79] There is Barthes's relief when a boy prostitute, paid in advance, does not show up—yet, like the mother who waits for her grown son, Barthes also feels stupid and silly for even pretending to believe that the beautiful young man would show as planned. And there is the moment when Barthes, as he walks the late-night streets of Paris, catches himself walking home to Mam, as if it were the old days, when Mam was not really gone, when Mam was not dead: "I climb the stairs and pass my own floor without realizing it, as if I were returning to our apartment on the fifth floor, as if it were the old days and Mam were there waiting for me."[80]

Barthes writes himself and his lover as a mother-child couple. Just as Winnicott subtly eroticizes the early relationship between mother and child as a couple (naming them in his own funny words as a "nursing couple"),[81] Barthes maternalizes his erotic relationship with his lovers. For Barthes, a pair of lovers is no more or less erotic and nourishing than the mother and child pair—nor is it any less of a catastrophe. Barthes moans of a lost love, "the amorous catastrophe"[82] in A Lover's Discourse: "I shut myself in my room and burst into sobs: I am carried away by a powerful tide, asphyxiated with pain; my whole body stiffens and convulses: I see, in a sharp, cold flash, the destruction to which I am doomed.... This is a clear catastrophe.... an abrupt sexual rejection:... seeing oneself abandoned by the Mother."[83]

Barthes feared, must have always feared, his mother's absences. Barthes writes in A Lover's Discourse: "Endlessly I sustain the discourse of the beloved's absence;... a very short interval, we are told, separates the time during which the child still believes his mother to be absent and the time during which he believes her to be already dead. To manipulate absence is to extend this interval, to delay as long as possible the moment when the other might topple sharply from absence into death."[84] As Winnicott himself writes in "Transitional Objects and Transitional Phenomena": "If the mother is away over a period of time which is beyond a certain limit measured in minutes, hours, or days, then the memory or the internal representation fades."[85] A few pages later, Winnicott dramatically elaborates: "Before the limit is reached the mother is still alive; after this limit has been overstepped she is dead."[86]

A Lover's Discourse is knitted into familiar cardigans of love, which give like a mother, even when it hurts or, perhaps, especially because it does hurt. ("Barthes surprises us in...A Lover's Discourse by making love, in its most absurd and sentimental forms, an object of interest.")[87] In these delicate, nearly invisible, always elegant twists of beautiful somber yarn (olive, sienna, charcoal), button holes, horn buttons, careful darning done with the exactly right color, even a fragment under the heading of "Blue Coat and Yellow Vest,"[88] Barthes uses Winnicott to cast off his maternalized discourses of love (along with Proust, and also Goethe's young Werther).

The blue coat and yellow vest is of course the "costume à la Werther."[89] It is the costume that Werther first wore when he danced with his love, the object of his indefatigable crush, Lotte. He wore it constantly until it wore out. Forlorn and threadbare, Werther had another blue coat and yellow

costume sewn. Ultimately, Barthes understands Werther's blue coat as a sign for his Mother, his Mam, his Madonna (the color of the Virgin Mother is blue), who stood alone, not for mankind, but for him. As Barthes writes in *A Lover's Discourse*:

> It is in this garment (blue coat and yellow vest) that Werther wants to be buried, and which he is wearing when he is found dying in his room. Each time he wears this garment (in which he will die), Werther disguises himself. As what? As an enchanted lover: he magically re-creates the episode of the enchantment, that moment when he was first transfixed by the Image. This blue garment imprisons him so effectively that the world around him vanishes: *nothing but the two of us:* by this garment, Werther forms for himself a child's body in which phallus and mother are united, with nothing left over.[90]

Going back to his lover, Werther is, according to Barthes, backstitching to the body of the mother. Barthes, too, wears the "perverse" costume of Werther, just as enthusiasts of *Die Leiden des jungen Werther* did during the height of the novel's popularity.[91] Barthes's is also wearing his mother's blue coat, mantle, veil. Queerly, boyishly, Barthes wears his love for Werther and his love for his mother on his sleeve, in one sartorial, Freudian gesture, so that his body just might remain that of "child": "phallus and mother are united."

Barthes comes out in *A Lover's Discourse* as a queer man whose relationship with his lover mirrors the crisis of the infant who, without transitional objects, believes that the breast is still under his magic control. Only for Barthes, the breast becomes a "being," a lover: "The being I am waiting for is not real. Like the mother's breast for the infant, 'I create and re-create it over and over, starting from my capacity to love, starting from my need for it': the other comes here where I am waiting, here where I have already created him/her. And if the other does not come, I hallucinate the other: waiting is a delirium."[92] Barthes purposefully refuses to open the trapdoor between illusion and disillusion, between being one with the mother and being separate from the mother.

Barthes is an eternal boy. As a boy, he wants to be loved by boys. But as Barthes writes in the year before his death (in "Soirées de Paris," the intimate journal that concludes *Incidents*), he is no longer desired by boys, by his lover/boy, "Olivier G.": "I sent him away, saying I had work to do, knowing it was over, and that more than Olivier was over: the love of *one* boy."[93] Aged, Barthes no longer has the privilege of loving a boy. Before sending Olivier away, Barthes records the following incident:

> I asked him to come and sit beside me on the bed during my nap; he came willingly enough, sat on the edge of the bed, looked at an art book; his body was very far away—if I stretched out an arm toward him, he didn't move, uncommunicative: no obligingness; moreover he soon went into the other room. A sort of despair overcame me, I felt like crying. How clearly I saw that I would have to give up boys,

because none of them felt any desire for me, and I was either too scrupulous or too clumsy to impose my desire on them; that this is an unavoidable fact, averred by all my efforts at flirting, that I have a melancholy life, that, finally, I'm bored to death by it.[94]

Barthes feared boredom all his life. He feared seeing bliss only "from the shores of pleasure." As he writes in *Roland Barthes* (1977; originally published in French in 1975): "As a child, I was often and intensely bored. This evidently began very early, it has continued my whole life, in gusts (increasingly rare, it is true, thanks to work and to friends), and it has always been noticeable to others. A panic boredom, to the point of distress: like the kind I feel in panel discussions, lectures, parties among strangers, group amusements: wherever boredom *can be seen*. Might boredom be my form of hysteria?"[95]

If in boredom, as Adam Phillips argues, the child waits for something to happen, for the reliable mother to come,[96] what happens to Barthes at the end of his life, without Maman, without boys? Barthes is caught between what he desires (boys and Maman) and what he cannot have (boys and Maman). Seen only from a distanced shore, their pleasure could not be experienced. Bliss was out of reach: no strings attached. Perhaps Barthes was truly bored to death.

In *A Lover's Discourse*, Barthes relates his fear of losing a lover to the child's fear of losing his mother. By recalling a patient of Winnicott's who was obsessed with string, Barthes, too, becomes a boy in hopes of reconnecting, of staying connected, with his mother. The boy's string (as we shall soon see) becomes an umbilical referent, inspiring Barthes to play (in *A Lover's Discourse*) with the body of his lover as if his lover were his mother.

In "Transitional Objects and Transitional Phenomena," the string boy's parents note that their seven-year-old son "had become obsessed with everything to do with string, and in fact whenever they went into a room they were liable to find...a cushion, for instance, with a string joining it to the fireplace."[97] Winnicott compares the boy's use of the string to the use of the telephone: "I explained to the mother that this boy was dealing with a fear of separation, attempting to deny separation by his use of string, as one would deny separation from a friend by using the telephone."[98] (One, too, wonders about Winnicott's attachment to string and the female body, given that his father, Frederick Winnicott, was a merchant, "specializing in women's corsetry.")[99]

Barthes invokes the string boy's attachment to his mother through the Winnicottian metaphor of the telephone: "Freud, apparently, did not like the telephone, however much he may have liked *listening*. Perhaps he felt, perhaps he foresaw that the telephone is always a *cacophony*, and that what it transmits is the *wrong voice*, the false communication...No doubt I try to deny separation by the telephone—as the child fearing to lose its mother keeps pulling on a string; but the telephone wire is not a good transitional object, it is not an inert string; it is charged with a meaning, which is not that of junction but that of distance."[100] The telephone, despite being a sign of

both separateness and union, is not a "good-enough" transitional object for Barthes. Barthes prefers a state of sustained illusion with both his mother and his lovers.

Calling up Freud again, Barthes recognizes that Winnicott's transitional object is yet another form of Freud's infant grandson's game of *fort/da*. Braiding the three together (Ernst, Freud, Winnicott), Barthes configures his relationship to his absent lover after the fashion of Ernst's longing (and playing) for his absent mother: "Absence persists—I must endure it. Hence I will *manipulate* it: transform the distortion of time into oscillation, produce rhythm, make an entrance onto the stage of language (language is born of absence: the child has made himself a doll out of a spool, throws it away and picks it up again, miming the mother's departure and return: a paradigm is created). Absence becomes an active practice, a *business* (which keeps me from doing anything else)."[101]

In addition to using Winnicott's theories of the transitional object to illuminate the mise-en-scène of lovers' talk in *A Lover's Discourse*, Barthes also deploys Winnicott's image of the "good-enough mother" to signal how one is *expected* to love without loving too much, without being overly possessive. According to Winnicott, the ideal mother—the healthy mother who produces the healthy child—is the "good-enough mother"; she knows exactly how and when to begin the procedure of letting go, of stepping back, of orchestrating her failure to be there. In the beginning, the mother must give herself over almost entirely to her infant, yet a small bit of herself must be left, must be kept intact, for the child to begin converting her failure into his own fulfillment. Gradually, the mother must encourage the growth of her tiny bit of leftover sacrosanct self in order to pull back adequately, so that the child may make the transition from illusion to disillusion, so necessary for the creation of transitional objects. Weaning (physical and emotional) encourages creative play. The daunting task for the mother, in Winnicott's eyes, is to give of herself almost entirely and then be able to pull back, at the right time, with confidence and care.

Yet for all his enthusiasm for Winnicott, Barthes was always wholeheartedly attached to his mother. As a result, he founded his creative play on an intriguing pattern of unweaned threads by turning the "transitional object" and the "good-enough mother" inside out. In one illuminating twist on Winnicott in *A Lover's Discourse*, Barthes lays out the impossible task of being a "good-enough lover":

> I know *right away* that in my relation with X, Y, however prudently I restrain myself, there is a certain amount of *being-in-love* ... it is also true that in *being-in-love* there is a certain amount of *loving*: I want to possess, fiercely, but I also know how to give, actively. Then who can manage this dialectic successfully? Who, if not the woman, the one who does not make for any object but only for ... giving? So that if a lover manages to " love," it is precisely insofar as he feminizes himself, joins the class of *Grandes Amoureuses*, of Women Who Love Enough to Be Kind.[102]

The "class of *Grandes Amoureuses*, of Women Who Love Enough to Be Kind," is made up, of course, of those women who, like "good-enough mothers," are able to squelch their overwhelming love (whether for their children or lovers), so that they can give their "loves" space.

The "good-enough" lover/mother also appears in a second lengthy passage from *A Lover's Discourse*. Barthes makes direct reference to Winnicott's notion of the perfect setting for play, in which the mother is lovingly there but is in no way controlling or interfering with her child's creativity. And again, just as Barthes "had nursed [his mother], held the bowl of tea she liked because it was easier to drink from than from a cup," turning her into his "little girl," Barthes becomes the mother-lover:

> In order to show you where your desire is, it is enough to forbid it to you *a little* (if it is true that there is no desire without prohibition). X wants me to be there, beside him, while leaving him free *a little:* flexible, going away occasionally, but *not far:* on the one hand, I must be present as a prohibition (without which there would not be the right desire), but also I must go away the moment when, this desire having formed, I might be in its way: I must be the Mother who loves enough (protective and generous), around whom the child plays, while she peacefully knits or sews. This would be the structure of the "successful" couple: a little prohibition, a good deal of play; to designate desire and then to leave it alone.[103]

Barthes travels between being a smothering lover and a distanced lover, but like "X" he was never able to be "good-enough" (though I do not think he ever actually desired to be among those "Who Love [dispassionately] Enough to Be Kind"). Yet, like Ernst and the unnamed "string boy," who pull and play with Mother's strings—taking us to and from metaphors of Ariadne, apron strings, and telephones, as well as to the heartstring itself: the umbilical cord—Barthes's pull on lovers (in *A Lover's Discourse* and *Incidents*) or photographs (in *Camera Lucida*) is ultimately an exaggerated, if obsessive, tug on the skirt of Maman.

In the introduction to *Playing and Reality,* Winnicott draws attention to the "*paradox* involved" in using a transitional object: what is significant "is not the cloth or the teddy bear that the baby uses—not so much the object used as *the use of the object.*"[104] Likewise, Barthes's emphasis on the Winter Garden Photograph is not so much an emphasis on "the object used as the use of the object." Both Winnicott and Barthes use the string/umbilical cord to symbolize a maternalized paradox of separateness and union, whether in the transitional object (whose paradox plays between reality and illusion, me and not me) or the photograph (whose paradox plays between real and not real, dead and alive, there and gone).

Just as *Camera Lucida* grew from loss, from a fear of being just one (without Henriette), Félix González-Torres's *"Untitled" (March 5th) #2* (fig. 11)

Fig. 11. Félix González-Torres (Cuban-born American, 1957–96)
"Untitled" (March 5th) #2, 1991, 40-watt lightbulbs, porcelain light sockets, and extension cords, H (two parts): ca. 287 cm (113 in.)
Installation at the Andrea Rosen Gallery, New York

grew from loss, from a fear of being just one (without Ross). González-Torres's subtitles almost always refer to his perfect lover: Ross. March 5 is Ross's birthday. Ross died in 1991, the year that *"Untitled" (March 5th) #2* was made — *Camera Lucida* was written in 1979, the year that Henriette died. In *"Untitled,"* we learn, "one bulb will dim first leaving the other to light the way,"[105] in the same way that Ross dimmed first, leaving Felix to light the way. Another piece that González-Torres executed in 1991 is *Untitled (Lover Boys),* in which two battery operated clocks almost touch, as if in a near kiss, but not quite, they "tick in unison until one begins to wind down."[106] The bare lightbulbs of *"Untitled" (March 5th) #2* are naked, just born, new, destined to die: they kiss too. Suspended in their becoming womb, these two bulbs, entwined in umbilical electric flex, are lit by love.

Notes

I would like to thank Richard Meyer, Michael Moon, Simon Watney, Teri Devoe, Mary Pardo, and Elizabeth Howie for their comments on an early version of this essay.

1. D. W. Winnicott, "Transitional Objects and Transitional Phenomena," in idem, *Playing and Reality* (London: Tavistock, 1970; reprint, London: Routledge, 1991).

2. Marcel Proust, *In Search of Lost Time,* vol. 1, *Swann's Way,* trans. C. K. Scott Moncrieff and Terence Kilmartin, rev. D. J. Enright (New York: Modern Library, 1992), 39.

3. Louis-Jean Calvet, *Roland Barthes: A Biography,* trans. Sarah Wykes (Cambridge, Mass: Polity, 1994), 216. First published in French as *Roland Barthes, 1915–1980* (Paris: Flammarion, 1990).

4. Richard Howard, "Remembering Roland Barthes," in Steven Ungar and Betty R. McGraw, eds., *Signs in Culture: Roland Barthes Today* (Iowa City: Univ. of Iowa Press, 1989), 35.

5. Calvet, *Roland Barthes* (note 3), 216.

6. Calvet, *Roland Barthes* (note 3), 226.

7. Roland Barthes, "Inaugural Lecture," trans. Richard Howard, in Susan Sontag, ed., *A Barthes Reader* (New York: Hill & Wang, 1982), 476–77. Barthes's lecture was first published as *Leçon: Leçon inaugurale de la chaire de sémiologie littéraire du Collège de France, prononcée le 7 janvier 1977* (Paris: Éditions du Seuil, 1978). The passage in French can be found on page 41.

8. Walter Benjamin, "The Image of Proust," in idem, *Illuminations,* ed. Hannah Arendt, trans. Harry Zohn (New York: Schocken, 1968), 213.

9. From a conversation with Richard Howard in February 1997.

10. *Oxford English Dictionary,* 2d ed., s.v. "apron-string."

11. Roland Barthes, *Roland Barthes,* trans. Richard Howard (New York: Hill & Wang, 1977), 121–22. First published in French as *Roland Barthes* (Paris: Éditions du Seuil, 1975).

12. Roland Barthes, *The Pleasure of the Text,* trans. Richard Miller (New York: Hill & Wang, 1975), 37. First published in French as *Le plaisir du texte* (Paris: Éditions du Seuil, 1973).

13. See Susan Suleiman, "Prologue," in idem, *Subversive Intent: Gender, Politics, and the Avant-Garde* (Cambridge: Harvard Univ. Press, 1990), 1–10.

14. D. W. Winnicott, "Cure," in Clare Winnicott, Ray Shepherd, and Madeleine Davis, eds., *Home Is Where We Start From* (New York: W. W. Norton, 1986), 112.

15. Winnicott, "Transitional Objects" (note 1), 19.

16. Calvet, *Roland Barthes* (note 3), 218

17. Howard, "Remembering Roland Barthes" (note 4), 34.

18. Howard, "Remembering Roland Barthes" (note 4), 34.

19. Roland Barthes, *Camera Lucida: Reflections on Photography*, trans. Richard Howard (New York: Farrar, Straus & Giroux, 1981), 72. First published in French as *La chambre claire: Note sur la photographie* (Paris: Gallimard, 1980).

20. Barthes, *The Pleasure of the Text* (note 12), 18.

21. Barthes, *The Pleasure of the Text* (note 12), 4 = Barthes, *La plaisir du texte* (note 12), 11.

22. Richard Miller translates Barthes's use of the word *jouissance* as "bliss." Richard Howard's "Note on the Text," which introduces Miller's translation of *La plaisir du texte* (note 12), discusses the inherent inadequacy of English when it comes to articulating the French vocabulary of eroticism: "an amorous discourse which smells neither of the laboratory nor of the sewer" (p. v). Howard continues, "Richard Miller has been resourceful, of course, and he has come up with the readiest plausibility by translating *jouissance* . . . as 'bliss'; but of course he cannot come up with 'coming,' which precisely translates what the original text can afford" (pp. v–vi).

23. Barthes, *Roland Barthes* (note 11), 116.

24. Barthes, *The Pleasure of the Text* (note 12), 21.

25. Adam Phillips, *On Kissing, Tickling, and Being Bored: Psychoanalytic Essays on the Unexamined Life* (Cambridge: Harvard Univ. Press, 1993), 68–78.

26. Walter Benjamin, "The Storyteller," in idem, *Illuminations*, ed. Hannah Arendt, trans. Harry Zohn (New York: Schocken, 1968), 91.

27. Barthes, *The Pleasure of the Text* (note 12), 25–26.

28. Barthes, *The Pleasure of the Text* (note 12), 17.

29. Barthes, *Roland Barthes* (note 11), 136.

30. Barthes, *Camera Lucida* (note 19), 65.

31. Proust invokes the notion of "une mémorie involuntaire" throughout *Swann's Way* (note 2), esp. 60–64, 262–64. Proust reads this involuntary memory prompted by the madeleine cake against the more base world of "voluntary memory, the memory of the intellect" (p. 59). In *Time Regained*, the topic of the madeleine cake and involuntary memory brilliantly reappears. Here, Proust uses the phrase "une mémoire involuntaire" not only to describe the pureness of three other memories (*les souvenirs*) that are prompted by the essence of their objects—a pair of uneven stones, a stiff napkin, and the sound of a spoon chiming on a plate—but also to inform his reader "that there exists too an involuntary memory of the limbs"; see *In Search of Lost Time*, vol. 6, *Time Regained*, trans. Andreas and Terence Kilmartin, rev. D. J. Enright (New York: Modern Library, 1993), 11. In French, the phrase is "mais il semble qu'il y ait une mémoire involuntaire des membres"; see Marcel Proust, *Á la recherche du temps perdu*, vol. 14–15, *Le temps retrouvé* (Paris: Gallimard, 1927), 8–9.

32. Proust, *Swann's Way* (note 2), 60.

33. Jonathan D. Culler, *Roland Barthes* (New York: Oxford Univ. Press, 1983), 21–22.

34. Barthes, *Camera Lucida* (note 19), 72.

35. Howard, "Remembering Roland Barthes" (note 4), 36.

36. Barthes, *S/Z,* trans. Richard Miller (New York: Hill & Wang, 1974), 160. First published in French as *S/Z* (Paris: Éditions du Seuil, 1970).

37. Barthes, *S/Z* (note 36), 160.

38. Barthes, *S/Z* (note 36), 160.

39. I have previously discussed the Winter Garden Photograph as the other half to Boudinet's *Polaroïd.* See my essay, "Becoming: The Photographs of Clementina Hawarden, 1859–1864," *Genre* 29, nos. 1–2 (1996): 93–134.

40. Barthes, *Camera Lucida* (note 19), 96.

41. Barthes, *Camera Lucida* (note 19), 81.

42. Barthes, *Camera Lucida* (note 19), 66.

43. Diana Knight, "The Woman Without a Shadow," in Jean-Michel Rabaté, ed., *Writing the Image After Roland Barthes* (Philadelphia: Univ. of Pennsylvania Press, 1997), 138.

44. In a letter to the author in April 2000, Nancy Spector pointed out that González-Torres read theory while at the Whitney Independent Study Program as well as when studying photography at New York University with Christopher Phillips and others. She believes González-Torres surely would have read *Camera Lucida* in this context.

45. Barthes, *Camera Lucida* (note 19), 7.

46. Barthes, *Camera Lucida* (note 19), 53.

47. Barthes, *Camera Lucida* (note 19), 66.

48. Sigmund Freud, *Beyond the Pleasure Principle,* trans. and ed. James Strachey (New York: W. W. Norton, 1961), 13–14.

49. Barthes, *The Pleasure of the Text* (note 12), 7.

50. Roland Barthes, "The Grain of the Voice," in idem, *Image, Music, Text,* trans. and ed. Stephen Heath (New York: Hill & Wang, 1977). First published in French as *Le grain de la voix: Entretiens, 1962–1980* (Paris: Éditions du Seuil, 1981).

51. Barthes, *Roland Barthes* (note 11), caption to snapshot of Barthes with his mother and younger brother, from a series of photographs and texts that serves as a preface to the book, unpaginated.

52. Barthes, *Camera Lucida* (note 19), 72.

53. Barthes, *Camera Lucida* (note 19), 68.

54. Françoise Heilbrun, "Nadar and the Art of Portrait Photography," in Maria Morris Hambourg, Françoise Heilbrun, and Philippe Néagu, eds., *Nadar* (New York: Metropolitan Museum of Art, 1995), 53.

55. Barthes, *Camera Lucida* (note 19), 70.

56. Roland Barthes, "On Brecht's Mother," in idem, *Critical Essays,* trans. Richard Howard (Evanston, Ill.: Northwestern Univ. Press, 1972), 139. First published in French as *Essais critiques* (Paris: Éditions du Seuil, 1964).

57. "Le-corps-á-corps avec la mére" is usually translated as "The Bodily Encounter

with the Mother," as in Luce Irigaray, *The Irigaray Reader*, ed. Margaret Whitford (Oxford: Basil Blackwell, 1991), 34–46. Carolyn Burke has provided me with the rich translation cited here.

58. See Susan Sontag, *On Photography* (New York: Farrar, Straus & Giroux, 1977), where she suggests that since the 1970s, "all art," whether painting, sculpture, video, performance, or photography itself, is influenced by ("aspires to") the condition of photography, which includes: anxieties about authorship; the ways in which multiple copies challenge notions of "original," "great" works of art; and the indexical connection to the "real" (p. 149). Henry Sayre's helpful book, *The Object of Performance: The American Avant-Garde Since 1970* (Chicago: Univ. of Chicago Press, 1989), turns on Sontag's provocative claim.

59. Barthes, *Camera Lucida* (note 19), 73.

60. Barthes, *Camera Lucida* (note 19), 73.

61. Barthes, *Roland Barthes* (note 11), 162, cited in Culler, *Roland Barthes* (note 33), 107.

62. Nancy Princenthal, "Words of Mouth: Lesley Dill's Work on Paper," *On Paper: The Journal of Prints, Drawings and Photography* 2 (1997–98): 28.

63. Barthes, *The Pleasure of the Text* (note 12), 66.

64. Ann van Dijk, "The Angelic Salutation," *Art Bulletin* 81 (1999): 421.

65. Barthes, *The Pleasure of the Text* (note 12), 66.

66. *The Rohan Book of Hours*, ed. Marcel Thomas, trans. Katharine W. Carson (New York: George Braziller, 1973), entry no. 63 (*Office of the Dead*).

67. *The Rohan Book of Hours* (note 66).

68. Jean Porcher, *The Rohan Book of Hours* (London: Faber & Faber, 1959), 30.

69. Elizabeth Grosz, *Sexual Subversions: Three French Feminists* (Sydney: Allen & Unwin, 1989), 161.

70. Grosz, *Sexual Subversions* (note 69), 161.

71. Barthes, *Camera Lucida* (note 19), 26.

72. Carol Mavor, *Pleasures Taken: Performances of Sexuality and Loss in Victorian Photographs* (Durham: Duke Univ. Press, 1995), 54.

73. Barthes, *Camera Lucida* (note 19), 51.

74. Meg Sheehan, "Inside the 'Winter Garden Photograph'" (essay for the course "Photographies and Sexualities," University of North Carolina, Fall 1989).

75. Barthes, *Camera Lucida* (note 19), 80–81 (emphasis added).

76. Barthes, *Camera Lucida* (note 19), 110 (emphasis added).

77. Barthes, *Camera Lucida* (note 19), 75.

78. Roland Barthes, *A Lover's Discourse: Fragments*, trans. Richard Howard (New York: Hill & Wang, 1978), 17. First published in French as *Fragments d'un discours amoureux* (Paris: Éditions du Seuil, 1977).

79. Roland Barthes, "Soirées de Paris," in idem, *Incidents*, trans. Richard Howard (Berkeley: Univ. of California Press, 1992), 61. First published in French as *Incidents* (Paris: Éditions du Seuil, 1987).

80. Barthes, "Soirées de Paris" (note 79), 65.

81. D. W. Winnicott, "Further Thoughts on Babies as Persons," in idem, *The Child, the Family and the Outside World* (Harmondsworth, England: Penguin, 1964), 88.

82. Barthes, *A Lover's Discourse* (note 78), 48.

83. Barthes, *A Lover's Discourse* (note 78), 48.

84. Barthes, referring to D. W. Winnicott, in *A Lover's Discourse* (note 78), 15–16. Barthes's Winnicott-inflected quotation reads, in full:

> Endlessly I sustain the discourse of the beloved's absence; actually a preposterous situation; the other is absent as referent, present as allocutory. This singular distortion generates a kind of insupportable present; I am wedged between two tenses, that of the reference and that of the allocution: you have gone (which I lament), you are here (since I am addressing you). Whereupon I know what the present, that difficult tense, is: a pure portion of anxiety.

> Absence persists—I must endure it. Hence I will *manipulate* it: transform the distortion of time into oscillation, produce rhythm, make an entrance onto the stage of language (language is born of absence: the child has made himself a doll out of a spool, throws it away and picks it up again, miming the mother's departure and return: a paradigm is created). Absence becomes an active practice, a *business* (which keeps me from doing anything else); there is a creation of a fiction which has many roles (doubts, reproaches, desires, melancholies). This staging of language postpones the other's death: a very short interval, we are told, separates the time during which the child still believes his mother to be absent and the time during which he believes her to be already dead. To manipulate absence is to extend this interval, to delay as long as possible the moment when the other might topple sharply from absence into death.

85. Winnicott, "Transitional Objects" (note 1), 15.

86. Winnicott, "Transitional Objects" (note 1), 22.

87. Culler, *Roland Barthes* (note 33), 113.

88. Barthes, *A Lover's Discourse* (note 78), 127.

89. Barthes, *A Lover's Discourse* (note 78), 128.

90. Barthes, *A Lover's Discourse* (note 78), 128.

91. Michael Hulse, "Introduction," in Johann Wolfgang von Goethe, *The Sorrows of Young Werther* (London: Penguin, 1989), 12.

92. Barthes, *A Lover's Discourse* (note 78), 39.

93. Barthes, *Incidents* (note 79), 73.

94. Barthes, *Incidents* (note 79), 73.

95. Barthes, *Roland Barthes* (note 11), caption to a family snapshot of Barthes as a boy, sitting alone on a grassy hill.

96. Phillips, *On Kissing, Tickling, and Being Bored* (note 25), 76.

97. Winnicott, "Transitional Objects" (note 1), 17.

98. Winnicott, "Transitional Objects" (note 1), 17.

99. Adam Phillips, *Winnicott* (Cambridge: Harvard Univ. Press, 1988), 23. The possible connection between a "tie-up" with the mother and a father who specialized in women's corsetry was pointed out to me by Elizabeth Howie. Furthermore, the unnamed "string boy" of "Transitional Objects" is not the only boy obsessed with string in *Playing and Reality*. Another young "string boy," who is given the name

Edmund, appears in D. W. Winnicott, "Playing: A Theoretical Statement," also reprinted in idem, *Playing and Reality* (London: Tavistock, 1970; reprint, London: Routledge, 1991), 38–52.

100. Barthes, *A Lover's Discourse* (note 78), 114–15.

101. Barthes, *A Lover's Discourse* (note 78), 16.

102. Barthes, *A Lover's Discourse* (note 78), 126.

103. Barthes, *A Lover's Discourse* (note 78), 137.

104. Winnicott, "Introduction," in idem, *Playing and Reality* (London: Tavistock, 1970; reprint, London: Routledge, 1991), xi–xii (emphasis added).

105. Nancy Spector, *Félix González-Torres*, exh. cat. (New York: Guggenheim Museum, 1995), 183.

106. Spector, *Félix González-Torres* (note 105), 183. Spector, in personal correspondence of April 2000, recalled both González-Torres's interest in *A Lover's Discourse* and the fact that he found the sections on waiting to be poignantly true and cruel. The cruelty of González-Torres's own ultimate catastrophe of waiting for Ross to finally dim, to wind down entirely, to become "absence," mirrors *A Lover's Discourse*, especially the aforementioned passage (see note 84), in which Barthes writes: "Absence persists—I must endure it. Hence I will *manipulate* it: transform the distortion of time into oscillation, produce rhythm, make an entrance onto the stage of language (language is born of absence...)." González-Torres's profound and original language of candy spills, printed paper stacks, paired clocks, ribbons of lights, and so forth embraces the condition of the photograph (making a presence out of absence), which turns on death and separation.

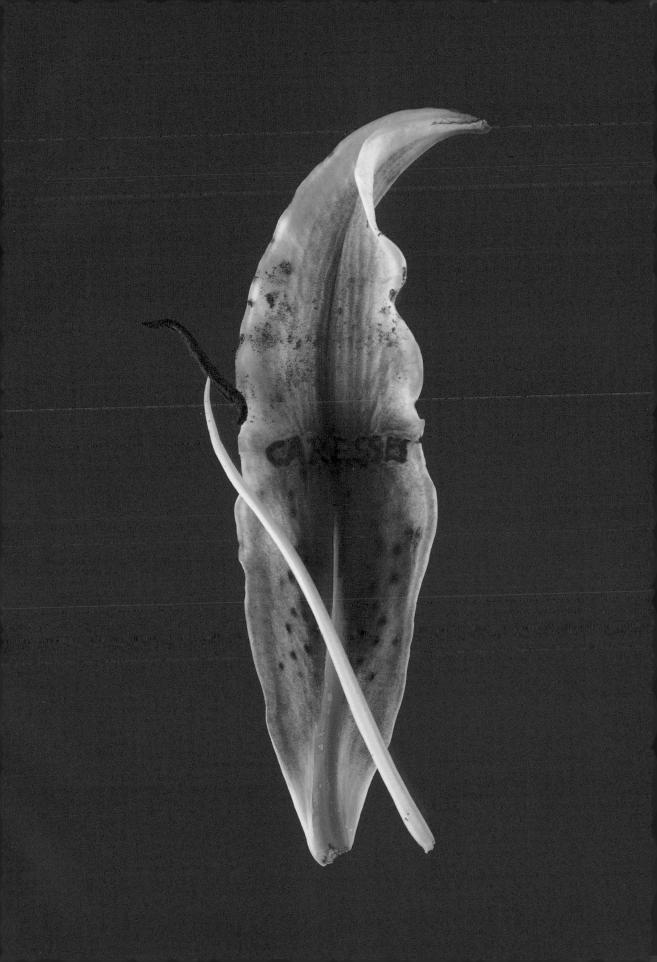

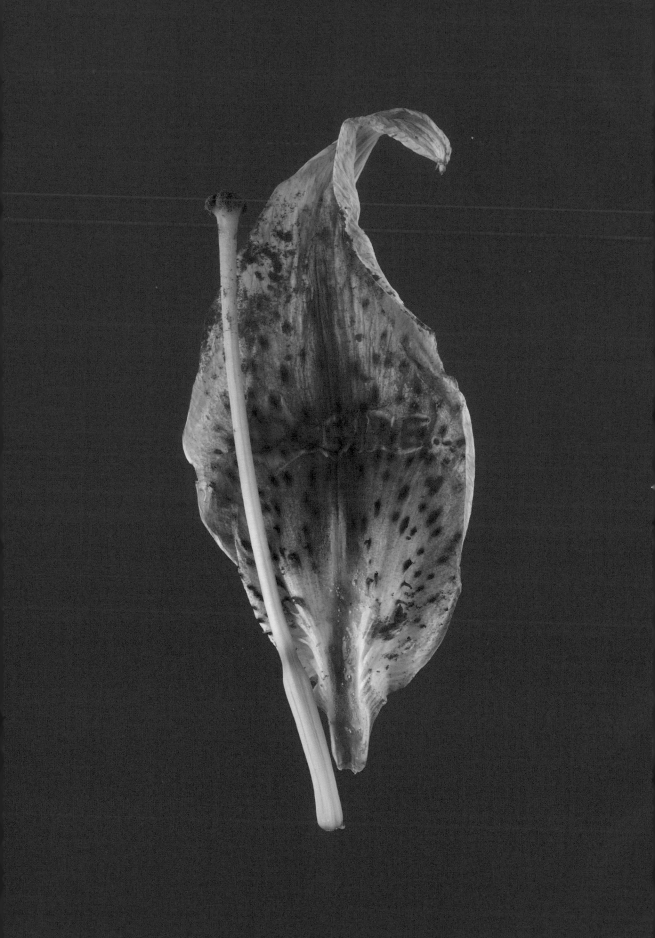

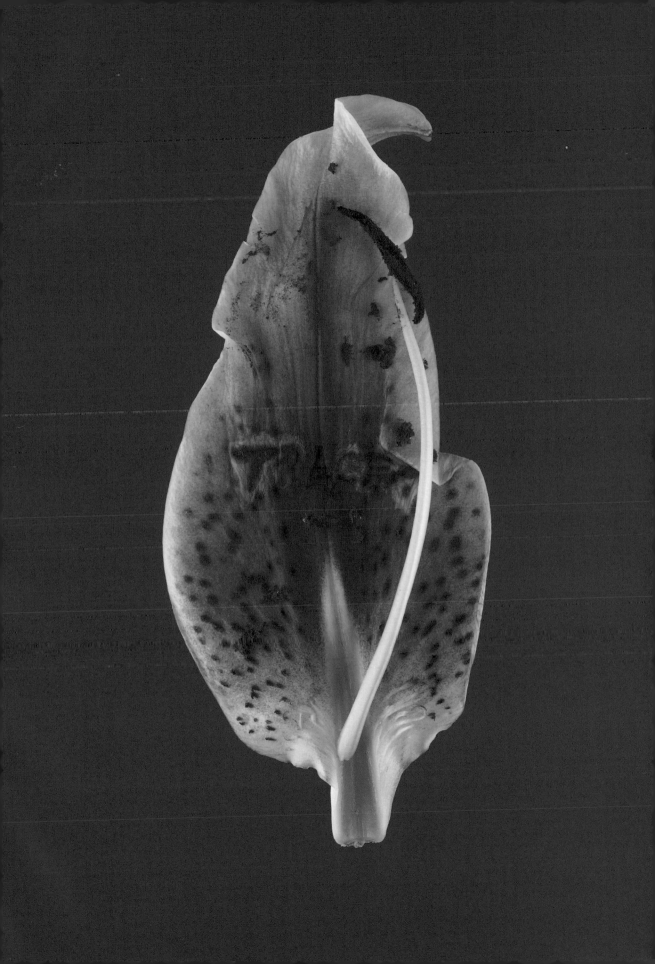

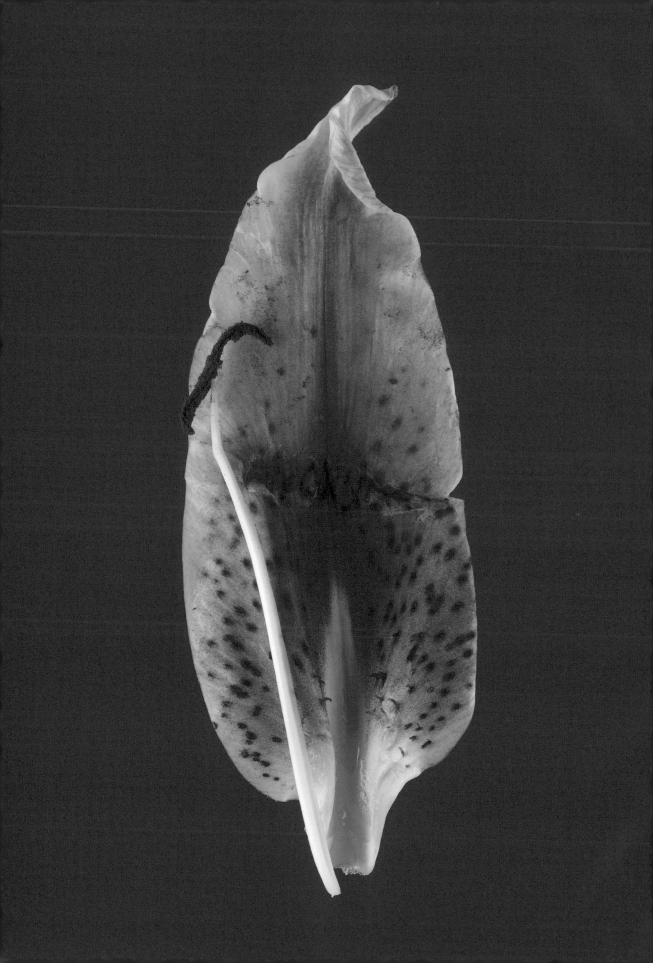

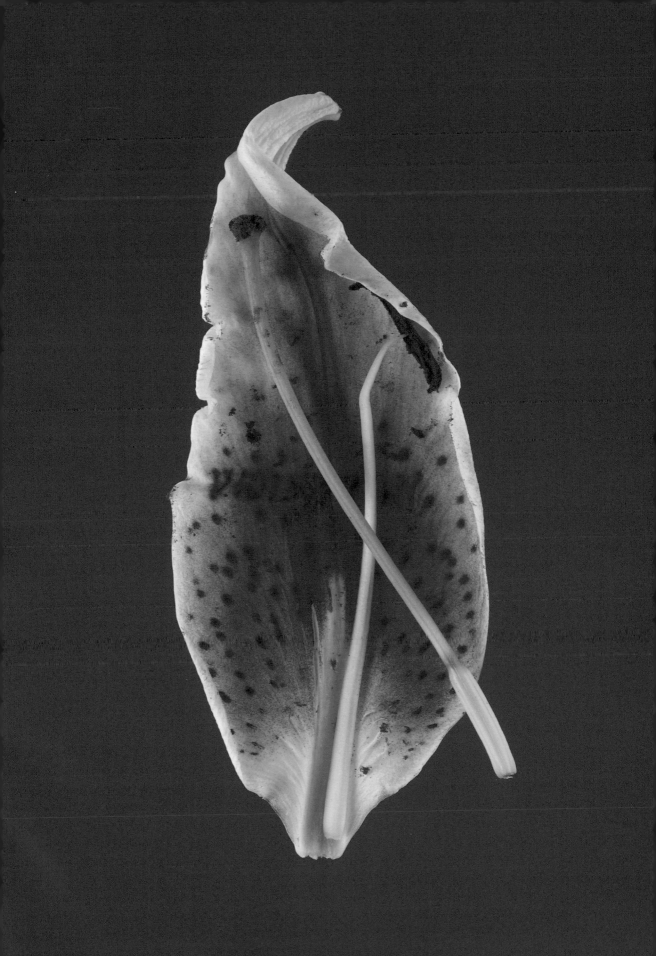

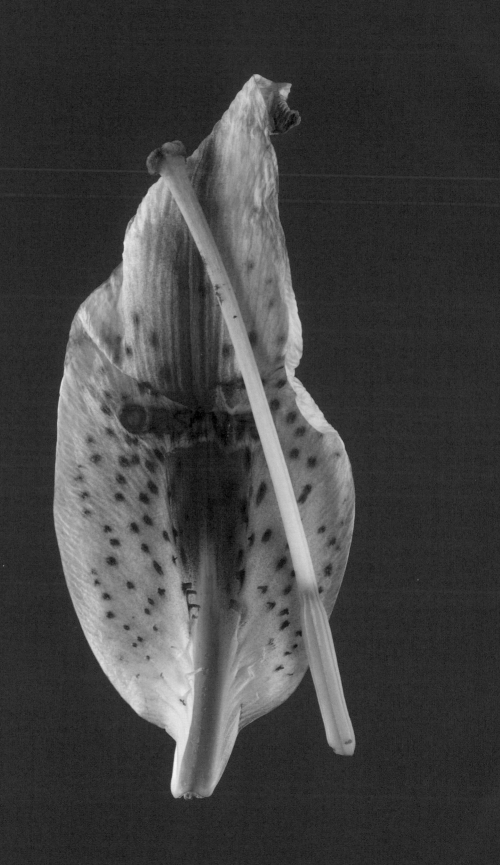

Visions

Pleasure and Misery: Catholic Sources of Paul Gauguin's and Pablo Picasso's Abstraction

Debora Silverman

> In the absence of religious painting, what beautiful thoughts one can evoke with form and color.
>
> — Paul Gauguin[1]

In the period between 1885 and 1910, a major paradigm shift took place in the visual arts as modern painters and their critical defenders sought to move painting beyond narrative representation and figurative language, toward what they called *abstraction*. It is well-known that the shift to a nonfigurative language entailed a heightened subjectivity, a turn, beginning with the symbolists, to the cultivation of inner vision, feeling, and experience as the basis of artistic creation. Less well-known is the way that painters venturing into this new terrain tried to connect the cultivation of inner vision and experience to the search for a new level of communication, a more direct and more universal mode of discourse. This paradox of subjectivity and idealism at the heart of avant-garde painting in the 1880s and 1890s was suggested by Robert Goldwater in his essay "Symbolic Form: Symbolic Content" (1963); he identified an urgent need among avant-garde artists to "make emotion meaningful, to give it a context by connecting it with humanity at large, and even beyond this, with the natural world."[2]

In seeking a new shared language of painting, artists mobilized the resources of their theological cultures even as they struggled to abandon them. Late-nineteenth-century post-Tridentine Catholicism, and the institutions of Catholic education in particular, nurtured a receptivity to the ideas of abstraction and antinaturalism that were championed by avant-garde artists in the 1880s and 1890s. Inwardness and otherworldliness, for example, were core concepts in this Catholic educational system, fostering what Ernest Renan, one of its most celebrated and, later, most anticlerical students, considered a realm of "surrender to dreams" and a "folding in on one's self."[3] Many of those who defined the fin de siècle language and the practice of abstraction — such as the painters Édouard Vuillard and Paul Gauguin, the poet and theorist Charles Morice, and the writer Octave Mirbeau — were products of Catholic seminaries, where they were inculcated in techniques of introspection and in ways to fix their eyes and hearts on an ideal essential order beyond the deficiency and corruption of the material world, in transcendent release to the

Fig. 1. Pablo Picasso (Spanish, 1881–1973)
Picasso and Pallarès Arriving in Paris, 1900, pen on paper,
8.8 × 11.1 cm (3½ × 4⅜ in.)
Barcelona, Museu Picasso

divine. Painters on the cusp of abstraction developed a variety of new formal strategies and subjects as they engaged in a shared, paradoxical search for spiritual ends through the plastic means of pigment, primer, and canvas.[4]

This essay will explore the links between two modernist "titans," Paul Gauguin and Pablo Picasso. A recent exhibition on Picasso's earliest years, from 1892 to 1906, revealed the construction of an artistic identity by an individual extraordinarily adept at appropriation.[5] By highlighting Picasso's discovery and emulation of Paul Gauguin, I will emphasize the theological affinities between the two artists. I will concentrate on their shared experience of the particular conflicts and challenges of the generation of lapsed Catholic artists, symbolists and modernists, who first defined the contours of painting as abstraction and for whom the source of value in painting lay beyond the visible world and the confines of figurative language.

Through a close reading of Gauguin's *La vision du sermon* (1888) and *D'où venons-nous? Que sommes-nous? Où allons-nous?* (1897–98) and Picasso's *La vie* (1903), I will explore the new language of art that both painters sought. Ostensibly a rejection of the particular Catholic cultures that had shaped their identities, this new language nonetheless imported certain theologically specific attitudes to their paintings: both artists chose *les misères humaines* as subject matter, both experimented with a new type of secular modern allegory with which to express the sacred, and both aspired to encompass in visual form the fundamental questions of human origins and destiny which they had earlier encountered in the Catholic catechism. And perhaps most important, both Gauguin and Picasso engaged stylistic practices to dematerialize the physical surface of the canvas, emulating the matte permeation of the fresco and linking the representation of modern allegorical subjects to the technical procedures of transcendence and purification.

These expressive patterns of content and form—the choice of *misères* subjects, the search for a new allegory, and the use of frescolike surfaces—suggest that Gauguin and Picasso transposed the underlying antinaturalism of their religious formations into pictorial production. By examining the theological coherence of Gauguin's and Picasso's mentalities and visual practices, I hope not only to identify some new ways to approach the links between biography, culture, and style but also to enrich the social history of modernist art by uncovering the historically specific and constitutive forms of religious legacies in artistic creation.[6]

Picasso, Symbolist Arts, and Catholic Formation
Picasso discovered in the Parisian generation of the 1880s and 1890s a powerful template for his pre-1906 modern vision. Among this generation, a group of painters and critics adopted the term *symbolist* to proclaim both their rejection of the Impressionist devotion to the sensory moment and their search for a permanent, essential order beneath the surface of appearances. The idealist posture of the symbolists directed the artist to cultivate inner vision and to seek new expressive forms capable of evoking the ineffable netherworld

of the divine. Finding the Impressionist affirmation of the fluidity and evanescence of the urban metropolis unsustainable, the symbolist generation looked for new ways to transform, negate, or neutralize the experience of an ungovernable and intrusive urban reality.[7]

In our tendency to oversecularize the modernist avant-garde, we have not recognized the extent to which particular religious legacies and problems were a source of symbolist aesthetics and transformative vision. For example, we have yet to come to terms with the way that the first language and practice of symbolist idealism and abstraction emerged from a circle of Parisian artists and writers who shared a Catholic, often Jesuit, seminary education; within this circle, supernaturalist Catholicism, idealist Neoplatonism, and avant-garde symbolism came together in a dynamic cultural mix. Paul Gauguin, Charles Morice, Auguste Rodin, and the poet Maurice Rollinat all rejected institutional religious practice but defined their art, as well as their theories of life and attitudes toward reality, in terms that bore the stamp of their theological backgrounds. These artists shared an expressive pattern, shaped in part by the mental habits and filters of their Catholic education: they defined material reality as irrevocably corrupt, deficient, and even perfidious; they deployed a language of sacrifice and martyrdom in their representations of the modern artist; they linked the infernal to the internal, wherein creativity is grounded in the necessary cultivation of the "volcanic flames" of the soul;[8] and they viewed art as encompassing a spectacle of human misery, a modern suffering rooted in the experience of Catholic culture but unrelieved by the consolation offered by traditional religious belief. Picasso spent much of his early Paris period in thrall to Paul Gauguin partly because, like his predecessor, he sought a modern form of allegorical painting to replace the religion that haunted them both.[9]

Gauguin's "Abstraction": Apparitions, Vision, and the Visual

After a brief apprenticeship as a painter in Paris, Paul Gauguin renounced urban existence, first for a preindustrial oasis in Brittany and later in the further reaches of Tahiti. In 1888 Gauguin sought spiritual and social wholeness in the Breton village of Pont-Aven, where he launched what he considered a modernist manifesto: *La vision du sermon* (fig. 2). At one point Gauguin thought of titling the work *Apparition*; later it became known as *La vision d'après le sermon* or *Lutte de Jacob avec l'ange* (Jacob wrestling with the angel).[10] *La vision* depicts Breton peasant women, in their distinctive regional costumes and headdresses, frozen in silent prayer and meditation. Heads bowed, eyes closed, and hands locked together, they project the contours of their inner vision—a scene of Jacob wrestling an angel—onto a dream landscape, rendered, as Gauguin explained, as an unmistakably *non*-natural color field of "*pure vermilion.*" The expanses of bright red that envelope the static figures signify the fluid outpouring of their inner vision, thus providing a formal medium for Gauguin's goal—to depict the passage across the divide of material reality into the realm of the supernatural.[11]

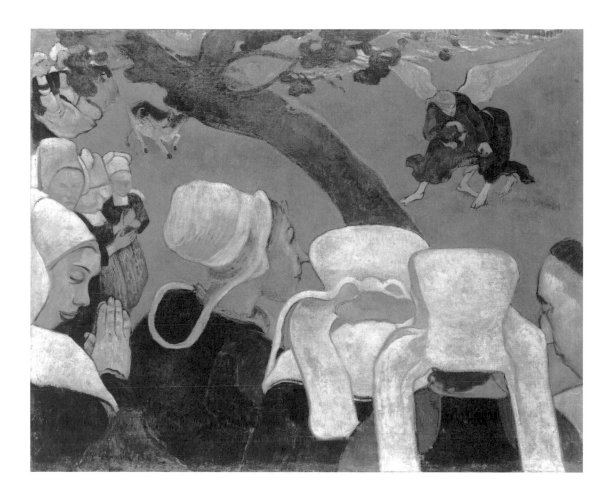

Fig. 2. Paul Gauguin (French, 1848–1903)
La vision du sermon, 1888, oil on canvas, 73 × 92 cm (28¾ × 36¼ in.)
Edinburgh, National Gallery of Scotland

Gauguin's choice of a religious theme for *La vision,* the theme of visionary rural piety, was particularly significant in the 1880s; that decade marked the height of a religious revival across France, including an upsurge of devotional cults and the spread of popular Catholicism. During the fall of 1888, for example, a young shepherd from the Forez region in central France claimed to have witnessed, up to twenty times, an apparition of the Virgin Mary, who spoke to him of the need for prayer and penitence. The Forez apparition was only one of a multitude of miraculous appearances of the Virgin to humble peasants in rural France after 1850, a period that came to be known as *l'époque des apparitions.*[12] In their efforts to counteract republican anti-clericalism and to rejuvenate the Church through dynamic, popular forms of Catholicism, the official clergy tolerated and even sanctioned these Marian visions. Official and popular ecstatic devotion came together in the unprecedented pilgrimage movement of the 1870s. This movement yielded the well-known annual festival of Lourdes, where the Virgin Mary was said to have appeared in a grotto to a young woman named Bernadette Soubirous, as well as the less familiar but equally important annual pilgrimage to Paray-le-Monial, which celebrated the visions of the Sacred Heart of Jesus that appeared to Marguerite-Marie Alacoque, a seventeenth-century nun beatified in 1864 and worshiped by one million French pilgrims in 1877.[13]

Of the many fascinating features of *La vision du sermon,* I will limit myself to exploring the elements that are of particular significance for an understanding of the young Picasso.[14] First, Gauguin devised the imagery of the painting after immersing himself in the culture of Breton folk piety and popular devotion, studying local churches, stained glass, archaic calvaries, and religious festivals. Gauguin may have witnessed some of the pilgrimage processions that were renowned in the region, and some scholars maintain that he based *La vision* on a specific ceremony called a Pardon, the feast of a patron saint, in which villagers circled the local church on their knees in an annual public ritual of repentance and reconciliation.[15] Gauguin explicitly assigned a sacred function to his painting, and he aspired to see *La vision* in a Breton church, thereby returning his depiction of popular piety to the site of his subjects' worship. "I wanted to give it to the Church of Pont-Aven," Gauguin wrote to Vincent van Gogh in September 1888. It "would be all right in surroundings of bare stone and stained glass," he noted, and indeed a pair of stained-glass windows in the apse of the Pont-Aven chapel portrayed angels whose unscrolling wings and radiant color scheme harmonized with these same elements in *La vision du sermon.*[16] One can imagine how Gauguin's painting might have operated as part of a rich and thematically unified environment for religious experience, much like the fifteenth-century Italian settings analyzed by the art historian Michael Baxandall, where sermon, gesture, and painting operated as inextricably linked elements of a communal choreography of worship.[17] While the priests at both Pont-Aven and the neighboring village of Nizon refused to hang *La vision* in their chapels, Gauguin's conception of the painting's religious function highlights his determination to

link his artistic vision to what he saw as the elemental, visual faith of the Breton peasant.[18]

Second, Gauguin linked the form and content of *La vision* to his credo of art as "an abstraction," a "glimpse" of a "dream" that might "touch the heavens," liberated from the "shackles" of tawdry, earthbound matter, in flight to metaphysical purity.[19] Throughout his writings Gauguin revealed a fundamental distrust of nature and material life, which he described as corrupt and perfidious, an arena of sullying muck and mire that weighed the artist down and impeded his release into the transcendent realm of the divine.[20] Soon after completing *La vision*, Gauguin wrote to Madeleine Bernard, the artist Émile Bernard's sister, that "everything divine must not be a *slave* to matter, the body.... *Every chain* springs from an inferior order, and to act as a slave is to disregard divine laws."[21] "When you come right down to it," Gauguin later declared to Bernard himself, "painting is like man, mortal but always living in conflict with matter."[22] This intractable conflict contributed to Gauguin's sense of the artist as a modern Christ, engaged in a "long" and mutilating "calvary," burdened by suffering, anguish, and unending melancholy.[23] To paint in this condition was to "sail on ... phantom vessels" to "the infinite," to "ascend toward God."[24] The visionary state of *La vision* is an expression of Gauguin's credo of abstraction from a sullied world — the painting explores shifting levels of reality, the melding of vision and the visual.

Art historians have emphasized how Gauguin divided the canvas into "physical and psychic halves,"[25] but Gauguin also employed a number of lesser-known technical strategies for dematerializing the physicality of the canvas surface as much as possible. As Reinhold Heller has suggested, Gauguin used a thinned and light oil paint and a special matte white ground, which allowed the paint to melt away and be absorbed into the surface, "enhancing flatness" and "sheen" and diminishing surface texture, thus contributing to *La vision*'s resemblance to a smooth and chalky fresco.[26] Gauguin himself likened the painting to a fresco when he wrote that it would blend well into the "bare stone" of the church walls. Another formal method that Gauguin later experimented with, in his ongoing efforts to suppress and attenuate materiality, was ironing over the surface of his canvases.[27]

Antinaturalism in Gauguin's Catholic Seminary Education

The visionary experience depicted by Gauguin in *La vision* expressed the long-term legacy of his particular religious education, a legacy that has never been adequately explored. During at least four years, from 1859 to 1862, in the Petit séminaire de la Chapelle-Saint-Mesmin, a French Catholic seminary near Orléans, Gauguin was taught by the bishop of Orléans himself, Monseigneur Félix-Antoine-Philibert Dupanloup.[28] An important educational reformer, Dupanloup considered children to be "fallen from heaven," though they were able to recover their "wings" in an inner flight to "invisible regions" through memory, imagination, and self-expression.[29] Dupanloup's teachings centered on a dialectic of admonition and transcendence. On the

one hand, Dupanloup emphasized a corrupt nature and a transgressive human nature, and he characterized children as plagued by the defects of their own carnality or "concupiscence." The lure and transience of worldly pleasures yielded only desolation and putrefaction, which Dupanloup graphically evoked in chants such as the "Misères de la vie présente." On the other hand, Dupanloup sought to impress upon the children's consciousness the spectacle of their supernatural destiny, the joys of "possessing the heavens," of ascent to a celestial light.[30] Deeply antipositivist, Dupanloup devised a new, more dynamic catechism, which encouraged children to move beyond dry recitation to sacred silence and to engage in active interior interrogations of supernatural beings, such as angels, thereby eliciting a state of visionary release from a deficient earthly world.[31] Gauguin assimilated from this seminary training a profound receptivity to idealism and antinaturalism; a presumption of man's supernatural destiny and of material reality as a treacherous and temporary way station to divinity; an inculcation in techniques of introspection; and a fluency in the practices of visual memory and interior visualization.

Catholic Theology and Modern Allegory

The resources of Gauguin's seminary training also offer a new context for interpreting his enduring preoccupation with the themes of misery, profanation, transgressive sexuality, and suffering, all of which he attempted to project through a modern form of allegory. Several other examples of Gauguin's work attest to a theological coherence to his visual practices, especially with regard to his representation of the dialectic of earthly pleasure and desolation.

For instance, Gauguin's sarcophagus-like decorated wooden box (fig. 3), with its dancing ballerina figures on the outside and a shrouded body inside, resonates with the allegorical impulses of Gauguin's training at the Petit séminaire. The recumbent figure inside the box was based on Gauguin's study of the mummified remains of a Bronze Age coffin that he had encountered at the Copenhagen National Museum when he was living in Denmark with his Danish wife Mette. Scholars have suggested that Gauguin's box, allegedly made as a jewelry case for Mette, was intended as a sardonic "comment on human vanities," a meditation on the theme of the emptiness of worldly pleasures, on the New Testament belief that "the wages of sin is death."[32] But what compelled Gauguin to produce such an unusual object, and why did he choose this particular form?

One impulse contributing to Gauguin's creation stems from the particular ethos of *contemptus mundus* as set by the teachings of Bishop Dupanloup and the program of the Petit séminaire. The juxtaposition of the worldly pleasures depicted on the outside of Gauguin's box with what has been called a "tomb effigy"[33] on the inside, for example, bears a striking affinity with the vivid association of vanity and perdition that coursed through the daily prayers and chants of the young seminarians. One canticle, "Sur les vanités du monde," contrasted the accumulation of gold and silver to the inevitable dissolution of

Fig. 3. Paul Gauguin (French, 1848–1903)
Decorated Wooden Box, ca. 1884–85, pear wood with iron hinges, leather, red
stain, inlaid with two netsuke masks, 21 × 51 × 13 cm (8¼ × 20⅛ × 5⅛ in.)
Private collection

matter in the tomb. Gauguin's jewelry box of death provides a visual ana-
logue to this dolorous admonition of Catholic education:

> Everything is only vanity, lies, fragility,
> .
> All these brilliant externals,... these treasures,
> Everything dazzles; but all eludes us
> .
> What will become of them, for man who must die,
> These accumulated goods, this gold, this silver hoard?
> .
> For him, all of it ceases to be:
> The day of his mourning
> He has nothing but a coffin
> .
> All succumb, all must be swallowed up in the tomb.[34]

The themes of carnality and suffering recur elsewhere in Gauguin's paint-
ing and sculpture. Like Auguste Rodin, Gauguin sought to modernize the
seven deadly sins, choosing, for example, lust as the subject for his sculpture
La Luxure (1890; Denmark, J. F. Willumsen Museet).[35] Further, a particular
female figure that appears early on and repeatedly in Gauguin's work takes on
new meaning when placed in the repertoire of allegorical images and their
theological foundations. In the painting *Vendanges à Arles: Misères humaines*
(1888; Copenhagen, Ordrupgaard Collection), this figure is seated in the fore-
ground, a hunched-up and "brooding" woman. Gauguin described her in his
letters as dejected and despairing; scholars have interpreted her as a symbol of
sexual transgression, desolation, and death.[36] In his notebooks Gauguin also
listed this painting as *Splendeur et misère*, a title that once again affirms the
dialectic of sensuality and reckoning accentuated in Dupanloup's teachings.[37]
The figure of a seated, afflicted female resurfaces in a set of allegorical images
of 1889: the watercolor and pastel called *Eve, Don't Listen to the Liar* (San
Antonio, McNay Art Museum) and the major painting entitled *La vie et la
mort* (fig. 4). In *La vie et la mort,* Gauguin positioned the seated female fig-
ure to resemble a Peruvian mummy he had seen in the Musée de l'Homme in
Paris. The trepanned mummy—a gruesome figure in a "foetal burial posi-
tion," "offset by a wide-mouthed, gaping scream"[38]—provided Gauguin
with a visual prototype in much the same way that the mummified remains
in Copenhagen were a source for his decorated wooden box. While the
appeal of these tomb effigies may offer evidence of Gauguin's incipient
"primitivism," it also signals the lingering salience of a religious system in
which putrefaction and perdition were integral and vivid parts of recitation
and representation.

Gauguin's allegorical works may not be as familiar to us as his Tahitian
exoticisms, but they are central to an understanding of his religious mentality

Fig. 4. Paul Gauguin (French, 1848–1903)
La vie et la mort, 1889, oil on canvas, 92 × 75 cm
(36¼ × 29⅝ in.)
Cairo, Mahoumed Khalil Museum

Fig. 5. Paul Gauguin (French, 1848–1903)
D'où venons-nous? Que sommes-nous? Où allons-nous?, 1897,
oil on canvas, 139.1 × 374.6 cm (54¾ × 147½ in.)
Boston, Museum of Fine Arts

and his importance to the young Picasso. To be sure, Gauguin's agonized meditations on human suffering coexisted with another dimension of his artistic temperament that was crucial to Picasso—namely, a notorious and merciless self-aggrandizement. Gauguin's Paris contemporaries credited him with inventing the marketing tactics of modern artistic self-promotion, a new engine of publicity and speculation in which the artist's personality was a significant element of production and commerce. From the beginning, the ever astute van Gogh saw right through Gauguin, calling him a "schemer" and a "speculator" who parlayed his experience as a successful stockbroker into the inflation of himself and the value of his art on the market.[39] Gauguin was also a voracious cannibalizer of other artists' innovations; he worked his way through a number of early mentors, such as Camille Pissarro, Edgar Degas, and Paul Cézanne, taking from them what he needed and then rather ruthlessly discarding them. Disgusted by Gauguin's exploitation of others, Pissarro called him "effroyablement ambitieux" (terrifyingly ambitious) and went on to say how "shamelessly Gauguin behaved in order to get himself elected [a] man of genius," by crushing "whoever stands in [his] path."[40]

Yet Gauguin the rapacious egotist, ferocious self-promoter, and imperious colonialist was also a product of a French Catholic seminary; and we need to take seriously his enduring religious torments and preoccupations to better understand the parallel chords they elicited in the young Picasso. Without attending to this aspect of Gauguin's temperament, we cannot make sense of his compulsion, while in Tahiti, to write a long polemical essay against what he saw as abuses of the Church. Gauguin sent this essay, "L'esprit moderne et le catholicisme," to the French bishop stationed in the South Seas, and he tried to engage the cleric in a vehement debate over the meaning of the parables and of modern faith.[41] Gauguin's essay has prompted one biographer, David Sweetman, to emphasize aptly that, "despite his anti-clericalism, Gauguin was far less anti-Christian than one might have supposed.... In common with many people who rant and rave against religion and the Church, Gauguin seems at heart to have remained a confused believer, forever castigating the thing he could not quite reject."[42]

Yet the most powerful and unacknowledged traces of Gauguin's Catholicism emerged not in polemical texts but in pictorial form. When his beloved daughter Aline died suddenly in 1897, Gauguin expressed his mourning in a monumental allegory, D'où venons-nous? Que sommes-nous? Où allons-nous? (fig. 5). This painting can be interpreted as a subversive catechism, in which Gauguin reengaged, in interrogatory form, the fundamental themes of his theological grounding: man's supernatural origin and destiny. The three questions of Gauguin's title corresponded closely to a trio highlighted by Bishop Dupanloup: "d'où vient l'espèce humaine" (where the human species comes from); "où elle va" (where it is going); and "comment elle va" (how it goes).[43] Gauguin's transposition of catechistic questions into painting unwittingly confirmed Dupanloup's assertion that the power and clarity of the catechism were so irresistible that once these questions were "engraved in

memory they remained there for life"; Dupanloup predicted that even "men who had lost their faith" and were living "the most irreligious lives" would find themselves "instinctively" summoning the formulas to consciousness.[44]

Gauguin's immense, friezelike painting presents a cycle of birth, life, and death in stages from right to left, with the hunched-up female figure of *Vendanges á Arles: Misères humaines, Eve,* and *La vie et la mort* here depicted as a white-haired old woman. Gauguin inscribed the painting's trio of questions in the gilded upper-left corner, one of two edging the canvas, and he described the painting as being "like a fresco with damaged corners on a golden wall."[45] While Gauguin relied on catechistic forms of thought when he conceived of the painting as a series of questions, he did not presume to represent the solace and redemption offered by the set of prescribed answers to the believing Catholic. He characterized *D'où venons-nous?* to the writer André Fontainas as evoking a human existence filled with "suffering," alleviated only by "*imaginary* consolation," the result of "our *inability* to plumb the mystery of our origin and future."[46]

Picasso's Gauguin: From Personal Hero to Catholic Visionary

Picasso certainly knew and admired Gauguin's master painting *D'où venons-nous?*, and we have compelling and explicit evidence of Gauguin's importance to Picasso from 1900 on. John Richardson, among other writers, has discussed how Picasso read and annotated Gauguin's Tahitian journal, "Noa Noa," noting that Picasso copied one of the plates, the only work he signed as "Paul" Picasso, in an obvious homage to his confrere.[47] Picasso saw the Gauguin paintings in the collector Ambroise Vollard's gallery, and he studied Gauguin's ceramics through the sculptor and ceramicist Paco Durrio.[48] And Picasso, who himself has been characterized by scholars as a predator and cannibalizer, a shrewd and unrelenting manipulator of men and women, certainly responded to these same traits in Gauguin—especially their usefulness in the marketing of modern art and the modern artist. Yet the pull of the exotic, the erotic, and the egotistic in Gauguin must have been intensified by the striking theological affinities between the two artists and their shared preoccupation with a particular kind of painting that expressed the vestiges of their religious formations: a kind of painting that navigated the divide between the natural and the supernatural, that engaged the lamentational condition of human carnality and modern misery, and that offered devotional and consolational forms as a substitute faith. Three examples of Picasso's work point to this type of painting in his emerging oeuvre.

At the start of his career, Picasso immersed himself in religious paintings, exploring, as Gauguin had attempted to do in his modernist *La vision,* the shifting levels of reality, vision, and the visual. Picasso was trained in Spain as a religious genre painter, and his early work abounded in sacred subjects, especially depictions of saintly suffering and scenes from the life of Christ.[49] Within his repertoire of religious images, Picasso included the representation of apparitions: the miraculous appearances of divine figures to earthly devotees.

Fig. 6. Pablo Picasso (Spanish, 1881–1973)
Christ Appearing to Blessed Marguerite-Marie Alacoque,
1896, oil on canvas, 24.4 × 18.5 cm (9⅝ × 7¼ in.)
Barcelona, Museu Picasso

Indeed, in the studio of Picasso's teacher, José Garnelo, there was a replica of the newly organized "grotto at Lourdes, with models posing for the Virgin and Bernadette."[50] In 1896 Picasso depicted a miraculous revelation in the oil sketch known as *Christ Appearing to Blessed Marguerite-Marie Alacoque* (fig. 6); like Gauguin before him, Picasso was drawn to the subject of the saint of the Paray pilgrimage. Church officials in Spain, as in France, endorsed ecstatic cults in order to revitalize Catholic authority by the recuperation of popular forms of devotion.

Picasso's painting of Marguerite-Marie Alacoque's vision may have been a side panel for an altarpiece he was commissioned to produce for a Barcelona convent.[51] The young Picasso thus accomplished early on what Gauguin had failed to achieve—the placement of his painting in a local church. Both artists were shaped by early immersion in Catholic iconography, as well by the culture of visionary experience that was acquiring new legitimacy across nineteenth-century Europe. In *The End of the Road* (fig. 7), which can be seen in part as a pictorial equivalent to Gauguin's *La vision du sermon*, Picasso offered a powerful image of rich and poor marching toward the final judgment, with a massive angel marking the boundary from this world to the next. While *The End of the Road* surely evokes issues of class disparity that were of intense concern to Picasso and his circle, the image also contains visual traces of the new pilgrimage cults of miraculous healing and devotion so prominent in the popular piety of the period: the figures in the foreground—the man leaning on a single crutch and the woman carrying her lame and afflicted son—both typify the fin de siècle pilgrim.[52]

Picasso also shared with Gauguin a reliance on popular devotional forms as a source for his modern primitivism. We have seen how Gauguin studied and incorporated sources of popular religious culture in Brittany, from Breton calvaries to stained glass. And Gauguin explicitly made use of the seventeenth-century yellow wooden Christ in the local Breton church at Nizon as a template for the painting *Yellow Christ* (1889; Buffalo, Albright-Knox Gallery). Picasso, too, would return as a mature artist to the archaic arts of his own regional religious culture, from the Romanesque Christ, originally in the church at Manresa and exhibited in Barcelona in 1902, to a twelfth-century wooden Madonna, which he saw while visiting the town of Gósol (Barcelona, Museu d'Art de Catalunya).[53]

Finally, Picasso expressed a striking affinity for Gauguin's emphasis on the fundamentally dolorous nature of human existence and on the role of painting as both a representation of modern wretchedness and a new, and lone, source of devotional power. In Picasso's *Self-Portrait* of 1900, drawn in Paris and inscribed "*Pictor e-n Misere Humane*" (fig. 8), the artist bound his subjectivity to lachrymosity and also to his form-giving powers to express human existence as fundamentally grounded in suffering, sorrow, pain, and anguish. This agonistic model of our shared human condition, and the artist's obligation to represent it, predated what is known as Picasso's Blue Period. The self-portrait of 1900, of the artist as the carrier of a modern *miséricorde,* joined

Fig. 7. Pablo Picasso (Spanish, 1881–1973)
The End of the Road (Au bout de la route), 1898–99, oil washes and
conté crayon on laid paper, 47.1 × 30.8 cm (18½ × 12⅛ in.)
New York, Solomon R. Guggenheim Museum

Fig. 8. Pablo Picasso (Spanish, 1881–1973)
Self-Portrait, Inscribed "Pictor e-n Misere Humane," 1900,
pen and sepia on paper, 20.5 × 12.6 cm (8⅛ × 5 in.)
Private collection

Fig. 9. Pablo Picasso (Spanish, 1881–1973)
Crucifixion with Embracing Couples, 1903, pencil and blue crayon
on paper, 31.8 × 21.9 cm (12½ × 8⅝ in.)
Paris, Musée Picasso

personal and universal affliction in a new visual language, transposing to the domain of art the spiritual tasks that hitherto had been defined by the institution of the Catholic Church: asserting the dolorous nature of human existence; exploring the panoply of vice, corruption, and infirmity to which man was inescapably consigned; and offering, through representation, consolation and a collective vision of redemptive suffering.

Friends of Picasso's and writers on Picasso have registered a general sense that, as his widow Jacqueline stated, "Pablo était plus catholique que le pape"; or, in the words of his friend Michel Leiris, that despite his bombastic irreverence and impiety, Picasso could never fully escape "the absurd power of Christian morality."[54] The constitutive force of Catholicism is detectable in the way that Picasso's mental world remains governed by a set of core dualisms, the linking of profanation and perdition, anguish and ecstatic transgression, sensuality and desolation, pleasure and misery. These same dualisms characterized the mentality and the artistic vision of Gauguin and thus heightened Picasso's receptivity to the older painter. We can compare, for instance, Gauguin's notion of life as a calvary, his identification with both the torments and creativity of Christ, with Picasso's preoccupation with the Crucifixion and its relation to the despair and exaltation of sexuality (fig. 9).[55] Sketches made very late in Picasso's career—in which he depicts himself as the subject of the Crucifixion, and Jacqueline as Dolores, Our Lady of Sorrows, with streaming tears and swords piercing her heart—are evidence of the long-term significance of these themes.[56]

Picasso's La vie *and Gauguin's* La vie et la mort: *Grief, Modern Allegory, and the Stylistics of Transcendence*

Looking back on the art of Picasso's Blue Period, at its height in 1903, Picasso's friend Jaime Sabartès described it as a repertoire that "emanate[d] from Sadness and Pain," from the "grief" that was "at the basis of life,... with all its torments."[57] At this moment, Picasso discovered in Gauguin's art a critical resource for a modern lamentational vision, and Picasso sealed his connection to Gauguin in a massive allegorical painting titled *La vie* (fig. 10).

La vie, one of the most monumental of Picasso's early paintings, assumes the scale, form, and message of sacred art. Picasso produced *La vie* soon after the death of his friend Carles Casagemas. The painting was an expression of personal grief, much as Gauguin's *D'où venons-nous?* had been an outlet for the desolation he felt after his daughter's death (see fig. 5). Like Gauguin's painting, Picasso's uses allegorical forms to engage fundamental questions, moving from the theme of personal affliction to the broader themes of the cycles and stages of life. Gauguin's mural moved from right to left, from youth to motherhood, from birth to old age and death; Picasso's moves in the opposite direction—the young lovers are placed on the left, with the male figure portrayed as Casagemas, and the mother and baby on the right.

Many scholars have pointed out the resemblance of the nude sketches in the background of *La vie* to the seated, rounded women in Gauguin's mural

Fig. 10. Pablo Picasso (Spanish, 1881–1973)
La vie, 1903, oil on canvas, 196.5 × 129.2 cm (77⅜ × 50⅞ in.)
Cleveland, Cleveland Museum of Art

D'où venons-nous?[58] But there are other, more basic links as well. As we have seen, these hunched-up and sorrowful women were integral parts of Gauguin's early repertoire of allegorical figures; they were partly inspired by the Peruvian mummy in the Musée de l'Homme in Paris, and they appeared in the paintings from Brittany, *Eve* and *La vie et la mort* (see fig. 4). Yet, to date, the connection between *La vie et la mort* and Picasso's *La vie* has not been made. Gauguin's pairing of woman bather and woman brooder, his modern allegory of life and death, matches Picasso's pairing of figures in *La vie,* and both painters explore suffering as the inevitable consequence of the pleasures of sensual life. Picasso's *La vie* signaled its own allegorical partner, *la mort,* in another way: *La vie* was painted on top of a painting that Picasso had exhibited in 1900, called *Last Moments,* which depicted a woman on her deathbed and a priest administering the last rites to her.[59]

Picasso's painting shares yet another element with Gauguin's: the search for a new stylistic language of the sacred, what we might call a metaphysics of the thinning brush, an attempt to link the exploration of transcendent themes with technical strategies of dematerialization. To emulate the effects of the fresco, Gauguin had employed a matte, absorbent ground, and he had even ironed on his canvases to suppress their surface density. Picasso similarly rendered his modern allegorical subject matter in the traditional, physical properties of the fresco: not only is *La vie*'s chalky, smooth, and filmy coloring suggestive of the fresco method, but the massive scale of the painting is fresco-like in that it replaces the wall. Moreover, the painting also seems to represent a set of frescoes within itself: along the cool, bare stone wall and the arches in the back, two Gauguinesque nudes are displayed in an ambiguous manner, as either resting against the wall or inserted into it, as part of the wall. So we have here, in effect, a *double* fresco—the massive painting itself acts as a wall, yet it also merges into its own bare walls the two Gauguin-inspired nudes. This gesture is reminiscent of Gauguin's earlier attempts to redefine sacred art in the Pont-Aven chapel and in the gilded corners of his mural *D'où venons-nous?*

"I DON'T SEEK — I FIND!" thundered Picasso. This statement surely resounds with the voraciousness, sense of entitlement, and sheer bravado that enabled the young painter from Barcelona, with friends but without funds, to barge his way into the history of art.[60] Yet in Paris Picasso *did* seek, and there were patterns to what he found. Gauguin's steamroller temperament surely bolstered Picasso's ferocious self-aggrandizement. But Gauguin's appeal to Picasso struck deeper, and more historically resonant, chords as well. With common formations and mental maps set by their theological cultures, the two artists continued to feel the press of the religious legacies they struggled to abandon. Both exposed, in visual form, the pressure points of Catholicism in the fin de siècle.

Notes

1. Paul Gauguin to Émile Schuffenecker, in Paul Gauguin, *Correspondance de Paul Gauguin: Documents, témoignages,* vol. 1, *1873–1888,* ed. Victor Merlhès (Paris: Singer-Polignac, 1984), 216 (no. 162, August 1888): "A défaut de peinture religieuse, quelle belles pensées on peut évoquer avec la forme et la couleur."

2. Robert Goldwater, "Symbolic Form: Symbolic Content," in International Congress of the History of Art, *Studies in Western Art,* vol. 4, *Problems of the Nineteenth and Twentieth Centuries* (Princeton: Princeton Univ. Press, 1963), 111–21.

3. Ernest Renan, *Souvenirs d'enfance et de jeunesse,* ed. Jean Pommier (Paris: A. Colin, 1959), 86, 89, xxxviii–xxxix. Renan was a junior seminary student at the Petit séminaire de Saint Nicolas du Chardonnet, Paris.

4. Jean Bouillon identified this paradox in the symbolist generation in his "Le moment symboliste," *Revue de l'art* 96 (1992): 7. I developed some of these ideas in my article, "At the Threshold of Symbolism: Van Gogh's *Sower* and Gauguin's *Vision after the Sermon,*" in Jean Clair, ed., *Lost Paradise: Symbolist Europe,* exh. cat. (Montreal: Montreal Museum of Fine Arts, 1995), 104–15; this material has been expanded in my book, *Van Gogh and Gauguin: The Search for Sacred Art* (New York: Farrar, Straus & Giroux, 2000), 49–118. Much more attention needs to be directed to this area of religion and modernism, construed not in terms of tracking overt symbols and subjects but as formative structures or mental frameworks that provide varying resources, and constraints, for the ways that artists conceive of the status of the self, the value of the image, the meaning of the visible world, and the physicality of the canvas surface.

5. The exhibition was held at the National Gallery of Art, Washington, D.C., 30 March–27 July 1997, and at the Boston Museum of Fine Arts, Boston, 10 September 1997–4 January 1998. See Marilyn McCully, ed., *Picasso, The Early Years, 1892–1906,* exh. cat. (New Haven: Yale Univ. Press, 1997). Picasso absorbed contemporary French painting during his formative stays in Paris during the period from 1900 to 1906.

6. A preliminary version of this essay was presented on 17 May 1997 at the symposium for the exhibition *Picasso, The Early Years, 1892–1906,* National Gallery of Art, Washington, D.C. My thanks to Jeffrey Weiss, Faya Causey, Jeffrey Prager, Nancy Troy, Jim Herbert, Temma Kaplan, Marilyn McCully, Richard Meyer, and John Richardson for their comments and suggestions.

7. I am employing the term *symbolist* here both as a specifiable movement and as a generalized framework of attitudes current among a generation of painters and writers during the 1880s. First, I follow the classification of antipositivism, subjectivism, idealism, and the cultivation of the dream state that Jean Moréas proposed in his manifesto published in 1886 in *Le figaro,* which was later echoed by the writer and poet Gustave Kahn. Second, I rely on the discussion of symbolist visual arts of the late 1880s presented by Robert Goldwater in his important article "Symbolic Form: Symbolic Content" (note 2). For other sources for this approach to symbolism, see the documents in "Symbolism and Other Subjectivist Tendencies," in Herschel Chipp, ed., *Theories of Modern Art: A Source Book by Artists and Critics* (Berkeley: Univ. of California Press, 1971), 48–123; Henri Dorra, *Symbolist Art Theories: A Critical Anthology* (Berkeley: Univ. of California Press, 1994); Robert Goldwater, *Symbolism* (New York: Harper & Row, 1979); Robert L. Delevoy, "Manifestos and Demands," in

idem, *Symbolists and Symbolism*, trans. Barbara Bray, Elizabeth Wrightson, and Bernard C. Swift (New York: Rizzoli, 1982), 68–93; John Rewald, *Post-Impressionism: From van Gogh to Gauguin* (New York: Museum of Modern Art, 1978), 133–66; the special issue of the *Revue de l'art*, "Symbolisme," 96 (1992); and Silverman, "At the Threshold" (note 4).

8. See Françoise Cachin, "Gauguin Portrayed by Himself and Others," in Richard Brettell et al., *The Art of Paul Gauguin*, exh. cat. (Washington, D.C.: National Gallery of Art, 1988), xx.

9. Important links exist between symbolist theories of abstraction and antinaturalism and Catholic religious training and education, which add a specifically theological origin to the idealist and subjectivist strains of early formalist experiments in painting and literature in the late 1880s. In late-nineteenth-century France, the institutions of Catholic catechismic education shaped artists' mentalities and "habits of mind," consolidating certain expressive patterns and preoccupations, which remained significant, regardless of later religious practice or the presence or absence of explicitly religious subject matter. These underlying structures of late-nineteenth-century French Catholic formation emphasized, for example, the skills of self-scrutiny and censorious self-examination and a fundamental distrust of material reality as debased and corrupt, two areas of critical importance to the development of symbolist antinaturalism and heightened interiorization. Symbolist artists expressed growing self-consciousness about the indelible imprint of Catholic mental formation on their adult consciousness, registering both very negative and positive results; this can be traced in memoirs and education surveys of the period, including Jean Rodes, "Enquête sur l'éducation," *La revue blanche* 28 (1902): 161–82. While links between symbolism, early abstraction, and the philosophy of Neoplatonism have been explored—most notably by Mark A. Cheetham's *The Rhetoric of Purity: Essentialist Theory and the Advent of Abstract Painting* (Cambridge: Cambridge Univ. Press, 1991), esp. chap. 1—I want to recover the pervasively Catholic and institutionally transmitted origins of the complex of attitudes of antimaterialism and transcendence underlying French symbolist theory and practice, which preceded artists' adoption of Neoplatonist philosophies and may have predisposed them to Neoplatonism. For the expressive patterns of deficient nature, the artists' self-sacrificing martyrology, and the ideal of ascent and transcendence, see Albert Aurier's *Oeuvres posthumes* (Paris: Mercure de France, 1893) and the cursory discussion of Aurier's *L'oeuvre maudit* and *La montagne de doute* in Sven Lövgren, *The Genesis of Modernism: Seurat, Gauguin, van Gogh, and French Symbolism in the 1880's*, rev. ed. (New York: Hacker, 1983), 137–38; I discuss infernal interiority, modern hell, and the agonies of creativity in Auguste Rodin and Maurice Rollinat in my book, *Art Nouveau in Fin-de-Siècle France: Politics, Psychology, and Style* (Berkeley: Univ. of California Press, 1989), 243–68, 303–6.

10. The titles *Apparition* and *La vision du sermon* are listed by Gauguin in his "carnet" (notebook) as discussed by Ziva Amishai-Maisels, "A Gauguin Sketchbook: Arles and Brittany," *Israel Museum News* 10 (1972): 70. Much of the literature on Gauguin relies too easily on the latter title for the painting and does not adequately distinguish it from Gauguin's own titles. The original titles are crucial and need to be reintroduced for interpretations of the picture. *La vision d'après le sermon* (Vision *after* the

sermon), for example, implies discrete phases of before and after, and the divisible stages of hearing the sermon followed by the projection of an inner image of it, while *La vision du sermon* (Vision *of* the sermon) suggests a more active and dynamic process of consciousness, and the interplay of sermon and vision, word and image, vision and the visual, which are part of the immediacy and nonlinearity of the mental and spiritual states explored by Gauguin.

11. As Gauguin explained to Vincent van Gogh in a letter of late September 1888, "for me in this painting the landscape and the fight only exist in the imagination of the people praying after the sermon, which is why there is a contrast between the people, who are natural, and the struggle going on in a landscape which is non-natural and out of proportion"; as translated in Richard Brettell et al., *The Art of Paul Gauguin,* exh. cat. (Washington, D.C.: National Gallery of Art, 1988), 103 (cat. no. 50 by Claire Frèches-Thory); for the original French, see Gauguin, *Correspondance* (note 1), 232 (no. 165, September 1888).

For other analyses of Gauguin's *La vision d'après le sermon,* see Lövgren, *The Genesis of Modernism* (note 9), 111–27; Ziva Amishai-Maisels, *Gauguin's Religious Themes* (New York: Garland, 1985), 18–32; Vojtěch Jirat-Wasiutyński, *Paul Gauguin in the Context of Symbolism* (New York: Garland, 1978), 89–92, 220–23; Brettell et al., *The Art of Paul Gauguin,* 102–5 (cat. no. 50 by Claire Frèches-Thory); Silverman, "At the Threshold" (note 4); and William Darr and Mary Matthews Gedo, "Wrestling Anew with Gauguin's *Vision after the Sermon,*" in Mary Matthews Gedo, *Looking at Art from the Inside Out: The Psychoiconographic Approach to Modern Art* (Cambridge: Cambridge Univ. Press, 1995), 56–86.

12. From Jean-Baptiste Estrade, *Les apparitions de Lourdes: Souvenirs intimes d'un témoin* (Lourdes: Imprimerie de la Grotte, 1911), 1; see also Philippe Boutry, "Marie, la grande consolatrice de la France au XIX^eme siècle," *L'histoire* (Paris), no. 50 (1982): 30–39; and Jean-Paul Clébert, "La France miraculeuse," in Aimé Michel and Jean-Paul Clébert, *Histoire et guide de la France secrète* (Paris: Planète, 1968), 416–28.

13. While scholars interested in the religious character of Gauguin's *La vision* have looked for specific Breton ceremonies as a source for the painting, to my knowledge no one has emphasized the link between this painting and the widespread extension of popular piety in the 1870s and 1880s, in which the cult of miracles, visions, and supernatural eruptions had particular meaning and significance. These phenomena deepened in rural areas in the immediate post-Commune phase of reparation and religious revivalism and in response to the anticlerical offensive mounted by Third Republic Opportunists led by Prime Minister Jules Ferry from 1883 to 1889. Gauguin's 1888 painting of praying peasants experiencing a vision of sacred figures thus has intense contemporary meaning and resonance and coincides with the height of the secularizing republican campaign.

French social historians and historians of popular religion have discussed the expansion and emotionalization of popular piety after 1850, its varying components (including new Marian cults, pilgrimage movements, and calvary building), and the way clerical, monarchist, and conservative elites attempted to adapt it to their own needs. Among the accounts most useful to me are Ralph Gibson, *A Social History of French Catholicism, 1789–1914* (London: Routledge, 1989); Thomas A. Kselman,

Miracles and Prophecies in Nineteenth-Century France (New Brunswick: Rutgers Univ. Press, 1982); Jean Marie Mayeur, *Les débuts de la Troisième République, 1871–1898* (Paris: Éditions du Seuil, 1973); Gérard Cholvy and Yves-Marie Hilaire, *Histoire religieuse de la France contemporaine*, 3 vols. (Toulouse: Privat, 1985–88); Boutry, "Marie, la grande consolatrice" (note 12), 30–39; and Ruth Harris, *Lourdes: Body and Spirit in the Secular Age* (New York: Viking, 1999). For the apparitions in the Forez in 1888, see Boutry, "Marie, la grande consolatrice" (note 12), 35; for Marian miracles, see Kselman, *Miracles and Prophecies*, 112–21; on the visions and beatification of Marguerite-Marie Alacoque, and the new pilgrimages to Paray-le-Monial after 1870, see Gibson, *Social History*, 148–51; and Kselman, *Miracles and Prophecies*, 62, 125–27.

14. For an extensive discussion of the form and content of the painting, see Silverman, *Van Gogh and Gauguin* (note 4), chap. 3.

15. Gauguin's immersion in local devotional culture was first discussed by Ziva Amishai-Maisels, who suggested the importance of Émile Bernard, who preceded Gauguin in Brittany and was undergoing an intense Catholic religious reawakening in summer 1888; see Amishai-Maisels, *Gauguin's Religious Themes* (note 11), 16–18. Much of the scholarly literature, beginning with Amishai-Maisels, has attempted to specify a precise local occasion—from regional mystery plays to sermons, pilgrimages, and Pardons—as a source for the Gauguin painting. Most recently, William Darr and Mary Matthews Gedo have proposed that Gauguin may have witnessed the local festival of the Pardon at Pont-Aven; see Darr and Gedo, "Wrestling Anew" (note 11), 67–71. The timing of the ceremony and the types of community action during it, such as the position of the faithful on their knees outside the church, offer the most convincing source to date for certain elements of the painting's content. Darr and Gedo use this material, however, to provide a personal and psychological interpretation of *La vision* as an image "encoding" Gauguin's repentance for his forbidden love for Bernard's sister, what they call a "psychoiconographic" analysis, which I find less compelling than their other evidence.

16. Gauguin's statement proposing the chapel site is quoted in Brettell et al., *The Art of Paul Gauguin* (note 11), 103 (cat. no. 50 by Claire Frèches-Thory). For the original statements about the "religious painting" and the church setting, see Gauguin to Vincent van Gogh, in Gauguin, *Correspondance* (note 1), 230 (no. 165, September 1888); and Gauguin's comments to Theo van Gogh, in Douglas Cooper, ed., *Paul Gauguin: 45 lettres à Vincent, Théo et Jo van Gogh* (Lausanne: Bibliothèque des Arts, 1983), 55 (no. 6, September 1888). The discovery of the Pont-Aven apse church windows and their possible harmonization with Gauguin's *La vision* is presented in Amishai-Maisels, *Gauguin's Religious Themes* (note 11), 28–29.

17. See Michael Baxandall, *Painting and Experience in Fifteenth Century Italy: A Primer in the Social History of Pictorial Style* (London: Penguin, 1983).

18. Gauguin's offers and explanations to the local curés and their perplexed and diffident reactions are noted in Brettell et al., *The Art of Paul Gauguin* (note 11), 103 (cat. no. 50 by Claire Frèches-Thory), based on Émile Bernard's recounting, published in his introductory essay, "L'aventure de ma vie," in Paul Gauguin, *Lettres de Paul Gauguin à Émile Bernard, 1888–1891* (Geneva: Cailler, 1954), 27–30.

19. Gauguin had been explicitly interested in exploring the dream and levels of reality since January 1885, when he wrote to his friend Émile Schuffenecker suggesting an art capable of conveying a mystical, ideal reality that lies beneath the surface of appearances — what Gauguin called "phenomena which appear to us supernatural, and of which, however, we have the *sensation*"; as translated in Linda Nochlin, ed., *Impressionism and Post-Impressionism, 1874–1904: Sources and Documents* (Englewood Cliffs, N.J.: Prentice-Hall, 1966), 158; for the original French, see Gauguin, *Correspondance* (note 1), 87 (no. 65, January 1885). Immediately before he began working on *La vision*, Gauguin proposed an art as "abstraction" from nature and as ascent to the realm of divinity: "Art is an abstraction; derive this abstraction from nature while dreaming before it.... This is the only way of rising toward God — doing as our Divine Master does, create"; as translated in Robert Goldwater, *Paul Gauguin* (New York: Abrams, 1983), 58; for the original French, see Gauguin, *Correspondance* (note 1), 210 (no. 159, August 1888). Gauguin wrote to Bernard in 1890 of the "glimpse of dream" that "is more powerful than anything material" and of his hope to "touch the heavens for just a fleeting moment"; as translated in Françoise Cachin, *Gauguin: The Quest for Paradise*, trans. I. Mark Paris (New York: Abrams, 1992), 143–44. Gauguin's quest to "free painting from its chains" and the "shackles" of worldly anchorage has been explored in Cheetham, *Rhetoric of Purity* (note 9), chap. 1. Cheetham considers Gauguin's themes of the artist's imprisoning chains and of abstraction and purity as evidence of general correspondences between Gauguin's thought and the major tenets of Neoplatonism. While I endorse Cheetham's notion that the chains had idealist overtones for Gauguin, I locate the specific sources of the theme of release from earthly shackles, and of Gauguin's quest for an art of ascent and purification, in the particular patterns of his Catholic theology and formation, which emphasized, as we shall see, a fundamental resistance to materiality concordant with symbolist strains of Neoplatonism.

20. These themes emerge in Gauguin's writings in his reliance on a persistent language of contamination and impurity, which have not been sufficiently accounted for. In September 1888, for example, Gauguin wrote to Vincent van Gogh of this "sale existence qui...me pèse" (sullied existence that...weighs on me); see Gauguin, *Correspondance* (note 1), 233 (no. 165, September 1888). Soon after, Gauguin described his *Self-Portrait as Les Misérables* as representing a painter who "un pur non souillé encore par le baiser putride des Beaux-Arts" (is pure, still unsullied by the putrid kiss of the École des Beaux-Arts); see Gauguin, *Correspondance* (note 1), 249 (no. 168, September 1888). A final example is from a letter Gauguin wrote in 1890, when he asserted "tout est pourri, et les hommes, et les arts" (everything is putrefied, even men, even the arts); see Lövgren, *The Genesis of Modernism* (note 9), 195, 193. This type of language expresses Gauguin's fundamental resistance to materiality and his quest for release to a transcendent realm, which have religious roots and stylistic consequences.

21. "L'âme le coeur tout ce qui est divin enfin ne doit pas être *esclave* de la matière c'est-à-dire du corps.... *Toute chaîne* vient d'un ordre inférieur et c'est méconnaître les lois divines que de faire acte d'esclave"; see Gauguin, *Correspondance* (note 1), 256 (no. 173, October 1888).

22. As translated in Daniel Guérin, ed., *The Writings of a Savage, Paul Gauguin*, trans. Eleanor Levieux (New York: Paragon, 1990), 33; for the original French, see Paul

Gauguin, *Lettres de Gauguin à sa femme et à ses amis*, ed. Maurice Malingue (Paris: Grasset, 1946), 166 (no. 87, September 1889).

23. "C'est un long calvaire à parcourir que la vie d'artiste! et c'est peut-être ce qui nous fait vivre" (It is a long calvary to be traversed, this life of an artist! and this is perhaps what makes us live); see Gauguin, *Correspondance* (note 1), 220 (no. 163, September 1888). The artist's martyrdom in terms of Christ's, which Gauguin describes elsewhere as, for example, being "flayed with thorns" and "doomed to perish under the blows dealt by the world," is another consistent thematic of his writings. A point of departure for this theme is Jirat-Wasiutyński, *Gauguin in the Context of Symbolism* (note 11), as well as Amishai-Maisels, *Gauguin's Religious Themes* (note 11); see also Kirk Varnedoe, "Gauguin," in William Rubin, ed., *"Primitivism" in Twentieth-Century Art: Affinity of the Tribal and the Modern*, exh. cat. (New York: Museum of Modern Art, 1984), 1:186.

24. Gauguin contrasts this art as "sailing on our phantom vessels" to the "down-to-earth pompiers, with their trompe l'oeil rendering of nature"; see Guérin, ed. *Writings of a Savage* (note 22), 23; for the original French, see Gauguin, *Correspondance* (note 1), 216 (no. 162, September 1888): "Comme ils sont bien sur terre, ces pompiers avec leur trompe-l'oeil de la nature. Nous seuls voguons sur le vaisseau fantôme." For the art as an "abstraction," and as "rising toward God," see the quotation from letter no. 159 (note 19).

25. See George Heard Hamilton, *Painting and Sculpture in Europe, 1880–1940* (Baltimore: Penguin, 1972), 84.

26. Reinhold Heller, "Concerning Symbolism and the Structure of Surface," *Art Journal* 45 (1985): 146–53; quotations from pp. 148–49, 153. Heller's article identifies the repertoire of techniques that Gauguin employed to diminish the "physicality" of the image and "disguise the medium of oil paint" so that his paintings had the matte effect of a fresco; Heller also places these techniques within the context of symbolist pictorial innovation. A new study by Vojtěch Jirat-Wasiutyński and H. Travers Newton provides extensive evidence of the experimental techniques Gauguin used in 1888 and after, such as his use of absorbent grounds, his interest in wax coatings and avoidance of varnish, and his adaptation to oil painting of the matte surface effects of the fresco. The authors suggest that Gauguin may have used a combination of wax and paint for *La vision* in order to achieve a "matte, non-reflecting surface like that found in frescoes"; see Vojtěch Jirat-Wasiutyński and H. Travers Newton, *Technique and Meaning in the Paintings of Paul Gauguin* (New York: Cambridge Univ. Press, 2000), esp. 98–100, 198, 200, 233.

27. The technique of going over a painting with hot irons "to produce an unvariegated matte surface" was first brought to my attention in Belinda Thomson's *Gauguin* (London: Thames & Hudson, 1987), 108; it is examined comprehensively in Vojtěch Jirat-Wasiutyński and H. Travers Newton, "The Historical Significance of Early Damage and Repair to Vincent van Gogh's *Self-Portrait Dedicated to Paul Gauguin*," in *Papers Presented at the Art Conservation Training Programs Conference, May 2–4, 1984* (Cambridge: Center for Conservation and Technical Studies, Harvard University Art Museums, 1984), 17–20.

Gauguin developed an extensive repertoire of techniques to diminish surface

materiality, including leaching out the oil from paint base for thinner application; newspaper blotting; wax and gesso coating; application of special absorbent primers; and washing the finished canvas to decrease shine and gloss. These formal strategies have been studied by restoration and conservation experts, as well as a few art historians; see Carol Christensen, "The Painting Materials and Techniques of Paul Gauguin," in *Conservation Research* (Washington, D.C.: National Gallery of Art, 1993), 63–104; H. Travers Newton, "Observations on Gauguin's Painting Techniques and Materials," in Cornelia Peres, Michael Hoyle, and Louis van Tilborgh, eds., *A Closer Look: Technical and Art-Historical Studies on Works by van Gogh and Gauguin* (Zwolle, The Netherlands: Waanders, 1991), 103–11; and Vojtěch Jirat-Wasiutyński, "Painting from Nature versus Painting from Memory," in Cornelia Peres, Michael Hoyle, and Louis van Tilborgh, eds., *A Closer Look: Technical and Art-Historical Studies on Works by van Gogh and Gauguin* (Zwolle, The Netherlands: Waanders, 1991), 90–102. I believe these techniques and materials have particular theological sources and resonance.

28. The junior seminary at Orléans, founded in 1856, was Bishop Dupanloup's personal laboratory for educational and religious reform; he lived nearby and supervised everything from curricula to building and chapel renovations. His role in forming and transforming the Petit séminaire de la Chapelle-Saint-Mesmin during and after the time Gauguin was a student there is discussed in François Lagrange, *Vie de Mgr. Dupanloup, évêque d'Orléans* (Paris: Poussielgue frères, 1883), 2:99–123; Christianne Marchilhacy, *Le diocese d'Orléans sous l'épiscopat de Mgr. Dupanloup, 1849–1878: Sociologie religieuse et mentalités collectives* (Paris: Plon, 1962), 82–90; and Émile Huet, *Le Petit séminaire d'Orléans: Histoire du Petit séminaire de la chapelle Saint-Mesmin: Souvenirs d'un rhétoricien de 1866–1867* (Orléans: Pigelet et fils, 1913), 107–30, 157–65, 203–16.

The record of Gauguin's stay at the Orléans junior seminary was first presented in Ursula Frances Marks-Vandenbroucke, "Gauguin: Ses origines et sa formation artistique," *Gazette des beaux-arts* 47 (1956): 29–32. This article established that Gauguin was at the seminary for the four years from 1859 to 1862 and that he was a boarder at the school for most of that time. Ziva Amishai-Maisels noted Gauguin's religious education at the beginning of her *Gauguin's Religious Themes* (note 11), but she does not examine this period in any detail and lists the seminary as a Jesuit school, for which I have found no confirmation in the contemporary literature. The only writer to have emphasized the role of Bishop Dupanloup is David Sweetman, who devotes three pages of his recent Gauguin biography to the period at the Orléans seminary; see David Sweetman, *Paul Gauguin, a Life* (New York: Simon & Schuster, 1995), 30–32. For a fuller discussion of Gauguin's Orléans training and Dupanloup's role, see Silverman, *Van Gogh and Gauguin* (note 4), chap. 4.

29. The architect of a new Catholicism for France shaken by the revolution of 1848, Dupanloup drafted the Falloux Law (passed 15 March 1850), which secured the church's future in France by revitalizing the nation's early education. He was celebrated as a brilliant catechizer and a gifted educator who had an unusual rapport with his pupils, among whom was Ernest Renan. On Dupanloup, French political culture and educational reform after 1848, see Gibson, *A Social History of French Catholicism*

(note 13), 59–63, 123–67, 200–1; for Dupanloup's extraordinary career and full range of activities, see Lagrange, *Vie de Mgr. Dupanloup* (note 28).

Dupanloup's emphasis on imagination and memory is presented throughout his *L'oeuvre par excellence; ou, Entretiens sur le catéchisme* (Paris: Douniol, 1869). His statement of those "fallen from heaven" and the longing for "wings" is translated and discussed in Charles E. de Vineau, *Bishop Dupanloup's Philosophy of Education* (Washington, D.C.: Catholic Education Press, 1930), 5–6, 20–29; for the original French, see Félix-Antoine-Philbert Dupanloup, *De l'éducation* (Paris: C. Douniol, 1857–62), 1:v–27. On Dupanloup's unusual rapport with his pupils, see Gabriel Monod, *Souvenirs d'adolescence: Mes relations avec Mgr. Dupanloup* (Paris: Fischbacher, 1903); see also Silverman, *Van Gogh and Gauguin* (note 4), chap. 4.

30. For Dupanloup's concentration on "concupiscence," see his *The Child*, trans. Kate Anderson (Boston: P. Donahoe, 1875), 160–86, 126–46. Here Dupanloup renders a "classification of defects" and details the "perils" and the "fatal habits of vice" that act as ever-present evil, threatening to "seize and devour" the "open hearts" and "expansive souls" of children. The "Misères de la vie présente," along with other chants on fragility, corruption, and putrefaction, such as the "Sur les vanités du monde," can be found in Félix-Antoine-Philbert Dupanloup, *Manuel des catéchismes; ou, Recueil de prières, billets, cantiques, etc.* (Paris: Rocher, 1866), 147–52, 227. The alternative vision of the pure heavenly realm and its joyful attainment through resplendent bursts of light are discussed in Dupanloup, *De l'éducation* (note 29), 3:506–7; on purity and "possessing the heavens," see Dupanloup, *L'oeuvre par excellence* (note 29), 74–75; and Dupanloup, *Manuel des catéchismes*, 343.

31. For the bishop's account of silent, intensely illuminated visual forms of interrogatory practice for the children, see Dupanloup, *De l'éducation* (note 29), 3:507–8; angels are discussed in the appendixes to Félix-Antoine-Philbert Dupanloup, *The Ministry of Catechizing* (London: Griffith, Farran, Browne, 1890), 615–40, esp. 624, 615–20. For other accounts of Dupanloup's imaginative renovation of the catechism and his antipositivism, see De Vineau, *Bishop Dupanloup's Philosophy* (note 29), 5–28; Marchilhacy, *Le diocese d'Orléans* (note 28), 239–53; and Dupanloup, *L'oeuvre par excellence* (note 29), v–224.

32. See the discussion in Brettell et al., *The Art of Paul Gauguin* (note 11), 30 (cat. no. 9 by Charles F. Stuckey); Amishai-Maisels, *Gauguin's Religious Themes* (note 11), 13; and Jirat-Wasiutyński, *Paul Gauguin in the Context of Symbolism* (note 11), 130. Merete Bodelsen first suggested that Gauguin may have studied mummified remains in a coffin at the Copenhagen National Museum; cited in Brettell et al., *The Art of Paul Gauguin* (note 11), 30 (cat. no. 9 by Charles F. Stuckey).

33. Brettell et al., *The Art of Paul Gauguin* (note 11), 30 n. 10 (cat. no. 9 by Charles F. Stuckey).

34. For the original French, see Dupanloup, *Manuel des catéchismes* (note 30), 147–49.

35. Illustrated, with commentary, in Christopher Gray, *Sculpture and Ceramics of Paul Gauguin* (Baltimore: Johns Hopkins Univ. Press, 1963), 208 (no. 88); for another interpretation of the statuette, see Jirat-Wasiutyński, *Paul Gauguin in the Context of Symbolism* (note 11), 183–86. For Rodin and the adaptation of the seven deadly sins,

see Silverman, *Art Nouveau* (note 9), 256–69, 301–14. Here I stress more the interiorization of sin and hell powered by contemporary clinical knowledge of mental medicine and its links to the poet Maurice Rollinat. But the theme of the lure and corruption of sensuality, and its terminus in *l'abîme* (the pit), has a specifically theological origin and resonance; this informs the choice of subject and the forms of representation of *luxure* (lust) from Baudelaire to Rodin and Gauguin, in ways that need further investigation.

36. See the discussions in Thomson, *Gauguin* (note 27), 76; Brettell et al., *The Art of Paul Gauguin* (note 11), 147 (cat. nos. 79–80 by Françoise Cachin); Jirat-Wasiutyński, *Gauguin in the Context of Symbolism* (note 11), 157–60, 197; Bogomila Welsh-Ovcharov, *Vincent van Gogh and the Birth of Cloisonism*, exh. cat. (Toronto: Art Gallery of Ontario, 1981), 190–91; and Ronald Pickvance, *Van Gogh in Arles*, exh. cat. (New York: Metropolitan Museum of Art, 1984), 205–6 (no. 118); I have reconsidered the form and content of *Vendanges à Arles* in Silverman, *Van Gogh and Gauguin* (note 4), 223–47.

37. The title is listed in the facsimile of the notebook, which was also a sketchbook, in René Huyghe, ed., *Le carnet de Paul Gauguin* (Paris: Quatre Chemins-Éditart, 1952), n.p.; see also Amishai-Maisels, "A Gauguin Sketchbook" (note 10), 68–75.

38. Wayne Andersen, "Gauguin and a Peruvian Mummy," *Burlington Magazine* 109 (1967): 238–42; Henri Dorra, "Gauguin's Dramatic Arles Themes," *Art Journal* 38 (1978): 12–17; Brettell et al., *Art of Paul Gauguin* (note 11), 147 (cat. nos. 79–80 by Françoise Cachin); Sweetman, *Gauguin, a Life* (note 28), 84–85. Another useful discussion of the Peruvian mummy, including a rare study drawing of it by Gauguin, can be found in *Le chemin de Gauguin: Genèse et rayonnement*, exh. cat. (Saint-Germain-en-Laye, Yvelines, France: Musée Départemental du Prieuré, 1985), 66; see also the discussion of the mummy and *Vendanges à Arles* by Welsh-Ovcharov, *Birth of Cloisonism* (note 36), 191.

39. Vincent van Gogh, *The Complete Letters of Vincent van Gogh* (Greenwich, Conn.: New York Graphic Society, 1958), 3:40 (no. 538, September 1888). Vincent van Gogh also advises his brother Theo, who acted as Gauguin's art dealer, to be "very firm" and clear with Gauguin and to resist his manipulations.

40. Camille Pissarro, *Letters to His Son Lucien*, ed. John Rewald, trans. Lionel Abel (New York: Pantheon, 1943), 170.

41. Neither of the two versions of this essay by Gauguin — drafted in 1897 and emended in 1902 — has been published in full; sections of these texts are translated and included in Guérin, *Writings of a Savage* (note 22), 161–73. See also Gauguin's discussion of the bishop and of these religious writings, in Paul Gauguin, *Paul Gauguin's Intimate Journals*, trans. Van Wyck Brooks (New York: Crown, 1936), 177–93.

42. Sweetman, *Gauguin, a Life* (note 28), 522.

43. Dupanloup, *L'oeuvre par excellence* (note 29), 132. Here Dupanloup is quoting from the philosopher Jules Jouffroy to underscore the foundational power of catechism questions and answers for adult life.

44. Dupanloup, *L'oeuvre par excellence* (note 29), 133, 27. Dupanloup considered the catechism "the source of all inspiration, all principles"; the "purest essence of Christian dogma and morality," equivalent to "religion itself." While there have been

many interpretations of *D'où venons-nous?*, the links between Gauguin's frieze and a specifically Catholic form of exploring human origins and destiny through the interrogatory format have never been mentioned.

45. For the original French, see Paul Gauguin, *Lettres de Paul Gauguin à Georges-Daniel de Monfried* (Paris: G. Crès, 1918), 201 (no. 39, February 1898).

46. Paul Gauguin to André Fontainas, in Paul Gauguin, *Lettres de Gauguin à sa femme et à ses amis*, ed. Maurice Malingue, rev. ed. (Paris: B. Grasset, 1949), 288–89 (no. 170, March 1899), emphasis added. For a more extensive discussion of the form and content of *D'où venons-nous?,* see Silverman, *Van Gogh and Gauguin* (note 4), 373–91.

47. John Richardson, *A Life of Picasso* (New York: Random, 1991), 1:264–65; see also Susan Grace Galassi, *Picasso's Variations on the Masters: Confrontations with the Past* (New York: Abrams, 1996), 32–33, especially her discussion of Picasso's drawing *Reclining Nude with Picasso at Her Feet* (1902–3), inspired directly by Gauguin's painting *Manao Tupapau* (1900; Spirit of the Dead Watching).

48. Richardson, *Picasso* (note 47), 1:230–31, 1:456–61.

49. Richardson, *Picasso* (note 47), 1:71–76. Picasso's pious mother was a member of a lay sisterhood, and the thirteen-year-old Pablo experienced a burst of religious fervor in 1894. Richardson emphasizes (p. 72) that "little or no attention has been paid to the quantity" and variety "of sacred subjects" from Picasso's earliest years.

50. Richardson, *Picasso* (note 47), 1:71.

51. The altarpiece sketch is included with Richardson's discussion of the panels in Richardson, *Picasso* (note 47), 1:73.

52. For the interpretation of the picture as a contemporary social and political statement, see Marilyn McCully, *Els Quatre Gats: Art in Barcelona around 1900*, exh. cat. (Princeton: Princeton Univ. Press, 1978), 37.

53. For Picasso, see Richardson, *Picasso* (note 47), 1:246–49, 1:444–53. Gauguin's adaptations of artifacts of Breton devotional piety are well documented; a good starting place is the discussion by Thomson, *Gauguin* (note 27), 102–11.

54. Quoted in Richardson, *Picasso* (note 47), 1:75. Richardson re-emphasizes this point in a recent unpublished paper by explaining that "blasphemy itself can attest to faith"; thus Picasso's very insistence on provocative affirmations of his impiety reveals the hold that his religious system had on him. In this way, Picasso's protestations of atheism were much like Gauguin's, who also employed irony against the Church. Both artists can be categorized, to use Sweetman's description of Gauguin, as "confused believers," "forever castigating the thing that [they] could not quite reject"; see Sweetman, *Gauguin, a Life* (note 28), 522.

55. Galassi provides an interesting discussion of Picasso's intense interest in the Crucifixion in her chapter on Picasso and Grunewald, noting, for example, that Picasso continually returned to the subject, producing forty images in six decades; see Galassi, *Picasso's Variations on the Masters* (note 47), 60–87, esp. 62–64. Picasso's drawing of the *Crucifixion and Embracing Couples* also evokes Rodin's drawings and themes of the modern sources of suffering in sexuality, such as the clambering, embracing figures he devised for *The Gates of Hell*.

56. Richardson, *Picasso* (note 47), 1:75; the unpublished sketch of the artist as the

flayed and wounded Christ is discussed in Richardson's unpublished Picasso paper (note 54).

57. Jaime Sabartès, quoted in Richardson, *Picasso* (note 47), 1:217.

58. The classic interpretation is presented in Richardson, *Picasso* (note 47), 1:275, who states that they "seem to have stepped out of Gauguin's *D'où venons-nous?*"

59. McCully, *Picasso, the Early Years* (note 5), 39, 31.

60. Mark Rosenthal, "Barging Into Art History: Subject and Style in Picasso's Early Work," in Marilyn McCully, ed., *Picasso, The Early Years, 1892–1906*, exh. cat. (New Haven: Yale Univ. Press, 1997), 289–96.

Collecting against Forgetting:
East of the River: Chicano Art Collectors Anonymous

Teresa McKenna

> Revolutionary art dwells, by its nature, on edges.... This is its power: the ten-
> sion between subject and means, between the *is* and what can be. Edges between
> ruin and celebration. Naming and mourning damage, keeping pain vocal so it
> cannot become normalized and acceptable.
>
> —Adrienne Rich[1]

> Police files are our only claim to immortality.
>
> —Milan Kundera[2]

Much is at stake in art that "dwells" on the edges, that recalls histories and
experiences that keep "pain vocal." This is art that calls communities to
remember and to claim that remembering for themselves. This art refuses to
let police files speak for the immortality of its community. It is art that dis-
comfits, not only in representation but also in the politics of that representa-
tion. Chicano art, for the most part, dwells on these edges: the history of its
representation in gallery and museum exhibitions reflects the institutional dis-
comfiture with Chicano art. In September 2000, the Santa Monica Museum
of Art mounted an exhibition titled *East of the River: Chicano Art Collectors
Anonymous*. Curated by Chon Noriega, *East of the River* exposed the inter-
section of many of the edges that Chicano art makes sharp. Though there
were some very fine pieces of Chicano art exhibited here, the exhibition was
not primarily about the art—it was more about the collectors of the art and
the spaces in which they display their collections.

East of the River raised questions about taste, about public and private
space, and about the role of the museum as the venue for the display of art. It
prompted us to think about the process of collecting and exhibiting art, about
the role of the collector in this process. Why did the collectors in this exhi-
bition choose art that emerged from a particular history, that has a varied
and complex relationship to that history? Much of the art displayed in *East of
the River* points to the pain of social, sexual, and class inequalities. As we
know, Chicano history is studded with wars and conquests. Chicanos' lives
are plagued with memories of *la migra* (the word for the Immigration and
Naturalization Service), the police, hunger, violence, and abuse, as well as
tremendous hope. From the Spanish conquest of Mexico in the sixteenth

century to the Mexican War of Independence to the Mexican-American War, in which half of Mexico's territory was ceded to the United States, Chicanos — Mexico's diaspora — claim a long and turbulent history. Chicano art has long had an inextricable tie to the political and social history of the Chicano people.[3] Inspired by the great Mexican muralists — David Alfaro Siqueiros, José Clemente Orozco, and Diego Rivera — Chicano/a artists of the Chicano Civil Rights Movement in the mid-twentieth century produced murals and other forms of public art to illustrate the history and future of Chicanos in the United States: poets wrote their lines on broadsides that were distributed to the marchers fighting for justice in the United Farm Workers union picket lines; actors performed their agitprop performances in union meetings and in the meetings of student groups such as the Movimiento Estudiantil Chicano de Aztlán (MEChA).[4]

This brings us to a basic question. Do the collectors of Chicano art feel themselves to be personally implicated in the politics of Chicano history, gender relations, and sexuality? Why are these collectors, who are for the most part middle-class, attracted to objects that focus on the pain of Chicano history? Why do they keep art that beseeches its viewers to not forget this history or the struggle? Perhaps the desire to not forget is linked to a related need to keep resistance to injustice alive. "If we ally ourselves in the struggle with the oppressed," bell hooks cautions, "how will our fictions, our theory, name this solidarity?"[5] Clearly, the practice of collecting Chicano art participates in the process of a community's resistance to cultural and historical amnesia.

In order to address the importance of the questions raised by the exhibition, we need to examine the mounting of the exhibition itself. Commonly, of course, museum shows focus our attention on the works of art on display and on the artists who made them. *East of the River,* by contrast, sought to direct the viewer's attention away from the individual art object and toward the practice of art collecting. The exhibition focused on the display of Chicano art as it appears in the private homes of art collectors. Parts of the interiors of two private homes were re-created in the exhibition in order to give the viewer a sense of the collectors' approach to decoration, as well as their occasionally compulsive disregard for hierarchy in the display of objects (fig. 1; see fig. 4).

The art in *East of the River* was mounted without any direct reference to the artists' names. Instead, a small numbered pin accompanied each object. Viewers were asked to check the number of the pin against a mimeographed handout — available near the entrance to the museum — which listed the artists' names. Sometimes the information on the list was incomplete or inadequate, as Noriega himself pointed out in a talk entitled "Collectors Who Happen to Be...," presented at the Getty Research Institute on 6 October 2000. Indeed, aside from a short video about the installation of the exhibition, no other background or supporting information was available to the viewer as he or she strolled through the several "rooms" of art (fig. 2).[6]

The physical and logistical dimensions of *East of the River* thus frustrate our search for answers to some of the theoretical questions the exhibition

Fig. 1. View of the Mary Salinas Durón and Armando Durón collection as installed at *East of the River*, Santa Monica Museum of Art, 15 September–18 November 2000

Fig. 2. View of the exhibition *East of the River*, Santa Monica Museum of Art, 15 September–18 November 2000

seemed to pose. Because museum theory does not help us understand these issues, we should perhaps turn our attention to the collectors themselves and to an exploration of that collective within the context of Chicano politics and art. The group of collectors in *East of the River* chose the name Chicano Art Collectors Anonymous (CACA) to refer to themselves. This name, whose acronym means "excrement" in Spanish, humorously cites another important exhibition of Chicano art, which took place in Los Angeles in the early 1990s: *Chicano Art: Resistance and Affirmation, 1965–1985,* whose acronym, *CARA,* means "face" in Spanish. Through its name alone, then, CACA successfully situated itself within a larger political and aesthetic context. Furthermore, by this ironic citation, CACA also can be said to participate in the process of resistance and affirmation, that is, in the conscious and unconscious need to remember, to stave off the dread of loss. Such remembering is essential for all "people globally who fight for liberation," bell hooks notes. Writing about the dread she feels at the prospect of being "unable to resist, afraid to resist" domination, hooks says: "This dread returns me to memory, to places and situations I often want to forget.... Remembering makes us subjects in history. It is dangerous to forget."[7]

For Chicanos, the rituals of collecting art take on the force of endangered subjectivity. This is especially true of the middle-class art collector, whose ties to working-class labor issues and to the Chicano Movement haunt his or her decisions about what to buy, what to keep, and what (and how) to display. Yet, the negation implied by CACA—excrement in the face of *CARA*—makes the association between efforts to collect and efforts to exhibit even more mystifying: CACA wants to name itself and display its collections publicly, yet there is an attendant desire to remain anonymous. It appears that to collect in private is not enough, yet public disclosure is also disconcerting. The Chicano art on exhibit in *East of the River* cited its own politics and history, yet the collectors chose to remain anonymous within the context of the exhibition and, to a certain extent, within the continuum of Chicano history.

Let's approach this problem from another angle. In his essay "Collectors Who Happen to Be...," Noriega sets out the terms of art collecting. He describes the element of the sacred as a salient feature of art collecting, and he calls attention to the "sacredness of art objects once they are removed from economic circuit and placed into a collection." Further, Noriega underscores the tendency toward specialization, which "brings sacredness into alignment with those aspects of collection that are more about particular collectors and their self-defined role within culture."[8] As Noriega points out, the movement of the sacred into the secular, and the secular into the sacred, is a vexed issue in *East of the River.* And more basic still is the question of how collectives are formed: the exclusion from, or inclusion in, a group is as political an issue as the slippage of the sacred into the profane or the private into the public.

CACA follows in a long tradition of Chicano art collectives that have informed the production as well as the dissemination of art. Historically, these groups have designated themselves as collectives not only because of

their need to forge a shared sense of cultural identity but also, and perhaps more important, to assume control of their own artistic production. Asco, for example, an East Los Angeles multimedia art group, which came together in the 1970s, sought to negate the terms in which art was described and evaluated. Asco is not an acronym; it means "nausea" and "disgust" in Spanish, and it obviously underscores the group's philosophical stance of negation. Asco member and artist Harry Gamboa Jr. recalls that "The artists [Patssi Valdez, Gronk, Willie Herrón, and Gamboa] dealt with the emotions of repulsion, elation, and rejection and with unconscious visual charges stemming from personal perspectives that allowed them to view the world at a distinctly different slant. After several intense months of drawing and eclectic conversation, they decided to manifest their ideas in the public arena of the streets."[9] The movement from the private process of production to group identification and finally "to the streets," to the public sphere, characterizes a tradition in Chicano art and politics. In addition to Asco, we can name the Royal Chicano Air Force (RCAF), a collective formed in Sacramento in 1969; or the Mujeres Muralistas, a collaboration of women muralists in San Francisco from 1974 to 1976; or the collectives Con Safo and Los Quemados, active in San Antonio in the early 1970s; or the Mexican American Liberation Art Front (MALAF), formed in Oakland in 1969.[10] This genealogy of Chicano art collectives can be expanded to include mixed-race groups, such as the collective of women writers who produced the anthology *This Bridge Called My Back: Writings by Radical Women of Color*. In all these instances, the movement of the personal into the public has been a collective mission, a creative project, and a political act.

Likewise, *East of the River* acknowledged a movement of the personal to the public. Take, for example, the personal home altar, whose sacredness begins in the church or place of worship and then is translated into the private space of the home. Through the public work of Chicano artists like Amalia Mesa-Bains, this personal and collective manifestation of faith and desire is brought into the public sphere. Mesa-Bains explains that, "established through pre-Hispanic continuities of spiritual belief, the family altar functions for women as a counterpoint to male-dominated rituals within Catholicism. Often located in bedrooms, the home altar presents family history and cultural belief systems." These altars, "characterized by accumulation, display, and abundance,... allow history, faith, and personal objects to comingle."[11] When personal or family altars are brought into the museum space, they extend the continuity of the sacred tradition in the domestic space, in effect, carrying this tradition *back* into the public space. Mesa-Bains's installation *An Ofrenda for Dolores del Rio* (1984), which was re-created for the *CARA* exhibition in 1990, graphically illustrates this fluidity of movement between personal and collective, sacred and profane, private and public (fig. 3).

Two installations in *East of the River* achieved similar ends. One, in a corner of the museum, re-created the living room of the collectors Mary Salinas Durón and Armando Durón (see fig. 1). The art on the walls and the furniture

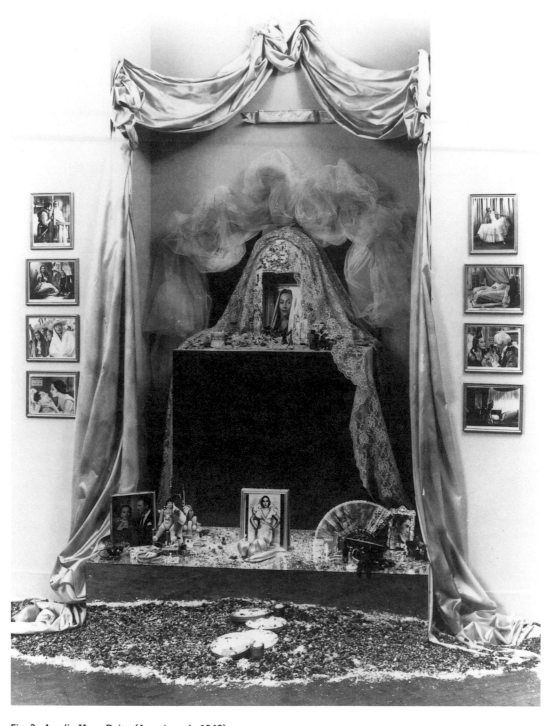

Fig. 3. Amalia Mesa-Bains (American, b. 1943)
An Ofrenda for Dolores del Rio, 1984, mixed media installation including plywood, mirrors,
fabric, framed items, and decorative elements, 244 × 183 × 122 cm (96 × 72 × 48 in.)
Washington, D.C., Smithsonian American Art Museum

on which the art was displayed not only drew attention to the decorative use of the objects but also brought the viewer into a space of artistic adulation, in which resident and viewer maintain ritualistic distance. In the other, located in the center of the museum space, the hallway of the collectors David Serrano and Robert Willson was re-created (fig. 4; cf. fig.7). In her essay for the catalog of *East of the River*, the art historian Jennifer Gonzalez comments on these two installations:

> Represented in its own *home-frame*, the Serrano/Willson collection exposes a domestic activity temporarily on public view. The hallway allegorizes the process while it reveals the extent to which art redefines the domestic setting. One has the same impression of the Mary Salinas and Armando Durón collection. Reinstalled in the exhibition is a portion of the Durón's living room interior. This Salon-style presentation reveals the density and intensity of artwork within the *home-frame* of these collectors, placing the works — many exploring female self-representation — into dialogue with day-to-day life.[12]

Yet this is not the only dialogue elicited by these installations. David Serrano is himself an artist and in the space of the installation he displayed a re-creation of one of his murals from the ceiling of his hallway. He imitated his art in a move that established him as both interlocutor and listener in the artistic event. The collective mission of *East of the River* was thus to achieve a larger communal concourse. The admonition "Mi Casa es Mi Casa," which adorns the entrance into one home (an image that appears in the catalog but not in the exhibition itself), ironically marks the museum space as *our* casa as well (fig. 5). The traditional saying in Spanish, "My house is your house," is transposed here to underscore the owner's control over the domestic space: "My house is my house." This transposition also belies the hospitality invoked in the traditional saying. Yet, the change in pronoun, "your" to "my," not only claims control over the space but also points obliquely to the tension between public and private that appears to have been a major factor in the decision by many of these collectors to exhibit their art. At the same time that they wanted the public to see their collections, they maintained a low profile in the exhibition. This would be fine if the exhibition had been about the art itself, but, as the title of the exhibition clearly shows, *East of the River: Chicano Art Collectors Anonymous* was an exhibition about the collectors.

If the art in *East of the River* tells a complex story, what stories do the collectors tell? Their vision appears to be the most obscured here. Who are they, and why are they so absent from an exhibition whose title points to them as a collective entity, but not as individual collectors? In order to understand this aspect of the exhibition, we have to turn to the catalog, which introduces us to the individual collectors of CACA through a series of photographs. In fact, the catalog appears to operate in exact opposition to the exhibition itself. One section of the catalog begins with the title: "Public Memories, Private

Fig. 4. View of the David Serrano and Robert Willson collection as installed at *East of the River,* **Santa Monica Museum of Art, 15 September – 18 November 2000**

Fig. 5. Collectors Luz Marie and Carlo Meyerson at the front door of their home in Pasadena
From *East of the River: Chicano Art Collectors Anonymous,* exh. cat. (Santa Monica, Calif.: Santa Monica Museum of Art, 2000), 13

Collections: An Inside View." Here the art collectors are visually located within their homes, and the art is relegated to the background. The art pieces are shown to be companions to living, rather than merely decorations or aesthetic objects. In the section on the Durón family—Mary Salinas, Armando, and their four children—we see an art object on the wall of their home: it is a hinged book of photographs, mounted in such a way that the first page obscures the one beneath (fig. 6). According to Noriega, Armando Durón asked the artist, Christina Fernandez, if he could mount her series of nude photographs in this manner in order to keep hidden from his children the more explicitly sexual content of the pieces.[13] In this way, the art is made to conform to the constraints of the domestic space.

In other photographs of the art collectors in their homes, we see art displayed in less than central places—in hallways, stacked in offices, in bathrooms and bedrooms (fig. 7). This does not necessarily reflect the accumulation impulse gone wild but rather a turn toward the Chicano phenomenon of *rasquachismo,* the aesthetic practice used by many Chicano artists and now applied by the collectors of their art to the design of the domestic sphere in which that art resides. Tomás Ybarra-Frausto defines *rasquachismo* as "a sensibility that is not elevated and serious, but playful and elemental. It finds delight and refinement in what many consider banal and projects an alternative aesthetic—a sort of good taste of bad taste. It is witty and ironic, but not mean-spirited (there is sincerity in its artifice)." *Rasquachismo* refers to people, things, and art that break boundaries, that irreverently mix high and low. It subverts tradition and official status, it turns "ruling paradigms upside down."[14]

Amalia Mesa-Bains refines the notion of *rasquachismo* in feminist terms: "Female rasquachismo defies the cultural identity imposed by Anglo Americans and defies the restrictive gender identity imposed by the Chicano culture. In the work of Chicana artists, techniques of subversion play with traditional imagery and cultural material, and together they characterize domesticana."[15] I suggest that the domestic spaces of many of the *East of the River* collectors are instances of *rasquache domesticana.* This female desire for control over space and identity appears to mark the homes of these collectors. Yet how do we evaluate the genesis of this desire if we are not given a separate view of each collector? The presence of six couples in CACA to a certain extent obfuscates attempts to trace the locus of desire. We do know that *rasquachismo* is an aesthetic based on the spaces in which Chicanos live and in which they find the material to make artistic choices: A Folgers coffee can that becomes a planter is *rasquache.* Amalia Mesa-Bains's use of a Spanish fan, the Mexican flag, and a lace mantilla in her altar in homage to Dolores del Rio is *rasquache.* Are the displays of the Chicano art objects in the collectors' homes *rasquache?* Who arranges the displays? How do the couples make artistic choices? Whose taste predominates? Does the woman materialize as the creator of the home as art?

All these questions point to the overarching issue of whether the term

Fig. 6. Christina Fernandez (American, b. 1965)
Bleed I and *Bleed II*, 1993, silver gelatin prints and hinged frame with lock,
prints: each 53.3 × 43.2 cm (21 × 17 in.)
Montebello, California, Mary Salinas Durón and Armando Durón Collection

Fig. 7. Collector David Serrano and the hallway of his home in Los Angeles
From *East of the River: Chicano Art Collectors Anonymous,* exh. cat. (Santa Monica, Calif.: Santa Monica Museum of Art, 2000), 40

anonymous in the acronym CACA may in fact be an elision of gender, sexual, and racial difference within the collective? Close inspection of the catalog reveals that one of the six couples is a same-sex pair. It also shows that several of the collectors are non-Chicanos, yet the name chosen for the group — Chicano Art Collectors Anonymous — signals ethnic identity. Are we to conclude that the titular *Chicano* is less an ethnic designation than a political one? How do the non-Chicanos of the group relate to this term? And since a number of the collectors who form couples are not Chicanos, whose desire, whose history, and whose culture is being addressed through *their* act of collecting? The *couple*, then, obscures gendered desire and racial identity.

There are two instances in which there is no couple at all. As photographed for the catalog, Esperanza Valverde sits by herself in her home. Absent is her husband Ricardo Valverde, who died before the show opened. There is one other single collector, Anita Miranda, who deserves some notice. Miranda states: "My collection consists of work that I like and affirms long overdue recognition for female and Chicano artists."[16] This statement underscores the need to *un*couple the collectors in CACA in order to determine individual taste and desire. The questions I am asking here are not just aesthetic questions; they are feminist ones, and they merit further exploration because they point directly to the forces of race and desire that drive collecting.[17]

The focus of *East of the River* on the collectors, rather than on the artists, elicited a number of negative responses from museum visitors. In the guest book in which viewers were invited to respond to the show, one artist vehemently decried the lack of attention paid to the art on display and to the artists who had created it. On the institutional side, the response was also negative, although for different reasons. The critical reception of the show reveals that the marking of the museum by Chicano artists and art collectors still meets with resistance on the part of the traditional gatekeepers of "sacred" museum space. The critic Christopher Knight's review of *East of the River* in the *Los Angeles Times* is an example of such resistance. According to Knight, the exhibition was "decidedly dull. Anybody who has been around contemporary art for any length of time knows people who acquire art in exactly this manner, and they've been in homes (or live in them) where art is displayed just like this." Having thus reduced *East of the River* to the level of banal interior decoration, Knight chastised the show for failing to place "the highest curatorial priority on what you see on the museum's walls."[18]

In response to Knight's review of *East of the River*, Noriega published a "Counterpunch" column in the *Los Angeles Times*, titled "Museum Walls are an Issue in any Show," in which he emphasized the importance of Chicano art and art collecting. Noriega notes that "art exhibition is never just about what you see on the museum walls. It's also about those very walls themselves and the social activities that result in selected art objects hanging on them."[19] Gamboa has a different take on the matter: "In East L.A., the cryptic stylized graffiti made it difficult for insiders and outsiders to read the writing on the walls."[20] Chicanos' long history with these walls has led to a deterritorializing

impulse in Chicano art, an impulse to nullify space that traditionally determines, interprets, and controls power. Consider the performance piece by Asco of 1972 in which the group scrawled its *placa* (stylized name) in vibrant graffiti on the pristine walls of the Los Angeles County Museum of Art. By claiming that space as its own, Asco made a graphic statement about the creative power of transgression. Not surprisingly, Asco's statement was whitewashed the next day. This event calls to mind the fate of Siqueiros's mural *América Tropical,* which he painted in 1932 on a wall in Olvera Street in Los Angeles. Though it was initially sponsored by the Plaza Art Center and the Los Angeles Public Library, the mural, with its graphic allegorical representation of American oppression and imperialism, was painted over within a year of its creation. Nonetheless, a faint outline of the mural survives to this day—a specter reminding us of the forces that drive our collective impulse to write our names on the institutional walls which, at worst, exclude Chicano art and, at best, designate what of that art is collectible and exhibitable. The *East of the River* collectors, even if unconsciously, participated in the long history of breaking down walls: by their very choice of what art to collect, they became part of the struggle of the Chicano artist to be seen.

At the end of "Museum Walls," Noriega suggests that "[Knight] seems sincerely befuddled as he stares into the white cube and sees only whiteness."[21] We stare at the colored walls of the reconstructed homes of the members of CACA and we see something else: we see the disconnection between what Chicanos value and what cultural institutions value, a disconnection that continues to inform the process of negotiating Chicano art. As Noriega aptly notes in his catalog essay, "In the end, CACA is about defining an alternative aesthetic rather than accepting a false distinction between diversity and quality that relegates Chicano art collection to a political gesture and leaves museum collection practices unchallenged."[22]

To understand the historical context and curatorial precedents for *East of the River,* let us briefly examine an earlier moment in which another innovative Chicano art exhibition met with critical and institutional resistance. In 1990, the exhibition *Chicano Art: Resistance and Affirmation, 1965–1985* opened at the Wight Art Gallery at the University of California at Los Angeles.[23] The exhibition, the most ambitious display of Chicano art of its time, was mounted both nationally and internationally. Rather than being organized by a single curator, the exhibition was put together by a collective of approximately forty artists, art historians, and scholars, all working in collaboration with the staff of the Wight Art Gallery. An elaborate system of decision making was agreed upon by the organizing collective: initial decisions about what art would be shown were made in regional curatorial committee meetings nationwide; these initial choices were then forwarded to a national committee, which made the final selection. Just as the *CARA* collective reimagined curatorial practice, so the subject of the exhibition challenged the traditional boundaries of museum display. *CARA* was about Chicano art

within the historical and political context of the Chicano Civil Rights Move-
ment—it was an exhibition about political art, which the *CARA* collective
insisted was not oxymoronic.

CARA elicited some heated response. William Wilson of the *Los Angeles
Times* felt that the art on display was overly political and not suitable for the
museum setting.[24] Even more telling was the response of the National
Endowment for the Humanities to funding proposals for the *CARA* exhibi-
tion. In correspondence with the Wight Art Gallery and the *CARA* Executive
Committee—comprised of Teresa McKenna, Alicia Gonzalez, and Victor
Alejandro Sorrel—Lynne Cheney, then director of the National Endowment
for the Humanities, summarized the internal response to the *CARA* proposal.
According to Cheney, the evaluators decried the political content of the exhi-
bition and questioned the objectivity of a nonwhite, predominantly Chicano
curatorial collective: "Some evaluators wondered whether the presentation is
objective and whether you have achieved the critical distance from the subject
required for an historically balanced perspective on Chicano art. One sympa-
thetic reviewer noted, for example, that 'this is definitely a political show,' and
another suggested that the political dimension overshadows the artistic with
the observation that 'the title should be 'El Movimiento: Resistance and
Affirmation.'"[25] The assumption here was that European Americans are the
only ones who can achieve "critical distance" and who can thus operate as
arbiters of taste and value. Ten years later, the Chicano art collectors of CACA
countered this assumption by locating the designation of taste within their
own collections, within their own homes.

The institutionalized resistance to Chicano art and its exhibition in Los
Angeles provides an important context for many of the individual works of
art included in *East of the River*. Of particular note is Judith F. Baca's sketch
for a mural commissioned by the University of Southern California in 1995:
as conceptualized by Baca, the mural was meant to comment on the alter-
nately tragic and affirmative history of Mexicans and Latinos in Los Angeles
(fig. 8). Baca's drawing, which includes comments from the president and
an administrator at the university, tells the tale of the collective struggle to
create, and maintain artistic control over, a Chicano mural at the University
of Southern California. At all stages of the process the university tried to exert
its political control over the artistic content of the mural. The central figure of
the mural is a woman on whose back the various historical atrocities commit-
ted against the Latino community are etched—wars, lynchings, and fights for
justice. The mural is a constellation of powerful images, which wind in a long
river of blood flowing from the head and back of the female figure. The
response by university officials to the original drawing was generally negative.
In order to tell this part of the story, Baca highlighted the comments of the
university officials on her preliminary sketch. Taken together, these comments
tell a distressful tale. One reads: "This represents victimization. Couldn't you
provide Anglo viewers more positive representations of Chicano history?"
Another reads: "Why are the Indians in a Mexican work?" To the latter, Baca

replied, "Do you really not know?" Perhaps the biggest objection had to do with the face of the goddess, about which one commentator asked, "Couldn't the sleeping giant be happier?" Again, Baca's response: "She is not Barbie. Besides someone has just hammered the steel blade of the border into her back." Throughout this process, Baca stood her ground with the university administrators, agreeing only to minor changes. In the end she prevailed, and hers was the only work of Chicano art publicly displayed on the university campus at that time. Given this history, we can say that the value of the artist's sketch in the exhibition lies not only in its content but also in its form and the circumstances of its production. Baca's sketch is a reminder of the struggle that Chicanos face in their ongoing efforts to breach the walls of resistive institutional spaces. The sketch testifies to the history of the mural's production; this history was validated by the sketch's inclusion in *East of the River.* We see here what hooks refers to as the struggle of memory against forgetting. To be sure, each piece of Chicano art in *East of the River* admonishes us that "it is dangerous to forget."

We have spent some time discussing museum practices and institutional spaces for exhibiting art. I would like now to turn to a different politics of location. The very title of the CACA exhibition calls attention to location by pointing to the area east of the Los Angeles river, East Los Angeles, where many Chicanos live. But it is the location of the exhibition itself that I am interested in here. The Santa Monica Museum of Art sits in the Bergamot Station, an arts complex comprised of galleries and artists' studios. It is somewhat anomalous to find a museum in the center of a space primarily dedicated to the buying and selling of art. If the title of the exhibition refers to the location of East Los Angeles—in relationship to the downtown and trendy Westside Los Angeles art establishments—the Santa Monica Museum of Art locates itself *west* of the Los Angeles County Museum of Art and the Getty Museum. Indeed, the Santa Monica Museum of Art seems to ally itself more with the artist than with the institutional museum space. We might ask, then, if the Santa Monica Museum, in focusing on collectors in this exhibition, was perhaps positioning itself as an intermediary space between art museum and private gallery.[26] This is yet another "edge" that the curator and the museum exposed when they chose to mount *East of the River* without reference to either the artists' names or the dates or narrative contexts of their works. In view of this, we must read the choice to downplay the artist as an ironic comment on the ever-changing role of the museum space.

Jennifer Gonzalez ends her essay in the exhibition catalog with an insightful comment on Los Angeles, a place that has no center. According to Gonzalez, Los Angeles is a collection of neighborhoods that can only be apprehended through multiple lenses: "It is a horizontal city, and therefore must be understood as a series of horizons that can only really be viewed from the street, from the freeway, from the car, from the overpass, from the gutter, or from the windows and doors of home. Like windows or mirrors, the artworks in *East of the River* frame views and reflect positions that are only a fragment

Fig. 8. Judith F. Baca (American, b. 1946)
USC Mural Commission in Progress with USC President's Comments and Administrator's Comments 11/17/95, 1995, digital print on paper with pencil, 61 × 132 cm (24 × 52 in.) Montebello, California, Mary Salinas Durón and Armando Durón Collection

of the larger whole, but no less revealing for that."[27] Where do we locate the collector within this landscape? What are the geopolitical implications of the locations in which the collectors house their art—their homes? Do they live east of the river, as the exhibition title suggests? Or is this a metaphoric designation that points to the collectors' displacement from the predominantly working-class East Los Angeles? We can perhaps read a subtle class identification underlying the collectors' choice of what to call themselves—Chicano art collectors—and where to exhibit their art—the Westside of Los Angeles.

East of the River underscored, if unwittingly, the tension between individual artworks and the curatorial framework within which they are presented. The exhibition's focus on the collector marginalized the art object at the same time that it revealed the discomfort that Chicano art continues to provoke within the space of the museum. Yet the curatorial strategy of bringing the private home into the museum accounts for only part of the tension that Chicano art produces in its collectors, exhibitors, and critics.

If *East of the River* raises more questions than it can answer, the individual artworks in the exhibition tell a more complete story. Many of these works commemorate the Chicano struggle for civil rights and the Chicana struggle for self-determination. Adrienne Rich notes that "over so many millennia, so many cultures, humans have reached into preexisting nature and made art: to celebrate, to drive off evil, to nourish memory, to conjure the desired visitation," to conjure "a language that is public, intimate, inviting, terrifying, and beloved."[28] The language of Chicano art is terrifying because it keeps the pain of history present; it is beloved because it affirms the value and necessity of representing oneself. The art in *East of the River* attempts to find an adequate way to represent, preserve, and extend a history of social critique within the public dialogue. Through its collecting, Chicano Art Collectors Anonymous became a part of the dialogue, a part of the production and dissemination of this art that dwells on opaque edges and performs in the struggle against forgetting.

Notes

I would like to extend my sincere thanks to Tania Modleski for the invaluable intellectual and editorial support that she gave to me in the writing of this essay.

1. Adrienne Rich, *What Is Found There: Notebooks on Poetry and Politics* (New York: Norton, 1993), 242.

2. Milan Kundera, *The Book of Laughter and Forgetting*, trans. Michael Henry Heim (New York: HarperPerennial, 1994), 87.

3. For more on Chicano history, the Mexican-American War, and the Chicano Civil Rights Movement, see Richard Griswold del Castillo, *The Treaty of Guadalupe Hidalgo: A Legacy of Conflict* (Norman: Univ. of Oklahoma Press, 1990); Richard Griswold del Castillo, *North to Aztlán: A History of Mexican Americans in the United States* (New York: Twayne, 1996); Juan Gómez-Quiñones, *Roots of Chicano Politics, 1600–1940* (Albuquerque: Univ. of New Mexico Press, 1994); Juan Gómez-Quiñones,

Chicano Politics: Reality and Promise, 1940–1990 (Albuquerque: Univ. of New Mexico Press, 1990); David Montejano, *Anglos and Mexicans in the Making of Texas, 1836–1986* (Austin: Univ. of Texas Press, 1987); and George J. Sánchez, *Becoming Mexican American: Ethnicity, Culture, and Identity in Chicano Los Angeles, 1900–1945* (New York: Oxford Univ. Press, 1993).

For more on Chicano history and art, see Shifra M. Goldman and Tomás Ybarra-Frausto, "The Political and Social Contexts of Chicano Art," in Richard Griswold del Castillo, Teresa McKenna, and Yvonne Yarbro-Bejarano, eds., *Chicano Art: Resistance and Affirmation, 1965–1985*, exh. cat. (Los Angeles: Wight Art Gallery, 1991), 83–95; David R. Maciel, "Mexico in Aztlán, Aztlán in Mexico: The Dialectics of Chicano-Mexicano Art," in Richard Griswold del Castillo, Teresa McKenna, and Yvonne Yarbro-Bejarano, eds., *Chicano Art: Resistance and Affirmation, 1965–1985*, exh. cat. (Los Angeles: Wight Art Gallery, 1991), 109–19; and Philip Brookman, "Looking for Alternatives: Notes on Chicano Art, 1960–90," in Richard Griswold del Castillo, Teresa McKenna, and Yvonne Yarbro-Bejarano, eds., *Chicano Art: Resistance and Affirmation, 1965–1985*, exh. cat. (Los Angeles: Wight Art Gallery, 1991), 181–91.

A word about terminology may be helpful. *Chicano*, as distinct from *Mexican American*, is a term that refers to individuals of Mexican-American descent in the United States who have a particular progressive political consciousness. The term *Chicano* in Chicano art refers to this perspective. It is also important to note that recently people other than Mexican Americans have used this term as a self-designation that places them in political solidarity with Chicanos and other progressive movements. There is no indication about how the individual members of Chicano Art Collectors Anonymous (CACA) consider their relationship to the term *Chicano*.

4. *Aztlán* is the Aztec term for the place of origin of the Aztec peoples; for more on this term, see "Chicano Glossary of Terms," in Richard Griswold del Castillo, Teresa McKenna, and Yvonne Yarbro-Bejarano, eds., *Chicano Art: Resistance and Affirmation, 1965–1985*, exh. cat. (Los Angeles: Wight Art Gallery, 1991), 361.

5. bell hooks, "Narratives of Struggle," in Philomena Mariani, ed., *Critical Fictions: The Politics of Imaginative Writing* (Seattle: Bay Press, 1991), 60.

6. The idea for the exhibition about the collectors and their art originated with one of the members of CACA. According to Chon Noriega, the group first wanted to hold the exhibition at the Los Angeles County Museum of Art. However, due to administrative changes in the museum, the idea for the exhibition was not acted upon. The search for a curator continued for some time. With interest from the Santa Monica Museum of Art and the choice of Chon Noriega as curator, the development of the exhibition accelerated. According to Noriega, he worked on this show for approximately four years. By its opening in 2000, the exhibition had been in development for seven years.

7. hooks, "Narratives of Struggle" (note 5), 54.

8. Chon A. Noriega, "Collectors Who Happen to Be...," in *East of the River: Chicano Art Collectors Anonymous*, exh. cat. (Santa Monica, Calif.: Santa Monica Museum of Art, 2000), 10.

9. Harry Gamboa Jr., "In the City of Angels, Chameleons, and Phantoms: Asco, a Case Study of Chicano Art in Urban Tones (or Asco Was a Four Member Word)," in Richard Griswold del Castillo, Teresa McKenna, and Yvonne Yarbro-Bejarano, eds.,

Chicano Art: Resistance and Affirmation, 1965–1985, exh. cat. (Los Angeles: Wight Art Gallery, 1991), 123.

10. The history of Chicano art collectives is too large to sketch here. For more information on these collectives and early Chicano art exhibitions, see Jacinto Quirarte, "Exhibitions of Chicano Art: 1965 to the Present," in Richard Griswold del Castillo, Teresa McKenna, and Yvonne Yarbro-Bejarano, eds., *Chicano Art: Resistance and Affirmation, 1965–1985,* exh. cat. (Los Angeles: Wight Art Gallery, 1991), 163–79.

11. Amalia Mesa-Bains, "El Mundo Feminino: Chicana Artists of the Movement — A Commentary on Development and Production," in Richard Griswold del Castillo, Teresa McKenna, and Yvonne Yarbro-Bejarano, eds., *Chicano Art: Resistance and Affirmation, 1965–1985,* exh. cat. (Los Angeles: Wight Art Gallery, 1991), 132.

12. Jennifer A. Gonzalez, "Windows and Mirrors: Chicano Art Collectors at Home," in *East of the River: Chicano Art Collectors Anonymous,* exh. cat. (Santa Monica, Calif.: Santa Monica Museum of Art, 2000), 39.

13. Chon Noriega, "Collectors Who Happen to Be..." ("Works in Progress" lecture series, Getty Research Institute, Los Angeles, 6 October 2000).

14. Tomás Ybarra-Frausto, "Rasquachismo: A Chicano Sensibility," in Richard Griswold del Castillo, Teresa McKenna, and Yvonne Yarbro-Bejarano, eds., *Chicano Art: Resistance and Affirmation, 1965–1985,* exh. cat. (Los Angeles: Wight Art Gallery, 1991), 155.

15. Mesa-Bains, "El Mundo Feminino" (note 11), 132.

16. *East of the River: Chicano Art Collectors Anonymous,* exh. cat. (Santa Monica, Calif.: Santa Monica Museum of Art, 2000), 31.

17. KarenMary Davalos argues persuasively for the importance of reading Mexico into the art of collecting Chicano/a art in her essay, "In the Blink of an Eye: Chicana/o Art Collecting," in *East of the River: Chicano Art Collectors Anonymous,* exh. cat. (Santa Monica, Calif.: Santa Monica Museum of Art, 2000), 42–51. She also argues that the relationship between Mexico and *el norte,* "with its interwoven inequalities made in gender, class, race, language, national, and sexual difference... produces an incomplete recovery of the subject/object for Chicana/o art collectors" (p. 49). Her reading of gender issues through the filter of the border space is an important contribution to gender analysis of art collecting. See also her recent book, *Exhibiting Mestizaje: Mexican (American) Museums in the Diaspora* (Albuquerque: Univ. of New Mexico Press, 2001).

18. Christopher Knight, "A Collective Effort," *Los Angeles Times,* 21 September 2000, Calendar section, p. 52.

19. Chon Noriega, "Museum Walls are an Issue in any Show," *Los Angeles Times,* 2 October 2000, sec. 6, p. 3.

20. Gamboa, "In the City of Angels" (note 9), 121.

21. Noriega, "Museum Walls" (note 19).

22. Noriega, "Collectors Who Happen to Be..." (note 8).

23. For an extended study of the *CARA* exhibition, see Alicia Gaspar de Alba, *Chicano Art Inside/Outside the Master's House: Cultural Politics and the CARA Exhibition* (Austin: Univ. of Texas Press, 1998).

24. William Wilson, "Chicano Show Mixes Advocacy, Aesthetics," *Los Angeles Times,* 12 September 1990, sec. 6, p. 1.

25. Lynne Cheney, personal correspondence, 20 December 1989.

26. The Santa Monica Museum of Art began as an artists' collective that was dedicated to the support and exhibition of the work of local artists. This fact supports my contention that the Santa Monica Museum of Art was consciously breaking the boundaries of traditional museum spaces in mounting *East of the River*. Nonetheless, it is ironic that this particular museum chose an exhibition that decentralized the artist by focusing on the collector to do so.

27. Gonzalez, "Windows and Mirrors" (note 12), 41.

28. Adrienne Rich, *What Is Found There* (note 1), 250.

A Passion for the Dead: Ancient Objects and Everyday Life

Page du Bois

This essay concerns not only my passionate interest in the ancient Greeks but also the passion, the endurance or suffering, of ancient peoples, and the endurance and survival of ancient objects into our present. In ancient Greek, *pathos* means either emotion or "anything that befalls one."[1] *Pathos* can refer to any experience, painful or pleasurable, and the root *path-* does not necessarily suggest suffering in the sense of pain but simply in the sense of experience, the lived encounter with the events of human existence. When used to mean powerful feeling, *pathos* often implies external or alienated agency: one is "set upon by lust," for example, or "carried away by emotion." The emotion of intense sexual desire is personified in a god, Eros, son of Aphrodite, who intervenes in human experience as a separate and distinct being. A human being moved by eros thus conceives of its source as outside the self, in the intention of the god—the human being is the victim of feeling imposed from elsewhere, which he or she must endure or *suffer.*

With the Christian description of Jesus' experience at the time of his death, the term *passion* first takes on connotations of bodily anguish and affliction. Subsequently, the meaning of *passion* evolves even further, turning almost into its own contrary. *Passion* now signifies "[a]n eager outreaching of the mind towards something; an overmastering zeal or enthusiasm for a special object; a vehement predilection."[2] The meaning has thus changed from passive experience—suffering in the sense of enduring, or being the object of action—to physical suffering and, finally, to the contrary of *pathos* or passivity, that is, to active desire.

The ancient Greek word *apatheia* (want of sensation or insensibility) derives from the adjective *a-pathes* (without passion or feeling)—in pre-Platonic texts, *apathes* connotes not only a lack of visitation by emotion but also inexperience. Like the Greek *aletheia* (truth or unhiddenness), *apatheia* is what is called an alpha privative term, formed through the negation of the positive term for feeling. More than other kinds of contraries, the alpha privative words preserve the presence of the contrary; it is as if instead of hate, we called the contrary of love *unlove.* The Greeks thus construct such concepts as *a-letheia* (unhiddenness) for truth, *a-topia* (placelessness) for eccentricity, *a-ponia* (nonexertion) for laziness, *a-polis* (a citiless person) for an outlaw. The kind of semantic formations that occur in positive terms in English, or that have a variety of forms of negation, are in Greek endlessly and allitera-

tively rendered with this privation, this alpha that both preserves and takes away the sense of the word's meaning.

The Greeks allow for experience by accounting for *pathos,* as an encounter, almost as possession; then they valorize the mastery of experience, and of the feelings that accompany experience, by cultivating and celebrating an attitude of *apatheia* (emotionlessness), an attitude that both encompasses the presence of feelings and negates that presence at the same time. Such condensed, imploded, syncopated, proleptic narrative becomes the model of the philosophical life and, subsequently, of the scholarly life. Academic intellectuals, scholars, and philologists have long been trained to ignore, suppress, or disregard their passion for the objects that make up their disciplines.

I'm concerned in this essay with the contrary, with the passionate attachment that scholars have to the objects of their study — what I consider the striking passion, the lack of *apathy* often involved in the best historical work. Walter Benjamin, the brilliant German Jewish critic who killed himself while fleeing the Nazis in 1940, once wrote:

> *Dining Hall.* — In a dream I saw myself in Goethe's study. It bore no resemblance to the one in Weimar. Above all, it was very small and had only one window. The side of the writing desk abutted on the wall opposite the window. Sitting and writing at it was the poet, in extreme old age. I was standing to one side when he broke off to give me a small vase, an urn from antiquity, as a present. I turned it between my hands. An immense heat filled the room. Goethe rose to his feet and accompanied me to an adjoining chamber, where a table was set for my relatives. It seemed prepared, however, for many more than their number. Doubtless there were places for my ancestors, too. At the end, on the right, I sat down beside Goethe. When the meal was over, he rose with difficulty and by gesturing I sought leave to support him. Touching his elbow, I began to weep with emotion.[3]

Benjamin's ominous, premonitory dream, recorded in the 1920s, evokes a passion for the traditions of German high culture and for the material remains of classical antiquity. After handling the urn, "[a]n immense heat," the pressure of this encounter with the past, "fills the room." Benjamin breaks down weeping after touching the great dead man — like the urn from antiquity, Goethe is fragile and filled with meaning for the young critic.

———

My own passion as a classicist began one day long ago. I was raised in a little town in California, with a little park in its center, a totem pole set in green grass, and an old museum at its heart. The museum was right across the street from the house of my great-aunt, Auntie Bee. I was fascinated by her; she lived in a big house with a porch, a house with satin cushions embroidered with words. Her house had a special smell I associated with her great age. Her skin was very wrinkled, and she powdered it, and the powder sat in its

wrinkles. I remember as a small child asking about that skin, those wrinkles, that powder, and being silenced.

The museum across the way, which I entered with a sense of wonder, displayed objects collected and donated by the citizens of the town. There was a huge, stuffed, fraying Komodo dragon, a relic of someone's trip to what was once called the Orient. There were miniature rooms outfitted with the appurtenances of American history — George Washington's house, John Adams's parlor, a pioneer cabin. There were some Native American relics, some fragments from the voyages of beaver trappers of the eighteenth or nineteenth century, and some remnants from the landholdings of the Spanish in old California.

But what I remember most vividly, what sealed my fate, was a cabinet of Roman glass. These vessels and fragments — small amphorae, perfume vases, an alabastron, shards of broken glass — had the characteristically complex surface of old glass: scaly, iridescent, pearly, as if the skin itself had depths. The glass was pink and turquoise and pearly gray, mother of pearl, and gold. What really struck me, though, as a third grader at Woodrow Wilson Elementary School, was that people long ago, now long-dead, had blown this glass, they had touched it, filled it with liquids, oil, tears, perfume, or wine, they had kept it whole, and though they had died, their objects, with their beautiful pearly shapes, fragile, frangible, and thin-skinned, had survived from Roman times. I didn't understand how to measure the distance between myself and these ancient people. I had seen movies of people in togas charging about in chariots who seemed very familiar, with their American accents and their American body language. But I knew that this glass was different, that it was really old, that the Romans had made it and kept it and passed it on, and that it had lasted all the way down to the present, to sit here in this little museum for me and others to see, older than anything else in the place, older than anything else in the town besides the rocks. These human-made artifacts looked so fragile, and yet they were tougher and more durable in their inanimacy than the soft, powdered, wrinkled skin of my Auntie Bee.

It is the sensation of contact with the everydayness of the ancient world, a passion for such contact, as in Benjamin's dream of the urn of antiquity, and the dead Goethe — as my title has it, a passion for the dead — that keeps me studying ancient things in a modern world inclined to fetishize only the masterpiece. Increasingly we separate the masterpiece from those who made it, lived with it, used it long ago, thus locating it ahistorically within a set of masterpieces, framing it as utterly remote and inaccessible, a work of genius, like something passed to us from ancient gods. What excites my passion just as much, if not more, than the works of art which are reproduced everywhere, which are signs for "high culture" and the "great European tradition," are commonplace objects, like the Roman glass of the provincial museum's cabinet, or Benjamin's urn: for me, these objects vividly convey a sense of the dead, of their manufacture, their habits, their treasuring of the things of ordinary life.

A *passion for the dead,* then, means thinking about those who made, used, and saw ancient things when they were new. I'd like to consider how objects from antiquity have the capacity to remind us that human beings were involved in their fabrication, their use, their preservation, and their descent to us. And I also would like to question the notion that it is only the great masterpieces, the finest, most aesthetically distinguished works of art, that can excite our passion as viewers.

The space of most great museums is occupied by works that are judged to have exceptional aesthetic value. Focus on the masterpiece as such dates back to the beginnings of the history of art. Renaissance excavators, for example, who uncovered Roman sculpture for contemporary artists like Andrea Mantegna and Michelangelo to admire and imitate, looked for masterpieces rather than for artifacts that could reveal the details of everyday life. Even in the eighteenth-century excavations of Pompeii and Herculaneum, where the trauma of the volcanic eruption cast a certain moment of everyday life into stone, the pathos of the petrified often overcame interest in Roman life in the first century: the disaster narrative overshadowed the details of quotidian existence preserved by the ash and lava. In Greece, the nineteenth-century excavator Heinrich Schliemann dug up the golden mask he assigned to the hero Agamemnon; in the process, Schliemann ignored much that might have shed light on the lives of ordinary people in the Mycenaean age.

Classicists too have concentrated on the monuments and the highest genres—tragedy and philosophy—of ancient Greece and Rome. In literary studies, for instance, scholars have given priority to the Athenian tragedies of Aeschylus, Sophocles, and Euripides, rather than to graffiti and such popular forms as the mime. Likewise, because the great institutions of the Athenian state and the Roman republic and empire have served as models for the proper governance of the polity in contemporary culture, the everyday life of human beings unknown heretofore, people without great names like Pericles and Julius Caesar, has often gone unstudied.

Even though archaeologists have long been concerned with everyday life—and, to this end, have excavated houses, middens, ordinary sites of human habitation—the exhibition of antiquities, both in this country and in Europe, has often meant the detachment of objects of cult from their original contexts, whether civic, political, or religious. For example, the Parthenon frieze was physically severed from the walls of Athens' great temple of Athena, a site of civic goddess worship. The Parthenon sculptures are now exhibited in isolation from the temple, in the British Museum and elsewhere. The treasures of the ancient democracy were thus reframed, sometimes in museums, sometimes in private collections, redefined as examples of cultured or aristocratic taste with which to form the aesthetic sensibilities of the new classes of the industrial world. As a result, the identities of the makers of these treasures—masons, sculptors, potters, painters, laborers, and public servants—were

effaced. Except in rare cases, usually speculative, in which a maker's name is attributed, these works of art are often now named for their possessors, modern collectors such as Lord Lansdowne or Lord Elgin.

Not surprisingly, the display of everyday life in the museum context has had a meager and predictable history. In 1908, for example, the British Museum set up an exhibition called *Greek and Roman Daily Life*. The exhibition, which is rigorously separated from the masterpieces of Greek art displayed on the floors below, contains objects of human rather than artistic interest, the things of domestic life, of women's work.

According to Ian Jenkins, a curator at the British Museum and the author of a companion guide to the exhibition upon its renovation in the 1980s, scholars in the eighteenth and nineteenth centuries consistently idealized Greek civilization. Toward the end of the nineteenth century, however, a shift occurred:

> Scholars came to realise that even the enlightened Greeks, those lovers of democracy, builders of the Parthenon and founders of modern philosophy, had their darker side. The study of ancient religion, in particular, revealed irrational and superstitious elements in the Greek mind which, it was soon recognised, were an integral part of the Greek way of life.
>
> The establishment of the first exhibition of Greek and Roman life at the British Museum in 1908, with its particular focus then, as now, on domestic life, may be seen historically as part of this development in Classical scholarship.[4]

Yet, when I last visited the exhibition in 2001, objects were grouped under such categories as "Sacrifice," "Gods," "Reading and Writing," "Women," "Trade and Transport" — not really the stuff of the "darker side." No category of "Slaves" or "Foreigners" or "Torture," for example. Nor was there much recognition of the passionate interest that some adult visitors might bring to this room.

In the British Museum, as in many other museums and cultural institutions, when presenting the details of everyday life, curators and scholars often assume the particular rhetorical tone of grown-ups instructing the young. In both Britain and America, exhibitions on everyday life in Greece and Rome have most frequently been designated the province of children. For example, in her recent book *Everyday Life in Ancient Greece*, Anne Pearson presents an illustration of terra-cotta perfume bottles as a puzzle for her young readers (fig. 1).[5] A display from the British Museum's exhibition on everyday life includes children's toys: a whip top, a dancing doll holding castanets, a baby feeder with the inscription "drink, don't drop," a miniature wine jug, and a rattle in the form of a pig (fig. 2). Another part of the same exhibition concerns the Greek farmhouse (fig. 3).

Representations of everyday life in the ancient world, whether in museums or in books, often evince a strong gender division. Books organized around women's work, or men's warships and weapons, encourage a conventional

MYSTERY OBJECT

What do you think these are? They were found in the women's room, near makeup containers. Clue: they would have smelled pleasant. You will find the answer on page 32.

Fig. 1. "Mystery Object"
From Anne Pearson, *Everyday Life in Ancient Greece* (New York: Franklin Watts, 1994), 14

Fig. 2. Children's toys
From Ian Jenkins, *Greek and Roman Life* (London: British Museum Publications, 1986), fig. 35

A Greek Farmhouse

Greek houses were built to a simple plan around an enclosed courtyard with only one entrance. This made them private and secure.

In the countryside south of Athens, near a place called Vari, were found remains of a house. It was occupied by a family living around 350-300 BC. They were farmers, and remains of stone-walled enclosures near the house suggest sheep-pens and places for growing crops and fruit trees. Bees were also kept in pottery hives of a type still used in parts of the Mediterranean today.

The house was built of mudbrick on stone foundations. Stone flagging was laid over the surface of the courtyard, and the roof was protected by pottery tiles. The courtyard had a south-facing verandah where the family could work or relax, shaded from the sun in summer and protected from winter winds. Thicker foundations at the south-west corner of the house suggest there was a tower giving the farm greater security.

Fig. 3. Didactic panel about a Greek farmhouse of 350–300 B.C.E., *Greek and Roman Daily Life,* British Museum, London, 1998

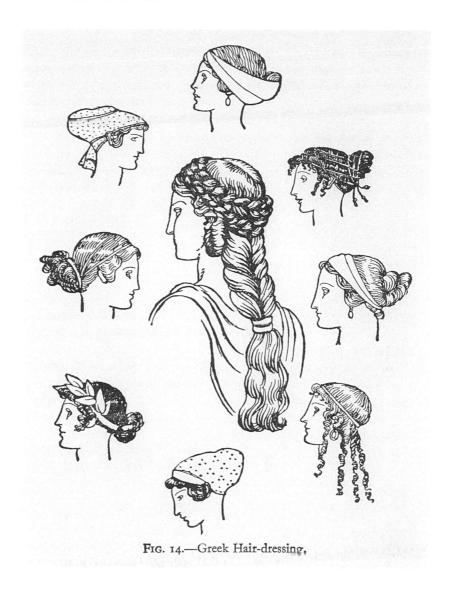

FIG. 14.—Greek Hair-dressing.

Fig. 4. *Greek Hair-dressing*
From Marjorie Quennell and Charles Henry Bourne Quennell, *Everyday Things in Ancient Greece: Homeric, Archaic, and Classical* (London: B. T. Batsford, 1932), fig. 14

division of labor between the sexes: terra-cotta figurines of women grinding grain and placing food in an oven appeal to girls, while displays of armor appeal to boys. According to one book written in the 1930s, *Everyday Things in Ancient Greece,* "no boy or girl can understand what has happened in this England, or this Europe, or, as a matter of fact, America, unless they are prepared to tramp along the road that leads to Rome. Arrived there they will find they must continue their journey to the Athens of Pericles; but they need only travel in imagination, because the tale is well told on a few square miles of English land."[6] Little children see in their own lands the toys of ancient children; girls see how ancient women spun and wove and made clothing for their households; boys, how ancient men waged war. Images of ancient Greek coiffures — such as this one from *Everyday Things in Ancient Greece* (fig. 4) — are common in books about everyday life in antiquity. Little girls, we conclude, like to think about hair.

A concern for what is called everyday life, or daily life, or the quotidian, is a relatively new aspect of the discipline of history. The attention of scholars to this realm reflects recent efforts in the humanities to account for the lives of the long-silenced populations of the world — women, slaves, people of color, and working people. The French philosopher Henri Lefebvre contends that everyday life only became visible or perceptible with the advent of capitalism and the beginning of the culture of modernity; that not until this time did the everyday become a domain of interest to artists and thinkers such as the Surrealists in the early twentieth century.[7] Lefebvre argues that before capitalism, life was lived as an "undifferentiated whole."[8] The things of the world had symbolic value and were linked to the meanings of existence; people lived by the rhythms of the day, the changes of the seasons. In the modern era, differentiation occurred, and the world broke apart into "autonomous subsystems";[9] art was separated from science, the public from the private sphere. Lefebvre proposes to "decode the modern world . . . according to the everyday," and he suggests that "the concept of everydayness [can] reveal the extraordinary in the ordinary":

> Thus formulated, the concept of the everyday illuminates the past. Everyday life has always existed, even if in ways vastly different from our own. The character of the everyday has always been repetitive and veiled by obsession and fear. In the study of the everyday we discover the great problem of repetition, one of the most difficult problems facing us. The everyday is situated at the intersection of two modes of repetition: the cyclical, which dominates in nature, and the linear, which dominates in processes known as "rational." The everyday implies on the one hand cycles, nights and days, seasons and harvests, activity and rest, hunger and satisfaction, desire and its fulfillment, life and death, and implies on the other hand the repetitive gestures of work and consumption.[10]

For Sigmund Freud, certainly, there was meaning to be found in the everyday. In *Zur Psychopathologie des Alltagslebens* (1901; *Psychopathology of Every-day Life,* 1914), for example, Freud values everyday speech, forgetting, lapses, and slips of the pen and the tongue because they can provide access to the otherwise inaccessible realm of the unconscious.[11]

Other theories about the everyday have emerged in recent years from social historians such as Fernand Braudel and Michel de Certeau, both of whom have thought about the everyday in the context of their broader efforts to restore to public view the invisible of the past, those social actors in the quotidian realm who have not had a voice — women, the poor, slaves. Braudel's *longue durée* points to a temporality characterized by the survival of features of history that are almost invisible because they endure for so long or persist so far beyond individual human existences that they are taken for granted, become part of a naturalized landscape of human history, and therefore must be excavated, revealed not as natural but rather as part of a long process of change and transformation, of a geological slowness.[12] For Michel de Certeau, the everyday presents itself as a site of resistance, a domain of social practices in which ordinary people can turn against their masters, subverting the structures of the world of domination — people can forge their own paths in cities or use company time for their own pleasures and enrichment. De Certeau sees the everyday as an immense field of uncharted, unaccounted-for practices of ingenuity and defiance.[13]

While classicists were not the first to embrace the study of the everyday — in part because they have often been asked to provide the rationale for the foundations of Western civilization, that is, for democracy, philosophy, the law, and political theories of the republic — classical archaeologists have consistently and enthusiastically emphasized the importance of the ordinary, the everyday, the material, the object world of antiquity. Archaeologists remind us that we can come to know ancient culture not only through the highest of genres or the greatest of masterpieces but also through what we can reconstruct from the ruins of everyday life. Accordingly, reconstructions of the material culture of ancient civilizations should not be the province of children, relegated to the British Museum's attic, for they are just as valuable an enterprise as the restoration and admiration of the works of the greatest artists of our tradition. Classical archaeologists teach us that the passion for antiquity and for the lost civilization of the ancient Greeks can be formed and nurtured by contact with the material culture of ancient civilizations: the ordinary objects and simple domestic spaces that were at the core of everyday existence.

Let me illustrate what I mean with some examples from the material and literary remains of antiquity. An Athenian amphora from about 520 B.C.E., now a part of the British Museum's *Greek and Roman Daily Life* exhibition, depicts an olive harvest; two older men use long poles to shake the olives

Fig. 5. Vitrine featuring a Greek black-figured amphora of ca. 520 B.C.E., *Greek and Roman Daily Life*, British Museum, London, 1998

loose, while a boy gathers the fruit from the ground (fig. 5). The image on this amphora represents everyday labor, but it also refers to the aesthetic and political culture of ancient Athens.

The first olive tree in Athens was a gift from the goddess Athena who, because of her gift, was chosen as the city's deity. In Sophocles' tragedy *Oedipus at Colonus* the chorus sings its praise of Attica, the olive tree, and Athena:

> Here...
> where the nightingale in constant trilling song
> cries from beneath the green leaves,
> where she lives in the wine dark ivy
> and the dark foliage of ten thousand berries,
> safe from the sun, safe from the wind
> of every storm, god's place, inviolable....
>
> There is a thing too, of which no other like
> I have heard in Asian land,
> nor as ever grown in the great Dorian
> island of Pelops,
> a plant unconquered and self-renewing,
> a terror that strikes the spear-armed enemy,
> a plant that flourishes greatest here,
> leaf of gray olive,
> nourishing our children.
> It shall not be rendered impotent
> by the young nor by him that lives with old age,
> destroying it with violence,
> for the ever-living eye of Morian Zeus
> looks upon it — and gray-eyed Athene also.[14]

It was a capital crime to cut down one of the sacred olive trees of the land of Attica. Olive trees were said to survive for centuries, and myth has it that from a ruined and burnt stump on the Acropolis, destroyed by the Persian invaders of the early fifth century B.C.E., miraculously, overnight, a new tree grew. A newborn male child received an olive bough that was placed over the door of his house. Victorious athletes won oil from the sacred trees, and crowns made from their leaves. The young man was imagined to grow in the cultivated soil of his city like a sacred tree, and the Athenian ephebe, the newly registered citizen, was symbolized by an olive tree.[15] The visual representations on the amphora, then, record the olive tree's complex cultural and political significance: the tree is sacred to the goddess, bearer of nourishing fruit and oil, and a symbol of the city and its soldiers. The amphora also reminds us of the labor required to fill vessels like this one, vessels made of clay and decorated by other laborers.

A common subject of ancient Greek figurines is that of women kneading and baking bread, a practice that engendered philosophical, literary, and also biological reflections. The comic playwright Aristophanes mocked scientists of his day with the following observation: they "teach that the heavens are one vast oven placed around us, and that we're the cinders."[16] And ancient writers often compared women's bodies, their wombs, to ovens.[17] The early Greek historian Herodotus told the story of the tyrant Periander, whose dead wife Melissa proved to an oracle in a dream that she was Periander's wife by saying that her husband had put his loaves in a cold oven· "The messengers reported what they had heard [at the oracle], and Periander was convinced by the token of the cold oven and the loaves, because he had lain with her after she was dead."[18] Thus visual and literary evidence come together to provide a richer picture of ancient society than either would provide separately. Often the two sorts of evidence can deepen the connections between literary and artisanal or artistic production, illuminating cultural studies and our understanding of the different dimensions of ancient society.

Of course some classicists, like some historians of ancient art, have restricted their study to the highest forms of ancient literary culture, to such genres as Greek tragedy. In Aeschylus's *Oresteia*—a synthesis of the archaic and the highest aspirations of the new democratic culture of Athens—the Eumenides, who were once avenging Furies, bless Athens in the elevated language of archaic lyric:

> Let there blow no wind that wrecks the trees.
> I pronounce words of grace.
> Nor blaze of heat blind the blossoms of grown plants,
> nor cross the circles of its rightplace.
> Let no barren deadly sickness creep and kill.
> Flocks fatten. Earth be kind.[19]

To be sure, Greek tragedy contains many such moments of high diction, of divine presence among mortals, of an idealized world without drought or hunger.

Yet if we turn from the highest cultural forms to the low, bawdy, raucous Athenian comedies, we find other intriguing aspects of ancient life. Aristophanes, for one, had a radically different view of life in the city than did Aeschylus. Aristophanes recorded the everyday, revealing the quotidian in ways that museums and idealizing narratives about ancient civilization do not. For example, in *The Acharnians*, the character Dikaiopolis sits, waiting for the assembly to begin, wriggling in his seat like a spectator at the theater: "I am always the very first to come to Assembly and take my seat. Then, in my solitude, I sigh, I yawn, I stretch myself, I fart, I fiddle, scribble, pluck my beard, do sums, while I gaze off to the countryside and pine for peace, loathing the city and yearning for my own deme."[20] Through these lines we are connected with the ancient Greek's experience of his own body, its materiality, its functions.

Fig. 6. Red-figured kylix with interior tondo of a woman with *olisbos*
Greek, ca. 3d – late 1st century B.C.E., terra-cotta, H: 13.8 cm (5⅜ in.), Diam.: 13.8 cm (5⅜ in.)
Formerly Elie Borowski Collection, Toronto

Mime was an even more popular theatrical genre than comedy. In one of the mimes by Herodas, women discuss the purchase of an *olisbos* (dildo), like the one illustrated on a cup here (fig. 6):

> At first glance my eyes swelled out of my head; I may tell you—we are alone—[it was]...firmer than the real article, and not only that, but as soft as sleep, and the laces are more like wool than leather; a kinder cobbler to a woman you could not possibly find.[21]

Representations such as this one open to the viewer or reader a fascinating complexity of sexual practices often suppressed in conventional, idealizing presentations on the ancient Greeks.

In a discussion of recent trends in archaeology, Ian Morris urges fellow classicists to abandon the "panoptic gaze of the art historian"; by doing so, he suggests, "we fragment our perspective into the countless points of view of actors in the past—that is, we re-figure classical archaeology in the sense of treating material culture as something used by real people in pursuit of their social goals."[22] Ancient objects, in other words, can provide a material basis for a passionate connection with the dead.

But what can it mean to communicate passionately with the dead through ancient objects? We rarely see, touch, smell, or handle something that people now long-dead saw, touched, smelled, handled, used. Such experiences sometimes produce shock. In his history of the British Museum, Edward Miller tells the story of George Smith. In the 1870s, Smith was working on clay tablets from Nineveh, tablets that seemed to confirm the flood story in the Old Testament: "On being handed the cleaned 'Deluge' tablet for which he had long been impatiently waiting...[Smith] read a few lines which confirmed his theories, shouted 'I am the first man to read that after more than two thousand years of oblivion.' Then, placing the tablet carefully on a table, he jumped up, rushed about the room in a state of excitement and, to the astonishment of all present, started to undress!"[23]

Yet how often do scholars imagine people using ancient objects, ancient vases, holding them, mixing wine and water in them, ladling oil from them? In a chapter called "Wine and the Wine-Dark Sea," in his book *The Aesthetics of the Greek Banquet*, François Lissarrague demonstrates the analogies that the Greeks drew between wine and the sea, navigation and the banquet, the symposium.[24] The drinker and the sailor alike relied on his vessel. Lissarrague illustrates this point with a *krater* (a mixing bowl), the neck of which was decorated with a frieze of boats; when the *krater* was filled with wine, the boats seemed to float on the wine-dark sea. With another cup, as the drinker drank the sea-colored wine, he revealed the god Dionysus reclining in his boat, his mast covered with grapevines.

We are sometimes so immersed in the practices and spectatorship of mod-

ern art that we forget that art figured differently in ancient societies than it does in our own. Modern art is made by individual, named artists, to be bought and sold, displayed in the homes of the wealthy, donated to museums, placed on walls or on pedestals, and admired by visitors. The mythification of the modern artist stands between the viewer and the work of art. But ancient Greek statues, representations of the gods, often figured in the landscape of festivals or everyday life; and Greek vases were used for drinking, for containing perfumes or ashes, for mourning, for the pleasures of weeping and touching and tasting, as well as viewing. If we look at and touch a Greek vase or a piece of Roman glass, although museums may inevitably have the effect of turning them into Art, still we encounter ancient, ordinary life.

When we see museum displays from ancient tombs, for instance, we come into contact not just with stores of artifacts but also with the grief and ritual and bodily remains of the ancient dead. Indeed, our sense of human history begins with the rituals of burial. J. M. Roberts, in his *History of the World,* writes of "the primitive [Neanderthal] community in northern Iraq which went out one day to gather the masses of wild flowers and grasses which eventually lay under and surrounded the dead companion it wished so to honour."[25] If we forget the significance of funerary objects, we miss the opportunity to connect with those who preceded us in the human record. It is easy to forget, especially in museums devoted to high culture and named artists and the tribute of imperial adventures, that others once lived among and used the things that we now call art, that they have since died, and that their remains were sometimes commemorated by or even held in these vases of ceramic and glass.

Ancient Greek glass was a special substance, expensive and rare, yet nonetheless used by some in the course of everyday life. Today, this glass is even more costly and rare. It was made in Egypt, on Cyprus, and at the great sanctuary of Zeus at Olympia, in the Peloponnesus. Before glassblowing was invented, artisans used already made ingots or canes that they melted or fused and then sometimes zigzagged like cake batter.[26] Figure 7 shows some early Greek core-formed glass vessels, containers for oils or perfumes from the eastern Mediterranean.

Glassblowing was discovered in the first century B.C.E. by an unknown adventurer. Hollow rods have been found in Jerusalem with slightly open ends. These rods were blown into, so that the shape of the glass retains the breath of the now long-dead maker. Lesley Stern, in her book on smoking, writes that smoke makes the shaman's breath visible.[27] Blown glass not only makes the breath visible but also preserves the breath, the outline of the breath. The Greeks talk about breath as the psyche, the soul. A living creature breathes. Blowing glass, the heat, the residues, damages the lungs; perhaps my passion, my attachment to ancient objects, stems from the fact that my great-grandfather was a Strasbourgeois glassblower who, like many glass artisans, died young.

Fig. 7. *Alabastron*
Mediterranean (Cyprus), 3d–late 1st century B.C.E.,
core-formed glass, H: 13.8 cm (5⅜ in.)
London, British Museum

Fig. 8. *Sprinkler Flask*
Eastern Mediterranean (Roman), 3d–4th century, glass,
H: 13.5 cm (5¼ in.)
Malibu, California, J. Paul Getty Museum

Part of what makes ancient glass so beautiful is the way in which it has mutated, become encrusted and iridescent, marked by the chemical transformations of centuries. Ancient glass takes light in an incredibly complicated, dappled, rich, layered pattern, so that it seems to have infinite depth. I once touched some ancient glass, thanks to the staff of the J. Paul Getty Museum. One vase was extraordinary because it seemed to have iridesced only on the inside, so that an immense richness lay behind a curtain of glass. Looking down into the vessels, I thought about the oil, the perfume that they once contained. To the touch, the glass was almost as I had imagined it, but in some places slightly coarse, with a resistant tensile quality, just the slightest pull. It didn't feel like contemporary commercial glass. It had varied patches, unpredictable encrustations on a once-uniform surface: cobalt and gold veining, and rougher bits, like excrescences on the skin, irregularities that appeared on the surface, due, I was told, to the variable quality of the sand, to the minerals added to produce particular colors. Figure 8 shows one such ancient vessel of blown glass, which has survived, intact, well more than a millennium beyond the life of its maker.

Antiquities are evidence of life before us. They exist outside modern aesthetic notions of the beautiful, which often assume a certain version of the classical, ideas of harmony, decorum, and balance that refer to the high cultures of Greek and Roman antiquity. In ancient objects we see not just the beautiful but also evidence of human history, of hands, labor, workers, artisans, and slaves. And for me, the objects of everyday life, signs of human beings who preceded us in the production and labor and use of things, create passionate interest and attachment. The objects of everyday life excite my passion as a scholar because they connect the present with the past; they evoke the desire which is the modern form of passion. Ancient objects implicitly and tacitly record the labor and effort and even pain of long-dead ancient people, their passion, in the sense of suffering. And the objects themselves, having endured through centuries of human handling or loss, come to embody that passion.

Notes

1. Henry George Liddell and Robert Scott, *A Greek-English Lexicon,* 9th ed. (Oxford: Clarendon, 1958), s.v. "πάθος."

2. *Oxford English Dictionary,* 2d ed., prepared by J. A. Simpson and E. S. C. Weiner (Oxford: Clarendon, 1989), s.v. "passion."

3. Walter Benjamin, "One-Way Street," in idem, *One-Way Street and Other Writings,* trans. Edmund Jephcott and Kingsley Shorter (London: Verso, 1997), "No. 113," 47.

4. Ian Jenkins, *Greek and Roman Life* (London: British Museum Publications, 1986), 70.

5. Anne Pearson, *Everyday Life in Ancient Greece* (New York: Franklin Watts, 1994), 14.

6. Marjorie Quennell and Charles Henry Bourne Quennell, *Everyday Things in Ancient Greece: Homeric, Archaic, and Classical* (London: B. T. Batsford, 1930–33), 1:173.

7. Henri Lefebvre, "The Everyday and Everydayness," trans. Christine Levich, Kristin Ross, and Alice Kaplan, *Yale French Studies* 73 (1987): 7–11.

8. Lefebvre, "The Everyday" (note 7), 7.

9. Lefebvre, "The Everyday" (note 7), 8.

10. Lefebvre, "The Everyday" (note 7), 9–10.

11. See Sigmund Freud, *The Psychopathology of Everyday Life,* ed. James Strachey, trans. Alan Tyson (New York: W. W. Norton, 1966).

12. See Fernand Braudel, *The Structures of Everyday Life: The Limits of the Possible,* trans. Siân Reynolds (New York: Harper & Row, 1981).

13. See Michel de Certeau, *The Practice of Everyday Life,* trans. Steven Rendall (Berkeley: Univ. of California Press, 1984).

14. Sophocles, *Oedipus at Colonus,* in David Grene and Richard Lattimore, eds., *The Complete Greek Tragedies* (Chicago: Univ. of Chicago Press, 1992), vol. 2, ll. 768–802.

15. For a discussion of the symbolic connection between the ephebe and the olive tree, see Marcel Detienne, "Un éphèbe, un olivier," in idem, *L'écriture d'Orphée* (Paris: Gallimard, 1989), 71–84.

16. Aristophanes, *The Clouds,* trans. Benjamin Bickley Rogers (Cambridge: Harvard Univ. Press, 1924), ll. 96–97.

17. See Page du Bois, *Sowing the Body: Psychoanalysis and Ancient Representations of Women* (Chicago: Univ. of Chicago Press, 1988).

18. Herodotus, *The Histories,* trans. Aubrey de Sélincourt, rev. A. R. Burn (London: Penguin, 1972), 5.92.

19. Aeschylus, *Eumenides,* in David Grene and Richard Lattimore, eds., *The Complete Greek Tragedies* (Chicago: Univ. of Chicago Press, 1992), vol. 1, ll. 937–42.

20. Aristophanes, *The Acharnians,* trans. Jeffrey Henderson (Cambridge: Harvard Univ. Press, 1998), ll. 28–33.

21. Herodas, *Mimiambi,* trans. Ian Campbell Cunningham (Oxford: Clarendon, 1971), 6.69–73.

22. Ian Morris, "Archaeologies of Greece," in idem, ed., *Classical Greece: Ancient Histories and Modern Archaeologies* (Cambridge: Cambridge Univ. Press, 1994), 46.

23. Edward Miller, *That Noble Cabinet: A History of the British Museum* (London: Deutsch, 1973), 309.

24. François Lissarrague, *The Aesthetics of the Greek Banquet: Images of Wine and Ritual,* trans. Andrew Szegedy-Maszak (Princeton: Princeton Univ. Press, 1990). First published in French as *Un flot d'images: Une esthetique du banquet grec* (Paris: A. Biro, 1987).

25. J. M. Roberts, *The Penguin History of the World,* 3rd ed. (London: Penguin, 1995), 22.

26. See E. Marianne Stern and Birgit Schlick-Nolte, *Early Glass of the Ancient World: 1600 B.C.–A.D. 50* (Ostfildern: Gerd Hatje, 1994).

27. See Lesley Stern, *The Smoking Book* (Chicago: Univ. of Chicago Press, 1999), 222.

Biographical Notes on the Contributors

Horst Bredekamp is professor of art history at Humboldt Universität zu Berlin. He has published widely on iconoclasm, medieval sculpture, the Renaissance and mannerism, political iconography, and new media. Among his works translated into English are *The Lure of Antiquity and the Cult of the Machine: The Kunstkammer and the Evolution of Nature, Art, and Technology* (1995) and *Sandro Botticelli: The Drawings for Dante's* Divine Comedy (2000).

Page du Bois is professor of classics and comparative literature at the University of California, San Diego. She has many publications addressing issues of gender and the body in classical culture, including *Sowing the Body: Psychoanalysis and Ancient Representations of Women* (1988), *Torture and Truth* (1991), *Sappho Is Burning* (1995), and *Trojan Horses: Saving the Classics from Conservatives* (2001). She is currently working on *Slaves and Other Objects,* in which she discusses the role of slaves in classical Athens.

Martha Feldman is associate professor of music at the University of Chicago. A specialist in sixteenth-century madrigals and literature, eighteenth-century opera, and Elizabethan music and poetry, in 2001 she received the Dent Medal of the Royal Musical Association for outstanding contributions to musicology. She is the author of *City Culture and the Madrigal at Venice* (1995) and is currently completing *Opera and Sovereignty: Sentiment, Salvation, and Modernity, 1759–1797,* which is an analysis of the changing relations between absolutism, opera, and emotion.

Stefan Jonsson is an independent scholar and writer. His most recent books are *Subject without Nation: Robert Musil and the History of Modern Identity* (2000) and *The Center of the World: An essay on Globalization* (2001). He is currently working on a project about political passions and theories of the masses and mass insanity. He is senior literary critic for Sweden's major newspaper, *Dagens Nyheter.*

Elizabeth Liebman is a doctoral candidate in art history at the University of Chicago. Trained as a studio artist, she has worked as a scientific illustrator for many American and European museums, including the Institute of

Human Origins in Berkeley, the American Museum of Natural History in New York City, and the Muséum national d'histoire naturelle and the Collège de France in Paris. Her dissertation focuses on the representation of nature in published art of the eighteenth century.

Carol Mavor is professor of art history at the University of North Carolina, Chapel Hill. She has published *Pleasures Taken: Performances of Sexuality and Loss in Victorian Photographs* (1995) and *Becoming: The Photographs of Clementina, Viscountess Hawarden* (1999). She is currently working on a book entitled *Reading Boyishly* which continues her studies on the representation of childhood and sexuality through an examination of the works of J. M. Barrie, Roland Barthes, Jacques-Henri Lartigue, Marcel Proust, and D. W. Winnicott.

Teresa McKenna is associate professor of English and American Studies and Ethnicity at the University of Southern California, where she also has served as director of Chicano and Latino Studies. She pursues her research interests in the politics of representation, critical theory, and the contemporary novel within a comparative framework of the languages and literatures of English, Spanish, and Italian. Her publications include several articles, two edited collections, an exhibition catalog, and the book *Migrant Song: Politics and Process in Contemporary Chicano Literature* (1997).

Richard Meyer is associate professor of art history at the University of Southern California, where he received the Albert S. Raubenheimer Award for teaching, research, and service in 1999. He is the author of *Outlaw Representation: Censorship and Homosexuality in Twentieth-Century American Art* (2002) and is currently working on a study of underground images entitled *Secret Histories of Art*.

Anne and Patrick Poirier are visual artists who have built a body of work over the past thirty years based on archaeological, architectural, and cultural ruins, real and imaginary. Their sculptures and installations exploring the links between past and present, memory and material, have been exhibited at the Venice Biennale and Documenta V Kassel in Germany, as well as at museums and galleries in Australia, Canada, Europe, Japan, and the United States.

David Román is associate professor of English and American Studies at the University of Southern California. He is the author of *Acts of Intervention: Performance, Gay Culture, and AIDS* (1998) and coeditor of *O Solo Homo: The New Queer Performance* (with Holly Hughes, 1998). His book *Downtown and Elsewhere: A Luis Alfaro Reader* is forthcoming.

Debora Silverman is professor of history and art history at the University of California, Los Angeles, where she holds the University of California

President's Chair in Modern European History, Art, and Culture. Her publications include *Selling Culture: Bloomingdale's, Diana Vreeland, and the New Aristocracy of Taste in Reagan's America* (1986), *Art Nouveau in Fin-de-Siècle France: Politics, Psychology, and Style* (1989), and the award-winning study *Van Gogh and Gauguin: The Search for Sacred Art* (2000).

David Summers is William R. Kenan Jr. Professor of the History of Art in the McIntire Department of Art at the University of Virginia. He is the author of *Michelangelo and the Language of Art* (1981), *The Judgment of Sense: Renaissance Naturalism and the Rise of Aesthetics* (1987), and *Real Spaces: World Art History and the Rise of Western Modernism* (2003).

Bill Viola is a pioneer in the medium of video art whose work explores the spiritual and perceptual side of human experience. Recipient of numerous awards and honors, including a 1989 MacArthur Fellowship, he has created over 125 videotapes and multimedia installations, which have been seen in galleries and museums worldwide and on public television. In 1997 the Whitney Museum of American Art organized a twenty-five-year survey of his work that traveled to major museums in the United States and Europe.

Illustration Credits

The following sources have granted permission to reproduce illustrations in this book:

Index

Issues & Debates
A Series of the Getty Research Institute Publications Program

In Print

Art in History/History in Art: Studies in Seventeenth-Century Dutch Culture
Edited by David Freedberg and Jan de Vries
ISBN 0-89236-201-4 (hardcover), ISBN 0-89236-200-6 (paper)

American Icons: Transatlantic Perspectives on Eighteenth- and Nineteenth-Century American Art
Edited by Thomas W. Gaehtgens and Heinz Ickstadt
ISBN 0-89236-246-4 (hardcover), ISBN 0-89236-247-2 (paper)

Otto Wagner: Reflections on the Raiment of Modernity
Edited by Harry Francis Mallgrave
ISBN 0-89236-258-8 (hardcover), ISBN 0-89236-257-X (paper)

Censorship and Silencing: Practices of Cultural Regulation
Edited by Robert C. Post
ISBN 0-89236-484-X (paper)

Dosso's Fate: Painting and Court Culture in Renaissance Italy
Edited by Luisa Ciammitti, Steven F. Ostrow, and Salvatore Settis
ISBN 0-89236-505-6 (paper)

Nietzsche and "An Architecture of Our Minds"
Edited by Alexandre Kostka and Irving Wohlfarth
ISBN 0-89236-485-8 (paper)

Disturbing Remains: Memory, History, and Crisis in the Twentieth Century
Edited by Michael S. Roth and Charles G. Salas
ISBN 0-89236-538-2 (paper)

Looking for Los Angeles: Architecture, Film, Photography, and the Urban Landscape
Edited by Charles G. Salas and Michael S. Roth
ISBN 0-89236-616-8 (paper)

The Archaeology of Colonialism
Edited by Claire L. Lyons and John K. Papadopoulos
ISBN 0-89236-635-4 (paper)

Claiming the Stones/Naming the Bones: Cultural Property and the Negotiation of National and Ethnic Identity
Edited by Elazar Barkan and Ronald Bush
ISBN 0-89236-673-7 (paper)

In Preparation

Situating El Lissitzky: Vitebsk, Berlin, Moscow
Edited by Nancy Perloff and Brian Reed
ISBN 0-89236-677-X (paper)

Designed by Bruce Mau Design Inc.,
Bruce Mau with Chris Rowat and Daiva Villa
Coordinated by Anita Keys
Type composed by Archetype in Sabon and News Gothic
Printed and bound by Transcontinental, Litho Acme, Montreal,
on Cougar Opaque and Centura Matte

Issues & Debates
Series designed by Bruce Mau Design Inc., Toronto, Canada